THE PORCELAIN THIEF

THE PORCELAIN THIEF

Searching the Middle Kingdom for Buried China

HUAN HSU

FOURTH ESTATE • *London*

Fourth Estate
HarperCollins Publishers
1 London Bridge Street
London SE1 9GF
www.4thestate.co.uk

First published in Great Britain by Fourth Estate in 2015
First published in the United States by Crown in 2015

1 3 5 7 9 8 6 4 2

A catalogue record for this book is
available from the British Library

Hardback ISBN 978-0-00-747943-6
Trade paperback ISBN 978-0-00-758092-7

Book design by Lauren Dong
Maps by Jeffrey L. Ward

Printed and bound in Great Britain by
Clays Ltd, St Ives plc

MIX
Paper from
responsible sources
FSC
www.fsc.org
FSC™ C007454

To my family,

the treasure I always had,

and to Jennifer,

the treasure I never expected to find

Contents

Author's Note *ix*

Family Tree *xi*

Map 1 *China: My Journey* *xii*

Map 2 *Liu Feng Shu's Journey* *xiv*

Map 3 *Poyang Floodplain* *xv*

PROLOGUE 1

1 THIS IS CHINA *7*

2 A CHICKEN TALKING WITH A DUCK *58*

3 LIU FENG SHU *76*

4 PANDA CHINESE *97*

5 THE ORPHAN *107*

6 STREET FIGHT *115*

7 JOURNEY TO THE WEST *125*

8 THE REAL CHINA *132*

9 END OF PARADISE *156*

10 FROM FAR FORMOSA *161*

11 CITY ON FIRE *172*

12 FALLING LEAVES RETURN TO THEIR ROOTS *234*

13 ALL DEATH IS A HOMECOMING *238*

14 NANJING *246*

15 NORTHERN EXPEDITION *257*

16 A STUMBLE FROM WHICH THERE IS NO
RECOVERING *294*

17 THE NINE RIVERS *299*

18 THE LONG VALLEY *310*

19 XINGANG MARKS THE SPOT *318*

20 CHASING THE MOON FROM THE BOTTOM OF
THE SEA *324*

A Note on Sources 365

Acknowledgments 367

Index 371

AUTHOR'S NOTE

THIS BOOK RECOUNTS MY TIME IN CHINA FROM 2007 TO 2010, and then the summer and fall of 2011. Although this is a work of nonfiction, any attempt to reconstruct recent history is inherently subjective, and my guiding principle was to tell a coherent story about China, my family, and my search for my great-great-grandfather's buried porcelain. Many of the people and places in this book were visited a number of times over many years. For the sake of narrative logic, I have in some instances compressed the time between these encounters, omitted extraneous details, or explained information out of time with its revelation to me. However, descriptions of people, places, or encounters themselves have not been altered, and the dialogue was recorded either as it happened or soon thereafter.

A word on translations: Many of my conversations with Chinese speakers took place in Mandarin Chinese. When translating the conversations, I tried to be faithful to my partner's intended meaning and re-create it as I understood it in everyday English while also preserving the unique qualities of their speech. The instances where Chinese speakers use English are noted as such. I have used pinyin transliterations except for names commonly spelled otherwise, such as Chiang Kai-shek, Sun Yat-sen, and the members of my family who write their names according to Wade-Giles conventions.

Chinese kinship terms are manifold and complicated; depending

on the relationship, each family member has a unique term by which they are called. I have simplified this by referring to characters either by their given names or according to their relationship to me, except for San Gu, my grandmother's aunt. Full Chinese names are written with the surname first, followed by the given name.

Finally, all dates have been converted from the lunar calendar to the Gregorian calendar. And the conversion rate for Chinese RMB to U.S. dollars for this book is 7:1.

[FAMILY TREE]

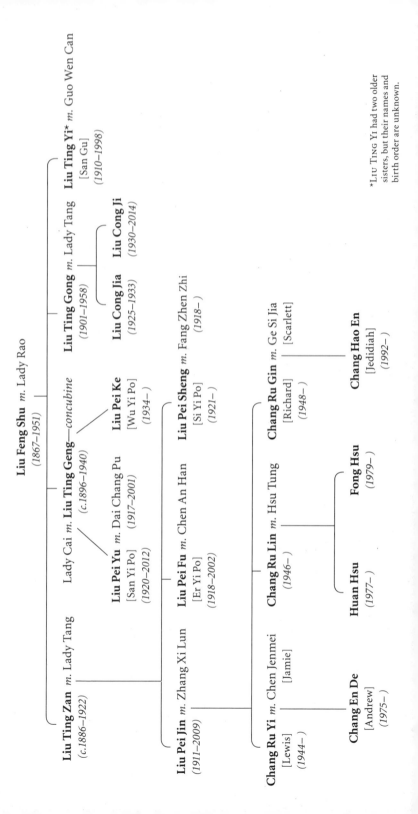

Liu Feng Shu *m.* Lady Rao
(1867–1951)

Liu Ting Zan *m.* Lady Tang
(c.1886–1922)

Lady Cai *m.* **Liu Ting Geng**—*concubine*
(c.1896–1940)

Liu Ting Gong *m.* Lady Tang
(1901–1958)

Liu Ting Yi* *m.* Guo Wen Can
[San Gu]
(1910–1998)

Liu Pei Yu *m.* Dai Chang Pu
[San Yi Po]
(1920–2012)

Liu Pei Ke
[Wu Yi Po]
(1934–)

Liu Cong Jia
(1925–1933)

Liu Cong Ji
(1930–2014)

Liu Pei Jin *m.* Zhang Xi Lun
(1911–2009)

Liu Pei Fu *m.* Chen An Han
[Er Yi Po]
(1918–2002)

Liu Pei Sheng *m.* Fang Zhen Zhi
[Si Yi Po]
(1921–)

Chang Ru Yi *m.* Chen Jenmei
[Lewis] [Jamie]
(1944–)

Chang Ru Lin *m.* Hsu Tung
(1946–)

Chang Ru Gin *m.* Ge Si Jia
[Richard] [Scarlett]
(1948–)

Chang En De
[Andrew]
(1975–)

Huan Hsu
(1977–)

Fong Hsu
(1979–)

Chang Hao En
[Jedidiah]
(1992–)

*Liu Ting Yi had two older
sisters, but their names and
birth order are unknown.

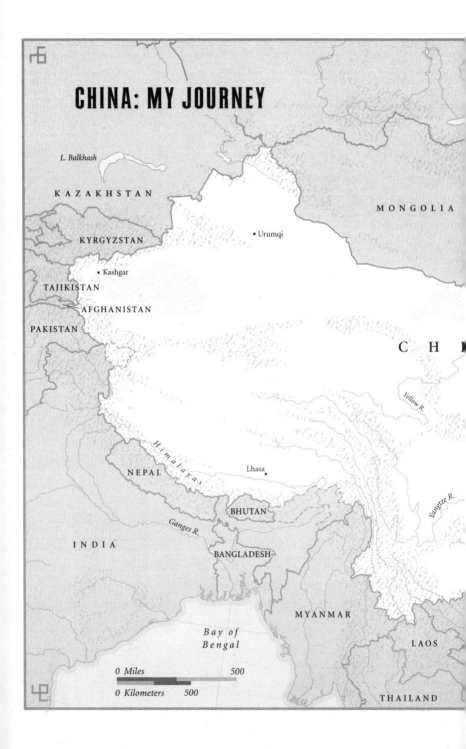

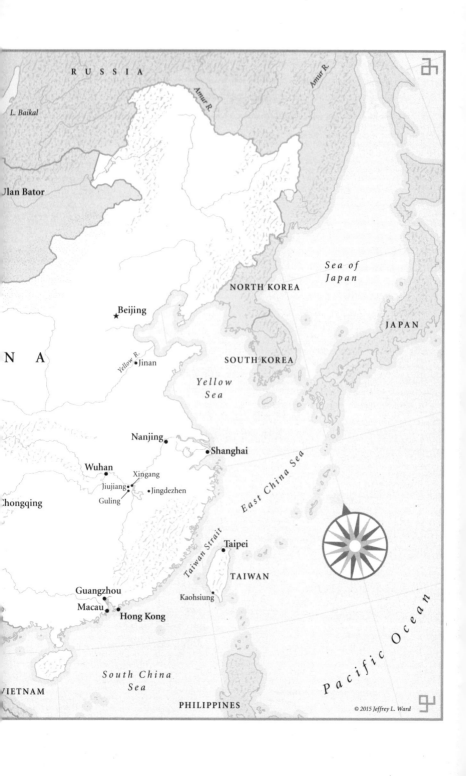

RUSSIA

L. Baikal

Amur R.

Amur R.

Ulan Bator

Sea of
Japan

NORTH KOREA

Beijing

JAPAN

Yellow R.

Jinan

SOUTH KOREA

N A

Yellow
Sea

Nanjing

Shanghai

Wuhan

Xingang

East China Sea

Jiujiang

Jingdezhen

Chongqing

Guling

Taiwan Strait

Taipei

TAIWAN

Guangzhou

Kaohsiung

Macau

Hong Kong

Pacific Ocean

South China
Sea

VIETNAM

PHILIPPINES

© 2015 Jeffrey L. Ward

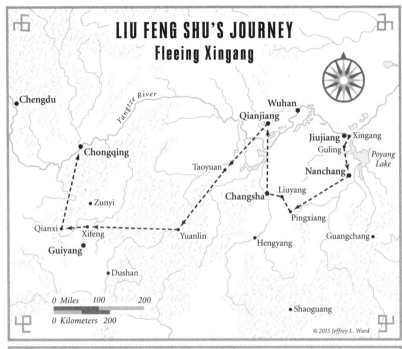

LIU FENG SHU'S JOURNEY
Fleeing Xingang

Chengdu

Yangtze River

Wuhan

Qianjiang

Jiujiang • Xingang

Guling

Poyang Lake

Chongqing

Taoyuan

Nanchang

Zunyi

Liuyang

Changsha

Qianxi

Xifeng

Yuanlin

Pingxiang

Guiyang

Hengyang

Guangchang

Dushan

0 Miles 100 200

0 Kilometers 200

Shaoguang

© 2015 Jeffrey L. Ward

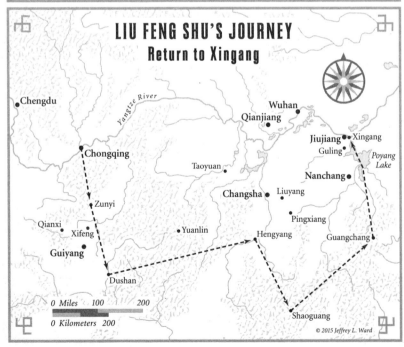

LIU FENG SHU'S JOURNEY
Return to Xingang

Chengdu

Yangtze River

Wuhan

Qianjiang

Jiujiang • Xingang

Guling

Poyang Lake

Chongqing

Taoyuan

Nanchang

Zunyi

Changsha

Liuyang

Qianxi

Xifeng

Yuanlin

Pingxiang

Guiyang

Hengyang

Guangchang

Dushan

Shaoguang

0 Miles 100 200

0 Kilometers 200

© 2015 Jeffrey L. Ward

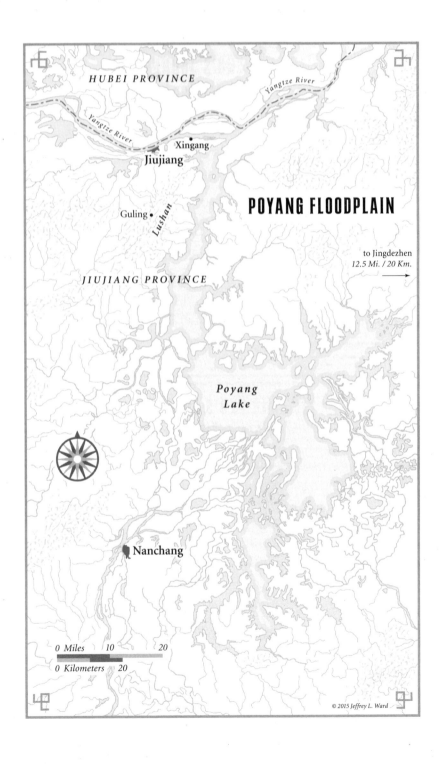

HUBEI PROVINCE

Yangtze River

Yangtze River

Xingang

Jiujiang

POYANG FLOODPLAIN

Guling

Lushan

to Jingdezhen
12.5 Mi. / 20 Km.

JIUJIANG PROVINCE

Poyang
Lake

Nanchang

0 Miles 10 20

0 Kilometers 20

© 2015 Jeffrey L. Ward

THE PORCELAIN THIEF

PROLOGUE

T HE FIRST SIGN OF TROUBLE CAME IN THE SPRING OF 1938. On the tails of the snow cranes leaving their wintering grounds in the Poyang Lake estuary, Japanese planes appeared in the sky, tracing confused circles as if they had lost their flock. It soon became clear that these reconnaissance planes were not stragglers but the vanguard for another kind of migration. After taking Beijing, Shanghai, and Nanjing, the Japanese army advanced through China not like a spreading pool of water but like a gloved hand, and in the summer of 1938 its middle finger traced up the Yangtze River toward my great-great-grandfather Liu Feng Shu's village of Xingang.

Liu presided over one of the most prominent families in Xingang, situated on a spit separating the Yangtze River and Poyang Lake, China's largest freshwater body, like a valve. His estate included most of the arable land along the river, worked by a small army of sharecroppers, and a number of residences at the western edge of the village, the largest being his own. Guarded by a trio of stately pine trees, the sprawling stone abode fronted the road heading into the nearby city of Jiujiang, a major trading and customs port. There lived a coterie of daughters-in-law, grandchildren, and servants; the eldest of Liu's three sons, my great-grandfather, died of tuberculosis in his thirties, and his school-aged children, as well as those of Liu's surviving sons, lived with him while their fathers worked elsewhere in the

province, a common arrangement in Chinese families. My great-great-grandfather filled the rooms with objets d'art befitting a scholar who had passed the imperial civil service exam, including his prized collection of antique porcelain. Accumulated by the crate, some of the items dated back hundreds of years to the Ming dynasty and had once belonged to emperors, and for all my great-great-grandfather's other forms of wealth, these heirlooms, as enduring as they were exquisite, best represented the apogee of both family and country. Across the road, beyond the communal fishpond, dug into a hill that gathered the setting sun, was the cemetery where eleven generations of his ancestors kept watch over his prosperity.

As the summer went on, phalanxes of Japanese bombers soared over Liu's fields to drop ordnance on westerly cities, unencumbered by a Chinese army with pitiful air defenses. According to the newspapers that Liu picked up in the mornings from the general store down the road, Republic of China president Chiang Kai-shek was prepared to stage a vicious defense of Jiujiang and had nearly one million troops dug in along the Yangtze. The presence of Chinese soldiers became a regular sight in Xingang, if not a welcome one, given the Nationalist army's reputation for incompetence and venality.

And now Chinese soldiers had taken up residence in Liu's house. Despite outnumbering the Japanese three to one, the Chinese resistance lasted mere days. Xingang stood in the path of the retreat, and the army had no qualms about demanding food and board from the local gentry. The rice and firewood that Liu had set out for them was not enough, the soldiers said. They eyed the house's heavy door bar and prepared to hack it apart for fuel. "You can't use that for kindling," Liu protested. "We need it to lock our door."

The argument turned physical, and a pair of soldiers began to beat Liu with a stick. Three of his granddaughters had been herded into a back room out of sight of the soldiers and watched the commotion from a window, horrified, until they couldn't bear it anymore. Pei Fu, the oldest one still at home, newly graduated from a Methodist

boarding school, instructed Pei Yu, not yet a teenager, to run into the village and fetch the elders. Then she and Pei Sheng, the second youngest but the boldest, sprinted into the fray, jumping on the soldiers' backs and thrashing them while they tried to pull their grandfather away. "You guys fought so poorly, ran away from the battle, and you still dare to hit an old man?" Pei Sheng shouted. "No wonder you're losing the war!"

Pei Yu found the elders, who alerted the commanding officers, and all parties converged on the house. The girls explained what they had witnessed, and the elders vouched for the girls. The chagrined commanders forced the offending soldiers onto their knees before Liu and offered to execute them. "Oh, don't kill anyone," Liu said. "That's not right, either. You come here and we give you food, a place to stay, and you act badly. As long as you understand what you did wrong, that's enough." He made them kowtow and apologize, and for the rest of their stay, the soldiers didn't even dare to touch the firewood left out for them without first asking. "We're afraid of what the three tigresses might do," they said.

My great-great-grandfather was not naïve about war. In midlife he had witnessed the end of dynastic China and the birth of a republic when revolutionaries overthrew the Qing monarchy in 1911, ending more than two thousand years of imperial rule. Ten years before the Japanese encroached, Chiang Kai-shek's campaign against local warlords had swept through the area, followed by sporadic skirmishes between Chiang's Nationalists and the upstart Communists. Each time *feng liu yun san*, "the winds flowed and the clouds scattered"; the crisis passed. Liu's wealth and land holdings continued to grow. Still, his blood curdled from the reports of Japanese soldiers *sha ren ru ma*, "killing people like scything grass," in occupied cities. He especially feared for the granddaughters still living with him at home. Most of the village men of fighting age had already left home, eager to avoid death by the Japanese or, worse, conscription into the Chinese army. Liu was a widower in his seventies and could hardly be counted

upon to protect his family. As he debated whether to flee everything he had spent a lifetime achieving, he must have wondered if perhaps this time things would not return to normal.

His eldest granddaughter—my grandmother—was safe, ensconced in neutral Macau as a high school chemistry teacher at a missionary school. He allowed Pei Fu, the second oldest and my grandmother's middle sister, to marry into a family he despised, figuring a woman wedded to a good-for-nothing was still safer than remaining unmarried during wartime. He had already sent away his one grandson, the sole heir to the family fortune, with his youngest daughter, another science teacher whose local missionary school had relocated to the Chinese interior. That left my grandmother's youngest sister, two of her cousins, a daughter-in-law, and a long-serving footman, Old Yang.

When the soldiers moved on, Liu and Old Yang waited for the sun to set and went into the garden with shovels and picks. Over the next few nights, they removed a patch of flax and dug a large hole, deeper than a man was tall and as wide as a bedroom, and lined the walls with bamboo shelving. Working by moonlight after the village had gone to sleep, they filled the vault with the family's heirlooms: intricately carved antique furniture, jades, bronzes, paintings, scrolls of calligraphy, and finally, Liu's beloved porcelain collection. Vases of every shape and size; painted tiles of Chinese landscapes; hat stands; figurines of the Fu Lu Shou, the trio of Buddhist gods that represented good fortune, longevity, and prosperity; decorative jars, plates, and bowls; tea sets; the dowries for his granddaughters. Liu and Old Yang packed the porcelain in woven baskets lined with straw, and once the vault could hold no more, they sealed it with boards, covered it with soil, and replanted the flax.

A few nights after the burial was completed, Liu heard a knock on his door. He opened it to find a raggedy Chinese soldier, who asked if he could spare something to eat. Liu took him in and fed him. The soldier ate as if it were his first meal in weeks. When he finished, he

looked up from his bowl. "Mister, is your family still here?" the soldier asked.

"Yes, they are," Liu said.

"Why have you not left yet?" the soldier said. "The city has fallen. The Japanese are here."

The next morning the family packed as much jewelry and silver coins as they could fit into their pockets and bundled their clothes in knapsacks. They stuffed winter and summer clothing for five people into a woven basket that Old Yang, who had no family but for the Lius, carried on a bamboo shoulder pole. The thousands of extra silver dollars that were too heavy to carry were thrown into jars and buried in a hastily dug hole in the floor of the living room. Then my great-great-grandfather barricaded the heavy front doors and joined the Chinese retreat.

Seventy years later I went to China to find what he buried.

THIS IS CHINA

F MY PARENTS EVER TOLD ME ABOUT MY GREAT-GREAT-grandfather's buried porcelain, it had never registered. Growing up in Utah, I paid little attention to family stories, most of which concerned overcoming hardships that I, preoccupied with overcoming my own hardship of being Chinese and non-Mormon in Salt Lake City, couldn't relate to and didn't care to hear about. Any reminders of my family history only impeded my goal of being as American as possible or, short of that, as un-Chinese as possible, a rebellion that included working harder at sports than math and refusing to apply to Harvard. As far as I was concerned, the Chinese people in my life, with their loud, angry-sounding manner of speaking and odd habits, were from another planet and had traveled to Earth for the sole purpose of embarrassing me.

But I always loved to dig, and as a child I made many holes in the backyard looking for arrowheads or fossils, usually giving up once I hit a thick layer of clay a few feet down, which was about the same time my mother noticed what I was doing to her lawn, anyway. As I got older, this preoccupation manifested itself in searching for things thought lost, nonexistent, or impossible to find. I spent most of my time in an MFA program ignoring my classmates' suggestions to write about being Chinese, instead researching the unique discovery of an antibiotic during World War II—it was isolated in the tissue

of a little girl who had been hit by a car—and trying to track down that girl. As a journalist, some of my favorite stories also involved hunting: looking for edible mushrooms in city parks, poking around the storerooms of Washington, D.C., institutions for forgotten art, stalking pickpockets with undercover police, and profiling an obsessive amateur archaeologist cataloging the Paleo-Indian history of his neighborhood (with whom I participated in a number of surreptitious excavations, satisfying an old itch).

After taking a job at the *Seattle Weekly,* I visited the Seattle Art Museum for a story and found myself drawn to SAM's Chinese porcelain collection. My parents never owned any such porcelain, and my encounters with it were limited to mentions of Ming vases (always pronounced "vahz") as signifiers of wealth in pop culture, but perhaps because I had just moved to my fourth city in seven years, the collection elicited some subconscious familiarity with it. My favorite object was a little red "chrysanthemum" dish, about six inches in diameter, with scalloped edges that caught the light in a way that rendered them almost translucent. Decorated with a square of sixty-four gold Chinese characters, all the SAM curators could tell me was that it had been fired sometime in the late eighteenth century.

Since the SAM curators had never bothered to translate the text, I called my father, a physics professor who, just for fun, once spent a sabbatical summer doing conservation work at Chicago's Field Museum. His nerdiness caused me no small amount of anguish when I was young (he wore a pocket protector well into my high school years), but he was also the exact kind of nerd who could translate the dish for me.

The poem, my father told me, had been penned by the owner of the plate, the fifth emperor of the Qing dynasty, Qianlong, and was a paean to the makers and craftsmanship of the dish. And because my father is incapable of answering any question without first fully contextualizing the answer in the most pedantic way possible, he went on to explain that Qianlong was known for leaving his mark, in the

form of calligraphy, stamps, and poems, on many precious pieces of art—a common practice among Chinese collectors. "His calligraphy was okay," my father said, "but he is not remembered as a poet."

Qianlong was one of the great figures in Chinese history, both a successful military leader who expanded China's territory by millions of square miles and a devoted patron of the arts. He commissioned one of the most ambitious literary projects in Chinese history, the creation of a library of classic Chinese texts, and fancied himself a bard. During his reign the imperial kilns in Jingdezhen, about ninety miles east of my great-great-grandfather's village and the center of world porcelain production, reached their zenith in technology and quality. But Qianlong was also famously sinocentric, refusing to increase trade with the West, and rejecting the Industrial Revolution as a fad and Western technology as toys. At the height of Qianlong's rule, China was the richest country in the world by a wide margin. When he died in 1799, his treasury was empty, porcelain exports to Europe had all but stopped, and centuries of progress and innovation were undone, setting China on course for humiliating defeats in the Opium Wars, the Sino-Japanese Wars, massive domestic rebellions, and finally, the overthrow of the Qing dynasty and the eventual rise of Communism.

"One more thing," my father said before we hung up. "Your mother's family had some porcelain. You should ask her about it."

Once my mother told me the story of my great-great-grandfather's porcelain, Qianlong's crimson plate, a burst of bloody color amid the mostly white pieces surrounding it, became more than just an example of the imperial porcelain that my family might have owned. It was the beginning of an epic narrative that began with my family's buried heritage and extended to my standing there in a Seattle museum surrounded by ceramics that, for all I knew, might have once passed through my great-great-grandfather's hands. Here was the house of Liu, ascending nicely through post-imperial China, when the Japanese invaded and they lost everything. The guns had barely cooled

from that conflict when the Communists took over, and my family lost everything again when they fled to Taiwan. In Taiwan my grandmother started from nothing once more, scrimping and saving to send her children to college in America, where things like Communist takeovers didn't happen. The longer I looked at that red chrysanthemum plate, the more I wanted to touch it, feel its weight, and run my fingers over its edge, which, like its country's—and my family's—history, was anything but smooth.

I harangued my mother for more details: How much porcelain and silver was buried? Were there really imperial pieces in the collection? Had anyone ever tried to dig it up? *What happened to it?* But to my surprise and consternation, neither my mother nor her two brothers, who had all been born on mainland China, emigrated to Taiwan as children, and emigrated again to the United States for graduate school, knew or cared much about this part of their history.

My best source of information, my mother said, would be my ninety-six-year-old grandmother, who had returned to China after my grandfather died to live with my uncle Richard. The youngest and most evangelical Christian of my mother's siblings, Richard had started out as an engineer at Texas Instruments and risen to a management position setting up manufacturing facilities in Europe. At age fifty, after spending two decades with Texas Instruments, having built his dream house in a north Dallas suburb where one of his neighbors was the quarterback for the Dallas Cowboys, he took an early retirement and established a semiconductor foundry in Taiwan called Worldwide Semiconductor Manufacturing Corporation, or WSMC. Richard served as the president of WSMC until 1999, when he sold the company to Taiwan Semiconductor Manufacturing Corporation, or TSMC, the behemoth global leader whose market cap was nearly 30 percent of Taiwan's gross domestic product, for $515 million. In its report on the deal, *The Wall Street Journal* dubbed Richard the "Taiwanese Tycoon."

On that same day he claimed to have received a vision from God

to start a similar company on mainland China as a way of both developing its high-tech industry and spreading the gospel there. With a $1 billion investment from the Chinese government, and plenty more from top venture capital firms, Richard installed himself as president and CEO and named his new enterprise Semiconductor Manufacturing International Corporation, or SMIC. He broke ground on his venture in Shanghai while I was finishing up college and heading off to work at my first job, in a high-tech public relations agency in San Francisco, and he asked me to work for him every chance he got. My mother posited that he wanted me as his assistant, where I would learn the company and eventually take over for him. The stock options alone should have been enticing enough, but I demurred each time, not interested in the work, the industry, or China. My other uncle, Lewis, bought up as many pre-IPO shares as he could, and the general sentiment was that the stock could double, even triple, its initial price. Lewis would sometimes phone my mother just to berate her for not forcing me to join the company. "There's a million dollars right there in front of him," he'd howl, "and he can't be bothered to bend over and pick it up!"

Ten years later Richard's company boasted twelve thousand employees and manufacturing facilities in Shanghai, Tianjin, Beijing, and Chengdu, along with another fab—short for "fabrication facility"—under construction in Shenzhen; offices in Tokyo, Milan, Silicon Valley, Hong Kong, and Taiwan; and a $1.8 billion initial public offering on the New York Stock Exchange (my aunt Scarlett helped ring the opening bell), larger than Google, which went public the same year. In the same spirit as the Methodists who had educated my grandmother nearly a century earlier, Richard built schools, health centers, and churches across China, all with the tacit approval of the Communist regime that my grandparents, scientists who researched weapons-grade ores for Chiang Kai-shek's Nationalist army, had fought against.

Because I could barely speak Chinese, and my grandmother,

despite having graduated from a missionary boarding school and college, had never demonstrated much ability with English, I conscripted my mother to ask my grandmother questions about the porcelain and report back the answers, an imperfect arrangement that led to many outbursts over why my mother had not asked the obvious follow-up question or clarified a detail. One day, after hearing one complaint too many, my mother heaved a sigh. "We're tired of trying to guess what you want to know," she told me. "Especially Grandma. She says you should just go to Shanghai and ask her these things yourself."

So I did. In 2007, equipped with only a few threads of a family legend and an irresistible compulsion to know more about it, I moved to China to find out what happened to my great-great-grandfather's buried treasure. In order to obtain a long-term visa, I contacted Richard for a job. I could sense his vindication over the phone, and I doubted he took me seriously when I insisted that I was going to China for the porcelain first and foremost. He must have figured that it would only be a matter of time before I came to my senses.

My plan was simple. I would work at Uncle Richard's company, take evening language classes to learn enough Chinese to speak with my grandmother about the porcelain, and use my weekends and holidays to look for it. Richard was notorious for paying low wages by American standards, but the cost of living in Shanghai was such that my monthly compensation—which included health insurance, three weeks of annual paid vacation, a biannual airfare allowance for trips home, reimbursement of moving costs, and heavily subsidized housing—could still fund the necessary travel, as long as I didn't try to live like the foreigners on expat packages. What the actual search would entail beyond talking to my grandmother remained nebulous, but I told my friends and family that I'd probably be back in the United States after a year.

✿ ✿ ✿

I ARRIVED IN SHANGHAI late one evening in August, connecting through Tokyo. As I walked through Narita to change planes, the Japanese had spoken Japanese to me. When I touched down at night at Pudong International, the Chinese spoke Chinese to me. I told everyone in English that I couldn't understand them, and they all looked at me like I was crazy.

Stepping out of the airplane, even well past sunset, felt like entering a greenhouse, the concentration of wet, stifling summer heat that would later coalesce into the rainy season. My cousin Andrew met me at the terminal with a driver. Andrew was almost two years older than me, born in Montreal. He had spent his early years in Singapore and Hong Kong while his father, Lewis, my mother's older brother, worked for a Thai multinational before the family settled in Texas, where, not knowing any better, Andrew showed up for his first day of elementary school in the Dallas suburbs wearing his Hong Kong schoolboy uniform: blazer, tie, Bermudas, knee socks, and loafers. He graduated from Baylor University with a philosophy degree and was an early pilgrim to Shanghai, joining our uncle's company in 2000, when it consisted of a circle of temporary trailers on a stretch of farmland east of the Huangpu River.

Andrew and I had always looked different, and mutual acquaintances often expressed surprise when they learned that we were related. One of the photo albums in my parents' house in Utah held a picture of the two of us as adolescents, building a sand castle at a Great Salt Lake beach, me, bow-legged and so scrawny that my protruding hipbones held up my swim trunks like an iliac clothes hanger, next to knock-kneed, heavyset Andrew wearing nothing but an unflattering Speedo and a grimace to keep his enormous eyeglasses from sliding down his nose.

When we were very young, our age difference was sufficient for him to know a lot more than me, and I was the one who annoyed him with elementary questions. I eventually caught up, literally, as

evidenced by the series of rules in the doorway of Richard's laundry room in Dallas, where our uncle had marked the heights of his nephews over the years. As our stature grew equal, our relationship also got more competitive. Andrew and I would stand back to back and argue who was on his toes or stretching his neck to make himself taller. In family photographs, he would stick his chest out and stand on his toes right as the shutter clicked, and it wasn't until I was back home that I found out he'd cheated. I had heard that he had taken up marathon running after moving to China and worked himself into terrific, almost unrecognizable shape. But he stopped training after contracting tuberculosis, and by the time we reunited in Shanghai, his body had sprung back to its original form.

The first thing Andrew said to me was "That long hair makes it seem like you're hiding something, like a physical deformity."

The second thing he said was "The sun has aged you. You look way older than your age."

We headed for the company living quarters in Zhangjiang, a district on the eastern outskirts of Shanghai, driving along a massive, well-lit, desolate freeway. Andrew had offered to let me stay in a spare room of his three-bedroom apartment in exchange for paying the utilities and the salary of the maid, or *ayi*—literally "auntie"—who came to clean three times a week. As we neared the living quarters, our route took us past the new church that our uncle had recently built, a cavernous glass-and-metal A-frame looming in the hazy glow of the streetlight, and I remarked that I had not seen it during my brief visit to the city three years earlier.

"We build things fast in Shanghai," the driver said.

"They seem to build things fast in all of China," I tried to say in Chinese, shaking my head.

I must have said something wrong, as the driver got defensive. "Yes, but we build things even faster in Shanghai," she said. She also mentioned that the church had been closed for a while due to structural concerns, as if the two observations were completely unrelated.

THE SUN ROSE EARLY and hot over the living quarters, a seventy-acre complex abutting a technology park on the edge of Shanghai's eastward urbanization as it churned through estuaries, villages, and farmland and left housing complexes, industrial parks, and manufacturing facilities in its wake. I didn't start work for another week and wanted to buy a voice recorder for when I talked to my grandmother, so Andrew took the day off and we headed into the city for one of Shanghai's massive electronics shopping malls.

The living quarters in Zhangjiang housed nearly six thousand employees and their families on a landscaped campus divided by one of the area's many canals. Every day elderly men set up along it with bamboo fishing rods curving over the water. On one side rose about sixty high-rise apartment buildings along with a health clinic, guest housing for visitors, an administrative center (including a control room for monitoring the video feeds from the dozens of closed-circuit cameras trained on the walkways), and three dormitories for the machine assistants, or MAs, largely young, single women with basic educations from rural provinces who worked in the fab, moving items from one step of the manufacturing process to the next. On the other side of the canal, accessed by a small footbridge or a separate guarded entrance, was the executive housing, a gated community of about fifty villas with private yards and two rows of townhouses. Camphor trees shaded the walkways, and in the fall the pomelo trees near the playground sagged with fruit, tempting residents to climb up or fashion makeshift pickers to get at them.

Across the street from the residential campus was one of the company's crown jewels, a bilingual K-through-12 private school headed by a former dean of Phillips Andover, and boasting all the facilities that a counterpart in America might have offered: a gymnasium with basketball and volleyball courts, a full-size running track, soccer fields that were repurposed into Little League baseball diamonds on

the weekends, even an observatory. Flanking the school was a community center where employees and their families could work out, play Ping-Pong, take classes, or swim in the Olympic-size pool, and a commercial strip of stores, beauty salons, and a rotating array of eateries. Two small supermarkets sold fresh fruits and vegetables, scary-looking meats, and a handful of imported goods, like peanut butter and grossly overpriced Häagen-Dazs ice cream. People in the surrounding farming villages still burned their garbage, and when the wind shifted, the smoke blew right into the living quarters.

A multicolored line of taxis waited outside the main gate. Andrew explained that each taxi company painted its fleet a different color, and we caught a sky-blue Volkswagen sedan; Andrew had noticed that its drivers tended to be the best, denoted by the stars printed on their licenses, though I later learned that those, like many, many other things in China, could be bought. The taxi ferried us to the nearest subway station, on the other side of the technology park, its wide, empty boulevards named after famous scientists in Chinese history and the cross streets named for Western scientists. Some blocks were more than a quarter of a mile long to accommodate the massive manufacturing facilities headquartered there, our uncle's being one of the largest. Street sweepers wearing sandals and reflective orange jumpsuits collected litter with handmade brooms and rickety carts at a languid pace. Many others dozed on the landscaped corners and medians, sprawled out as if dead.

After about three miles the taxi dropped us off at the Zhang-jiang Hi-Technology Park metro station, an elevated monstrosity of concrete and dirty white tiles strewn with garbage and vomit and crowded with vendors selling street food and pirated DVDs ("Porn, porn," one of them whispered to me as I walked past) and taxi touts angling for fares. The train zipped us over villages where small farm plots sat beside enormous, ever-growing mounds of trash, then dived underground as we approached the Huangpu River. Each time the train pulled into a station, passengers massed on both sides of the

doors and charged forward as soon as the doors opened, crashing into and off of each other until both groups somehow osmosed to the other side. Despite stationing attendants at the turnstiles wearing signs to be polite, stand in line, wait one's turn, and generally "be a cute Shanghai person," the Western idea of civility was all but absent in the subways. While riding public transportation, or in public spaces in general, the Chinese had the same sense of personal space as puppies, often literally piled on top of one another. On escalators they stood on whichever side pleased them. They stuffed elevator cars so tightly I wasn't sure everyone had their feet on the ground, and would often ride opposite their desired direction of travel just to ensure they got a space. Occasionally, on the less crowded trains, young men with spiky, chocolate-colored hair holding stacks of business cards advertising travel agencies would stride the length of the train and fling the cards onto the passengers, hitting each person's lap with the accuracy of a casino dealer. I found this kind of guerrilla marketing obnoxious, but the Chinese riders never objected, brushing off the card as they would a stray hair.

After thirty minutes we arrived at the East Nanjing Road station in the heart of the city. It was a bit of a stretch to call the place where I would be living and working Shanghai. Situated at the mouth of the Yangtze River and bisected by a tributary called the Huangpu River, Shanghai consists of two sections, Puxi, literally "west bank of the [Huangpu] river," and Pudong, "east bank of the [Huangpu] river." Historically, Puxi had been the city's cultural, economic, and residential center, and home to the nineteenth-century colonial concessions that included the Bund, the mile-long stretch along the river where Western architects had erected dozens of impressive consulates, bank buildings, and trading houses, a concentration of international financial and commercial institutions that made the Bund the Wall Street of Asia. In the middle of the Bund, straddling the east–west thoroughfare of East Nanjing Road, real estate magnate Victor Sassoon built a pair of hotels in the early 1900s. From the subway

station, the pyramidal art deco top of the north building, dubbed the Peace Hotel, which was closed for a three-year-long renovation, loomed like a hilltop citadel. At the Bund's north end is the oldest park in Shanghai, built in the late nineteenth century for the city's affluent and growing foreign population, where, according to legend, a sign proclaimed "No Chinese or Dogs Allowed." (No such sign existed, but the park did prohibit locals and pets.) The Bund remains the most desirable real estate in town, and the colonial-era buildings have been recolonized by luxury brand boutiques, art galleries, and five-star restaurants.

Far from the old city, my uncle had established his company and its living quarters in Pudong's Zhangjiang area. Until the 1990s Pudong was undeveloped and agricultural, and most people crossed the river by ferry; it might have taken the better part of a day to travel the fifteen miles from the living quarters to the Bund. But after two decades of frenzied, nonstop growth, I could access downtown Puxi from Zhangjiang by taxi in thirty minutes, crossing the Huangpu on a seven-lane, quarter-mile-long suspension bridge so monumental that the spiraling off-ramp made three full revolutions before reaching street level, and all for about 70 RMB, or roughly ten dollars.

It was Pudong that built the landmark, skyscraping towers that had replaced the Bund as Shanghai's—and China's—iconic skyline: the futuristic Oriental Pearl Tower; the serrated, crystal-topped, eighty-eight-story Jin Mao, home to the five-star Grand Hyatt hotel and its peerless dinner buffet—until the Shangri-La came along and did it bigger, better, and more expensive; and the bladelike, 101-floor Shanghai World Financial Center nearing completion right next door to the Jin Mao, tower cranes (the national bird of China, as the joke went) perched on its peak and putting its final beams and panels into place.

Pudong is home to the city's convention center, biggest shopping mall, largest park, tallest buildings, and lots and lots of dust. As in

many American exurbs, Zhangjiang's wide streets indicate that its preferred mode of travel depends on internal combustion engines, and its scale verges on the inhuman. Residents live in gated communities, and the rare sidewalk tends to disappear abruptly. Pudong contains the expat enclaves of Big Thumb Plaza and Jinqiao (Golden Bridge), home to international schools set on expansive, manicured playing fields, community centers offering Western psychologists to treat the population of trailing spouses suffering from adjustment disorders, and Western-style eateries luring families of polo-shirted parents and their cloistered children with weekday dining specials. On weekend nights tourists and locals alike gather on each bank of the Huangpu to gaze at the other side. Puxi is where nostalgic expats go to see how China used to look, but Pudong seems to better illustrate where China is going.

As we emerged from the subway in Puxi, Andrew insisted we first stop at a stationery store. "You should probably get a pen and notebook, because you're never going to remember everything I tell you," he said.

I assured him—sarcastically enough, I hoped—that I had a pretty good memory. He shrugged and gave me a skeptical look. And thus began, nearly half a century after China's students and professional classes were involuntarily sent to the countryside, my own forced reeducation, as Andrew nagged me about my Chinese and sought every opportunity to test my vocabulary, reading comprehension, and even sense of direction. Andrew had never resisted speaking Chinese as a child and had since added the ability to read, and he seemed to relish watching me rifle through the sackful of memories from my one previous trip to Shanghai, a patchwork of fragments that might not even exist anymore, and he clucked his disapproval when I failed, which was often. When I squeezed out questions between gritted teeth, he responded with either an incredulous how-could-you-not-already-know impatience or a patronizing explanation. I wondered how someone so generous—he would frequently treat me to meals

and taxi rides—could be such a pain in the ass. Yet as annoying as I found his officiousness, I still felt a sense of accomplishment when I was able to recall certain phrases or routes with enough precision to impress him. All these years later I was still trying to persuade my older cousin that I was smart enough.

The streets in Puxi reeked of raw sewage and stinky tofu while the industrial paint slathered over the endless new construction projects gave off a noxious stench that I would come to identify as Shanghai's natural scent. We made our way farther west, into the leafy streets of the French Concession, lined with colonial-era villas and hundred-year-old European plane trees. The neighborhood's stately homes had long since been parceled out to house multiple families, and many had fallen into disrepair. Tangles of ad hoc wiring snaked over their edifices and through empty doorways and windows, and laundry flapped on lines strung up in the overgrown yards. Whether it was their mouths when they were laughing or buildings under repair, the Chinese loved to shroud things from view, as if trying to hide their private selves. Yet they commonly wore their underwear—boxer shorts and tank tops or pajama shirts and bottoms—on the street, and they literally aired their laundry on tree branches, utility poles, or whatever public structure would do the trick, a habit that many expats found charming but made me cringe.

I disappointed Andrew again at the electronics mall, one of at least three within walking distance, several overbright floors of vendors, grouped by the items they sold, peddling an overwhelming array of consumer products from flat-screen televisions to coaxial cables. Everything, it seemed, except for voice recorders. Just asking vendors if they carried them required a long explanation from Andrew, and I deemed inadequate the few that we managed to find. Our circuit of the mall revealed that the sheer number of goods disguised their homogeneity. Neighboring shops sold nearly identical items, and I would never truly understand the provenance of their inventories. Every shopkeeper insisted that his or her products were bona fide,

using terms like *AA huo* (think bond ratings) or *shui huo* (smuggled goods) and often pointing to the plastic-sealed packaging as evidence of its legitimacy. Andrew's opinion was that I wasn't buying anything expensive enough to worry about that; the dubiousness of Chinese goods rendered everything under a certain price point as disposable as the bottled water I consumed each day.

Before heading back to the living quarters—by subway, and unaided, as part of Andrew's colloquium on Shanghai transportation—Andrew took me to an upscale Japanese-owned supermarket in the basement of a luxury shopping mall in the Jing'An district, the western border of the French Concession and which took its name from an opulent Buddhist temple dating back to 1216 that now sat atop a major metro station. We entered the supermarket at the fruit section, which displayed model specimens of lychees, dragonfruits, custard apples, and fig-shaped *salaks,* or snake fruit, named for their scaly skins. On the shelves stood pyramids of imported cherries, every flawless garnet fruit individually stacked with its stem pointing straight up, priced at nearly fifty dollars a pound. In the seafood section fishmongers wearing crisp white aprons, paper hats, gloves, and face masks sliced sushi-grade tuna to order. Under the fog of the open frozen food bins rested king crab legs, their joints the size of softballs. Almost everything was imported, sparkling clean, and very, very expensive. We exited through the perfume of freshly baked cream puffs. The scene was such a far cry from what I remembered of Shanghai, when it was nearly impossible to find a decent loaf of bread or chocolate chip cookie, much less a carton of Greek-style yogurt, that my awe left no room for hunger, which was probably the most un-Chinese part of it all.

Andrew surveyed the store with equal parts amazement and dismay. "Look at how clean this is!" he said. "The Japanese are superior to the Chinese. If I could renounce my family and everything about being Chinese, and be able to speak Japanese fluently, I'd do it."

I found Andrew's attitude toward his own ethnicity, including

the liberal and unironic use of *chink* in his speech, a little disturbing. "You know, Chinese people are just not capable of innovation," he said another time. "They're just not. I'm not talking about the culture. I'm talking about the race."

"I think that guy from Yahoo!, Jerry Yang, was pretty innovative," I said.

"An exception that proves the rule."

I was running out of Chinese innovators. "What about the guy from Wang Computers?" I said. "Wasn't he Chinese?"

"Yeah, and his company went under. You know why? Nepotism! This is what I'm talking about."

"You know, if you hate being Chinese so much, we've made a lot of medical advances so people can change themselves," I said. "Michael Jackson wanted to be white too."

"I'm just saying. There's a reason why Chinese people have to copy everything."

"Your degree of self-loathing is incredible."

"I'm just talking facts here, man," he said. "I'm a realist."

As we left the supermarket, I asked Andrew who could afford to shop there on a regular basis. "The rich," he said. We paused under an escalator and used a section of it to plot an imaginary graph. "Okay, here's China." He drew a horizontal *x*-axis. "And here's their income." He drew a vertical *y*-axis. "Here are most of the people." He marked off 90 percent of the *x*-axis. The last 10 percent fit between his thumb and forefinger. "This is the middle class," he said, referring to 90 percent of the space between his fingers. "They make, oh, two to five thousand RMB a month." That was roughly what the local engineers made at the company. He narrowed his fingers. "Here is the upper middle class, who make more than ten thousand RMB a month. That's you and me." He brought his fingers together until they were almost touching. "And here are the rich." Those were the ones buying up all the luxury apartments, driving Ferraris, and eating fifty-dollar-per-pound cherries.

"How do they get rich?" I said.

"They start their own companies and get contracts from the government."

"Could I do that?"

"Sure, if you had the political connections. But you don't." Andrew shook his head. "Richard does. He could make himself a lot more money than he is."

"Why doesn't he?"

Andrew sighed. "Because he's a Jesus freak."

THE NEXT EVENING Andrew suggested we pay our respects to our uncle, the man enabling me to come to China for our family's porcelain. I had always wanted to like Richard, the requisite rich uncle of the family. I bragged about him plenty: smart, successful, committed to his causes, wealthy without ostentation. But my family was too Chinese for my uncles to engage their nephews with the easy congeniality I saw in American families, so I mostly remembered Richard as overworked, stressed out, and as likely to explosively express his disapproval as he was to be affectionate. It was difficult to know what he expected, which made it difficult to relax around him. Even talking on the phone with him about the job had filled me with anxiety, as if I were meeting royalty without any understanding of the protocols.

I followed Andrew over the bridge to Richard's three-story, five-bedroom, six-bathroom villa abutting the canal. Richard had filled every available spot in his garden with trees and shrubs—camphor, pomelo, peach, lemon, and rosebushes. His wife, Scarlett, who was as even-keeled and intuitive as Richard was impulsive, liked to kid that Richard's designs had "no white space."

The other half of Richard's garden was given over to the chickens, ducks, and geese that he had received as gifts, and the groundskeepers collected their eggs every morning and placed them at Richard's

door. At the far end of his property, he had built an aviary to house the pheasants someone had given him. It wasn't unusual for Richard to receive as gifts chickens live and butchered, sections of pigs, and even a year-old Tibetan mastiff, a massive creature that barked non-stop and terrified everyone for the few months that she stayed staked in a corner of his garden until he donated her to the company's security guards.

I had last seen Richard three years earlier, when I finally visited Shanghai one summer during graduate school, meeting up with my mother on her annual trip to see my grandmother. Back then the company living quarters had yet to mature, staked with rows of camphor saplings that shivered like wet dogs, and fresh soil still ringed the apartment buildings, reminding me of anthills. The villas had not yet broken ground, and the other side of the canal remained a blanched tract of desolate land that appeared to be in a state of ecological shock. The company had made its initial public offering in the spring, but the stock had since dropped about 40 percent, which might have explained the lukewarm welcome I received from both Andrew and Richard. Richard was preoccupied with work and mostly left me alone, except for nagging me to get a haircut every time he saw me.

I didn't see much of China, or even Shanghai, on that trip, spending most of my month there bedridden with fever and diarrhea. I recovered in time to accompany my mother and Richard to church one Sunday and marvel at the size of the building and congregation and the number of worshippers who lined up after the service to shake Richard's hand or pitch him a business proposition. Then, in the crowded parking lot, he asked if I felt like getting a haircut later. I rebuffed him again, and he erupted, screaming at me for not taking his advice ("I even offered to pay for it!" he said, no small gesture for a man who removed the batteries from his laser pointers when not in use) and for being disobedient, willful, and stupid in general. He

turned to my mother, excoriated her for raising such a disobedient, willful, and stupid son, ordered her into the car, and left me to find my own way home. In hindsight, perhaps the most remarkable aspect of the whole episode was how none of the other congregants seemed to notice his tantrum, going about their postchurch business as if this kind of thing happened all the time. After walking in circles for a while in the blazing heat, I eventually found my way back to the living quarters.

Andrew laughed when I reminded him of this episode. "I can't believe you're still harping on that haircut incident," he said.

"So?" I said. "He's never apologized."

"He won't. I'm sure he's forgotten it even happened."

My hair had not changed much since then, and I braced myself as we rang the doorbell, which played the opening to Beethoven's *Für Elise*. Richard answered, dressed in his after-work outfit of long denim shorts and a white T-shirt. He exhibited the typical Chang phenotype: a large, round head on a thin neck, a slight hunch, and a gangliness in his limbs that made him seem taller than five foot seven. Though he was nearly sixty years old, his face remained cherubic, light pooling on his cheekbones, chin, and nose. His bare feet had the same shape as my mother's.

We followed him into the house, which he had designed himself and featured the utilitarianism of a scientist, the expediency of a businessman, and the eccentricities of a middle-aged Chinese man. The tiled floors were heated. The ground-floor bathroom had an automatically flushing urinal. The décor was strictly exurban immigrant, and crosses and Christian scriptures hung on the walls. Most of the furniture, and many of the rooms, served mostly to store stuff. In addition to animals, he received trunkfuls of food and drink as tribute and acquired so much wine that he ran out of shelf space on which to store it, so he bought a couple of wine refrigerators, even though much of the wine was barely of drinking quality and he didn't

drink. In his office, bookshelves overflowed with technical manuals and business and management tomes, and there was a tatami room for hosting Japanese businessmen.

Richard said nothing about my hair and betrayed no memory of the incident at all. My grandmother was napping, he said, so I would have to wait to say hello to her. He ushered us in and disappeared into the kitchen. I heard the sound of drawers opening and closing. Then he returned with a tape measure and pencil and ordered me to stand with my back against one of the weight-bearing columns in his dining room.

Just as he used to during the summers of my youth, Richard set a book on my head and drew his pencil along its edge. I stepped away, and he unwound the tape measure. In my stocking feet, I came in right at 180 centimeters, the height at which Chinese considered someone to be tall. He looked satisfied. "I've been telling all the single women at the company that my tall, handsome nephew is coming to work there," he said.

I wasn't sure if the flutter in my stomach was the nostalgic thrill at his approval, or recognition of the infantilization that would make it difficult to extricate myself from the company to search for my family's porcelain. When I'd contacted Richard about a job, he rejected every arrangement I proposed that would have allowed me to conduct a proper search: a half-time employee, a contractor, an unpaid "consultant." He had an answer for everything. I said I had to learn Chinese; he said the company offered free courses. I said I needed to spend more time with my grandmother; he said, "Grandma will be around for a long time. She'll live to over one hundred. The Lord has blessed her. Don't worry about her." I said I wanted to travel; he said that was what weekends and holidays were for. I said I had to find my great-great-grandfather's house and the porcelain; he said there was nothing to find.

I had figured that my coming to Shanghai—Richard didn't disguise his disappointment in my chosen profession, or for not having

kept the same job for more than a few years—would demonstrate enough commitment to win some slack from him. But as I stood barefoot in his house, I realized that for him, the whole of my existence could be reduced to a short, penciled line 180 centimeters above the floor. The company was the only thing that mattered, and he was expecting the same loyalty to it from me. "The Lord gave us this project," he said. "We need to make sure it isn't run by people who are nonmissionaries." If I left the company, I would lose my visa. And while unlikely, Richard could fire me anytime he wished, which would also cancel my visa. I was stuck.

ON THE WAY BACK to the living quarters one night, as Andrew and I got into a taxi, instead of instructing the driver where to go, as he usually did when we were together, he turned to me and said, "Let's see if you can get us home."

I rolled my eyes. "Longdong Avenue and Guanglan Road, please," I told the driver.

"*Guanglan Lu, da guai haishi xiao guai?*" the driver asked.

I lost him after *Guanglan Lu* and waited as long as I could before asking Andrew for help. He somehow managed to smirk and *tsk* at the same time. After instructing the driver, he told me, "He's asking if he needs to take a left or a right at Guanglan Lu."

"I thought 'turn' was *zhuan wan*." That was one of the few phrases with which I had been equipped when I arrived.

"That's how they say it in Taiwan," Andrew said. "Here 'turn' is *guai. Da guai,* 'big turn,' means 'left turn,' and *xiao guai,* 'little turn,' means 'right turn.' Because the radius of a left turn is bigger than that of a right turn."

"How was I supposed to know something I didn't know?" I said.

"Keep practicing," he said.

"Why are you talking to me like I'm an idiot?"

"Because you *are* an idiot."

Eager to escape both his condescension and the heat—he refused

to use air-conditioning at home—I was all too happy to venture into the city on my own in Shanghai's temperature-controlled taxis and subway cars. I started at the clothing stores, to update my wardrobe with work attire. But my stature, just slightly above average in the United States, indeed rendered me a veritable giant in China, and the common lament from expat women that they couldn't find any clothes or shoes remotely their size applied to me, too. The manager of one outlet of a famous German shoe brand assured me that none of its stores in Shanghai carried my size, or the two sizes below mine for that matter. I bought a pair of slacks at a Japanese chain that seemed to have been made for a human spider. The store offered free alterations, but the salesperson refused to shorten them for me. "They're fine," he insisted. "Pants are supposed to touch the ground."

"Not when you're wearing shoes," I said. "Look, I'm the one who has to wear them, okay? Just shorten them a little."

He squatted down and told me to join him. Local Chinese could hold a flat-footed full squat without support for an eternity, and most preferred to relieve themselves that way. The cuffs of my pants rode up flush with my shoe tops. "See?" he said. "They're perfect. You're 180 centimeters, and a tall guy like you would look really silly in pants too short."

We argued back and forth until he finally agreed to take off the length that I requested. "Just promise me that if they end up too short, you won't come find me," he said.

The fabric market also failed me. It was a popular destination on the expat circuit, a run-down multistory building filled with a labyrinth of colorful stalls offering tailor-made suits and *qipaos,* traditional Chinese dresses that most female visitors bought as a matter of course. I had three suits made, choosing my fabric from a book that the purveyor assured me contained the most expensive swatches, getting measured, selecting a style, and finally haggling over the price. None of them ended up fitting. The waist was too small, or the collar too low, or the chest too large, but even my sharpest protests were

met with assurances that the suits were perfect or, short of that, were exactly what I'd ordered. The only luck I ever had at the fabric market was when giving them existing pieces of my wardrobe to copy in different materials. Those always came back perfect.

Thank goodness for the knockoff markets, which reliably stocked larger sizes. Though they had been moved underground, literally, they continued to trade in flagrant, sometimes skillful reproductions of designer goods, and my need for clothes that fit justified my momentary disregard for intellectual property. The touts were so adept that they could somehow distinguish among Japanese, Korean, and Taiwanese shoppers and switched the language of their entreaties accordingly. When I walked past one store, the hawker shouted "Shoes!" to me in English.

WHEN I MOVED to China, I knew it would be mean. I expected chaos, overcrowding, pollution, the absence of Western manners and sanitation, inefficiency, and stomach problems. While China was known for rigid control, everything outside the political sphere appeared to be a free-for-all, and daily life in China hardly resembled the regimented totalitarian image that foreigners held. The short— and cynical—explanation was that the government had an unspoken agreement with its citizens: as long as they stayed out of politics, they were free to enjoy the fruits of capitalism and consumerism. Vendors could set up their carts on any public space they saw fit, hawking household goods, fruit, and English-language books, including *The Wealth of Nations, Balzac and the Little Chinese Seamstress* (a novella about the Cultural Revolution), and *1984,* with neither shame nor irony. The city buses careened around their routes at reckless speeds, a holdover from the Mao years, when drivers were paid according to how many circuits they made per hour. There were no means for passengers to notify the driver, yet they made all the right stops and always paused to let sprinting passengers catch up. Everything operated

according to unspoken and unwritten rules, and it was no wonder why so many Westerners became seduced by China, because the foundation for all this chaos was exactly what they had been told their whole lives that China lacked: freedom.

Nowhere was this more evident than on the roads. For all the environmental hazards in the air and water, the biggest health risk in China probably came from crossing the street. Despite having just one-fifth as many cars as the United States, China had twice as many car accident deaths each year. Though the taxi fleets boasted high-tech touch screens built into the headrests with a recorded message reminding passengers (in English) to wear their seat belts, none of the taxis had seat belts in the backseats. I quickly got in the habit of riding shotgun and not wearing white—the seat belts were so seldom used that they usually left a sash of dust across my chest. Meanwhile, cabbies took my wearing a seat belt as a grave insult. "I'm a good driver," they huffed. "You don't have to worry." City buses swerved into oncoming traffic and cut across two lanes to make their stops. Drivers used their horns so liberally that expats joked about it being the Chinese brake pedal. Drivers could, and did, disobey every explicit and implicit traffic rule on the books. Police, fire, and medical vehicles enjoyed no special dispensation on the roads; nor did police seem interested in pursuing reckless drivers. It was common to see cars stopped in the middle of a freeway, crossing elevated medians, or driving long distances in reverse after they'd missed an exit, and in each case the rest of the cars simply purled around the offender like a stream around a boulder.

The streets follow a design that can only have been created by someone who didn't drive. (The use of headlights was actually prohibited in China until the mid-1980s, when officials began going overseas and realized it was the norm.) Rights-of-way are completely reversed. The larger the vehicle, the more carelessly it drives, expecting everything smaller, including pedestrians, to give way. I pounded on many hoods of too-close cars, only to get yelled at by drivers for my

physical invasion of their spaces or, worse, was ignored completely. In Hebei province, a local police official's son ran into two university students while driving drunk, killing one and breaking the leg of the other. When arrested, he boasted that his father's position rendered him immune to punishment. There is no affinity for the underdog in China. There isn't even a word for it.

To face the absurdities of daily life, expats in Shanghai keep a mantra: *This is China.* The Middle Kingdom was not so much a foreign country as it was a parallel universe that managed to offend all five senses plus one more—common. China was cockroaches in pharmacy display cases, and employees who reacted to this being pointed out to them by responding, "Yep, that's a cockroach." China was people spitting, blowing their noses, or vomiting onto the sidewalk next to me, crowding entrances, pushing, cutting in line, littering, and smoking in the elevator. China was restaurants listing menu items that they never intended to serve (the loss of face from not offering something outweighing having "run out" of it). China was poorly insulated, badly heated apartments, and the *ayi* leaving my windows open while the entire area was burning garbage. The Chinese were pathological about the idea of circulating "fresh air," even if it was some of the dirtiest air in the world.

China was people taking an eternity to use bank machines, bathrooms with hot-water taps that didn't work, soap dispensers that never had any soap, and long, gross-looking fingernails that served no apparent purpose. China was where children were clothed not in diapers but in pants with open crotches so they could easily relieve themselves, and they were encouraged to do so whenever they felt the urge. It wasn't uncommon to see mothers or *ayi*s instructing children to piss or shit on sidewalks, in public parks, or on subway platforms. I once came home to encounter a girl urinating in the hallway of my apartment building while her father waited. When I asked local Chinese about these behaviors, they either professed to not like it any more than I did or claimed not to notice. Those who tried to offer

explanations usually referred to some variation of China's history of overpopulation and deprivation. If the Chinese didn't fight for something, whether it was a cup of rice or a seat on the train, they had to do without it.

China was where cheating, cutting corners, and corruption appeared to be so ingrained that I began to question the supposed immorality of it all. Test preparation services advertised that their most expensive packages included actual copies of upcoming GMATs. To prevent cheating on the written portion of the driver's license examination, some areas required candidates to take tests at computer terminals outfitted with webcams. An American friend who lived in rural China and couldn't read Chinese made a few phone calls and, on the day of the test, sat before the computer while a Chinese man crawled over on his belly, out of the camera's view, inched his nose over the keyboard, and completed the test for him.

China is one of the world's largest markets for digital piracy, and the failure to stop it has less to do with an enabling government (though it is rumored that the People's Liberation Army controls the pirated DVD trade) than with the sense of entitlement people have about illegally downloaded materials. Chinese watch Internet videos on YouKu and assume that Americans copied it to create YouTube. There are giant retailers in Beijing called Wu Mart. Copying is simply a way of life. Whether it is fruit stands, electronics malls, or factories, the surest bet for a business is to wait for someone else to figure out a successful model, then open up an identical shop down the street with slightly cheaper prices. On Shanghai's Dagu Road, one of the city's first expat enclaves, the venerable Movie World had sold pirated DVDs for years. Then along came a new store named Even Better Than Movie World, after which the original place changed its name to No Better Than Movie World.

Underlying all this anarchy was a sense of menace. Though crime in China tends not to be violent, and I felt perfectly safe anywhere, anytime in Shanghai, I couldn't shake the feeling of a systemic

dysfunction. From counterfeit drugs to cooking oil reclaimed from sewers under restaurants, there seemed to be a new scandal every month. Meat so packed with steroids that consumers got heart palpitations when eating it. Vinegar contaminated with antifreeze. Watermelons exploding on the vine from growth accelerants. The most egregious was the revelation that nearly two dozen milk companies had laced their products with melamine, a nitrogen-rich chemical used to manufacture plastics, in order to boost their apparent protein content. The tainted milk caused kidney damage in hundreds of thousands of infants in China and at least six died as a result. A local reporter in Beijing revealed that street vendors were filling their steamed buns with cardboard, sparking widespread anger, until he admitted it was all a hoax and was sentenced to a year in jail. Or was it? Had he, as some suggested, been forced to confess in order to maintain "social harmony," the catchall term that gave the government extrajudicial rights and was invoked the way Western countries used the phrase "war on terror"?

It didn't help that while filling out my visa application in the United States, I had thoughtlessly written "journalist" as my occupation— technically true, since I was still employed by a newspaper at the time. The Chinese consulate refused to process my application until I faxed over a promise that I was not traveling as a writer and would not write anything while in the country. I eventually solved the problem with a carefully worded letter stating that I was not traveling as an employee of a newspaper, but this misstep only heightened the paranoia I already felt about going to China, where no one told you what the rules were until you broke one, and I arrived in Shanghai convinced that I'd been marked for government monitoring.

All the unease and crassness made me appreciate the occasional moments of kindness and civility. There was the man who answered when I called the service number listed on a subway drink machine that had eaten my money. He apologized and promised to send my refund—two RMB, or about thirty cents—to my address within a

week. I could have hugged the Chinese woman who, before exiting the subway train, told her son, "*Xian xia, zai shang,*" or "First off, then on." There was the woman I called at the bank who spoke good English and found me the address and hours for two nearby branches. Fearing that the branch employees might not understand me, she even gave me her personal cell phone number in case I ran into trouble. I thanked her profusely, to which she replied, "No problem. Welcome to China." These encounters reminded me that China renews itself every day, and every day needs its own welcome.

THOUGH I TRIED to avoid eating raw vegetables at restaurants, drank only bottled water, and used gallons of antibacterial hand gel, I still fell victim to a virulent stomach bug that left me with a high fever and diarrhea, or *la duzhi.* A variant of *la shi,* or "pull shit," which describes a regular bowel movement, *la duzhi* means "pull stomach," which described my condition and, no less accurately, the sensation of having my stomach pulled out of me every time I went to the bathroom. Once the fever subsided, the stomach cramps continued, feeling as if my intestines were being wrung out like a towel. Andrew didn't believe me. "You're weak," he declared. "I think you like this."

I recovered in time to start work. My uncle's company was one of the Zhangjiang technology park's anchor tenants, a dozen glass and poured concrete boxes the size of airplane hangars occupying a hundred-acre parcel about a mile from the living quarters at the intersection of two major roadways. Emblazoned at the top of the main building was the company's name, SMIC, superimposed over a silicon wafer, which lit up at night like a beacon. I took a taxi to the company's front gate, signed in at the guard booth, and walked through neatly trimmed hedges to the main building, its curvilinear blue glass facade the only exception to the Mondrian architecture of the campus. Though it was just eight in the morning, the short walk through the heat and humidity soaked my clothes with perspiration. At the

building entrance, a circular drive ringed a dry water fountain that was switched on when important customers or government officials visited. Inside, a security guard ordered me over to a bin of blue shoe covers and made me put on a pair.

A few minutes later a Malaysian Chinese woman from human resources named Ivy escorted me to the auditorium for the new employee orientation, where I was the only American. A screen above the stage bore a projection reading "Welcome to SMIC Big Family Orientation Meeting." Another Chinese woman from human resources introduced herself as Grace, who would be supervising us over the next three full days. She clicked a button on the laptop on the podium, and the next slide appeared: "Training Purposes." I realized then that I had been misled in terms of how much the company relied on English as its lingua franca. Though all the orientation instructors, called "owners" in the company's business-speak, introduced themselves by their English names, that was often the only English I heard during their sessions. Their Mandarin sounded familiar, and their speech didn't seem fast to me, and sometimes I could even understand a good number of the words. But I couldn't comprehend a thing because I was missing all the important ones, so I would hear something like, "Okay, and now we're going to talk about [blank] and why you [blank] and [blank] because [blank] [blank] [blank] [blank] [blank] [blank] otherwise [blank] [blank] [blank]. Any questions?"

We filled out stacks of paperwork, some of which I had already completed before I was hired. I said as much to Ivy, who had stuck around to translate for me when I revealed that I was all but illiterate in Chinese. Ivy gave me a look as if to say that I'd better get used to this kind of thing and told me to just do it again.

Almost all of the company's paperwork was in Chinese.

"What's this?" I would ask.

"It's the SMIC corporate culture," Ivy would say.

"I mean, what does it say?"

Ivy would read the Chinese. I would try to conceal that I had no clue what she was saying. Then I'd sign the form.

Despite having already been hired, I had to fill out a job application for the company records, which asked for my Chinese name. I scratched out mangled versions of the two characters, which Ivy recognized and rewrote properly. The next line on the form, Ivy said, was "where you put your English name."

While all the other Chinese parents in America appeared to have given their children "American" names, my parents—born in China, raised in Taiwan, and educated in the United States—neglected to do so for me and my brother, for reasons that they never fully explained. All my parents' siblings in America had English names, and so did all my cousins, but not me, and when I was young I hated it for the inevitable mispronunciations during classroom roll calls, the misguided compliments on my English when I introduced myself, and the constant questions about where I was from—*No, I mean, where are you FROM?* I lost count of how many times I parsed the answer to that question in a manner that was probably familiar to other hyphenated Americans: I was born in California, and my parents grew up in Taiwan (which people often confused with Thailand).

Whenever I complained to my parents, they told me I was free to change my name to anything I liked when I turned eighteen. That felt light-years away in my mind, and my parents always said it in a tone that suggested such an unfilial act might cause them to die of disappointment. My father liked to point out that common Chinese surnames are about as plentiful as common English given names, so did I really want to be another one of the thousands of Michael or Steven Hsus in the world? (I did.) My mother, who never passed up an opportunity to trot out her well-worn, Christian-inspired "think of the less fortunate" palliative, would remind me that it could have been worse. "Your name could start with an X or something," she would say.

Now, given the opportunity to adopt the English name I had

always wanted, I froze. The forty or so other employees, all Chinese, and all presumably with English names, began passing their completed forms up to the front for collection. Ivy, who already seemed panicked at how little Chinese I could read or speak, made impatient noises.

"Sorry," I said finally. "But I don't have one."

"You don't have an English name?" Ivy gasped. "You should really pick one." She folded her arms and waited for me to do just that, as if I could make such an existential decision on the spot.

"Can I just leave it blank?" I said.

I could not, she said. This was the name that was going to be printed on my identification badge and all my company records, including my work visa, and leaving it blank would delay all the processing. We were holding up orientation. I was already a curiosity for being the only newcomer with a personal assistant, and I could feel the other employees watching me.

"What do your friends call you?" Ivy asked.

"Uh, Huan?"

"Well, that's fine," she said. "Just put that down for now. You can always change it later."

After that she had to get back to work. "Just do your best," she said as she left.

I spent the next three days of orientation sitting through a blizzard of Chinese characters punctuated with the occasional English word. Much of the English was also incomprehensible, as the company seemed to employ acronyms at every opportunity, a penchant that I chalked up to the representational nature of its mother tongue, so I remained mystified through sessions such "Q&R Intro," "IP Intro," "KMS & DMS Intro," and "Quality System Intro & ISO/TS 16949/TL900."

My comprehension improved when the information moved away from business or technical terms. I gathered that, to motivate employees to arrive at work early, breakfast was free in the cafeteria before seven-thirty a.m., that there were hot water limits in the dormitories

housing the MAs, and that the company's management style was de-cidedly punitive. During a session explaining clean rooms, where blank silicon wafers were etched into chips, cut, and packaged, and which had air filters extracting everything larger than five microns (the size of a human red blood cell) because even the tiniest particle could interfere with or damage the equipment or wafers, we learned that employees could be fined for using their storage cabinets for anything other than their full-body clean suits or shoes. Or for stepping on the wardrobe clapboard when changing out of the clean suit. Or for "doodling on clean suit or shoes" (a 700 RMB fine, which was a month's salary for an MA). Or for failing to hang the suit on the right rack (100 RMB; employees were fired after the third offense). Or for failing to escort a visitor (200 RMB). Inside the fabs there was to be no food, drink, or communication or recording devices, no games, no running, and no more than two people chatting at one time. "Violators ticketed and told on," the signs warned. There were also fines for spitting in sinks, running in the hallways, and not wearing clean socks.

The importance of clean socks came up often during orientation, one instructor after another exhorting us to mind our pedal hygiene. In an effort to reduce the dirt and dust that might ruin wafers, the mass of employees who surged through the turnstiles every morning first went into a locker area, where they changed into a pair of indoor shoes, a familiar habit for Chinese. The company provided white canvas slippers for this purpose, an affront to even my rudimentary sense of fashion, and everyone got a pair the first day except for me, because they didn't have any big enough for my feet.

We were reminded to smile for the photograph that would appear on our identification badge and to wear it around our necks at all times. To flush the toilets after using the bathroom, to be polite and mannered when getting on and off the elevator, to show up for work on time and every day, to have a good attitude ("Your boss isn't look-ing for who's smart but who's helpful"), and once again to wear clean socks. "Buy enough and wash them so that you can wear new ones

every day," another instructor, Christa, said. "We can look up your locker number and find out who has stinky socks and tell their boss."

I looked around to see if anyone else was amused at this paternalism, but most of the other new recruits seemed engaged and interested. Some of them took notes. After Christa exited, Grace asked if there were any questions.

One man raised his hand. "Yes," he said, "when's the test?"

I chuckled at his joke.

"Right after class," Grace answered.

There was even a session devoted to graft, during which we were told that it wasn't okay to accept kickbacks, it wasn't okay to offer kickbacks, it wasn't okay to suggest giving or receiving a kickback, and so on. When I asked Andrew later for the reason behind all the lecturing, most of which seemed common sense to me, he said, "Because they'd all take kickbacks if they could."

There is a term that describes the way interpersonal relationships work in China: *guanxi*. Basically, *guanxi* is a person's connections, the social network in which members look out for one another—similar to the way family members can count on one another for a favor. Originally a value-neutral idea rooted in Confucian values, *guanxi* was critical to doing business in China and had lately become conflated with nepotism, cronyism, and other corruption.

"You mean that's not understood as unethical?" I asked.

"Listen," Andrew said. "I went to a Chinese university for my MBA. Plagiarism isn't seen as such here. They copy *everything*. It's all about the grades. It's probably because of the entrance exam system. They compete for spots, and once they're in, they're not well served. It's not like America, where there's always the guy who buys the beer and pizza, provides the apartment, and sort of skates by. Here they're cribbing on *exams,* and everyone's doing it."

In a twist to Deng Xiaoping's famous pronouncement that it didn't matter if the cat was black or white as long as it caught the mouse, the Chinese valued results, not processes. And now, in a race to catch up

with the West, it didn't matter how the cat caught the mouse. This created an environment where, as one popular saying went, China's hardware (technology, machinery, materials) far exceeded its software (knowhow, critical thinking, moral reasoning, the entire education system). That's why motion sensors in public bathrooms were installed upside down. And road and building construction flouted safety codes, established practices, and even basic physics in contractors' haste to present a "finished" project that could pass eye tests. Across the street from the company, next to a landscaped park with winding stone pathways and groves of bamboo along a canal that would have offered the neighborhood a rare green space if the iron gates hadn't been locked at all times, the local government erected and tore down a new administration building three times before the last try was deemed satisfactory (or the building and demolition contractors had enriched themselves enough).

WITH MY ORIENTATION completed, I was assigned to the business development department and given a desk in the reception area of a suite on the fifth and top floor, near the executive offices. From the windows, I had a view of the neighboring farmland on which had encroached luxury home communities, wanton monstrosities assembled from every convention of European architecture, adorned with swimming pools and tennis courts, and as far as I could tell, completely unoccupied. The multimillion-dollar properties had all been purchased solely as investment properties. At night the communities were completely dark.

My colleagues, all of whom had English names, consisted of a fellow American-born Chinese (or ABC), two local Chinese, and another born and raised on the mainland, educated in the United States, and returned to China in midcareer. Those were affectionately termed *haigui,* or sea turtles, and the company's management was full of them. The head of the department, a genial Taiwanese man

who received his bachelor's degree from Cornell and a doctorate from Columbia, was known as one of the best, most Westernized managers in the company. He had struck me as efficient but not overly friendly during my phone interview, perhaps due to his compromised position. "You're the CEO's nephew," he explained to me one day after work. "We *had* to hire you."

My first duty was to read a semiconductors for dummies book. My second was to review about four hundred pages of electronic presentations about the company and its processes and products, full of acronyms and unfamiliar terms. When I asked where I could find the answers to my questions, I was told to check the Internet. But Internet access was so tightly controlled that the entire company had a fixed number of "permissions," irrespective of employee numbers or needs, of which my department of six people had only two. Even though the company had grown exponentially since those permissions were first doled out, the quota had not increased. I couldn't have imagined that an international high-tech company like my uncle's could be so draconian, but Andrew assured me the Internet arrangement wasn't the norm in China. It was a productivity measure concocted by the chief technology officer and head of the IT department, a buddy of Richard's from Dallas known as "NYC," whose seemingly innocuous initials were uttered with the same dread as "KGB," and even Richard somehow didn't have much veto power when it came to this. The Internet permissions were so coveted that anytime someone with Web access left the company, a frenzy ensued as other employees, and sometimes even entire departments, scrambled to get that person's access transferred to them.

The idiosyncrasies extended to the phones, which didn't allow callers to leave messages—China had leapfrogged voicemail as it tried to catch up with the world's technology. Instead, employees carried long-range cordless phones with them whenever they left their desks, and they were expected to answer without delay whether they were midbite at lunch, midsentence in a meeting, or

midgrunt in a bathroom stall, which were marked "Western" and "Eastern" for having regular toilets and porcelain-lined pits in the floor, respectively.

Speaking Chinese at a preverbal level had its benefits. Nobody expected me to say anything in meetings, which were conducted almost exclusively in Chinese, with a few technical or business English terms that tempted me into believing I understood what was being discussed. And it forced executives into their nonnative languages, relinquishing their positions of power, though not everyone played along. Chen Laoshi (*laoshi* means "teacher" and is used as a respectful way to address elders), the Communist Party cadre and vice-president who oversaw my department, spoke Chinese with complete indifference to the person in front of her. An otherwise pleasant, fashionable older woman who liked to experiment with hairstyles, she nonetheless terrified me, owing to her status as a party member old enough to have participated in the Cultural Revolution. I had read of the heinous crimes committed during that period, including students who killed and ate their teachers to demonstrate their ideological bona fides. Another cadre in the company, Zhang Laoshi, spoke only in the inflected rhetorical style of revolutionaries and said that when she passed away, she would see Lenin and Engels in heaven.

With little work to do and no Internet, I spent most of my early days at the company browsing the employee directory. Ivy's bewilderment at my not having an English name proved to be no isolated event. My Chinese colleagues, with names like Caroline, Catherine, and Lanna, had done double takes when I introduced myself and asked me to spell out my name in both English and Chinese. Though the company was 90 percent mainland Chinese, just about everyone I interacted with had an English name, usually selected or received in school, and commonly used it when addressing one another, even when the rest of the conversation was in Chinese. Unable to recall my name, one Shanghai-born vice-president called me "Steve" for almost three months.

Even the characters of my Chinese name confused my colleagues. For as long as I could remember, I had been asked what my name "meant"—some people assumed that it must be Chinese for "John," which it was not. My answer was always more complicated than people wanted—Chinese just didn't translate one-to-one into English, something I would come to understand better when I started taking language lessons—and drawn from a childhood conversation that I remembered having with my parents, probably after the first time someone asked me about my name. The character for Huan is an obscure, seldom-used one that appears almost exclusively in personal names and has to do with the main wooden beam of a traditional Chinese house. The radical, 木, or *mu*, means "wood," and the second part, 亘, or *gen*, consists of the character for "sun" between two columns. So my name means something like "pillar" and connotes things like strength, steadfastness, and permanence. But modern Chinese often aren't familiar with the ancient character 桓, which differs from the more common *heng*, 恒, by a single stroke. I fielded a lot of phone calls from people asking for Hsu Heng and found myself correcting my name's pronunciation just as often as I had back home.

I also learned that in China my mother's be-thankful-it's-not-spelled-with-an-X words of comfort didn't hold up, because it *was* spelled with an X. My family spells our surname "Hsu" because Taiwan and other diaspora regions anglicize according to the Wade-Giles rules. But in the People's Republic, which uses the pinyin system developed during Mao's rule, my surname appears as "Xu," one of the few spellings that make it even more difficult for non-Chinese to pronounce.

As most of the English names in the company directory were chosen, not bestowed, I concluded that the "regular" Western names had been selected for their ease of pronunciation—there were almost two hundred employees named Jacky. Meanwhile, the more unusual names appeared to reveal hobbies, aspirations, and values. There was a man in the legal department named Superiority. There was a

Holy, a Hebrew, and a Leafy. There was a Shopping, a Running, and a Cooking. A Snow and a Vanilla. A Mars, a Soda, a Silk, and a Coma. There was a Quake, whom I later met; he'd chosen the name because he liked the computer game. There was a Snoopy, a Fantasy, a Leeway, and a couple of Creams. There was a Fire and an Ice, a Fish, Lion, Bison, Fox, Gazelle, and Ducky. There was a Water, Fjord, and Mountain; a Spring, Summer, Winter, and Season. There was an Ares, Apollo, Zeus, and Socrates. There were Zhongs named Stuck and Feeling. There were Wangs named Double, Soda, Viking, Power, Burden, Sprite, Wonder, and the unfortunately chosen Blown. There were Lions (one), Tigers (eight), and Bears (three). There was a Sky, Rainbows (two), a Sleet, a Rain, a Cloud, five Dragons, a Condor, and an Icecrane. There were many Ivys but only one Yale. A man named Penguin really did resemble a penguin. There were soccer fans: Baggio, Lampard, Bolton, and Arsenal. And basketball fans: two Magics (plus one Earvin), three Birds, three Jordans, two Kobes, an Iverson, and even a Shaquille. Oddly, there wasn't a single Yao Ming. There was a Chocolate and a Greentea. A Charming, Hansome (without the *d*), Bright, and Hyper. There was a Demon, the second to come along at the company, and a couple of Lucifers. A married couple at the company was named Alpha and Beta (Alpha was the male), who subsequently named their son Gamma. There was a Cheney but no Bushes. No Obamas appeared after the 2008 presidential election, but there was a Change. And who said there was no freedom in China? Freedom Huang worked in the IT department.

I wasn't the only one wasting time. The news back home tended to be a chorus of lamentations over America losing ground to Asian students, who were scoring better on science and math tests. But from my perch, and considering the rampant cheating, apathy, ineffectiveness, and outright incompetence and laziness of some local employees, many of whom were graduates of China's top universities, the world could rest easy. Despite the ABCs' grumblings over the company's many regulations, such as wage garnishment for any

employees who failed to clock in by eight-thirty a.m. or who clocked out before five-thirty p.m., even if it was only by a minute, most also had to concede that they were necessitated by a workforce that didn't exactly disprove the notion that if they weren't carefully watched and supervised every second of the day, they wouldn't get anything done.

If they exhausted all other forms of time wasting, there was always napping. Employees dozed in the darkened cafeteria between meals, or at their desks. Andrew discovered cardboard pallets in a corner of the solar cell fab where his subordinates literally slept on the job. An engineer on the floor below me even tucked a chaise longue, pillow, blanket, and eyeshade under his desk. The Westerners who liked to characterize China as a sleeping dragon were focused on the wrong word. I began to suspect that the groundswell of Christianity at the company had something to do with the permission it gave people to shut their eyes at their desk. Anyone with their arms folded, eyes closed, and head bowed before an open Bible on their desk was typically beyond reproach.

Eventually I gave up my search for an English name, but I did acquire one of sorts, as I became known around the company as Li Xiao Long, or Bruce Lee. I learned of this from another ABC at the company, who told me that the entire human resources department referred to me as the kung fu movie star, owing, I supposed, to my shaggy hair. In fact, he said, my given name usually elicited blank or confused stares. But when he said, "You know, that ABC guy with the long hair," everybody smacked themselves on the forehead and said, "Oh, you mean Bruce Lee! Why didn't you just say so?"

EXCEPT FOR THE final afternoon of my orientation, when Richard had given a short presentation to the new employees on the differences between a mercenary and a missionary ("I hope everyone here will be a *missionary,* not a *mercenary,*" he said), I didn't see my uncle much. I sometimes encountered him in the hallways, dressed in

his usual work outfit: loose-fitting black pants; a light-colored short-sleeved dress shirt with his identification badge clipped to his collar; a chunky multifunction metal wristwatch one or two links too large, requiring him to constantly shake it back up his right arm; and black leather shoes with round toes and rubber soles. His only sartorial concession was his hair, which he dyed black, a popular practice among aging Chinese executives and party officials. A retinue of important-looking people dangled around him like eager accessories. If he noticed me, he'd wave and remind me to "be a good boy."

Despite having told Richard from the beginning that I was coming to China to look for the family's porcelain, he seemed to consider it a waste of time, aside from the filial component of talking to my grandmother, disbelieving that I could possibly be more interested in that than in all the opportunities his company afforded. Whenever I brought up the subject of the porcelain, he got so annoyed that I stopped talking to him about it. Still, I understood and respected his sensitivity to any appearance of nepotism and was happy to be just another employee, especially when I saw the way some people would react—sensing an opportunity, shying away, or projecting their animus toward him onto me—when they found out I was Richard's nephew.

For all the money behind Richard's company, it was hamstrung from the start. Because he had hired many employees from the major competitor, TSMC, which had acquired his first company, TSMC sued him almost immediately, claiming that he stole intellectual property via its former employees. It didn't help that the name SMIC—which Richard insisted be pronounced as an acronym and not as a word—had a certain Even Better Than Movie World ring to it. In 2003 SMIC paid a $175 million settlement. But a year later TSMC sued again, claiming SMIC had broken the terms of the settlement and alleging more intellectual property theft; that suit remained unresolved when I arrived. The party line at the company was that the lawsuits were frivolous and the cost of doing business; being targeted by the top

dog was a kind of honor and Richard was noble for settling in the first place to avoid a protracted battle. Some Christians at the company even cast the lawsuit in terms of spiritual warfare, a tribulation that would eventually be triumphed over by faith and good works.

Amid the legal wrangling, the company went ahead with a much-anticipated IPO in 2004; the demand for shares was 272 times what was issued. On the day of the IPO, Andrew and a group of expats gathered at his apartment to rejoice—they were about to become rich. But as soon as Scarlett helped ring the opening bell on Wall Street, the stock price dropped 15 percent, and what should have been a celebration turned into a wake. The stock price never recovered. "It was one of the worst days of my entire existence," Andrew told me. "If anyone should be pissed, it's me. I've paid a huge price. I've taken years off my life by living here." At the time of the IPO, he had transformed himself into a marathon runner. Then he caught a cough he couldn't shake, began coughing blood, and was diagnosed with tuberculosis. He spent half a year convalescing and didn't run much after that.

By the time I got to Shanghai, the stock options that my other uncle, Lewis, had once castigated me for turning down were trading at less than a third of their IPO price, an all-time low. Despite Richard's ambitions, the company had only a handful of profitable quarters since its inception, and his investors—the Chinese government among them—were growing impatient. Yet for the prohibitive start-up costs—a single fab could run upward of a billion dollars, and SMIC operated half a dozen of them—and the crushing pressure to consistently produce more for less money, chip making was paradoxically a long game. I often wondered why Richard chose to take on such an endeavor. The easy answer was that he knew something others didn't, that the conditions were right to fill a vacuum, and that he, perhaps due to some kind of Christian exceptionalism, believed he could succeed where others couldn't. I guess that part ran in the family.

Unable to win big high-margin orders, the company relied on cutbacks to help balance its books. Richard never passed up the chance

to remind people that the reason a rival foundry in the technology park, backed by the sons of Taiwan's second-richest man and China's former president Jiang Zemin, respectively, had floundered even worse than SMIC was because it spent too lavishly, citing the widespread provision of company cars and laptops as prime examples. So at SMIC the bathroom taps gave only cold water, the paper towel bins were empty, and the soap dispensers usually were, too. Workmen went through the office suites and removed every other fluorescent light from the overhead banks. They turned off the hallway lights and air-conditioning and disabled the area thermostats. Only facilities management could activate the air-conditioning and didn't dare to even on the most sweltering days; one meeting room had its thermostat set at 88 degrees in the middle of summer.

Like many Chinese, Richard didn't equate time with money. His assistants spent entire afternoons trying to save a few dollars on airplane tickets. (Unless someone else was paying, Richard flew coach.) Purchase orders for as little as fifty dollars had to wait for his approval first. Even the supply of company tchotchkes was kept in his office, and only special occasions warranted their gifting. The entertaining budget for the sales department was capped at thirty RMB per person, or roughly four dollars. That was typical Richard, noble in his unwillingness to wine and dine or dirty-KTV (the karaoke with "companions" that highlighted many Chinese business trips) his way to business deals and unconcerned how it was perceived.

Had I not been related to Richard, I probably would have found his habits endearing. And I did feel a certain protectiveness when disaffected former employees criticized him. He certainly didn't fit the profile of a CEO, especially in China, and visitors almost always found him disarming and refreshing. While other CEOs traveled by chauffeured luxury car (Communist cadres favored black, German-made sedans), Richard drove himself to work every morning in a white Volkswagen Santana, the same model as the Shanghai taxi fleet. He didn't have a designated parking space because he didn't need

one—he was always the first to arrive. He also tried to minimize the environmental impact of his company with schemes befitting an eccentric genius—as soon as he was old enough to manipulate small tools, he had dissected every electric appliance the family owned, studied their innards, and reassembled them in perfect order. He spun off an energy company that used scrap wafers from the fabs to make solar cells. The factory rooftops housed solar panels, wind turbines, and a rainwater-recycling system. Instead of lawn mowers to trim the company's grass, Richard kept a herd of goats, which he never hesitated to mention had the added benefit of excreting odorless fertilizer. An American technology reporter based in Shanghai told me that he always enjoyed talking to Richard, whose inner nerd and disdain for bullshit frequently led him afield from carefully prepared talking points; the reporter described him as a small-town diner owner who just happened to be running a billion-dollar tech company.

WHEN I STARTED WORK, the first question many of my co-workers asked me was not "Where are you from?" but "Are you a Christian?" Thanks to Richard's evangelism, his company could have been considered one of the largest ministries in China. He closed meetings with his inner circle with prayers, which sometimes included praying for the stock price to improve. Prospective employees were asked if they were Christians at job interviews. On my first visit to Shanghai, I sat in on a meeting held with about a dozen other ABCs in Richard's office while he gave a presentation about the company's evangelical aims, complete with a map of China, the company's footholds on the coast, and arrows pointing inland, indicating the desired direction of the spread of the gospel and probably what a lot of Japanese army maps of China looked like during World War II.

On Sundays much of the living quarters population made the short walk to the twin churches, one Chinese and one English, that Richard had built nearby and where company security guards sometimes moonlighted at the entrances. While the English church, dubbed

Thanksgiving Church, was between pastors, members of the congregation volunteered to give the weekly sermon. The service was standard, raised-hands-and-hallelujahs, clapping-to-the-music Chinese American evangelical. Song leaders with guitars strummed major chords and guided the congregation through contemporary Christian rock anthems, for which the lyrics were projected onto a screen, and everyone seemed to know the tunes except me. One morning the substitute preaching duties fell on an ABC from Texas. During the discussion of a scripture passage, he focused on the word *therefore*, explaining that it was important to pay attention to the phrases it linked, as it signified a causal relationship. "For example," he said, "some people believe in evolution, *therefore* they abort their own babies."

Richard didn't have to hide or minimize his beliefs or his ministry. He had the government's full approval, and he liked to point out high-ranking officials who were in fact Christians. So the company's employees held weekday Bible studies and prayer fellowships at their homes without fear of incursion—it wasn't unusual to hear hymns emanating from the high-rise apartments in the evenings. Nor did anyone bother them when they went to church—as long as it was a state-approved one. At the official churches, a pastor from the government gave a fifteen-minute sermon at the beginning and then left the congregation to hold the rest of the service as it wished, a convention that seemed rooted more in insularity than in oppression. The content of that sermon varied widely. One Sunday a young government pastor gave a message at the company's Chinese church ostensibly about the importance of a life lived with joy. He gave an example: In photographs and in movies, Mao Zedong was always smiling and jolly while Mao's mortal enemy, Chiang Kai-shek, was always somber and buttoned up in his Western-style suit, surrounded with American weapons. So it was no wonder Mao had won the civil war, because he was full of joy.

As job and life homogenized, SMIC employees worked together,

lived together, worshipped together, and ate meals together at the nearby restaurants. My guess was that it stemmed from Richard's desire to run the company—all twelve thousand employees of it—as a family. Though it wasn't my style, I wouldn't have minded if I had not had to deal with the widespread expectations to attend church and demonstrate proper missionary zeal. But I soon learned that even if the government wasn't watching me, someone else always was.

Richard couldn't persuade me at first, but he successfully lured many other ABCs to work in Shanghai, by "selling the dream" of proselytization, exoticism, and of course, stock options. Although that first wave of ABCs at SMIC consisted of just a few dozen men and women, they had apparently demonstrated sufficient entitlement, superiority, and disdain for the local population not only to rival China's colonial-era occupiers but also to preemptively ruin the reputations of the ABCs who followed, which helped explain why I was greeted mostly with circumspection and, when I did anything correctly or on time, surprise.

There was nothing particularly unique about misbehaving foreigners in China—the Puxi party scene, replete with a full complement of recreational drugs, crawled with them. But the Chinese reserved a special scorn for ABCs, reacting with smug disappointment when we admitted we couldn't speak Chinese, and monitoring us for putting on even the faintest of airs. A native term for overseas Chinese is *huaqiao*. *Hua* means "Chinese" and *qiao* is a homonym for "bridge." When I first heard the term, I imagined myself stretched across the Pacific Ocean with my head in America and my feet in China (or vice versa, a fitting confusion for an ABC) and getting trampled on by people from both sides.

I lost count of how many times I was asked, usually by middle-aged men, if I felt Chinese or American. They wanted me to say, "Chinese, of course," but I always said, "Half and half," or "Chinese in America and American in China." One man, unsatisfied with these answers, pressed me to the point of asking, "Let's say the U.S. and

China went to war right now. Which side would you fight for?" I told him I'd run away to Canada.

The same discomforts, corruption, and disregard for the environment and human life that bothered expats living in China exist in many developing countries. But unlike our non-Chinese counterparts, ABCs can't just dismiss them as the novelties of an exotic place. While the Holy Grail for some foreigners living abroad is the day when they become native, I wondered if that was really possible for an ABC. It took so much effort, both psychic and physical, to maintain the bulwarks defending against Chinese culture that ABCs tended to be measured when I asked them how they felt about China. A frequent answer for how long they had lived in China was "Too long." But for non-ABCs, assimilation didn't necessitate acquiescence. I was reminded of that every time I watched a white guy part the crowds on a French Concession street wearing a collarless shirt, loose pants, canvas slip-ons, and a giant smirk, speaking bad Mandarin with a ridiculous Beijing accent while locals practically fainted in admiration around him.

Though ABCs enjoyed many perks as foreign students or workers, it often seemed that the Chinese took great pleasure devising complications to remind us where we came from. Whether it was not getting the discount for "foreigners" at happy hour, or having to produce identification before entering the international, foreigners-only church (a white face was the best passport in China), being ignored for jobs teaching English (nearly all the private language schools requested a photograph of the applicant to weed out those with Chinese heritage), or being complimented on our English by Westerners, ABCs got the Chinese treatment at foreigner prices.

This fetishization of Westerners was perhaps the most exasperating part of being an ABC in China. Crimes against foreigners, colloquially known as *laowai*, were taken seriously, and just being American was usually enough to deter criminals, but the Chinese still regarded *laowai* as an ethnicity, not a nationality, so we lacked

the necessary skin tone and hair color. For Chinese companies, there was great value to bringing on a *laowai* in order to legitimize it, a concept explained to me as "the nose." If one Chinese company was doing business with another Chinese company, it was better to bring along a white guy—any white guy—because it implied that the company was international, high profile, well run, and ethical. It didn't matter if the nose was actually in charge. I met a Canadian-born architect whose fluent Chinese made a skeptical client spend an entire meeting making her prove that she had been born, raised, and educated in the West. There was only one white person at her company, and he usually gave all the presentations, even if he wasn't involved with the project. The company even moved him to a window office, so passersby could see him.

And still I felt wounded when a fellow expat's gaze passed over me without acknowledgment. Non-Chinese foreigners seemed to always notice one another on the street, sharing a knowing, conspiratorial glance, and when I tried to catch their eyes, they probably regarded me as just another impolite, ogling local. Though I stood out to the local Chinese, I was also invisible to many of my countrymen. What allowed me to move between local and Western cultures also meant that I could be frustrated by both. Every time I went out, I felt like I was in the middle of an enormous family reunion, surrounded by backwoods relatives bent on embarrassing me in front of my fellow expats.

Because of that familiarity, I found myself engaging in behavior I would have never even considered back home. I had no inhibitions telling locals to pick up their trash, step aside, queue up, or otherwise mind the business of anyone who broke my personal code of ethics. I shoved a man who flew through a red light on his scooter. I welcomed rainy days for the opportunity to carry an umbrella, which I tucked under my arm, pointed end forward, and swiveled it back and forth to delineate my personal space, or swung it like a cane while I walked, allowing me to "accidentally" hit offending cars, scooters,

or people. Almost once a week, as the subway train pulled into my stop, I scanned the riders on the platform waiting for the car doors to open, searching for the person in most flagrant violation of not moving aside for exiting passengers, and charged into him like a football lineman. It was always unsatisfying. Feeling his lungs empty in a surprised "oof!" when I drove my shoulder into his chest only reminded me that in his judgment, he was just minding his own business when some jerk broke the Chinese code that, for all the molestation one endured when pushing and shoving his way through public spaces, you didn't touch someone in anger.

Coming from lily-white Utah, I had never spent much time around ABCs, but I soon discovered the comfort of the shared experience of growing up with Chinese parents in America; it was nice to know that my parents' weird habits were more or less universal among overseas Chinese, as were my own. My fellow ABCs instinctively knew what I meant by Chinese and *Chinese,* American and *American.* They never called themselves "Chinese American," a meaningless term that doesn't describe anything at all, least of all the people it intends to describe. I always knew what they meant when they asked where I was from. No one teased me for flushing when I drank alcohol, because their faces were red, too. Everyone took off their shoes when entering houses.

ABCs understood my obsession with food in general and fruit in particular, as well as my discrimination when selecting fruit and my belief in it as a panacea. I had always thought my fruit fetish was because my mother, a health food junkie, refused to buy candy for my brother and me when we were young; fruit was our only source of sugar. We regularly fought over the last cluster of grapes or the right to gnaw on the remains of a disassembled mango, and like the ancient Chinese who dropped their chopsticks in horror when they saw Western barbarians butchering their food with knives and forks, I recoiled when I watched my American friends eat kiwis with a spoon or smear their hands and faces as they attacked a wedge of melon. In

our house, kiwis were peeled and sliced, and watermelon was always chilled before it was deseeded and cubed so that it could be eaten with forks. The hollow burst of a knife plunging into a ripe watermelon elicited a delicious anticipation akin to cracking a crème brûlée's shell and had a Proustian effect on me.

But it wasn't just our household. Fruit is China's apple pie. Dessert in China most commonly takes the form of a plate of fresh-cut fruit. The phrase for "consequently" or "result" in Chinese is *jieguo,* or "bear fruit." Even the humblest fruit shack in China offers dragonfruits with flaming petals and pink or bloodred flesh, like a sweeter, milder kiwi; strands of purple grapes, plump as roe and bursting with intense, bubblegum flavor; or crispy, refreshing starfruit. The native kiwis, known as Chinese gooseberries before New Zealand farmers rebranded them, are sweeter and more pungent than their exported counterparts. Bowling-ball-sized pomelos, like meaty, fragrant grapefruits, whose rinds my grandmother used to fashion into hats for her children. Mangos of all kinds, from the small champagne varietals to the leathery giants named "elephant horns." Lychees, grown in southern China and quick to spoil, but the taste so ethereal that one emperor supposedly uprooted an entire tree and had it shuttled back to Beijing in horse carts. Sacks of tiny *sha tang ju,* aptly named "sugar mandarins," that I peeled and ate whole, a dozen at a time.

As difficult as being an ABC in China could be, ABC women had it even harder. ABC men could dip into both local and expat dating pools, while I never met a single ABC woman who expressed interest in local men. But having witnessed the kind of nagging, overprotective dragon ladies that Chinese women could become, I never had much interest in dating one, and even Chinese people characterized Shanghainese women, though beautiful, as conniving and high maintenance. I certainly noticed plenty of attractive women walking the streets of Shanghai. Sometimes they were flocked two or three at a time under a foreigner's arm, an implicit sex-for-financial-security

exchange that universally disgusted female ABCs almost as much as the ankle-length nylons local women favored. It wasn't just Western men who took advantage of their elevated socioeconomic status in China. Plenty of my ABC friends ran through local women with an exuberance that belied a sense of unshackledness; some admitted to having four or five different sexual partners every week. Part of the allure, as one friend explained to me, was that local women could be shaped into anything the boyfriend wished. They were open to acquiring new ideologies, new languages, and perhaps most important, new talents in the bedroom. An expat bartender in a swanky club summed it up for me one night. "Chinese girls, they don't have the same sexual hangups as Americans," he said. "They'll do *anything*, you name it." And just as the music paused between songs, he shouted, "Even anal!" I couldn't help thinking this was one of the variables in some subconscious calculus that persuaded ABC men, despite all their complaining, to stay in China long after they had planned.

AS SHANGHAI ENTERED the rainy season, a typhoon always seemed to be spinning somewhere off the coast. Most of the time it just cleared the smoggy skies, but occasionally a wet tendril would inundate the city. One morning a heavy shower flooded the streets and drenched me as soon as I stepped into it. With the sidewalks and gutters under many inches of water, I walked along the crest in the middle of the driveway encircling the living quarters. As I neared the exit, a white Toyota sedan came up behind me. I knew the driver expected me to move. If it hadn't been raining so hard, I probably would have, but he was dry and I was the one in the rain; I figured he could accommodate me for once. The driver honked. I kept walking. The driver lay on the horn, a long, unbroken proxy for his annoyance, which under the circumstances only irritated me more.

A local would have just given way, because in China the ones being honked at, not the drivers, controlled whether the honking continued.

As soon as the pedestrian yielded, the driver would have gone by, and because Chinese seemed to lack object permanence for these types of exchanges, both would have ceased to exist in each other's minds. A non-Chinese foreigner also probably would have moved, bemused, perplexed, and possibly upset with the driver but not wishing to appear as the arrogant foreigner. And then there was me, the American-born Chinese. I decided that I wasn't going to move. I couldn't disavow our common heritage, but being Chinese didn't mean I had to be *Chinese*, too.

This was more than a traffic dispute or a cultural misunderstanding. The driver was the Chinese Red Army, a column of armored vehicles rolling over the principles of right of way and common courtesy, and I was the Tiananmen Square Tank Man, armed with nothing but an umbrella, staring down the machine for the millions of oppressed pedestrians and bicyclists forced to run for their lives to avoid vehicles blowing through stop signs and red lights, making left turns from right lanes, crossing medians, and diving into bicycle paths. The honking got louder, longer, and angrier. I put my head down and kept walking. Go ahead and run me over, I thought, because I wasn't budging. I had *rights*.

I walked all the way to the gate with the car crawling behind me, its horn sounding a continuous, grating wail. When I finally peeled off, the driver pulled up to me, rolled down his window, and screamed, *"Ni you shenme yisi?"* Basically, "What the hell is your problem?" I had neither the energy nor the vocabulary to retort. For the rest of the day I indulged in violent fantasies of tearing the driver apart while berating him with immaculate Chinese and resolved to learn the Chinese word for "motherfucker."

A CHICKEN TALKING WITH A DUCK

INTENDED TO STAY IN CHINA FOR JUST A YEAR, BUT AFTER a few months I had learned nothing more about my family's porcelain. I hadn't even found my own apartment, despite Andrew's frequent hints that I had freeloaded long enough. At work, Richard moved me to the corporate relations department, where I had marginally more to do, editing press releases, but mostly I waited for the delivery of the English-language dailies in the afternoon. On weekends I played basketball and poker with a group of ABCs, many of them former SMIC employees, whom I'd met through Andrew. Though my Chinese had improved as a matter of course and immersion, I still couldn't really speak it outside taxis or restaurants, and I risked becoming one of the expat dilettantes whom I so readily impugned.

Having shaken the illnesses that dogged me when I arrived, I regained my weight by rediscovering Chinese food. My mother had eschewed many typical Chinese dishes that she found too greasy, so I knew what couscous was long before *san bei ji,* clay pot chicken cooked in soy sauce, rice wine, and sesame oil and dressed with ginger and basil. Or *yu xiang qiezi,* spicy, stir-fried sweet and sour eggplant that was the platonic ideal for topping a bowl of rice. Though my family frequently ate dim sum on the weekends, it wasn't until I moved to China that I discovered *boluo bao,* pineapple buns, named for the checkered crust of golden sugar on their tops and best eaten steaming

hot with a slab of butter sandwiched in the middle. Or *xiaolongbao,* the famous steamed soup dumplings, delicate bite-size morsels that sagged like water balloons when picked up between chopsticks, were placed on a spoon with a splash of vinegar and shredded ginger, and were then popped whole into your mouth.

Despite the horror stories that street vendors cooked with oil reclaimed from sewers, or that the meat of the *yangrouchuan* lamb skewers was actually cat, I managed to eat street food with no ill effects, breakfasting on *jian bing,* a thin eggy crepe wrapped around pickled vegetables and a smear of chili sauce. For lunch or dinner, I gobbled *shengjianbao,* another type of soup dumpling, but larger, thicker skinned, and pan-fried to create toothsome sesame-sprinkled tops and browned bottoms with the crunch of a perfectly cooked french fry. These were rested on soup spoons in order to bite a small hole in the top to release the steam and suck out the minced pork juices, and then were eaten with vinegar in two or three meaty, doughy, oily mouthfuls.

As the vise of the Shanghai summer loosened, the air grew sharper, and autumn in the city brought blue skies and soporific temperatures. One afternoon at the office, a headline in the *Shanghai Daily* caught my attention: "Police Hunt for Treasure Trove of Old Coins." A one-hundred-year-old residence in Nanhui, a transitioning rural district of Shanghai between Zhangjiang and the airport, was being developed into an entertainment center. Junkmen visited the construction site every day to gather scrap metal, and one day a neighbor heard a shout that gold had been found. Moments later the neighbor saw people scattering from the construction site with jars of coins. Apparently the junkmen, looking for metal with homemade detectors, had unearthed jars full of silver coins. As quickly as the initial discoverers fled, more treasure hunters descended on the site, and an overwhelmed security guard called the police, who were able to recover a few of the jars containing coins that had circulated during the 1920s. Once the police took control of the site, the local cultural relics

department found another jar full of silver coins marked "Mexican Republic" and estimated that they had been buried at the end of the nineteenth century, though the reasons for the burial were unclear. Efforts to recover the rest of the coins taken from the site were under way. "Any relics found under the ground or sea in China belong to our country and not to individuals," an official was quoted as saying.

That weekend I returned to Richard's house to visit my grandmother, whom I had seen only in glimpses since I arrived in China. Halfway through the first bar of *Für Elise,* Richard opened the door. "Ma!" he shouted. "Huan's here! He wants to hear your stories!"

I found my grandmother in the kitchen, watching the *ayi* make *jiaozi,* dumplings of minced pork and chicken, scallions, and garlic folded into hand-rolled skins and then pan-fried or boiled. My family ate them doused with soy sauce infused with chopped chilies and more garlic. The *ayi* mentioned that about fifteen cloves of garlic had gone into the meat mixture. My grandmother nodded as she dredged a *jiaozi* in sauce and said, "You have to have garlic with *jiaozi.*"

I asked her why, thinking it related to some ancient Chinese proverb or principle of traditional Chinese medicine. My grandmother paused, pinching a *jiaozi* between thin metal chopsticks with a dexterity I would never achieve. She looked at me over the plastic eyeglasses obscuring half her face and replied, in English, "Tastes better."

After we finished our *jiaozi,* we moved down the hall to her room so she could floss and brush her teeth, all original and all very healthy. I had not spent time with her since my grandfather's funeral in 1997, when she was already in her eighties. Now ninety-six and less than five feet tall, she seemed even smaller than I remembered. The many layers of clothing she wore, even in the middle of summer, disguised her frailness. Her hands tremored too much for her to write, her eyes had cataracts that she refused to treat, and she didn't hear very well. She seldom left the house, spending most of her waking hours at the desk in her room praying or reading scripture with a magnifying

glass. When she napped, lying on her back inside a mosquito net with her mouth drawn over her teeth, she looked dead. Still, she remained in good health, and her mind was especially sharp.

When I was young, I always envied how a day with the grandparents, for my friends, was an anticipated event, skiing or tennis followed by a meal at a nice restaurant. But my grandparents had been old, infirm, and inscrutable for as long as I could remember them. Visits to Texas, where they lived with Richard at first and then in a senior home, typically consisted of us staring at each other in silence. The liveliest thing I ever witnessed them doing was singing in their senior choir or playing mah-jongg. Though my grandmother had helped care for my brother and me after we were born, I couldn't remember her touching us except for the occasional pat on the arm. When my grandmother called on Christmases and my birthdays, my vocabulary limited our conversations to *ni hao ma?* (hello, how are you?) and, after a sufficient period of awkward silence, *zai jian* (goodbye). Probably because of this, I never learned to respect her the way I should have.

We sat in chairs next to her bed. It wasn't clear if she remembered that she was the reason I had come to Shanghai. Perhaps she didn't believe that I actually moved there just to ask her about her family's porcelain.

"Did you go to church last Sunday?" she asked. "How was it?"

"Boring," I said. "There's no pastor, not until December."

"Do you take Andrew with you to church?"

I laughed. Andrew was even less interested than I was. "No."

"I hope you can be an 'encourager' to him," she said, using the English word. She showed me the current page on her daily devotional calendar: "Remind me to be an encourager to others." "How are things with him? Is he very bossy? Wants to 'dominate' you?" Another English word.

"Yeah, he's like an older brother."

My grandmother chuckled. "Yes, like a big brother," she said. "You

should help each other. Your nature is better than his, your temper is better than his, so don't take it personally."

"So I want to hear your stories," I said, fumbling with my voice recorder.

"What would you like to know?" she asked.

"Your, um, house," I said. I didn't know the word for "family."

My grandmother seemed to understand and began talking about her grandfather. I tried to follow along, scribbling terrible phonetic equivalents of words to look up later. Her grandfather was bad tempered but principled. Her grandmother was compassionate. They lived outside the Jiujiang city limits, in the countryside. My grandmother listed relatives who lived with her or nearby, but I couldn't understand their names—most of which I was hearing for the first time—or kinship terms. The Chinese had unique terms for every possible family relationship, of which I knew only a few. After about a half hour, unable to keep up, I thanked my grandmother and told her I would come back another day. This was the longest I had ever spoken to her, if that's what you could call it.

I TRIED TO VISIT my grandmother every weekend, sitting with her while she squinted over her medicine or slurped her lunch of rice noodles in a broth with bits of ground pork, pumpkin, egg, and vegetables. No one seemed very interested in translating for us, so we made do with my very limited Chinese and what English my grandmother had retained. That allowed me to grasp the topic being discussed, but since I had no control over the language, I couldn't control the conversation. When I felt myself drowning, feet clawing for bottom, I attempted to gain purchase by asking questions about her life.

"My story is still later," she'd say, with a hint of annoyance, and continue on with her story about some relative.

Her energy would flag after about an hour, and I would say goodbye. Though I often left our visits feeling confused and overwhelmed, I also felt energized to be finally speaking with my grandmother. I

managed to glean the basic story of her childhood as the eldest of five sister-cousins, her schooling, and her immediate family. She recalled the arrival of the Japanese and the chaos of the war and, without prompting, confirmed both the existence and the burial of my great-great-grandfather's porcelain.

One Saturday, after I gathered that Japanese officers had occupied my great-great-grandfather's house during the war, I speculated to Andrew that the trail for the porcelain might lead to Japan. "So are you going to get us kicked out of two countries?" Andrew said. "Going to Japan is idiotic."

His forcefulness took me aback. "Why?" I said.

"It'd be one thing if you had a name, like Colonel Nagasaki in some city. What makes you think you'll need to go to Japan?"

"Jesus, I said 'might.'"

"There's no way you're going to Japan," Andrew insisted.

"Why not? The Japanese were the ones occupying the town. It's reasonable that a Japanese guy could have taken the stuff."

"So? Why would you go to Japan?"

"I didn't say I was going. I said it was a possibility."

"So there's an infinitesimal chance, and you're going to go?"

It was typical of Andrew, ascribing to me motivations that I hadn't even considered yet. "I'm not going to argue with you about what percentage of chance 'might' means," I said. "It's a possibility, that's all."

"Well, I 'might' date a supermodel, but I'm not going to."

"Not with that attitude, you're not."

"There's no way you're going to Japan. They won't even compensate comfort women from the war."

"Who's asking for compensation?" I said. "Why are you so keen on disagreeing with me, especially when I've just barely started? Forget it. This is infuriating."

As my grandmother wound up her family history, she must have wondered why I kept visiting and asking her the same questions. I

probably asked her five times for all the names of her relatives, but I still couldn't manage to create an accurate family tree because I couldn't comprehend her answers. The day she spoke of leaving Macau through Guangzhou Wan, I wasted the whole time trying to figure out what a *wan* was (a bay). Her Jiujiang accent, which I had never noticed before, added to the confusion. A workmate taught me a Chinese expression that described these conversations: *Ji tong ya jiang*. A chicken talking to a duck. They were both birds, they sounded sort of the same, so they went on clucking and quacking and thinking they were having a dialogue.

My grandmother, having dispensed with the biographical information, began using my visits to interrogate me about my dating status, followed with long-winded testimony, evangelizing, and parables. I heard her entire conversion story. Even a retelling of her time as a science teacher at a missionary school in wartime Macau was framed as a fable about industriousness. "I had no home to return to, so I focused on teaching," she said. "The big point here is that teachers worked hard, students worked hard. This is a lesson."

"I know, I know," I said. "Did you know how your family was doing back in Jiujiang?"

"I wrote letters back to my grandparents at home," she said.

"Did you keep any of them?"

"There were lots of things I didn't take with me from Macau," she said. "A whole suitcase of photos. But that's my family business, we don't have to talk about this stuff. My point is to say that we all worked hard, because—"

"Grandma, you already told me this! I've written it down many times!"

Of her time in Chongqing during the Sino-Japanese War, she mentioned running into one of her college professors, who was later swept up by the Communists. "Don't write this," she said. "Absolutely don't write this."

"I don't understand," I said, playing dumb.

"The part I just said, these people killed by the Communists," she said. "Don't write this political stuff."

My grandmother refused to discuss "political stuff," which turned out to cover just about everything I was interested in knowing, and her stories grew vague and obtuse. Regarding one of my great-great-grandfather's sons, her uncle, all she would say was that he graduated from the prestigious St. John's University in Shanghai. "I think he was an economics major, but he didn't use it," she said. "I think he taught English after graduation."

He was also the only one of my great-great-grandfather's sons to survive the war. But my grandmother wouldn't say more. "There's some stuff that has to do with Communists that I'm not going to tell you," she said.

"Tell me what?"

"Breaking the law. So this you don't want to know. Stuff that has to do with politics, Communists, it's better not to talk about it."

"But he might have an interesting story," I said. I had not yet mentioned that I wanted to go look for the buried porcelain.

"Just say he graduated from college and then taught school," she said. "Leave it at that."

The more I pressed, the more resistant she became, which only tantalized me more. "You're just a *xiao wawa*," she said once, calling me the equivalent of a "wee babe." "You don't understand."

Andrew never expressed any interest in our family history or my conversations with our grandmother, but when I recounted these exchanges with our grandmother to him, he didn't seem surprised. "The Changs put the 'fun' into 'dysfunctional,'" he said. And it all started with our grandmother.

I CAME HOME from work one evening to find a pile of hard-sided suitcases blocking the doorway. Andrew sat on the couch with the owner of the suitcases, his father, Lewis, watching television. "What

kept you?" Andrew acknowledged my entrance without taking his eyes off the television.

"One of the vice-presidents advised me to stay late," I said. "He sounded pretty serious. I didn't want to get in trouble with him."

Lewis laughed and slapped at the air. "Shit, the only thing he'd do to you is pray for you," he said.

Uncle Lewis was the eldest sibling, belligerent, profane, speaking primarily in exclamation marks and, perhaps owing to his time at the University of Georgia for a graduate degree in veterinary science, a self-described Chinese redneck. The family attributed his temperament to having been raised by servants while my grandparents were working as government scientists. The servants had frequently scolded and beat him for no reason. When my mother was born, the *ayi* said to Lewis, then just three years old, "Your mom has a daughter now, so she doesn't love you anymore." My grandmother didn't learn of the reasons for his frequent tantrums until later, and she didn't dare punish the servants for fear they would take it out on Lewis behind her back. By the time Richard was born, my grandmother's youngest sister had moved in with them and she could release the servants. "These *no education* Chinese people, their knowledge isn't good," my grandmother had explained. "It's all negative. We're Christians, and that's all about loving each other, but Chinese people, they've never had discipline, they teach you to hate each other. No one has taught them otherwise. No education, no Christian love."

Long retired after a career in Asia as an industrial agriculture executive, Lewis and my aunt Jamie lived in a tony Dallas suburb most of the time, but as the co-owner of the apartment that I shared with Andrew, Lewis made regular trips to China and kept a bedroom full of things that he constantly reminded us not to touch. He and Richard mostly avoided each other, owing to internecine hostilities that stretched back for decades. The first was a land deal in Texas gone bad. More recent was when Richard started SMIC and Lewis assumed he would be offered a job. "Sorry," Richard said, "that would

be nepotism." When Richard built the executive villas, on the cusp of the Shanghai housing bubble, Lewis assumed he would be able to buy one at the employee discount. "Sorry," Richard said, "that would be nepotism." Lewis bought an apartment through Andrew, but relations between the brothers had never thawed. Now whenever Richard came up in conversation, Lewis usually referred to him as "asshole." But there were lots of assholes in Lewis's book. Richard. All the "phony" Christians at Richard's company. The Kuomintang president of Taiwan, Ma Yin-jeou. Me and Andrew, occasionally. For Lewis, Chiang Kai-shek's name was never preceded by the customary "Generalissimo" but rather "That Son of a Bitch."

Lewis spent most of his visits in his bedroom, watching Taiwanese television from a pirated satellite feed while he made Internet phone calls to friends, or forwarded e-mails of conspiracy theories and crude jokes from the laptop perched on his knees. Once I overheard him talking about me to someone on the phone. "My nephew, Huan," he told the caller, "as in Qi Huan Gong." It was common for Chinese to offer context in order to distinguish their names from homonyms, sort of the way someone might say "V, as in Victor" when spelling a name aloud.

When he hung up, I asked him what a Qi Huan Gong was. "Not what," he said. "Who. He was the emperor of China."

"Wait a minute, really? An emperor? How long ago?"

"A long time ago. Two thousand years at least."

Qi Huan Gong, Lewis explained, wasn't technically an emperor. He was a powerful hegemon with a title that translated into English as "duke," and he ruled the state of Qi in northeastern China, roughly what was now Shandong province, during the Spring and Autumn Period around the seventh century B.C. Qi reached its pinnacle under his rule, and Qi Huan Gong is regarded as something of a Chinese founding father.

"Why have I not been told about this?" I said.

"I don't know. Ask your mom."

"What else do you know about my name?"

"Your dad wanted you and your brother to have 'wood' in your names," Lewis said. "He and his brothers were 'silk,' and you guys are 'wood.'" According to Chinese tradition, the names of descendants in a lineage incorporated a character from a set of about a dozen characters, all of which were auspicious words and in sequence formed a kind of poetic verse. Each successive generation used the next word in the sequence in its names, and once those were exhausted, a new verse was chosen.

"Why has it taken thirty years for me to find out that I have the same name as an emperor?" I said.

"See, next time someone asks you your name, you just tell them, 'Huan, as in Qi Huan Gong,'" Lewis said. "Everyone will know what you're talking about."

Though Lewis's antics mortified Andrew, who shooed him out of the house whenever he had guests, I enjoyed Lewis's company. I had remembered him having an even more volcanic temper than Richard, but he seemed to have mellowed with age and revealed himself as the only one on that side of the family who didn't see the world through the narrow prism of Christianity. I could speak to him as plainly as he did with everyone else, and he always had time to explain Chinese or family history. And he was the only one who encouraged me when I talked about looking for our family's porcelain.

I CONTINUED TO PRESS my grandmother for more names and personal details, and she continued to ignore me. During one rambling parable about two of her former neighbors, she was so vague that I had trouble keeping the characters straight, and she refused to be more specific. "You don't need to know these things," she said. "What I've told you is enough."

"Why don't you want to say?"

"I just said—"

"If you don't know, that's fine, but—"

"Because this is my *gexing*," she said. It was just her personality. "I've given a lot of testimony, and whether it's mine or others', I'm not going to discuss it with you. People with names, I'll discuss. People without names, I won't discuss. There were two boys and two mothers, that's all you need to know."

I bristled when she said "testimony." I was tired of being surrounded by people who saw everything in religious terms. And I was really, really tired of people telling me what was good for me. "If you're just going to tell these stories, I don't want to hear them," I said. The words had been dammed up for a while. "You're just telling half stories. I'm asking what people's names are, and you won't tell me. It's so annoying."

My grandmother rubbed her arm. "I've written down a lot of testimony, and I've never used names," she said. "What's so important about names?"

"How can you tell a story without names?" I said. "I don't care if it's a real name or a fake name. All this 'he' and 'her' and 'him.'" Chinese didn't have gendered pronouns, just *ta* for all occasions. "It's confusing."

"Some people, I don't know their names."

"That's fine, but the people you do know, they don't know you're saying their names."

"That's individual philosophy," my grandmother said. "I just don't like doing it. It's not virtuous."

"I know, I know. You don't want to gossip."

"Maybe it's because I'm a Christian."

"It's not a matter of being Christian," I said. "I know you only want to say good things about people. You don't want to say bad things."

"Even the good things, I'm not going to use names."

I took a deep breath. "Why?"

"It's in the Bible. Don't tell other people's secrets."

"But there are names in the Bible! And there are tons of bad stories about people, with names."

"Yes, there are names in the Bible, but it also teaches us how to act," my grandmother said. I thought I caught her smirking. "The Bible teaches us not to leak other people's secrets. Of course, you haven't read as much of the Bible as I have."

"Okay," I said, knowing I was about to pass a point from which it would be difficult to return. "I don't think I want to hear any more of your stories."

"Fine. Don't listen. I have my own ways of doing things."

THE WINTER IN Shanghai was overcast, cold, and wet. The Chinese didn't employ radiant heating systems south of the Yangtze, relying instead on inefficient forced-air appliances that were easily overwhelmed by the damp chill. It didn't help that the *ayi*, in her endless pursuit of fresh air, left the windows open every time she came to clean. The sun set before I left the office. I had not spoken to my grandmother since our argument.

One dark evening Richard informed Andrew and me that we had plans. He was having dinner with government officials, whose children were attending schools abroad and didn't have much in common with local Chinese anymore. He offered Andrew and me to entertain them. "Goddamn, I hate having to preen for Communists," Andrew complained. "At least dinner will be good. They eat well."

In the car on the way to dinner, Andrew mentioned that the head of the Communist Party of Shanghai and other high-ranking officials had just been sacked for accepting bribes, abusing their power, and siphoning nearly half a billion dollars from the city's pension fund. Most people expected the ousted party chief to be executed or, as Andrew put it, given "a nine-gram headache."

I was still paranoid about my visa snafu and a brief stint giving English lessons to two men from the "public safety" department, which I was convinced were related. A few China-based reporters whom I had befriended told me that they were regularly called in for unannounced meetings with government honchos to discuss their work. They assumed that their phones were tapped and that they were being followed. But they said I probably had nothing to fear. The worst thing that could happen to me was being called an unpatriotic Chinese and told to leave the country. Besides, they said, being Richard's nephew was pretty good protection.

Even so, I hoped to keep a low profile. "Can you do me a favor?" I asked Richard. "Can you just tell them I taught English literature when I was in the States? Don't tell them I worked for newspapers or what I'm trying to do here with the porcelain."

"Sure, sure."

We met the officials at a Chinese restaurant in a shady quarter of the French Concession. Most of the diners wore the telltale signs of nouveau riche party cadres: ill-fitting suits of shiny material, garish belt buckles, cheap-looking leather loafers, and the ubiquitous designer man-purses slung over their shoulders. A four-foot-tall shark fin in a glass case rose prominently from the middle of the floor. A middle-aged man with dyed hair and stained teeth greeted us. This was Speaker Hu, head of the People's Congress of Shanghai and one of the highest-ranking officials in the city. Speaker Hu had been in charge of Pudong when Richard started his company, and he remained an important ally in the local government. They met for dinner a couple times every year.

Already at the table were two other couples and their daughters. One of the husbands was the head of the government-run venture capital firm that was heavily invested in Richard's company. The servers made a big show of setting out dishes of cold appetizers on the lazy Susan. Speaker Hu made formal introductions of the two

couples and their daughters. One of the daughters, Bonny, worked for the British Council in Shanghai. She had gone to the top college in Shanghai and completed postgraduate studies in London.

Richard went around the table and gave short biographies for Andrew and me, trying to impress with our educational and work backgrounds. "He was a journalist in the States," he said of me. "And he's doing research on a project now."

I sank into my chair, but Speaker Hu and his friends seemed more interested in whether I was married. Richard told them I didn't speak Chinese very well but was learning—*typical ABC*, he said, as everyone nodded knowingly—while I concentrated on the food. Richard updated Speaker Hu on the company, and the conversation took place mostly over my head. As part of the youngest generation at the table, I was not expected to speak unless spoken to, a return to the boring, endless dinner parties of my childhood where I spent the whole time wondering if there would be dessert.

Then Speaker Hu asked Andrew about his impressions of China. Without hesitating, Andrew rattled off a long list of China's problems. "And I think China really needs to improve two major things, the pollution and the health care," he continued.

I considered tackling Andrew to get him to stop talking. I had seen the inside of a Chinese police station before, when I accompanied a non-Chinese-speaking friend to report a stolen purse. The officer in charge led us through a dark row of subterranean jail cells to a dingy questioning room with a single, barred window high above our heads, where he took down my friend's statement. The room was empty except for a couple of metal chairs and four scarred wooden tables that had been pushed together to form a larger one that would have been just the right size on which to lay a person. Every single inch of the grimy walls between the floor and eye level was gashed or splattered with dark stains or the kind of streaks that result from flailing legs or missed kicks.

Andrew mentioned an incident during a departmental trip to

Huangshan, one of China's most famous mountains and known to me as a shooting location for *Crouching Tiger, Hidden Dragon*, when one of the company's vice-presidents suffered a heart attack on the peak. Members of the tour group called an ambulance, but its drivers refused to budge until they received 40,000 RMB (about $6,000) in cash, far more than what the employees had on them. The drivers were unmoved by the group's pleas and promises that they were good for the money as soon as they reached a cash machine in town. Fortunately the tour guide managed to borrow the difference and got the vice-president to the hospital.

"Was that in Shanghai?" Speaker Hu asked. He spoke with a nicotine-laced growl. I wondered if we would get nine-gram headaches, too. "I can't believe it happened in Shanghai."

"Well, no, it was on Huangshan, but—"

"Ah, that's what I thought," Speaker Hu said, sitting back. "That would not happen in Shanghai." He indicated that the subject had reached its conclusion.

Speaker Hu turned to me. "So, Mr. Hsu, what are you researching?" he asked.

I tried to think of the most unimpeachable subject I could. "My family history," I said. "And, um, porcelain." I readied myself for an interrogation.

Speaker Hu smiled. "What a great topic!" he said. "Porcelain is one of China's most famous inventions. The history is so long and rich, you're sure to find a lot of worthwhile material."

The venture capitalist spoke. "You know, I'm something of a writer myself," he said. He had just finished writing a book about the history of Shanghai's textile industry and presented Richard with a signed copy. Everyone acted impressed. "It's just a vanity project," he said, waving his hands. "I'm not a professional. But I thought it was important that someone write about their history before it's forgotten."

"If you're interested in porcelain, then you must have been to Jingdezhen," Speaker Hu said.

"No, not yet."

"Oh, you must go there. It's full of history. It was the capital of porcelain production for the world for centuries."

Jingdezhen frequently came up whenever I mentioned my family's porcelain. About ninety miles east of my grandmother's hometown, Jingdezhen was an entire city that had since ancient times been devoted to manufacturing porcelain, everything from daily wares for civilians to the exquisite imperial pieces destined for the Forbidden City, including that red Qianlong chrysanthemum plate in the Seattle Art Museum. Nearly all the porcelain exported to the West during the Ming and Qing dynasties originated in Jingdezhen, as did most of my great-great-grandfather's collection. One of my grandmother's relatives—I remained confused about which one—had supposedly worked in Jingdezhen during the late Qing, early Republican period and brought cases of fine porcelain with him every time he returned home. I'd heard that even now Jingdezhen remained awash with porcelain, its markets overflowing with antiques real and fake, its streetlights encased in blue and white porcelain, and its earth inundated with ancient ceramic shards that anyone could take. I imagined it as a kind of ceramic El Dorado, with streets paved with porcelain, where I might understand why porcelain was so important to the Chinese history and culture that I could trace my roots to, and why my great-great-grandfather went to such great lengths to protect his collection.

I was so surprised by Speaker Hu's encouragement that I didn't think to explain why I was researching porcelain, or my desire to try and find my great-great-grandfather's collection. I sat in a relieved daze until I noticed one of the daughters at the table trying to get my attention.

"I think I might be able to help you," Bonny said. She had done her graduate thesis on the history of Jews in Shanghai and was putting together a documentary film about it. "Two of my tutors"—she used the British term—"at university here were from Jingdezhen. I'll put you in contact with them."

I exchanged information with Bonny while Richard beamed like a proud parent. Contrary to my expectations, these party cadres didn't seem suspicious or sinister at all, and I felt silly for having been so paranoid. My reporter friends were right: the government wasn't going to care about me wandering around China looking for my family's porcelain. That was even more of a shock than when I learned that for all of Mao Zedong's deification in China, everyone agreed that exactly 30 percent of what he had done was wrong. I began to believe that I might be able to find my great-great-grandfather's porcelain. I just had to get my family to cooperate.

[3]

LIU FENG SHU

Y POOR GRASP OF MY FAMILY ROOTS AND THE CHINESE language paled in comparison to my cultural illiteracy. I didn't know the difference between a Mongolian and a Manchurian, ancestries that my father's side of the family claimed, or between the Ming and Qing dynasties (the last two Chinese dynasties, which ruled from 1368 to 1912), or Chiang Kai-shek and Jiang Zemin, whose Chinese pronunciations sounded nothing like their English transliterations. Though my parents often mentioned that I shared a birthday with Sun Yat-sen, I had no idea who he was, or why my parents and their friends from Taiwan always discussed the Kuomintang with such stridency at dinner parties, until I encountered them in a high school history book.

By the time I got to China, I sought to become more informed. But those "five thousand years of history" that modern Chinese loved to boast about remained for me as impenetrable as it was long. I knew that China defied easy explanation, and I had a general idea of its primacy in world history—the Chinese had a claim to several of the most important scientific and technological inventions in recent human existence—but these glories glinted like stars in a constellation I couldn't decipher. Even the basic primers on Chinese history that I got from a teacher at the SMIC school left me cross-eyed with confusion.

So instead of trying to take the whole of Chinese history in one gulp, I picked at its edges until a thread separated—my family. Then I pinched it between my fingertips and started pulling.

MY GREAT-GREAT-GRANDFATHER Liu Feng Shu was born in the Yangtze River town of Xingang, in the Jiujiang countryside, in 1867, the *Ding*—or fourth, according to the Chinese sexagenary cycle—year of the Qing dynasty emperor Tongzhi's impotent reign. Gone were the days of wealth and territorial expansion. The Opium Wars had bankrupted and humiliated the country, civil order was undermined by a corrupt and antiquated bureaucracy, and the reckless rule of Empress Cixi had alerted the Chinese to the shortcomings of their culture and left them in the mood for rebellion. Despite the turmoil, the imperial examination system remained in place, a thirteen-hundred-year-old tradition that rewarded those who passed the grueling three-day test with positions in the government—possibly even inside the Forbidden City—regardless of family wealth or pedigree. The test was open to all, and even in the Qings' waning days, becoming a scholar-bureaucrat secured one's social and financial standing, so Liu's father, a laborer, put everything he could spare toward his sons' schooling at a local *sishu,* or private academy.

The network of *sishus,* heterogeneous, unregulated, and run by scholarly tutors in rural and urban areas alike, provided the bulk of primary education in China, imparting basic knowledge and Confucian morality. For most, a *sishu* offered the opportunity to encounter Chinese classics and achieve rudimentary literacy. For the few who could afford to study beyond the basic primers—parents paid tuition in cash or in kind—they were the first step toward possibly passing the imperial civil service examinations.

After ten years of study, Liu traveled to the county seat of Jiujiang for the annual county-level examination, carrying a basket with a water container, a chamber pot, his bedding, food, an inkstone, ink,

and writing brushes. Guards patrolled the walled examination compound, in which hundreds of wooden huts—one per test taker—were set out in rows, and they searched each of the hopefuls for hidden papers before allowing them into their cells, furnished only with two boards that could be fashioned into a bed or desk and chair. There were no age or retake limits for prospective candidates, who ranged from precocious teenagers to stubborn elderly men. After the exam was distributed, a cannon sounded, and Liu started writing: eight-part essays on ancient texts, poems in rhymed verse, and opinions on past and present government policies. For three days, the only interruptions came from the proctors stopping in to mark and authenticate his progress with red stamps.

Liu received the second-highest score in the county and earned the title of *xiucai,* or "cultivated talent." Those who passed the exam won the right to take the triennial provincial-level exam, after which a certain number would earn a place in the government. But because of Liu's score, he was immediately offered a minor local post. Mindful of the reputation of Qing bureaucrats, as well as the tenuousness of the government, he declined. "I'm poor now, and if I accept this 'little official' position, I'll remain that way," he said. "And I won't participate in corruption—I want to be able to feel the breeze through my sleeves. Just let me go home."

The bureaucrats urged him to reconsider. He came from a poor family, with just a speck of land to his name. Did he really want to spend the rest of his life plowing with a writing brush? But Liu, a strict Confucian, figured that an overeducated man in the fields was still more virtuous than a cultured one taking bribes. He returned to Xingang and started his own *sishu,* where he became known for reducing or waiving fees for especially bright students. Just about every male in the village received some kind of training from my great-great-grandfather. "If you don't go to school, you have no prospects," he liked to say. "So go to school."

He was a good teacher, and his *sishu* was highly recommended. He

made a name for himself as a traveling scholar in the Yangtze delta cities of Suzhou and Hangzhou, where wealthy merchants paid him handsomely as a private tutor for their children. His income allowed him to *chi chuan bu chou,* or not have to worry about his food or clothing, which qualified as an comfortable life back then. He invested the rest of his money in land, accumulating a hundred acres in Xingang, on which sharecroppers raised wheat, barley, millet, sesame, and other grains. He also bought up most of the paddies in the Poyang floodplain, where they alternated rice and vegetable plantings. Between the two harvests, they grew rapeseed, and each autumn the blossoms covered the countryside with a blanket of gold, interrupted occasionally by the whitewashed walls and curved tiled roof of a Buddhist temple. Most families split the harvests fifty-fifty, but Liu kept only four bushels out of every ten, giving the remainder to the farmers, reasoning that they were the ones bearing the expenses and putting in the labor. Besides, his land, in concert with the river, lakes, and orchards of persimmons, sweet-tart loquats, crispy jujubes, yellow plums, and sugary "southern wind" oranges, already provided all the food he could eat, trade, or sell. As word of Liu Da Xian Sheng's, or "Lord Liu's," generosity spread, sharecroppers flocked to work his land. His prosperity grew in a *liang xing xun huan,* a virtuous cycle.

Meanwhile the country verged on collapse. Much of China's recorded history consisted of various peoples fighting for, conquering, and—because the territory persistently proved too amorphous and difficult to govern—abdicating control of parts of it or its entirety. Throughout the upheavals, an ambient continuity managed to survive. Cities rose and burned, and their importance waxed and waned, but they remained cities. Sacred places were revered, ignored, and then rediscovered and rehabilitated. Material possessions made of jade, ivory, wood, stone, and porcelain long outlived their makers, and royal collections of art and antiques were often subsumed and added to by newly victorious rulers. The imperial civil service exam, a thread of meritocracy that stitched together half a dozen dynasties,

offered a pathway for all qualified men to make generational changes to their socioeconomic standings. The entire country was a palimpsest over which each successive regime had written a different legend, and for almost all of the oft-mentioned five thousand years of China's recorded history, those former iterations simply receded underground, one stratum at a time, a slow accretion of something that, over the millennia, formed not just Chinese history but also Chinese culture.

Under the Qing, a Manchu people from the north, China reached its zenith of social, cultural, military, and economic power in the eighteenth century. This golden age spanned the reigns of three emperors, Kangxi, Yongzheng, and Qianlong, who, while not above the brutality, depravity, or immorality of their time, continue to be held up as the standard for effectiveness. By Qianlong's rule, the Qing had consolidated double the territory the Ming had governed, including all of Mongolia and parts of Russia. Despite being foreign occupiers, the Qing became increasingly sinicized, and Qianlong anointed himself the preserver of Chinese culture and history. He was a ravenous collector of objects and penner of poems and was known to travel with paintings so that he could compare them to the actual landscapes. He closely supervised the imperial porcelain kilns in Jingdezhen and compelled artisans to impress him. As a result, the kilns made great leaps in creativity and technology during his reign.

Despite its reputation as insular and xenophobic, China had regular contact with outsiders and accepted foreign trade as an inevitability. Jesuit missionaries from across western Europe were fixtures in Kangxi's court, serving as translators, scientific advisers, and cartographers. Qianlong also employed them as painters, musicians, and architects—so frequently that some complained of not having time for missionary work. As Qianlong became fascinated with exotic buildings, he commissioned Giuseppe Castiglione, a Jesuit missionary-cum-artist, to the Qing court, to design the Western-style mansions in Beijing's Yuan Ming Yuan, or "garden of perfect brightness," made

of stone instead of wood, the Chinese building material of choice. The general manager of Beijing's famed glass factory was a missionary, tasked with producing scientific instruments. The technique of painting on glazed porcelain, or *famille rose,* developed from European enamel technology.

Chinese porcelain, tea, and silk commanded top prices, paid for by silver, and by the eighteenth century China had become known as the world's silver repository. But as foreign countries saw their treasuries dwindle in the procurement of these exotic goods, they sought schemes to equalize trade with China. One such scheme was addicting the Chinese to opium. The Qing court allowed for the importation of opium by the British, as it generated tax revenue, but it restricted the trade to the port of Guangzhou (known then as Canton), conducted through Chinese merchants instead of directly with the general population, and only during a certain season—terms that chafed the British, whose belief in their heavenly mandate surpassed even that of the Chinese.

This uneasy accord frayed as the Qing government grew alarmed about more and more of its population falling prey to the drug. The Daoguang emperor, Qianlong's grandson, appointed Lin Zexu, a principled scholar-bureaucrat, as the governor of Guangzhou with an edict to stem the flow of opium into the country. Lin launched an aggressive campaign against the trade, arresting thousands of Chinese opium dealers and confiscating tens of thousands of opium pipes. When British merchants refused to halt shipments into Guangzhou, he blockaded them in the designated enclave for foreign traders and cut off their food supplies. After a month-long standoff, the British turned over more than two million pounds of opium—approximately a year's supply—which Lin destroyed and threw into the sea. Lin also led expeditions onto ships at sea to seize crates of opium.

When Britain learned of the situation in Guangzhou, it demanded compensation for the destroyed merchandise and better trade terms. Over the following months, tensions escalated to the point that in

1839 the British foreign secretary finally declared war on China. It was too much to bear for the Qing, which had already begun to decline at the end of Qianlong's reign. In this First Opium War, British gunboats operating with steam engines and modern firearms decimated the rickety Chinese defenses; China, despite having invented gunpowder, had failed to weaponize it with the same sophistication. The Qing court quickly capitulated and agreed to cede Hong Kong to the British, pay an indemnity, and open five ports to trade of all kinds, through which foreign missionaries flowed along with the goods and currency. Lin Zexu was the scapegoat and exiled to the country's remote northwest.

Palace intrigue was as constant in Chinese history as change and was often the source of that change. In the latter part of his reign, Qianlong, for all his wisdom, had divested many of his responsibilities and much of his decision-making to a man named Heshen. Heshen was said to have come from a family of some means, though his education did not result in any imperial degrees, and he first went to the Forbidden City to serve as a guardsman. There he encountered Qianlong and within just a few years was promoted up through the most important positions in the imperial government, ultimately being appointed the grand secretary, the highest post in the government and akin to prime minister.

How Heshen attained such power and the favor of Qianlong, a man forty years his senior, was an enduring mystery. According to one legend, probably created by Qianlong's critics, the pale, feminine Heshen reminded the emperor of his first lover, a concubine of his father, Yongzheng. In some tellings, Qianlong and Heshen also became lovers. In others, the old emperor, already mentally insolvent with age, was inexplicably taken with Heshen and showered him with affection and confidence, especially when Heshen's son married one of Qianlong's favorite daughters.

Whatever the case, Heshen took full advantage of his lofty perch. He filled the bureaucracy with family members and henchmen, and

they stole and extorted public funds on a grand scale for more than two decades. Although Heshen's clique was not the only corrupt one, it was one of the most powerful and, because of his most-favored status with the emperor, could act with impunity. Even when Qianlong abdicated his throne so as not to serve longer than his revered grandfather, Kangxi, Heshen remained the de facto ruler, and his rivals—even Qianlong's son, Emperor Jiaqing—were powerless to stop him. It wasn't until Qianlong died that Jiaqing, a progressive ruler facing the unenviable task of reforming a nearly bankrupt country wracked with rebellion, could finally prosecute Heshen and his cronies, and Heshen was forced to commit suicide.

So the Opium War wasn't the sole event that precipitated the collapse of the Qing empire, but it was the most prominent in the narrative that the Chinese had of their country, containing all the ingredients—a foreign incursion overpowering righteous Chinese martyrs—to deflect attention from the self-inflicted wounds, discourage self-examination, and stoke nationalism at the same time.

The Qing court also had to contend with threats outside the palace walls. After the Opium War, a failed imperial examination candidate in southern China happened to read a Christian missionary tract. After digesting the ideas of divine creation and salvation, spiritual warfare, and the apocalypse, he claimed to have received a vision from God anointing him as "the true ordained son of Heaven," arming him with a "golden seal and sword," and instructing him to descend to the world to enlighten and save its people. This man, Hong Xiuquan, baptized himself one night in his courtyard and set out to preach his homegrown, warped version of charismatic Christianity. Hong traveled the countryside, attracting the disaffected and disillusioned and sowing the seeds for revolt.

By 1850 Hong had accumulated enough followers to earn the attention of the Qing court. The attempts to suppress him and his sect—which he dubbed the Taiping Heavenly Kingdom—grew into a conflagration that lasted fourteen years, claimed thirty million lives,

and required a multinational force to extinguish. At its height, the Taiping had more than one million followers and conquered much of central and southern China, including the Ming capital of Nanjing, where they dynamited its famed porcelain tower and slaughtered forty thousand Manchu "demons" within the city walls.

Meanwhile the Qing had backslid on concessions from the Opium War. Foreign powers—foremost the British—sought even more expansive trade opportunities in China and responded to China's diplomatic missteps with gunboats, sparking a second Opium War in 1856. The Qing court, preoccupied with fighting the Taiping, could muster little defense and made further concessions, opening more treaty ports, including one in Taiwan, allowing for foreign embassies in Beijing, and permitting unrestricted travel on the Yangtze River and in the Chinese interior. In the war's final act, the Imperial Gardens were destroyed as reprisals for the imprisonment, torture, and execution of a British envoy and his entourage. Over three days, French and British troops burned and looted the grounds, which contained countless masterpieces of Chinese art and antiquities dating back to the very first Chinese dynasties, as well as literary works and records. A royal engineer who was part of the British forces wrote:

> We went out, and, after pillaging it, burned the whole place, destroying in a vandal-like manner most valuable property which [could] not be replaced for four millions. You can scarcely imagine the beauty and magnificence of the places we burnt. It made one's heart sore to burn them; in fact, these places were so large, and we were so pressed for time, that we could not plunder them carefully. Quantities of gold ornaments were burnt, considered as brass. It was wretchedly demoralising work for an army.

Only the stone structures of Castiglione's Western-style villas survived. This complex of palaces had been five times the size of the Forbidden City and is regarded as one of the most magnificent lost

treasures in history. A full accounting of the destroyed and stolen artifacts was never completed, as many of the records burned with the buildings; but many of the imperial objects—especially porcelains, which the foreign armies targeted—in Western museums and collections and circulating on the auction market today originated from those sackings, a cultural disaster that still resonates with the Chinese.

As the Qing tried to restore its empire, complicated by other rebellions, plagues, and disease, some progressive statesmen sought to modernize China. These "self-strengtheners" advanced frameworks for the country to adopt Western weaponry and military technology, incorporate modern science, and develop diplomatic strategies. The vision for a reformed China—boasting a healthy mix of traditional Chinese elements with Western ideas and technology—was there. Now it just needed the support of a strong central government to make it a reality.

But inside the Forbidden City, palace intrigues continued. This time it was a concubine—with whom all Chinese rulers consorted except for one, the Ming emperor Hongzhi—at the center, an exceptionally ambitious one who managed to attain real power. Cixi was the mother of all dragon ladies, born to an official family in Anhui, and who journeyed to Beijing as a teenager where she was selected as a concubine for Qianlong's great-grandson, Xianfeng. Concubines were segmented into ranks, which determined the allotments of food, clothing, jewelry, cash stipends, and handmaidens they received. Cixi entered the palace as a low-rank concubine but ascended quickly after giving birth to Xianfeng's only son, and when the child reached his first birthday, she was elevated to the second rank, with only the empress above her.

Xianfeng died shortly after the Second Opium War. Eight ministers were appointed to advise his heir, five-year-old Tongzhi, and Cixi was elevated to empress dowager with the expectation that she and the empress would cooperatively help the young emperor as he matured. But Cixi had by then gained a firm grasp of court

machinations and quickly maneuvered to consolidate power. Following the coup, and after executing "only" three of the appointed ministers, Cixi issued an imperial edict affirming her as the sole decision maker.

Tongzhi remained the nominal emperor, but Cixi ruled from "behind the curtain," as she would for most of the second half of the nineteenth century. Tongzhi was an unhappy, stifled young man who died at age nineteen, officially of smallpox, possibly of syphilis. His consort died a few months later, either by committing suicide or because Cixi had starved her to death. She was rumored to have been pregnant with Tongzhi's son at the time. With no heir apparent, Cixi installed her nephew, Guangxu, as the new emperor.

For many Chinese, Cixi's legacy, beyond her overprotectiveness, vindictiveness, xenophobia, and paranoia, was excess. Instead of imposing austerity while the government battled the Taiping and other existential crises, she oversaw the production of vast amounts of brightly colored porcelain from the imperial kilns for personal use. To commemorate each of her fiftieth, sixtieth, and seventieth birthdays, she commissioned dinnerware sets and matching boxes. Unsatisfied with her tomb, she ordered it reconstructed from scratch during the First Sino-Japanese War. She was said to have diverted funds designated for modernizing China's outdated navy—which had been embarrassed again and again in engagements with foreign forces—to pay for the renovation and expansion of the Summer Palace, which became her personal retreat.

FAR REMOVED FROM BEIJING, Liu built the finest residence in Xingang, a sprawling complex of stone buildings arranged around a courtyard and encircled by a brick wall. The estate fronted the dirt road to Jiujiang and featured three pine trees, traditional symbols of longevity, friendship, and steadfastness, under which Liu often set out a bucket of cool water and jars of herbal medicine for travelers resting in the shade during the sweltering summers.

He married the daughter of a rich peasant family that had made its money selling Yangtze River fish. The Yangtze was full of fish back then, shad and herring and Chinese sturgeon, an ancient species that grew to more than ten feet long and a thousand pounds and is now nearly extinct. Each spring fish migrated up the river past Jiangxi to lay their eggs. The fertilized eggs hatched as they floated back down the river. By the time the fry reached Jiujiang, they were transparent needles, and the patriarch of the Yao clan went out around the fifth day of the fifth lunar month and collected these fry, which he sold to buyers from all over the country. His business grew until it became an area industry, but the man remained so thrifty that he would eat three bites of rice for every piece of salted black bean.

Liu became the benevolent dictator of Xingang. In addition to his teaching and land holding, he employed villagers, doled out extra bushels when they were hungry, acted as their legal representative, mediated their disputes, wrote correspondences for the illiterate, loaned money, and forgave the debts as often as he collected them. A skilled calligrapher, he wrote scrolls or proclamations for villagers without charge during the Lunar New Year. He was an expert with an abacus and helped merchants and shopkeepers with their accounting. Having trained himself in traditional Chinese medicine, he also served as the village doctor.

Every morning, after he finished his breakfast, Liu paid a visit to the Shi family's general store to pick up his newspapers or check for mail. Then he might receive an audience of villagers in need of dispensation or adjudication. Or he took a stroll to inspect land for sale. One reason rural families had difficulty preserving their wealth from one generation to the next, aside from the gambling, disease, and drug addiction that stalked the countryside, was the inheritance system that split land evenly among the heirs. Over a few generations, even the largest properties were eventually parceled into insignificance, if they weren't sold off to feed the heirs' vices. Liu would then

make his way into the village to spend the afternoon chatting with other elders, reading, or leisurely attending to the matters of a man with culture and means. He would return home to rest before dinner. His favorite meal was an oily combination of salted, pickled spinach with meat, steamed all day until it practically melted.

His wife bore him three sons—whom he named Ting Zan, Ting Geng, and Ting Gong; one meaning for the generation name of Ting was "Palace Courtyard"—and three daughters. The birth order of the first two daughters, as well as their birth dates, is lost to history. In those days, women seldom even had names, and Liu's wife would have gone by her nickname or kinship term with family members or Lady or Madam Liu with others. Through a matchmaker, Liu arranged a marriage for his eldest daughter according to the tenet of *men dang hu dui*, harmony in social position and economic class. But the matchmaker failed to disclose that the prospective husband was a widower. When Liu's daughter moved into her new home, she learned that she was the stepmother, which carried a terrible stigma. A widely circulated folk song, often the first one a child would hear, illustrated the disappointment of being or having a stepmother:

> *O Little Cabbage that withers in the fields,*
> *I lost my mother at the age of three.*
> *Living with father is still an easy time,*
> *But I fear he will marry a stepmother.*
> *Three years after he finds a stepmother,*
> *Stepmother gives birth to a little boy.*
> *Little brother is more fortunate than me,*
> *He eats dumplings but I only drink the soup.*
> *When I hold the bowl I think of mother,*
> *And when I think of mother, I cry.*
> *Stepmother asks why I'm crying,*
> *And I say the soup is too hot.*

The daughter fell into a depression and died young. The middle Liu daughter was sent to a family of farmers as a *tong yang xi*, a child bride who was adopted into a family who either had a son or hoped to have one soon and then raised her as a future daughter-in-law; the arrangement subtracted one less mouth to feed from Liu's ledger and demonstrated both the value of women at the time and Liu's thriftiness. Liu's youngest daughter had the benefit of being born much later, in 1910, just one year before my grandmother, when attitudes toward women had begun to change. She received a name—Ting Yi—and tagged along with Liu to his *sishu* every day, studying readers for girls while the boys learned Confucian classics.

In the tradition of Chinese scholar-gentry, Liu patronized the arts and collected porcelain by the crate. Jiujiang was the customs port that processed rice, tea grown on nearly Lushan (*shan* meaning "mountain"), and ceramics from Jingdezhen. Whether imperial pieces destined for the Forbidden City or export ware headed to a Victorian porcelain room, it all moved through small waterways from the kilns to Poyang Lake, then to Jiujiang, the gateway to the Yangtze, and the daily boats from Jingdezhen always seemed to have something for my great-great-grandfather. Flower vases with mottled, running red glaze. Cylindrical hat stands. Fine handmade figurines of countryside characters or Buddhist gods. Painted tiles of Chinese landscapes in different seasons. Blue and white jars for storing pickled vegetables or tofu. Tea sets, vases, decorative plates, and tableware. Visitors heaped gifts of porcelain on my great-great-grandfather. When a boat loaded with Jingdezhen porcelain sank near the docks, he bought up what the locals scavenged out of the river. The relative who worked in Jingdezhen during the tail end of the Qing dynasty brought crates of porcelain home with him to Xingang every Lunar New Year. And his subordinates were only too happy to curry favor with him by slipping him imperial pieces. It was illegal, but by then the Qing court had more pressing matters.

ON THE HEELS of the Opium Wars came the Qing's defeat in the
First Sino-Japanese War, fought from 1894 to 1895 over control of
Korea. China had historically dismissed the Japanese as a regional
player, but while the Qing government was too busy stealing and
squabbling with itself to devise a coherent and long-term foreign pol-
icy, Japan had reacted to its own brush with gunboat diplomacy, cour-
tesy of the Americans, by industrializing and Westernizing at a torrid
pace. The war was one-sided, the outmatched Chinese navy was once
again decimated, and the Japanese won Taiwan as a concession.

Cixi had since named her nephew, Guangxu, as emperor. Al-
though dominated by Cixi, Guangxu was a bright, curious young
man with an open mind about international affairs, perhaps owing
to his boyhood fascination with Western technologies like watches,
clocks, and bicycles. The revelation that China was far less developed
than its perceived subordinate—Japan boasted more railroads and
telegraph lines than all of China—compelled Guangxu to make real
the reforms that the progressive ministers in the court had been wait-
ing for.

Guangxu issued a series of decrees intended to transform China
into a constitutional monarchy along the lines of Meiji Japan, estab-
lish a Western university system, invest in infrastructure, and per-
haps most controversially, overhaul the imperial civil service exam,
by which nearly every official in the Qing court had attained his po-
sition. These edicts became known as the Hundred Days' Reform of
1898, for the amount of time (technically 104 days) that passed before
Cixi, who had ostensibly "retired" but sensed a threat to her klep-
tocracy, staged a military coup, placed Guangxu under house arrest,
and exiled or executed most of his supporters. Guangxu spent the
next decade of his life in a small, isolated palace in the Forbidden City
tinkering with clocks and watches and waiting for Cixi's death, after
which he hoped to be restored as emperor.

In response to the series of indignities suffered at the hands of foreign powers, an ultranationalist movement sprouted in China, and with the twentieth century came the Boxer Uprising. The Boxers were disenfranchised peasants upset by the same social ills as the Taiping—economic desperation, the scourge of opium, a corrupt and self-interested government—and, like the Taiping, subscribed to a millennial outlook. In the decades since the First Opium War, foreign powers had forced the Chinese into importing opium, accepting unequal treaties, tolerating the dissemination of the alien religion of Christianity, and granting extraterritorial rights to their citizens when on Chinese soil; the country was perilously close to becoming formally colonized. The Boxers blamed the Qing, which skillfully deflected the fury toward Westerners. Boxers subsequently attacked foreign missionaries and Chinese Christians, whom they viewed as traitors, and burned churches and cathedrals. They stormed through the countryside and eventually marched on Beijing, besieging the legation quarter that housed foreign embassies.

The moderates in the Qing court opposed going to war with the foreigners, but Cixi overruled them and backed the Boxers. The fighting in Beijing lasted just one summer, during which the royal family evacuated inland to Xi'an, one of China's ancient capitals, under the pretense of an "inspection tour." When the Boxers were finally suppressed by an alliance of military forces from the United States, Britain, France, Germany, Japan, Russia, Italy, and Austria-Hungary, the country paid for it. Foreign forces occupied cities in northern China for more than a year, carrying out reprisal killings, raping, and collecting indemnities. Soldiers, diplomats, and even missionaries participated in what one writer called "an orgy of looting"; it was such a gold rush that an American church worker was even arrested by French troops for beating them to the punch in one village. The Imperial Gardens were pillaged and destroyed again. On top of it all, the Qing government was forced to execute some of its own ministers and pay yet another massive indemnity.

When Cixi returned to Beijing, she seemed to realize that the foreigners could neither be ignored nor repelled and finally enacted sweeping political reforms, many of which were more progressive than those suggested by the ministers she had eliminated just a few years before. Guangxu never reclaimed his throne. He died young and heirless, at thirty-seven and under mysterious circumstances. One theory was that Cixi, herself in failing health but still determined to dictate the terms of succession, had him poisoned. Cixi died the following day, just hours after installing Guangxu's two-year-old nephew, Puyi, as the new—and famously last—emperor. By then it was too late for the Qing. In 1911, the country revolted, and the following year the emperor was forced to abdicate, bringing an end to feudal China.

THOUGH BORN DURING Tongzhi's reign, Liu had come of age during the struggle between Guangxu's progressiveness and Cixi's conservatism, and someone of his intelligence could plainly see that Cixi's muzzling of Guangxu was only delaying the inevitable. It might have been while he was working in the cosmopolitan Yangtze delta that he took good stock of the direction China was moving. Or perhaps it was living near a port city, where the locals liked to say they resembled the wandering Yangtze, their minds flexible and curious, perpetually moving and reshaping the landscape, bringing in new goods, people, and ideas. When Liu considered the fragility of the Qing regime and the waves of Western education, technology, and infrastructure that appeared to be as endless and unyielding as the tides, he must have concluded that Western educations, not the traditional Chinese schooling he received, would confer the greatest advantages to his three sons.

Likewise, China's defeat in the First Sino-Japanese War finally forced the Qing to acknowledge the importance of modernization, and railroads in particular. The Chinese had always been skeptical of

railways, considering them eyesores that upset feng shui, brought far more nuisances than benefits, threatened the livelihoods of canal porters and ferrymen, and potentially provided access to invaders. The first rail line in China opened in the 1860s, connecting the American concession of Shanghai with Wusong, fourteen miles up the Suzhou River and now a district of the megalopolis; it was promptly closed after a train struck a local Chinese. The railroad reopened briefly in 1877, but the Qing government considered it a blight. At the time of the First Sino-Japanese War, China had only 370 miles of track.

But as Herbert Giles, the British diplomat and sinologist who developed the Wade-Giles romanization system that was the standard for transliteration until the mid-twentieth century, observed, "The Chinese, who are extraordinarily averse to novelties, and can hardly be induced to consider any innovations, when once convinced of their real utility, waste no further time in securing to themselves all the advantages which may accrue." The Chinese also rejected the telegraph at first, partly because of similar feng shui concerns, but mostly because they didn't believe such an invention had any real benefits. But once they learned that some wily Cantonese (a persistent regional Chinese stereotype) had enriched themselves by hearing the results of the triennial imperial exam in Beijing via telegraph weeks before everyone else, and then buying all the lottery tickets with the names of the top graduates, opposition to the telegraph crumbled. After that, Giles wrote, "the only question with many of the literati was whether, at some remote date, the Chinese had not invented telegraphy themselves." And so it was that after rail lines helped move troops to quell the Boxer Rebellion, the Qing realized the utility of railways, and they expanded accordingly. By 1905, when Liu's eldest son, Ting Zan, my grandmother's father, was a teenager, China's rail network had grown to more than three thousand miles of track.

Around the same time the Qing established the first modern institutions of higher learning in China, modeled after American and

European universities, staffed with foreign faculty, and intended to close the scientific and technological gap between China and the West. To supply the expanding railways with trained engineers and managers, specialized colleges were created. With all the money flowing into railroads, my great-great-grandfather must have pegged it for a growth industry and had his two eldest sons, Ting Zan and Ting Geng, tested into the railway institute in the provincial capital of Nanchang, where they studied engineering.

Liu sent his youngest boy, Ting Gong, off to St. John's University in Shanghai, an elite school tucked into a bend of the Suzhou River. St. John's was registered as an American university, making it easier for graduates to pursue master's or doctorate degrees in the United States, which attracted children from China's most prominent and wealthy families. Upon graduating from the railway college, Ting Zan took a job managing the construction of a new rail line connecting Jiujiang and Nanchang, while Ting Geng went to work as a civil engineer for the provincial transportation ministry. Ting Gong, who majored in English and Latin at St. John's, accepted a position teaching at the medical school in Nanchang.

Liu's hunch was proven right in 1905, when the Qing government abolished the imperial civil service exam system for good, a cataclysm that removed one of the pillars of Chinese society and the only surefire, democratic avenue for class mobility. Having an imperial degree was still respected, but those who had studied at Western institutions or overseas became the new elite. The men returning to China with degrees from Harvard or Oxford—these were the ones that Liu's crowd wanted to marry their girls to, and they weren't looking for women with bound feet, a barbaric practice that became even more retrograde in this light. They sought educated women who could speak English, whom they could talk to, and who could accompany them abroad.

Liu arranged all the marriages for his sons, pairing them with prominent families in the area according to *men dang du hui*. The

two families would meet with a soothsayer, who considered the birth years, months, days, and hours of the bride and groom and decided on the most auspicious date for the wedding. On the wedding day, the groom arrived at the bride's house on a sedan carried by eight porters (less wealthy families used four-man sedans). The bride's family would meet the sedan with her dowry ready. Ten men carried dozens of pairs of shoes for her and her husband (once a girl got engaged, she spent most of her idle time making shoes, and by the time of the wedding, she was practically drowning in them), wooden pans for washing feet, night pots, trunks containing blankets and pillows, and money for the groom's brothers. The bride's family cried as the sedan approached, the louder the better. Sometimes the family would pay others to join in the crying. With the sedan in front of the house, the bride was carried on the back of a male relative—she wasn't allowed to touch the ground lest she walk off with the family's good luck. After she entered the sedan, the doors locked, and they only unlocked once they reached the groom's house.

Then began a series of banquets, first for the matchmaker, to dispense of the person who, according to a Jiujiang saying, was "tossed over the wall" once the bride arrived. The next morning was a banquet for the bride's side. Villagers and beggars lined both sides of the main gate between the banquets to cheer, and rich families would toss silver coins at them like confetti. Then there was another extravagant banquet for the family and villagers. After three days of feasting, the bride returned to her new home, accompanied by a male relative who sent over a porcelain dowry jar for storing oil.

As the section chief of the Jiujiang-Nanchang line, Ting Zan earned a good salary, but in keeping with tradition, he sent most of his income back to his father in Xingang, setting aside just enough to care for his wife and three daughters. His brothers followed suit, and these three revenue streams flowing back to Xingang swelled my great-great-grandfather's property holdings until he came to own most of the buildings on the main road of Xingang.

By his fiftieth birthday, Liu curtailed his teaching and bookkeeping to devote more time to managing his estate, which had grown to six families. His brothers' lives had not been as prosperous, and they relied on him for help. The middle brother hadn't made any effort to study the classics as a youngster and grew into an opium addict who spent his days idling with food and drink like the pampered son of an official. The youngest brother had studied diligently for the imperial exams but couldn't manage to pass, and the repeated failures destroyed him. There were also nephews, daughters-in-law, grandchildren, a young daughter not yet of marrying age, and various servants to support.

Ting Zan's work, while prestigious and well compensated, was also arduous. He spent much of his time in the field, where, in addition to the daily responsibilities of supervising the construction of the eighty-mile length of rail, he was tasked with settling disputes between the company and local landowners whose property stood in the path of the lines. If a cemetery happened to be in the way, those families demanded reparations. Ting Zan would lead excavations to first determine the veracity of the claims—locals would sometimes bury animal bones and claim them as their ancestors' in the hopes of getting a settlement—and then arrange for the reburial of the remains in another location. He worked long hours, ate poorly, and eventually contracted tuberculosis. The railway was completed in 1915, four years after the birth of my grandmother, and Ting Zan retreated to an office in Sha He, the first southbound stop on the line.

[4]

PANDA CHINESE

ACCORDING TO MY FAMILY, THE FIRST WORD I EVER SPOKE was in Chinese. It was a phrase, actually, uttered when I was eight months old and my mother saw that I had thrown my stuffed rabbit out of my crib. "Where's your rabbit, Huan?" she asked. I said, "It fell," and my mother almost fainted. I was supposedly a Chinese chatterbox as a toddler, but I couldn't remember ever speaking Chinese, other than to mimic or make fun of Chinese people. At home, my parents spoke mostly Chinese to each other and a mixture of Chinese and English to me and my younger brother, while we responded exclusively in English.

Growing up in a Chinese-speaking household must have created enough neural connections that, while dormant for many years, nonetheless would provide me with a head start with the language, though not without the many deficiencies unique to ABCs. My biggest problem was vocabulary, which consisted primarily of what my parents talked about to me when I was a child, effectively limiting my lexicon to that of a seven-year-old with a Christian schoolteacher mother and a scientist father. Thus I knew the words for *tithing, church, homework, laboratory,* and the phrases for *lose face, clean your room,* and *or I'll spank your behind into four pieces,* but not, say, *boring,* or *surname,* or *napkin,* or *department,* or any business terms whatsoever. I could say *camera* but not *video camera,* because my father thought taking

moving pictures was lazy. Whenever I searched for a word, I first tried to recall one of my parents saying it, and if I could hear their voices—discussing Taiwanese politics with their friends, recounting their workdays, ordering me to do chores—I had the word. This could be impressive, as when I could tell people my father worked with *electron microscopes*. And it could be very embarrassing, as I learned that the Chinese I thought I knew was often either Taiwanese vernacular (with differences like those between British and American English) or diminutives that parents use with children. The first time I tried to buy a cup of *juzi shui,* or orange juice, at the company's coffee café, the cashier giggled uncontrollably. I later learned that *ju* means the color orange, not the fruit (that's *chengzi*), and that *zhi,* not *shui,* is juice. When I ordered *juzi shui,* I was basically asking for "orangey yum."

In Chinese, each word can have up to four tones attached to it, which makes for plentiful opportunities to mangle the language. It isn't an accent, like the American and British pronunciations of *schedule;* it's the difference between saying *deficits* and *defecates*. And then there are the homophones. While Westerners spell out difficult or unfamiliar words, Chinese often trace out the characters with their finger, which was useless for illiterates like me.

Though I had a good ear for tones and could reproduce them fairly accurately, I often had trouble remembering them. "Take me to Yan'an Road, please," I'd say to a taxi driver, hoping that the tones I'd chosen for *Yan* and *an* were correct.

"Where?" he'd ask.

"Yan'an Road." I would repeat it with another combination of tones.

"There is no Yan'an Road."

I would start to get angry, thinking he was just trying to squirm out of a bad fare. "Of course there is! Yan'an Road, now!" A third combination of tones.

"I'm telling you, mister, there's no Yan'an Road. Do you know how to write it?"

"No, I don't. Don't be so lazy. Just take me to Yan'an Road." A fourth. There were still twelve more possibilities.

"I'm not being lazy. I have no idea where Yan'an Road is."

"Then you're stupid."

"Whatever you say."

Eventually, after calling Andrew or someone who spoke better Chinese and who was more familiar with the city and handing the phone to the driver (a much-used tactic among expats), the driver would exclaim, "Oh! Yan-AN Road! Of course."

After many months of these exchanges, and the withering looks from Andrew that followed, I signed up for the company's Chinese class, taught by a good-natured woman from human resources named Jewel who wore her hair in a pixie cut and spoke excellent English; she was one of the few local Chinese who would eat lunch with the expats. There were about a dozen students, mostly teachers from the company's school, and I was the only one of Chinese descent. It was supposedly the intermediate course, for those with some familiarity with the language, but we spent most of the class on basic grammar and characters. Despite my resoluteness in avoiding all things Chinese as a child, I couldn't avoid developing an intuitive sense of the former, and while the latter was useful, it wasn't a pressing need. I wanted to arm myself with words, but the other students seemed preoccupied with perfecting their pinyin (China's official phonetic system for transcribing Chinese characters) and memorizing grammar rules that struck me as esoteric and nitpicky. There was the added distraction of one of the other men in the class, an Italian engineer named Roberto. When we paired up to read a simple dialogue, he demanded that I slow down so that he could translate every character, first into pinyin and then into Italian. "You shouldn't be in this class," he grumbled.

I agreed with him but tried to be gracious. "No, I have a lot to learn," I said.

"No, you shouldn't," he said. "You're just going to keep me from learning."

One night in class Jewel explained how to modulate a request depending on the situation. She wrote one example on the board, and Roberto asked, "But is it polite?" With his accent, *polite* sounded like *bulai*, or "don't come." They shouted at each other in confusion until another class member translated.

I decided to call one of the many private language schools in Shanghai. An ABC friend recommended an outfit called Panda Chinese in Puxi. The office manager tested my Chinese over the phone. I surprised myself at how easily I understood and answered her questions. "You're too advanced for our beginner class," she said. "I recommend you sign up for one-on-one tutoring."

I'd also had enough of the suburban dystopia of the company living quarters and began looking for an apartment in Puxi. After a few weeks searching listings geared toward expat renters (renovated lane houses, often furnished with items from Ikea, which had cachet in China), and exploring Shanghai's concession architecture, some charming, some neglected, I moved into a one-bedroom apartment in a well-kept lane house on West Nanjing Road, the continuation of the east–west thoroughfare that originated at the Bund and demarcated the northern border of the former French Concession. In my great-great-grandfather's time, the street was quaint, treelined, and known as Bubbling Well Road, for the natural spring surfacing at its terminus, Jing'An temple. Now only the trees remained, nd from my window I could see three shopping malls full of luxury brands, including flagship Gucci and Louis Vuitton stores, towering above their crowns. Men circulated in the pedestrian traffic hawking fake watches and leather goods to the white faces, and women sat on the plazas selling fruit out of baskets balanced on bamboo yokes, mangosteens one month, bing cherries—always proudly advertised

as imported from California and always overripe—another month. During one of the city's occasional antiterrorism initiatives, a bomb-sniffing beagle patrolled the plaza wearing a doggie vest emblazoned with "Explosive Dog."

The language school placed me with a young woman named Crystal who wore short-shorts, chunky wedge sandals to make her taller, and blue eye shadow. She was from Wenzhou, a coastal city about three hundred miles south of Shanghai known for savvy business-people. As China reformed its economy in the wake of the Cultural Revolution, Wenzhou received little investment from the central government, but its inhabitants embraced entrepreneurialism as families and friends pooled their money to set up private enterprises, primarily in light manufacturing; the city produced 60 percent of the world's buttons and 70 percent of its cigarette lighters. Many of those entrepreneurs became astronomically rich. When the Chinese spoke of *baofa hu,* literally "explosive rich," a slightly pejorative term for overnight millionaires with more money than taste, they often had Wenzhou people in mind.

Crystal and I followed a workbook, but most of the time we just chatted about our lives and experiences while she explained new words and phrases as they came up. Instead of systematically building a great wall of knowledge brick by brick, I mortared vocabulary ad hoc onto an unstable, incoherent foundation, patching holes with mismatched material selected on the basis of how easily it could be acquired. It was all very Chinese, really.

I met with Crystal three times a week, and many of our sessions centered on questions of Chinese-ness; I was the child who had suddenly discovered the word *why?* One day Crystal told me about Kong Rong Rang Li, an ancient story of virtue akin to George Washington and the cherry tree. Kong Rong was the sixth of seven brothers in the Han dynasty. When his father brought home some pears and picked out the largest, sweetest one for him, Kong Rong refused it and chose the smallest one instead, explaining that since he was younger,

he ought to leave the best fruit for his older brothers. But what about your younger brother? his father asked. Kong Rong replied that as the older brother, it was his obligation to take care of his younger sibling, and thus he should also get a bigger pear.

"Wait, if everyone is taught this story about selflessness, then why are people so selfish?" I said. "I hardly ever see people give up subway seats for elderly or pregnant people. There's no courtesy getting on or off the subway, going up escalators, standing in line . . ."

"Yes, a British student of mine once asked me why we keep talking about five thousand years of history and culture," Crystal said. "It seemed to him that there was only about a hundred years of culture, because all the ancient stuff was gone. And that caused me great shame. He's right in a way, because now, especially in Shanghai, there is such an emphasis on money and thinking that as long as you have money, nothing else matters. But a lot of it is just because people don't know. This will slowly improve, like the spitting."

That led to me asking her about another Chinese habit: wearing pajamas in public. "I get asked this a lot by my students," Crystal said.

"I heard it's because historically only the very rich could afford to have two sets of clothes, and that wearing sleeping clothes outside shows how wealthy you are," I said.

"No!" Crystal said. "That's completely wrong! Back in the old days, people didn't have pajamas. They just wore their innermost layer of clothing to sleep in. The tradition is taking off clothes, not changing them. Chinese people just don't know that pajamas are only for sleeping in. They think, well, they might be designed for sleeping, but they're really comfortable, so why not wear them on the street? Even my mom, she'll go downstairs or into our compound's court-yard and hang out with other ladies in her pajamas. I tell her all the time it's not right. But she just ignores me or tells me not to worry about her, because she's the mother and I'm the child."

"Okay," I said. "Now what is it with the long fingernails?"

Crystal sighed. "I get that question all the time, too."

When we moved on to Chinese customs in gift giving (a favorite topic among teachers), I probably wasn't as enthralled as Crystal's other students. According to Chinese tradition, a clock, or *zhong*, signifies the end, and to *song zhong*, or "send a clock," is a euphemism for attending a funeral. Small shoes are also discouraged, since they make the wearer's life painful. So are shoes in general, because they allow one's partner to run away. Umbrellas make bad gifts, because they are a homonym for "separation." A green hat for a man means he is a cuckold. Neither black nor white dresses are appropriate for weddings. Chopsticks shouldn't be placed vertically in a bowl of noodles or rice, as that resembles incense sticks, and incense is associated with death. Buildings seldom have fourth floors, as the number four, or *si*, is a homonym for "dead."

Where others might have delighted in these cultural peculiarities, I only saw examples of the Chinese people imprisoned by their own language, their behavior dictated by words that sounded like other words, reminders of China's obstinacy and failure to innovate. The clunkiness of first sinocizing Western words or ideas before adding them to the lexicon means that the Chinese use the same word for "alligator" and "crocodile" and categorize them as "fish." Same goes for rat and mouse, and cow and bull. With every new zodiac calendar, the English-language newspapers would debate whether to call it the year of the rat or the mouse, or cow or bull. *Fanqie jiang* describes "tomato sauce," "ketchup," or "salsa," which may explain why some restaurants serve pasta with ketchup and why even a Westernized Chinese person can still make the mistake of buying a jar of pasta sauce for dipping tortilla chips. There are words for the different pieces of equipment used in skiing and snowboarding, but nothing to differentiate the two sports.

The Chinese language is like an uncooperative child, staying rooted when it needs to move forward and sprawling when one tries

to gather it up. Whereas the twenty-six English letters can be combined to reproduce most sounds, assimilate foreign words and ideas, and encourage invention and evolution, Chinese is iconographic, a set of tens of thousands of distinct symbols, each of which represents a certain idea. Like Richard's company requiring ever more complex machines to produce chips that would keep up with the ever-changing market, every new Chinese word or idea requires an addition to the language, not a repurposing or recombination of existing equipment.

That makes Chinese difficult to reconcile with the digital age. As more documents and records are kept electronically, new complications arise for the written language, ones that have to do with the very characters themselves. Some Chinese characters simply cannot be input electronically. The creation of a new English typeface simply requires the design of its fifty-two constituent letters. But with tens of thousands of discrete characters in the Chinese language, creating Chinese typefaces is painstaking work, even with the assistance of computers. Despite having invented movable type, the Chinese still have only a handful of type designs at their disposal; most word processing software used in China ships with nearly 150 different Western fonts and just six Chinese ones. Chinese citizens with untypable characters in their names are forced to select new ones; the language is so rigid that even identities become obsolete. Adapting Chinese for digital use is so unwieldy that it often relies on a decidedly analog solution: in the backstreets of Shanghai are old masters creating new types by handwriting each of the 47,000 Chinese characters with a calligraphy brush, an endeavor that literally takes a lifetime to complete. The characters are then individually scanned at type foundries and converted into electronic fonts.

I often wondered if the lack of an alphabet, and the easy system of ordering and categorization that it enables, explains why the Chinese are incapable of queuing up. When I asked around the office how, say, schoolchildren lined up, I was told that it was usually by height. In

ancient times, Chinese categorization relied on the *Thousand Character Classic,* a poem with one thousand unique characters commissioned in the sixth century and originally intended for practicing calligraphy. It is also used as a reading and writing primer for children, who recite it much as Western children sing the alphabet song.

But the Chinese I was learning actually bore little resemblance to the language of just sixty years ago, when Mao Zedong, in an effort to increase literacy, created a new written language that would be easier for peasants to learn. Traditional Chinese characters could contain dozens of individual brushstrokes, and Mao's lexicographers simplified them sometimes beyond recognition. The reforms were a continuation of the May Fourth movement during the Republic of China in the early 1900s, when intellectuals viewed the Chinese language—the "writing of ox-demons and snake-gods," as one put it—as holding the country back from modernization. During the 1950s and 1960s the new Communist government released two rounds of simplified characters to be gradually integrated into the language, boosting literacy but also severing the organic nature of the language, which had evolved over thousands of years, from oracle bone carvings to a complete lexicon. The traditional character for *China,* which combined a tone with a pictogram, now appeared in simplified form as a "mouth" with "jade" inside, a nice but ultimately meaningless image. Unlike the disastrous Great Leap Forward, however, the creation of simplified Chinese was a success, even if those who opposed the reform were deemed political enemies and sometimes severely persecuted.

As much as I complained to Crystal that Chinese lacked proper equivalents to English terms or ideas, some concepts were expressed best in Chinese. *Taoyan* has an English equivalent, "annoying," but conjures the image of someone pulling her hair out and screaming "Ack!" Or *renao,* the kind of crowded, bustling bonhomie of a holiday market or an Olympic festival. Or *luosuo,* which can describe the troublesome obstructionist who always has an answer (or question)

for everything. Though it lacks the order, structure, and precision of English, Chinese is able to convey multisensory, layered, and figurative concepts with striking comprehensiveness.

Often these concepts are described with *chengyu,* mostly four-character idioms that in Chinese are akin to proverbs or old saws. One of the first *chengyu* most people learn is *ren shan ren hai,* literally "people mountain, people sea," meaning a huge crowd. *Dui niu tan qin,* or "playing a lute for a cow," is the equivalent of talking to a wall. There is even a *chengyu* for the Chinese xenophilia that so exasperates ABCs: *chong yang mei wai,* or "worship the foreign, fawn over outsiders." One of my favorite sayings is a way of stating redundancy: *tuo kuzi fang pi,* or "take off your pants and fart." These *chengyus* seem to reflect the culture's emphasis on the overall purpose. What was the point of standing in line as long as everyone eventually got on the train? As I began to see the language as representational, as ideas expressed in characters expressed in words, China began to unfold. Instead of getting frustrated that the Chinese had only one word, *che,* to cover automobiles, railroad cars, and horse carriages, I understood that *che* represents a wheeled machine. To master a language is to master a culture.

[5]

THE ORPHAN

AFTER MY QUARREL WITH MY GRANDMOTHER, MY MOTHER and Richard explained to her that I wasn't interested in recording her collected wisdom or prying into the affairs of others but rather in understanding her life and times. (I didn't mention the porcelain, thinking we would discuss that when it came up.) My grandmother understood, and I went back to see her, apologizing for the miscommunication and for being disrespectful. I got the feeling she accepted my apology out of equal parts charity and exhaustion.

"So you want me to tell my own story," she said.

"Yes," I said. "Where do you want to start?"

"I'll just start at the beginning."

MY GRANDMOTHER WAS born on August 23, 1911. A few months later came the birth of the Republic of China. Republican president Sun Yat-sen, a Western-educated physician, and his protégé Chiang Kai-shek—both Christians pushing a platform of "nationalism, democracy, and the people's livelihood"—envisioned a remarkably different China. Their Kuomintang, or "Nationalist," government modernized the courts, banks, infrastructure, and public health facilities and reclaimed the concessions that feudal rulers had made to foreign powers. The industrial sector grew to new heights. Chinese

students went to the West in droves and returned with Western degrees, ideas, expertise, and clothing. Campaigns promoted women's rights, including an official ban on foot binding. In Nanjing, a Mount Holyoke graduate founded Ginling Women's College, staffed it with Seven Sisters alumnae, and made it a sister school of Smith College.

While my grandmother's father, Ting Zan, completed his studies in Nanchang, she spent her first years in the Xingang house under her grandfather, who, once he saw that his eldest son had not borne him an heir, gave little thought to her welfare. Her mother didn't have enough milk to feed her, but her grandfather didn't hire a wet nurse or dispatch a servant to fetch milk from town, as he might have if she were a boy. If they had lived in Jiujiang city, her parents could have bought her condensed milk and diluted it into a formula. But in the countryside, even the firstborn grandchild of a wealthy man, by dint of her gender, survived on rice mashed into powder and mixed with water and sugar. Poorer families substituted salt for the sugar, and the destitute simply used the leftover water from boiled rice, so my grandmother, skinny and underweight as she was, didn't really stand out among the girls in Xingang.

She did stand out for having a proper name, as would all the Liu granddaughters, who shared the generational name of Pei, which could mean "respect" or "wear." My grandmother was named Liu Pei Jin, *jin* meaning "gold." Her sisters were Pei Fu and Pei Sheng. Their cousins, the daughters of Ting Geng, were Pei Yu and Pei Ke. *Fu, sheng, yu,* and *ke* are all different kinds of jade. At home everyone went by her kinship term. My grandmother was Da Jie, "Big Sister." Her middle sister was Er Jie, "Second Sister," and the youngest was Si Jie, or "Fourth Sister"; Pei Yu, the eldest daughter of Ting Geng, was a year older than Si Jie and thus was considered the third sister, or San Jie. The youngest, Pei Ke, went by Wu Mei, "Fifth Sister," *mei* being the term for a younger sister. Only Ting Gong managed to bear sons. The eldest, Liu Cong Jia, died in childhood, leaving his brother, Liu Cong Ji, as the only male to continue the line.

Aside from hunger, the other hallmark of my grandmother's early life was fear. Though principled and kind at heart, my great-great-grandfather expected others to listen and obey, or else. No one knew why he was so quick-tempered, only that it was his nature to go from a whisper to a shout in an instant, especially if something violated his principles. He once suspected a shop owner of being unscrupulous and stood outside the shop telling everyone not to give it any business while the owner hid in the back. The entire village cowered in his presence, including his wife. When he walked down the street, dogs didn't dare to bark and children didn't dare to cry.

My grandmother's life improved when her father, Ting Zan, finished school and began work on the railway. Ting Zan moved his family out of Xingang and settled in a comfortable house in the town of Sha He, the first southbound stop on the Jiujiang–Nanchang rail line, on a small street bookended by a church with stained-glass windows, ministered by a Chinese pastor, and a small school, run by Chinese teachers. My grandmother ate much better. She whiled away her afternoons constructing dolls out of sticks, cotton, and scraps of cloth. When it came to rearing children, her parents were typically Chinese, pragmatic and unaffectionate, though my grandmother could remember being spanked only twice in her life. The first was when she was doing her homework and heard some neighborhood children outside singing pro-Communist songs and ran out to listen. "What's so nice about those songs?" her father said, and spanked her for not being studious. The second time was on a summer evening, when the neighborhood had gone outside to cool off after dinner. The mosquitoes had also come out, and my grandmother's mother was burning wood to smoke them away. My grandmother, upset at the dual assault of mosquitoes and smoke, cried, "For God's sake, I can't even open my eyes! Stop it!" Her father grabbed her and told her that children shouldn't disrespect their mothers.

Though reared on a traditional Confucian education, Ting Zan's time in college had Westernized his views, and his three daughters

grew up in an uncharacteristically progressive house as the Qing dynasty gave way to the Republic of China. The Chinese revered sons, who, like Ting Zan and his brothers, could work and contribute to the family's coffers, and according to the tradition of patrilineal kinship, only males could be heirs. Daughters, on the other hand, were bad investments, draining resources only to cut all ties to their families when they married. The Chinese philosopher Mencius, the Socrates to Confucius's Plato, said that of the three unfilial acts, failing to produce an heir was the worst. Female infanticide was common. After Ting Zan's wife gave birth to her third daughter, she wept for days. She begged her husband to take a concubine so that he might have a son and save face for her and the family. Ting Zan wasn't interested. "What a strange thing to say," he said. "Boys or girls, they're all the same these days. I don't want another wife."

None of the Liu girls had their ears pierced or feet bound. Foreigners didn't do it, so why should Ting Zan's family? But his wife persisted and bound my grandmother's feet behind his back. It didn't hurt at first, but my grandmother didn't like the idea of it and purposely hobbled back and forth in front of her father in exaggerated pain. "Why are you walking like that?" he asked.

"My feet hurt," she said.

"What's wrong with your feet?"

My grandmother showed him her wrapped feet. "Your mother's bound your feet!" he said. "Take those off immediately."

"How are they going to find husbands if they don't have bound feet or pierced ears?" her mother said. "I'm trying to help them."

Ting Zan was more concerned about his children getting educations. In Sha He, my grandmother occasionally attended the church school and learned to read and write a few simple characters: *big, small, person, hand, knife, eat.* When she got older, she attended a *sishu* in the village, where an old scholar had set up a school at his home to educate his grandsons. Every morning a servant would piggyback her to the *sishu*, where she was the only girl in the room, copying

characters and reading tales of famous historical figures like Sima Guang and the porcelain cistern. When Sima Guang was a boy, he and some friends were playing around a group of large water vats—the ancient Chinese fire system—when another boy fell into one. Everyone ran off except for Sima Guang, but he was too small and the container too large for him to help the boy. In a moment of inspiration, he found a rock and smashed open the bottom of the cistern. The water rushed out and the boy was saved. Sima Guang grew up to become one of the youngest scholars to pass the national imperial examination and served as high chancellor of the Song dynasty. And ever since, children heard the folktale of Sima Guang Breaking the Porcelain Container, encouraging them to be as clever and level-headed as he.

My grandmother learned to recite the standard eight primers in just over a year; students typically took four years to finish them. "This girl is very smart!" the teacher told the class. Around my grandmother's tenth birthday, the family moved into Jiujiang, where her mother became friendly with missionary school teachers, who encouraged her to send her to study at a Western school.

In Jiujiang, the Rulison-Fish Memorial School for girls was one of the best, founded in 1872 by Gertrude Howe, a University of Michigan graduate and Methodist missionary. Howe had created a stir in the foreign missionary community by living outside the mission compound and adopting two Chinese infants, Kang Cheng and Shi Meiyu, whom she named Ida Kahn and Mary Stone, respectively, and who in 1896 became the first Asian women to receive American medical degrees, from Howe's alma mater.

When it was decided to enroll my grandmother at Rulison, my great-great-grandfather's youngest daughter, Ting Yi, one year older than my grandmother and whom the girls called San Gu, "Third Aunt," threw a fit. "Brother's daughter can go to a Western school and I have to stay at home!" she cried. Liu paid no attention to her, but when Ting Zan found out, he had San Gu admitted to Rulison,

paid her tuition, and sent her and my grandmother off to school with matching luggage.

My grandmother was ten, San Gu eleven. They joined in the middle of the term and lived barracks style, sleeping in a row of dozens of students. Every morning they attended a short chapel service with boys from Rulison's brother school, Tong Wen Academy, before heading to their classes dressed in the Rulison uniform of a green skirt and white shirt. They encountered subjects like geography, history, and mathematics for the first time. They began their English training, speaking as they acted: "I sit down," "I open the door," "I read my book." My grandmother picked it up quickly, and once she reached high school, she was translating for the foreign teachers, who, despite having private tutors, knew very little Chinese. My grandmother could still rattle off the names of her teachers: Laura Schleman, Leona Thomasson, Clara French, Rose Waldron, and Helen Ferris, the only one who took real interest in learning Chinese and amused the students with her fumbling syntax before becoming conversant.

During my grandmother's second year at Rulison, her father succumbed to tuberculosis. Heartbroken and penniless, her mother moved the family back into the Liu house in Xingang. She refused to eat and spent her days sitting next to her husband's grave, weeping. The neighboring farmers heard her wailing day and night, until she died a few months later, of heartache, according to my grandmother. She had been my great-great-grandfather's favorite daughter-in-law, and when she passed, it was said that he walked down to the lakeside and broke down in tears. My grandmother remained at Rulison, returning home only for summer and winter holidays, and when she went back, life was very different. Besides providing a minimum of food, clothing, and shelter, no one paid any attention to her and her orphaned sisters. They ate when everyone else did. They did what everyone else did. She could only imagine what it must have been like for her sisters, living there all year.

While San Gu distinguished herself at Rulison as an obedient, hardworking student, my grandmother coasted in class, spending her free time in the schoolyard, jumping rope, eating peanuts, or just daydreaming. Even before her parents died, she was known for getting into trouble with teachers and classmates. Her grades were still excellent, but her "moral character" was noted as being deficient. Despite all the Bible study and Sundays in church, and having been "saved" during a talk by a visiting minister, my grandmother regarded chapel as something to be suffered or skipped altogether. She bad-mouthed her classmates, showed up her teachers, and was quick to start arguments, determined not to let anyone else have the last word. She didn't fight, but as she told me, "If you touched me, then I'd touch you."

San Gu tested into China's top women's college, Ginling College in Nanjing, where she majored in geography and had her tuition paid for by Rulison, on the condition that she return after graduation to teach. My grandmother dreamed of following in the footsteps of Ida Kahn and Mary Stone and studying medicine. She earned the highest score in all of Jiujiang on the high school exit exams and applied to two universities, the Xiangya Medical School in Hunan, established by Yale University, and Ginling College, her backup school.

Once she passed the Xiangya entrance exam, she withdrew her application for Ginling. But her grandfather, though progressive enough that he would pay for all his granddaughters to attend Rulison, forbade her from attending a coeducational school. Ginling College was the only school he would allow her to attend.

"But I already enrolled in Xiangya," my grandmother pleaded. "I didn't take the Ginling test, and it's already passed. If I don't go to Xiangya, I have nowhere to go."

"I have a way," he said. He rushed to Jiujiang, found the Rulison principal, and asked if he could pull some strings at Ginling. The principal, hoping that my grandmother would return to Rulison as a

teacher, as many Rulison-Ginling grads did, arranged for her to take the Ginling test. She passed, and among the possessions she took with her to Nanjing was a grudge against her grandfather, so deep and unyielding that the first thing she told me, in English, when I asked about him, half a century since he passed away, was that "he was a dictatorship."

[6]

STREET FIGHT

Y GRANDMOTHER'S CONDITION DURING OUR CONVERSA-
tions varied. Some days she was alert and in high spirits. Other
days she was unsure of the date or time, spoke in a gravelly
whisper, and became exhausted after talking for a few minutes.

I learned that she never returned to her hometown of Xingang
after she left for Ginling College. "I won't go back," she said with a hu-
morless chuckle. "I don't have any interest. It's too sad, too *nanguo.*"
Nanguo translates as "uncomfortable" but conjures something much
more visceral: the squirming distress that emanates from the depths
of one's being. "I went back to see Ginling once, and it was nothing
like it used to look. That beautiful campus has been turned into a
mess. If I go back to Xingang and see what it's like now, my heart will
be too *nanguo.*"

So my grandmother could only speculate about the fate of her
grandfather's porcelain. Though she wasn't present when the objects
were buried, having just finished college and taken a teaching post
in Guangzhou, she was confident in her memory of the items. "His
porcelain was all ancient," she said. "Just a few of those things in my
mother's room would now be worth a lot of money."

"What happened to it?" I asked.

"It's all gone. Stolen, probably."

"Who do you think stole it?" I said. "The Japanese?"

"No."

"Your grandfather's worker, Old Yang?"

"No way," she said. "He was very loyal. He would not have dug it up. It was stolen by other people. They came at night and dug it up. You know who?"

I shook my head and leaned forward.

"Relatives. I heard it was my *san shen de niangjia*," she said, referring to the in-laws of her uncle Ting Gong. "They were rednecks. They had money but no culture. We had education, and they really disliked people like that. Strangers probably wouldn't have known about it or its value. So I think it was taken by someone who knew the value, insiders or family members."

I tried to hide my disappointment. Then I imagined tracking down those family members and looking on their shelves. "If you saw some of the porcelain, would you be able to recognize it as your family's?" I said.

"Oh, I wouldn't dare say it was mine," she said. "Other people had porcelain, too. But I could say yes, my family owned that piece before."

"What if," I said, "I wanted to go back to Xingang and see for myself?"

"There's nothing to see!" she said. "When the Communists took our house, they used it as a workshop, and then I think they tore it down to open a factory, I'm not sure. Now you can't find the burial sites out in the yard, and the *environment*"—she used the English word—"has been completely disturbed. When my cousin went back after the Cultural Revolution, she stood there and couldn't even figure out where the house had been. They tore down all the houses, changed the streets—everything's changed. It's impossible to find the original location. And if you did, it's all probably gone."

"Did your grandfather draw a map or anything when he buried his things?" I said.

"No, and if he did, it's no use," she said. Xingang suffered a major

flood in 1954 that devastated the village. "It's all different. There's no context. I'm guessing all the things we buried might have been already dug up. Those people knew our family would have buried things, so they dug our garden with purpose. And even if they didn't dig them up, you can't find them. Who are you going to ask? The people there probably don't even remember the houses. Impossible."

"But you weren't there when it was buried. You never went back. Isn't it possible that some of it could still be there?"

"You're dreaming," my grandmother said. "Don't choose this fantasy. You're thinking like a child."

"A child?" I said. "How am I a child?"

"This stuff happened seventy years ago. How can you understand it? Your Si Yi Po went back, couldn't make sense of anything." Her youngest sister, Pei Sheng, was Si Yi Po, "Fourth Grandaunt," to me. "My uncle's son, he grew up there, went to school there, and when he went back, he couldn't make heads or tails of things," my grandmother continued. "It'd be better if Er Yi Po"—Pei Fu, the middle sister, "Second Grandaunt" to me, who died in Jiujiang in 2002— "were still around. She was older when it all happened. The valuables, they're all gone. I can't encourage you to go back."

"Why not?" I said, making a note to find out who this "uncle's son" was. Despite having gone through the Liu genealogy many times, I still had a poor grasp of who everyone was, who was still alive, and where they lived. And my grandmother, who didn't appear to be close with any of them, didn't offer to connect me. "What harm is it for me to find out for myself?"

"People will be all over you," she said, rubbing her arm. "They'll make you meet all these people, take you to the family cemetery."

That didn't sound so bad to me, and I told her so.

"They'll see you're from the city and ask you to get them a job," she said. "That's why I don't talk to relatives back there. I don't want them to know how well Richard's doing here, or everyone will flock to him for a job." She had unhappy memories of her father, the railroad

chief, having to deal with extended family members trying to use their *guanxi* with him to get hired.

"Maybe I just want to see where you're from," I said, making an appeal to filial piety. "What about the family cemetery? Is that still there?"

"No, don't go looking for my parents' graves!" she said. "The countryside is full of people who will think you're rich and bother you for money. Lots of people think I'm arrogant about not being the same as them. But it's because we received a missionary school education. And Chinese people's traditional education is to be jealous of others, to criticize, to have confrontations. If you're not good enough, they're too good for you. If you're too good, they're jealous of you. So interactions with people are complicated."

She wouldn't say more, reminding me that she was not the serene, transcendent sage that I had envisioned. In our conversations, she revealed herself as a person with her own neuroses and anxieties, many of which had petrified over time. I sought omniscience, exposition, and a searchable archive, but she was the product of a life experienced, not just observed, and could no more easily detach herself from it and its limits or its consequences than anyone else.

"Anyway," my grandmother said, "the stuff we buried the first time during the Sino-Japanese War wasn't completely dug up. They overlooked some things. My family even gave me a porcelain jar, about this big." She held her hands two feet apart. I assumed she had received the jar after the war, before she went to Taiwan. "But the cover was gone, so it wasn't complete." When she emigrated to the United States, she left that jar in Taiwan with a man named Chang Guo Liang. When I asked my mother about him, she described him as an apprentice to my grandfather who had practically grown up with the family.

My grandmother also mentioned that her cousin Pei Yu, my San Yi Po (Third Grandaunt), also lived in Taiwan and knew all the details about the porcelain. She had even helped with the burials. "She

probably has a few bowls left," she said. But she discouraged me from visiting her. "She's very weak and out of it," she said.

And she absolutely forbade me from going to Xingang. "They're our family, but they're country people," she explained, spitting out "country" like a rotten piece of fruit. "Don't go to Xingang. Don't contact those relatives. Promise me this, Huan."

"Fine," I said. I gave up and left, thinking I'd try again with her another day. Later that night my grandmother phoned me. "I want to tell you something," she said, sounding very serious. "You shouldn't go to Jiujiang. Really, I don't want you going to the country. I can explain, but you won't understand. It's very dangerous."

WITH THE SPRING came the financial crisis, ruining any hope of a profitable quarter and casting a pall over Richard's company. I cashed in my vacation days to take a solid month off to work on my Chinese. As the summer went on, clouds and haze piled on top of each other, building a woolly layer of insulation that suffocated the city with heat and humidity. One morning a high tropospheric gust snagged the swath of gray and peeled it back, exposing a rare blue sky. I escaped to a swimming pool in a longtime expat complex for a couple of hours and then rushed to Chinese class, still wearing my swimming trunks. At one of the busy intersections near Jing'an Temple, posted with (largely ignored) traffic attendants with white gloves and whistles, I waited for the light to change. As usual, when the light turned red, the right-turn traffic didn't stop or yield, and as I stepped into the crosswalk, a white van traveling in the same direction made a right. I continued walking and the van continued turning, putting us on course to meet in the crosswalk. At the last second, I stopped, the van curved around me, inches from my nose, and I discharged more than a year of pent-up anger by slapping the side-view mirror.

The mirror exploded, and the sound of breaking glass cut through the din, catching everyone's attention. As soon as I felt the mirror

crumble, my anger evaporated, replaced by guilt, and I stood in the intersection feeling naked and very alone. The van stopped, leaving tire marks on the road, and the driver burst out, a stocky man with a buzz cut and red shirt. He charged me, grabbed my left wrist, and with his free hand struck me on the shoulder and chest again and again. He also tried to choke me, but his arms were too short, so he couldn't quite get his thick fingers around my throat, resulting in repeated, uncomfortable pokes in the neck. His hands were unusually large and incredibly strong. I tried to twist my arm out of his grip, then karate-chopped at it with my free hand, but the fleshy vise clamped on my wrist didn't budge. "What did you do that for!" he screamed. "Who do you think you are?"

My first instinct was not to run, or fight back, but to protect the phone in my left hand, on which I had recorded many of my conversations with my grandmother and which had become one of my most valued possessions. But the man showed no signs of stopping, and after about a dozen more strikes, I yelled in English, "Get the fuck off me!"

The man's eyes widened, and his red face turned even redder. "Don't give me that English!" he said. "You know what you did! You're going to pay for that."

As the man continued flailing at me, a series of thoughts crawled through my mind. *Well, this isn't so bad. Maybe he'll finish soon. But what if he pulls out a knife or something? Should I fight back? But then I'd have to drop my phone.* It had all happened so quickly that I still had headphones in my ears.

With one hand rendered useless and the other clutching my belongings, I turned sideways and crouched in a defensive pose. After punching me some more, the guy pulled me to his van, which had stopped just ahead of the broken pieces of mirror, scattered like the tail of a comet. He slid the passenger door open and said, "Get in!"

"No fucking way," I said in English, and dug in my heels. "Get your hands off me right now."

The woman in the van came out and attempted to act as mediator. The man, seeing that I wasn't going to run, released my wrist.

I switched to Chinese and explained to the woman that the driver was by law required to yield to people in the crosswalk. "Fine," she said, "but you still broke our mirror. So what are you going to do about it?"

"You picked the wrong guy to mess with," the man said, breathing heavily. "I have a really bad temper. That's why I wear red."

"Yeah, I can see that," I said. "You should be more like your wife. She's reasonable."

"She's not my wife. She's my co-worker."

"Well, lucky her," I said. "I feel bad for your wife."

He either didn't hear me or let it pass. "You need to pay for the mirror," he said.

"Bullshit." I had no idea what to do and hoped for a police officer to come upon the scene and take charge. A crowd had assembled, mostly older men who still lived in the rapidly gentrifying neighborhood, and I began to fear the kangaroo court that my friends had warned me about. Traffic accidents and altercations in China were usually adjudicated by the principals on scene, with the help of the rubberneckers who invariably gathered. So long as the damage and personal injury remained nonfatal, the victim (yet to be determined) extracted a sum of money from the perpetrator and everyone went on their way. I was told that if one of the parties involved was a foreigner, the kangaroo court always ruled in favor of the local.

"Where are you from?" one of the older men asked.

"This isn't about where I'm from," I said. "It's about him not obeying the law."

The van man snorted. "You keep going on and on about the law," he said. "Shut up about the law."

"If you'd obeyed the law, none of this would have happened," I said. "It's your wrongdoing."

"My wrongdoing! What does the law say about you breaking my mirror? You want to fight again?"

"Of course not. But if I'd kept walking, you would've killed me. So I got mad. I'm tired of Shanghai drivers disobeying the law."

"If I'd hit you, I would have been wrong, okay?" the man said. "I would have had to pay reparations. You need to pay for my mirror. That costs six hundred RMB."

The price was exorbitant. I kept repeating my side of the story until one of the elderly onlookers waved me over. "Just call the police," he said. "Have them come over and sort this out."

So I did. When the dispatcher answered, I told him, in English, that there had been an incident and someone had jumped out of his van and attacked me. "He just started hitting you?" the dispatcher said. His English was excellent. "Yes," I said, thinking the full story could wait until someone arrived. "Okay," the dispatcher said. "Someone is on the way."

Before long a pair of police officers arrived. The older one let the chubby one take the lead. The van man gave his story first, in Shanghainese, which I couldn't follow.

Then it was my turn. "I'm sorry, but my Chinese isn't very good," I began.

"Where are you from?" the chubby officer asked.

"It's not important," I said. "You see, I was crossing the street—"

"Hey," the van man said. "The policeman asked you a question. You'd better answer him."

"It's just a question," the officer said. "Don't be nervous."

"I'm Chinese, okay?" I said. "But I was born in America." I told the officers my version of the events, reminding them of the law that pedestrians had right of way in crosswalks, and that I had confirmed the law before with police.

"And was the light green when you were crossing?"

"Yes."

The chubby officer looked at the van man and frowned. He said something in Shanghainese, which incensed the van man, who restated his case with renewed vigor. I noticed that the man kept leaving out the part where he attacked me. "Stop lying!" I said. "Tell them about when you hit me!"

I turned to address the officers and the crowd. "Listen, I came to China because I have Chinese blood and I love China and I love Chinese people," I said. "But then I ran into you"—I pointed to the van driver—"and you're a jerk. You're an embarrassment to Chinese people. I'm embarrassed to be Chinese because of you."

Everyone stared at me as if I'd sprouted another head, and despite the midday traffic, it seemed very quiet. The police officers broke off to discuss. After a moment the chubby one suggested that I pay the man a hundred RMB and settle it. By then I was resolute about saving both my money and my face. "What about him hitting me?" I said. "How much does he owe me for that?"

"Can you prove it?" the older officer asked. "Any witnesses who will confirm it?"

None of the onlookers claimed to have seen anything. Only the traffic attendant admitted to seeing the man grab me, but he wouldn't say that he saw him hit me.

"All right," I said to the driver. "If you want me to pay you, first let me hit you as many times as you hit me."

The man squared himself with me and stuck out his chin. "Go ahead," he said. "The policemen heard me give you permission."

Everyone's heads swiveled as if watching a tennis match. Ten minutes ago I might have taken a swing, but now I was just tired and late for my Chinese class. "I'm not going to hit you," I said, stalling. "People who hit people are bad people. I'm not a bad person. I don't want to be like you."

We stared at each other for a while longer. "How about this," the man offered. "How about I hit you one more time and we forget about the hundred RMB?"

"Absolutely not," I said. "What is it with you and hitting people?"

"I want my hundred RMB," he persisted. "We're all busy, let's just settle it. Look, I've apologized, okay?"

"No, it's not all right," I said. "I shouldn't have to pay you in addition to getting hit. If you wanted me to pay you, you shouldn't have hit me. You've already gotten your compensation."

The man kept pressing, and I kept refusing. "Fine," he said finally, "don't pay, then." He and the woman turned heel and walked to their van. Too spent to feel triumphant, I watched them open the doors, step up into the cab, and look back at me.

"Next time I see you, I'm going to hit you!" the man shouted, shaking his fist.

"Asshole!" the woman screamed.

JOURNEY TO THE WEST

WITH MY GRANDMOTHER AND SAN GU AT COLLEGE IN Nanjing, the household in Xingang was reduced to my grandmother's two orphaned sisters, Pei Fu and Pei Sheng, along with Pei Yu and Pei Ke, the daughters of Ting Geng, who worked all over the province supervising road construction for the Kuomintang. Pei Yu and Pei Sheng, just one year apart in age, were so inseparable they might as well have been twins. The only male grandson, Cong Ji, bounced between Xingang and wherever his father, Ting Gong, the St. John's graduate, was working.

For all his progressive attitudes toward education, Liu was as *fengjian,* or feudal (the character for *feng* means "sealed" or "closed"), as the next member of the gentry when it came to raising his granddaughters. Since respectable girls weren't seen in public, they weren't allowed to leave the house unless it was for school. They were forbidden any contact with boys or even walking the same path as them, which sometimes required some absurd maneuvering to make sure they never caught up to a group of boys or allowed a group to overtake them. They couldn't answer the door when salesmen came by, much less buy anything. If they wanted a snack, they had to wait until someone brought home something from the market. Or they would have to pick something off one of the fruit trees, which the servants harvested and divided among the Liu families. With all the rules in

the house, the girls joked that it was a good thing their grandfather had refused the post offered to him after the imperial exams. He would have been intolerable if he'd had official authority, too.

Although Liu employed as many servants as there were members of the household, the girls had to do chores. They got up at first light to sweep the floors ("Sweeping leads to longevity," their grandfather told them), wipe the tables, and wash the teacups. Sometimes they got lazy, and once their grandfather left the house, they'd call in a servant to finish the sweeping while they retired to a daybed for a nap. As soon as they heard the tapping of the metal tip of their grandfather's cane as he approached, they'd spring off the bed, snatch the brooms back from the servants, and finish the job.

As the oldest girl in the house, Pei Fu acted the boss, and the other girls avoided her, finding her selfish, bossy, and aloof. For a time Pei Fu dressed in boys' clothes and made everyone address her as "Mr. Liu" or "sir" instead of "miss" or "young lady." When the seamstresses came to make the girls' clothes, she demanded the cap and tunic of Qing dynasty officials. Because of Pei Fu's seniority, she was allowed to serve the cakes, cookies, and sticky rice treats to guests. The rest of the girls envied her duties, as she could help herself to the snacks before she put them back into the cupboard.

Pei Sheng was the only one who dared to defy my great-great-grandfather. Every morning when he left for his daily rounds, she'd sneak out behind him, whispering to her sisters to close the door after her, and spend the day exploring the countryside, climbing trees, or playing with the daughters of sharecroppers. Usually she made it back before her grandfather. Sometimes she lost track of time, but no matter how many times she was punished, she'd be right out the door again the next morning.

Still, the sisters enjoyed a gentler grandfather than my grandmother had. Perhaps it was just his advancing age, but he treated his wife better and even laughed with embarrassment while she excoriated him for mistreating her and the villagers. If he was in a good

mood, he'd tell stories, and when he did lose his temper, he fizzled and popped but didn't explode. He seldom struck his granddaughters and forbade their mothers from spanking them when they misbehaved. "You should spank boys more and girls less," he said. "Girls aren't at home for very long. They get married off, and you want them to have happy memories of home."

Continuing the tradition that his son Ting Zan began, Liu sent the rest of his granddaughters to Rulison. His neighbors couldn't understand why he was spending so much to educate women. "What he spends on tuition, we could live on for the rest of our lives," they muttered. But it had become fashionable within his class, and the Christian morality being taught in missionary schools wasn't that far removed from the Confucianism on which Liu had been raised. The girls loved Rulison, where they could laugh, sing, or argue and wouldn't be bothered as long as they followed the basic rules. On summer vacations, the girls retreated to Lushan, the ancient mountain with a handsome resort for Jiujiang's foreign missionaries and Chinese elite, where their villa sat across a small stream from Republic of China president Chiang Kai-shek's. Occasionally, while playing in the creek, the girls would spot the Generalissimo or his Wellesley-educated wife, Soong Mei-ling. "Hello, Mr. President," they said as he passed by with his bodyguards. Chiang would wave and warn them to be careful in the water.

The girls' country idyll ended with the outbreak of the Sino-Japanese War in 1937. Liu followed the developments in the newspapers he picked up every morning. As the fighting spread inland, banditry increased, and the girls were sent to spend the nights at sharecroppers' houses. By the summer of 1938 Japan's gunboats were steaming up the Yangtze, and its bombers made sorties over my great-great-grandfather's fields to strafe Jiujiang, a strategic port and—due in part to Ting Zan's work—railroad junction. In Poyang's fertile waters, home to a rare species of freshwater dolphin, Chinese mines multiplied.

Jiujiang's mission schools packed up and relocated to the Chinese interior. San Gu evacuated with Rulison, and my great-great-grandfather entrusted her with Cong Ji, the only male heir and the family treasure. My great-great-grandfather released his servants except for Old Yang, who had served the clan for as long as anyone could remember, and sent the newlywed Pei Fu off with her husband to Changsha, the capital of Hunan province, Jiangxi's westerly neighbor, and where they hoped to enroll in one of the many universities that had relocated there. Pei Fu took with her her late mother's jewelry and four hundred silver dollars, money that her late father, Ting Zan, had set aside for his daughters' dowries before he died. Then my great-great-grandfather and Old Yang got busy burying his treasures. They worked at night, when visitors wouldn't be expected and neighbors would be asleep. Of the three granddaughters left at home, Pei Sheng was too disobedient and Pei Ke was too young, so Pei Yu helped carry the objects from the house to the pit.

Just before they left, Liu filled a bucket with silver dollars, hoping it would last them until they returned to Xingang, and buried the remainder of the silver. Now refugees, the family first headed south for Lushan. Other relatives without the means to make such a trek stayed in Xingang or scattered into the surrounding countryside. The Liu girls had tried to stuff their packs with the entirety of their possessions, and before long a trail of toys and clothes formed behind them as they walked up the mountain. The baby of the group, five-year-old Pei Ke, followed along with an aunt, clutching a pack of fruit candy. Every time she began to cry from exhaustion, the aunt popped a piece of candy into her mouth.

When they reached Guling, the mountaintop resort, they found that the foreigners had already evacuated, and the villas, including their own, were crowded with frantic families who had occupied the first empty house they found. Liu managed to secure a hotel room, hanging French and American flags on the door as a protective

measure, but the refugees flooding into town quickly depleted its supplies. The family waited on Lushan for a week, each day bringing no rice, only more hungry mouths as the fighting coiled up the mountain. Then one morning Liu became aware of Japanese ships massing on the Yangtze. He gathered the family and left that instant.

Too afraid to use the road, they stumbled along a creek down the backside of the mountain. Near the foot of Lushan, they ran into one of my great-great-grandfather's former students, fleeing with his pregnant wife and his sister, and they traveled together for a ways. The wife was to give birth at any moment, but she refused to impose on a stranger and deliver in an unfamiliar house, so she struggled along, held up by her husband and sister-in-law. They fell behind my great-great-grandfather's group, and then Pei Sheng heard gunfire. They ran back to find that the wife had been shot through her stomach. The husband and sister-in-law tried to drag her with them, but the wife asked them to set her down. "I'm not going any farther," she said. "I know I'm not going to survive. Come and visit this place in the future. When your children grow up, take them here."

My great-great-grandfather aimed for Nanchang, the provincial capital eighty miles due south, where Ting Gong worked. They hid and slept under trees during the day while Japanese planes patrolled the countryside. At dusk they started walking and didn't stop until dawn, never knowing where enemy soldiers might lie. No one dared to use a torch or lantern, so they felt their way along small roads and mountain trails guided by the glowing tips of incense sticks that they appropriated from temples, or they followed the sound of jingling coins in Liu's pocket. When Pei Ke couldn't walk any farther, Old Yang put her in a basket and carried her on his shoulder pole.

A coal truck took them into Nanchang, but Ting Gong had already left for Pingxiang, near the mountainous border with Hunan province. It wasn't an accident; Ting Gong had badly damaged his relationship with his father when he abandoned his wife for a cousin.

Liu sent word to his son to come back, thinking to leave Pei Yu and Pei Sheng in his care, and arranged for the group to settle in Nanchang until the matter was resolved.

In a fit of adolescent hubris, Pei Yu and Pei Sheng decided to join the military. A recruiter placed them with a unit of other girls in the Kuomintang's youth corps, but they found themselves unsuited for the constant drilling, cold-water baths, and meatless meals. *Aiya*, forget it, they decided, and sneaked off to reunite with their grandfather, who was still waiting for his son to return. Though the war had turned toward Nanchang, Liu didn't want to subject the girls to more travel. "No problem!" the sisters cried. "If our unit catches us for deserting, we'll be shot! Let's go!"

From Nanchang, they hopscotched west, the war at their heels, staying in one place just long enough to plan their next move or until the fighting got too close. It was a motley group, my great-great-grandfather and Old Yang, both in their seventies, leading a pack of women and children. The surviving family members would later describe its composition in a kind of verse: a house of the old, the weak, the distaff, and the young. Sometimes they could buy food and accommodations. Sometimes there was nothing left to buy and they dug up overlooked vegetables in abandoned gardens and scavenged empty houses for food. One night, exhausted, the family stopped at a clearing where people were already sleeping. They found an empty space and fell asleep. The next morning they woke to see that all the sleeping bodies around them were actually dead soldiers.

In one city on the border of Jiangxi and Hunan, they found a landowner who had more rooms than he needed, so the family could stay for free. Still, Liu insisted on teaching the man's children as payment and refused to accept the excess garden vegetables that the man offered. Whenever they took refuge in a city with a functioning or relocated school, he registered the girls for classes. My grandmother, who after graduating from Ginling College had taken a teaching job with a missionary school in southern China, followed the progress of her

family through the occasional letters her grandfather mailed along the way.

Over the next few months, they traversed Hunan province, moving through Liuyang, Taoyuan, and Yuanlin; they fled Changsha hours before the Kuomintang burned it in a reckless attempt to discourage the Japanese from entering. By the time they reached Guizhou province, they had journeyed hundreds of winding miles from home, and it would have been illogical not to go to Chongqing, the Republic of China's relocated capital, where San Gu and Cong Ji had gone with the Rulison school and where Liu thought he might find his middle son, a civil engineer.

As they got closer to Chongqing, signs of the Kuomintang's military-industrial complex appeared. Liu's party made its final push to safety in the backs of military trucks, trying not to suffocate in the whirlwind of dust kicked up from the wheels. By then my great-great-grandfather was no longer the lord of Xingang, whiling away his later years in the leisurely routines of a country gentleman. He was just another old man, far from home, running for his life.

THE REAL CHINA

FTER A STRETCH ON THE MAINLAND, WHICH IS WHAT Taiwanese called China, Taiwan felt like an oasis of order and tranquillity. It started as soon as I got to the airport in Shanghai. While the gates for domestic flights resembled Shanghai's subway platforms, the passengers for Taipei queued and boarded without pushing or shoving. The flight landed in Taipei late, but everyone waited in their seats and spoke to each other or on their phones in hushed voices. Bins full of fake DVDs and displays explaining why fake handbags were prohibited greeted us in the baggage area. Cartoon characters and bubbly script dominated the public signage.

I had come to find Liu Pei Yu, the third "sister" in my grandmother's generation (though actually a cousin), and whom I called by the kinship term San Yi Po. According to my grandmother, San Yi Po had helped bury my great-great-grandfather's porcelain and might still have some pieces. Uncle Lewis, who was friendly with the family, had arranged for my visit. The Taipei scrolling past the taxi window on the way to San Yi Po's apartment didn't appear to have changed much since my first and only other trip to Taiwan. I was fifteen years old, annoyed at having to spend the summer away from my friends, and I complained nonstop about the food, the heat, the humidity, the noise, and the Chinese people. Any hope of making

a connection with the country where my parents grew up vanished when, a few days after arriving, I contracted a virus and spent the rest of the month feverish and shitting myself in my sleep.

Much of modern Taipei's architecture, largely constructed in the 1970s and 1980s with little sophistication in aesthetics or design, looked even more weatherbeaten and haphazard than Shanghai's. Neon signs crowded the city's long avenues, protruding from buildings as if trying to wave down a bus. There were so few traces of colonial-era Taiwan, let alone old Taiwan, that filmmakers making a movie set in 1940s Taiwan had to shoot it in Thailand. Even the city's iconic piece of architecture, the Taipei 101 building that for a moment had stood as the tallest in the world before Shanghai's World Financial Center surpassed it in 2007, seemed incongruous. Rising above the drab city like an obelisk, it only underscored how unremarkable the rest of the place was.

Lacking Beijing's primacy or history, Shanghai's modernity, or Hong Kong's internationalism, Taiwan's capital of "only" about two million people felt sleepy and undistinguished. Most of Taiwan's tourism came from mainlanders or Japanese visiting their former colony in the tropics, the way the Dutch might check out Indonesia. The infrastructure wasn't geared toward Westerners, and it was hard to find good Western food. The level of English was often little better than that on the mainland, and the Taiwanese were just as shy about speaking it, leading to plenty of Chinglish and awkward translations ("tuna floss" for dried, shredded fish; a law firm named "Primordial").

But where China's modern cities were rank with sewage, rotting garbage, and industrial paint, Taiwan's tumbledown alleys and narrow side streets were perfumed with tea, incense, and beef noodle broth that began simmering at dawn. There was such an emphasis on green space that park benches were even tucked into road medians. The bus drivers exchanged waves when they passed one another. And while the buses in China had weapons-grade air horns under

their hoods, the horns in Taiwan were governed to beep like scooters'. Taxi drivers insisted I wear my seat belt. Without fail, cashiers and customers greeted and thanked each other during transactions. The subway platforms had painted lines to show where riders should line up, keeping the doors clear for passengers to exit first. In the stations, standers and walkers obeyed invisible barriers, and no matter how crowded a train might get, which they often did, no one intruded on my space or touched me without apologizing. One afternoon on a packed train, an exiting schoolgirl said, "Excuse me, pardon me for a second, could you please let me by, I'd like to get off the train," to every single person she encountered on her way to the doors.

I ARRIVED AT San Yi Po's apartment around noon, leaving my shoes at the door while her eldest daughter, whom I called Da Biao Yi, searched through a stack of house slippers for a pair big enough for my feet. San Yi Po lived in a three-bedroom apartment in a high-rise complex in Taipei's Songshan district, a particularly charmless area of the city. The apartment had been provided by the military for San Yi Po's late husband, a high-ranking officer in Taiwan's air force, and it demonstrated that for all the differences between Taiwan and the mainland, their aesthetic sensibilities remained similar. The floral print sofas in the living room, sitting on glossy tile floors and arranged around a large flat-screen television, wore cheap bamboo seat covers. Clutter grew on table surfaces like mold. Though all the Liu girls had attended missionary schools, only my grandmother had emerged as a devout Christian, and the religious symbols in San Yi Po's apartment were Buddhist ones. A glass cabinet took up one wall, full of knickknacks, military citations, and dusty bottles of brandy. If San Yi Po had any of my great-great-grandfather's porcelain, as my grandmother had suggested, she didn't have it on display.

San Yi Po was eighty-seven years old and had recently broken her leg, confining her to a wheelchair. She lived with Da Biao Yi, who was

six months older than Uncle Lewis, never married, and had worked for the national television company until her retirement. They shared a bedroom, sleeping side by side in separate beds. Da Biao Yi and her five siblings, most of whom were born on the mainland during the war years, spoke to each other in a pidgin Mandarin, Jiujiang, and Sichuan dialect, the product of having grown up in *juan cuns*, or military dependents' communities, all over China. "Our speech has grown confused," she laughed. "Our Mandarin isn't correct, our Sichuan dialect isn't correct, and if you asked me to use a correct Jiujiang accent, I wouldn't be able to."

I presented San Yi Po with a bag of fruit and a stoneware dish purchased from a boutique selling contemporary ceramics. San Yi Po, whose tastes apparently ran counter to mine, barely glanced at the dish before setting it down on a side table, where the clutter immediately swallowed it up. Her live-in *ayi*, a young Indonesian woman, prepared a simple lunch served directly from the old pots in which they were cooked.

San Yi Po was the oldest daughter of Ting Geng, my great-great-grandfather's middle son, a civil engineer who died of tuberculosis during the Sino-Japanese War. I had a hard time seeing any resemblance to my grandmother; San Yi Po's chubby cheeks, doughy body, and slouched arms gave her the look of an overfed, elderly orangutan. Despite what my grandmother had said about her health, San Yi Po was as energetic and talkative as my grandmother was reserved. She gossiped about everyone, including my grandmother, whose devout Christianity had long puzzled her; she described my grandmother as having been too religious for her own good. It was nice to find a family member who liked to dish.

As a child, San Yi Po was the compliant granddaughter. She was the one my great-great-grandfather took with him when he inspected his fields, whom he taught how to settle harvests and accounts with the sharecroppers and keep accurate financial books. Cong Ji might have been the heir, but San Yi Po was who my great-great-grandfather

envisioned would operate his empire when he was gone. So even though San Yi Po was only eleven years old when the Imperial Japanese Army reached the confluence of Poyang Lake and the Yangtze, she knew the complete story of my great-great-grandfather and his porcelain because she had helped bury it.

"Let me tell you, when we were fleeing, we were really pitiful," she said. "We'd hide under trees and sleep during the day, and when dusk came, we started walking and didn't stop until dawn."

"Were you scared?"

"What use was there being scared?" She swiped the air as if backhanding a mosquito. "There were so many refugees. We saw dead people all the time on the roads."

During the war, San Yi Po remained in Chongqing until she finished high school at the relocated Rulison school, where San Gu taught. Tired of the itinerant life of a refugee and eager to attend college, she made arrangements to enroll in her top choice, Soochow University. Then one day San Gu told her she needed to go to Guizhou, where her mother and younger sister, Pei Ke, were living with Pei Fu.

"Why?" San Yi Po asked.

"They want you to help take care of your mom and Pei Ke," San Gu said.

What San Gu didn't mention was that my great-great-grandfather had arranged for San Yi Po to marry. He'd selected her husband, Dai Chang Pu, a junior officer in the army's special operations corps, on the basis of having seen him sew a button, figuring such a man would be a capable provider for his granddaughter. Dai happened to be a Jiangxi native and a graduate of Tong Wen Academy, Rulison's brother institution, and recognized my great-great-grandfather's name. Stationed far from home and eager for company, he agreed to the marriage.

"But what about college?" San Yi Po asked San Gu.

San Gu replied that Grandfather had lined up a teaching job for her, too.

"But I can work somewhere else and send them money and support them that way," San Yi Po said.

"Pei Fu works all day, so someone has to be there to take care of your mom and sister," San Gu said. "Besides, you don't have a choice. Grandfather's waiting for you."

San Yi Po relented. When she got to Guizhou, Pei Fu told her of the marriage agreement. "Who the hell is getting married?" San Yi Po demanded.

"You," Pei Fu said.

San Yi Po, ever the obedient granddaughter, married Dai Chang Pu on Christmas Day 1941, just a couple of months after their introduction. "I couldn't disobey my grandfather," my grandaunt said. "But it turned out okay."

Dai Chang Pu was just a captain when they married, but he was tapped for the air force's *zheng zhan*—political warfare—department and rose through the ranks. When I asked Uncle Lewis, who like all young men in Taiwan had completed two years of compulsory military service, what *zheng zhan* meant, he explained that it was the equivalent of the military police, tasked with rooting out subversion, especially Communist sympathizers. Dai Chang Pu was nominally the second-in-command wherever he was stationed, but everyone knew he was really in charge. Running afoul of him could at the very least make a soldier's life difficult, or even result in his execution, which meant that *zheng zhan* officers were despised as much as they were feared. "They were the people in the army in charge of brainwashing you," Lewis said. And just in case it wasn't clear, he added that these people were "assholes."

Dai Chang Pu retired in 1958 and died in 2001. "They say no affection in a marriage is a bad thing," San Yi Po said. "But it can also be a good thing. Everyone compromises with each other. Our temperaments were total opposites. He liked to put on a good face and host all these important people. Me, I was very casual. He could be so annoying, saying I had to wear these clothes and behave this way. But

we made it through sixty years. Long ago that was your whole life—
get married, have kids, live your life. We were pretty good, actually.
Pretty harmonious."

THE DISTANCE FROM China to Taiwan was only eighty miles, less
than Cuba was from Florida, yet I couldn't have felt farther from the
mainland. Shop floors and streets were remarkably clear of litter. Peo-
ple took their waste home with them, where they sorted it and then
delivered it to recycling trucks that made rounds in the evening like
ice cream trucks, complete with jingles blaring from their speakers.
Seemingly humble eateries became hubs where Chinese of all ages
and socioeconomic backgrounds gathered. Drivers stopped for pedes-
trians; the first few times I let cars pass in front of me, their operators
smiled and waved thank you. The old factories in the overgrown hills
had displays reporting the day's air particulate concentrations, and
construction sites posted all the same notices as in Western coun-
tries: the developer's information, the phone numbers for questions
or complaints, and the running total of incident-free workdays.

Taiwan felt like the mainland with polished edges, even down to
the language. The Taiwanese accent was a soft drawl, and the manner
of speaking was hushed. They ended their sentences with a breathed
"oh," a bit like the Canadian "eh." But the differences in syntax and
diction between Taiwan and the mainland, similar to British and
American English, resulted in a different kind of Mandarin. In Tai-
wan avocados were *e yu li,* or "alligator pears," while on the mainland
they were *niu you guo,* "butter fruit"; Australia was *Ao Zhou* instead
of *Ao De Li Ya;* and bicycle was *jiaotache* ("foot step vehicle") instead
of *zixingche* ("self-powered vehicle"). Other mistakes could be more
fraught. Chewing gum, or *kou jiao* on the mainland, meant "blow
job" in Taiwan. Requesting a wake-up call, or *jiao chuang,* from the
hotel receptionist was actually asking for morning sex. Every time I
spoke, I cringed, hoping I wouldn't be taken for a mainlander.

A cynic like Andrew might have pointed out that the cleanliness, efficiency, and courtesies that I adored were influences from Japan, Taiwan having been a Japanese colony from 1895 to 1945, when it was returned to China as one of the conditions of the Japanese surrender in World War II. Most elderly Taiwanese spoke Japanese and didn't bear the same animus as mainlanders did toward the people that had made a host of educational, economic, and public policy modernizations on the island; many street and business signs still contained Japanese characters. Whatever its origins, Taiwan struck me as the ideal China, both a reminder of its cultured past and an example of what it could become: a functioning democracy with a free press, universal health care, and a strong middle class. Though little of Taiwan's infrastructure was truly old, its sights, scents, and sounds budded from ancient, authentic Chinese roots, and the people seemed to have found a way to participate in a global culture without sacrificing their own.

And the best thing about Taiwan's culture was its food. While the obsession with eating here was no different from on the mainland, and food remained the primary social organizer, it had been refined to place added importance on quality, cleanliness, and freshness. I could see why my ABC friends always returned from trips to Taiwan noticeably heavier. I normally couldn't stand Chinese breakfasts but could eat a fried *you tiao* and a *dan bin* every morning, washing it down with chilled, freshly pressed soy milk. Though I had not grown up with Taiwanese beef noodle soup and the side dishes commonly served with it, it still somehow triggered nostalgic comforts. Taiwan's famous night markets offered dozens of drinks and snacks both sweet and savory; I could graze for a week without eating the same thing twice. Around the corner from San Yi Po's apartment was the world's best shop for *fengli su,* flaky pineapple cakes. I made trips across town just to get a cup of *xingren doufu,* a chilled dessert resembling an almond milk flan topped with fruit cocktail that I could have eaten by the gallon and that had the most Proustian associations of all.

And of course, there was the fruit, which flourished thanks to the island's volcanic soil and varied terrain. I used the markets as a marathoner would water stations, snatching a fistful of fruit every time I passed one. Peeled, sliced, and bagged mango; a creamy, sugary custard apple, best eaten with a spoon; a box of juicy local pineapple chunks; or my favorite, crisp ruby-red wax apples, tasting faintly of rosewater.

One afternoon outside the Chiang Kai-shek mausoleum complex, Taiwan's answer to Tiananmen Square, I wandered over to a large booth advertising wild strawberries. But instead of baskets of fruit, I found young volunteers handing out pamphlets for the Wild Strawberries, a protest movement. The name was a reappropriation of the pejorative nickname for Taiwanese born in the 1980s, having grown up in prosperity that their parents couldn't have imagined, and stereotyped as being indulged, selfish, apathetic, and "easily bruised." With its multiple security checkpoints, CCTV cameras, undercover police, and labyrinth of barricades, you'd be tackled in Tiananmen Square before you got your sign out of your backpack. To witness a large group of Chinese people perform an act of protest, on the founding father's memorial site, no less, was both jarring and emotional. For the first time since moving to China, I felt proud to be Chinese.

But Taiwan's civility, democracy, and progressiveness didn't come easily or perhaps even naturally. When the Communists ended the Republic of China in 1949, they also cut short one of the most intriguing *what ifs* in history. The same zeitgeist that had led to the revolution in 1911 had also nurtured free-floating intellectuals who eschewed the imperial civil service system and grew disillusioned with traditional Chinese culture, which they blamed for China's precipitous fall from power and inability to keep up with Japan and the West. This self-examination coalesced on May 4, 1919, when

thousands of students massed before Beijing's Forbidden City in one of the largest mass demonstrations in Chinese history, a thousand-year storm of intellectual exuberance that pushed China into a national renaissance. In what became known collectively as the May Fourth Movement, Chinese intelligentsia criticized Confucianism, agitated for new scholastic traditions and moral values, and sought practical solutions for coping with Western countries, such as establishing a civil, academic society.

As the country attempted to sort out its very Chinese-ness, every strand of its social fabric was reconsidered: science, engineering, philosophy, political science, economics, architecture, literature. But this "new culture" movement wasn't so much a call to embrace the West and Western democracy as it was a break from the old while the new was still being formulated, and ideas ranged far and wide. Chen Duxiu, one of the leaders of the May Fourth Movement and the dean of Peking University, cautioned that establishing a constitutional democracy in a country with thousands of years of feudalism and imperialism would be nearly impossible without first changing the Chinese character. Chen would later gravitate to the left and cofound the Communist Party. By 1920 the strands of the Communist Party's genetic material had begun to braid.

For all the progressive ideas on Chiang's platform, he was a failure on the mainland. Today's Chinese revile him as much as they revere Sun Yat-sen. Chiang's government lasted only from 1912 to 1949, most of which he spent trying to legitimize his party's tenuous rule amid natural disasters, uncooperative warlords, Japanese incursions, and the Communists. I had always thought of Chiang Kai-shek's obsession with defeating the Communists as a principled, noble pursuit. The charitable portrait of Chiang—Christian, pro-West, pro-democracy—was that he played a losing hand as well as he could have. He lost China but saved Taiwan, which developed into one of the economic "tigers" of Asia. And he preserved the National

Palace Museum's collection—China's most precious hoard of art—from possible ruin.

But to his many detractors, Chiang was the very straw man—wealthy, powermongering, corrupt—that galvanized the Communists. He was a bigamist, a fair-weather Christian, a crook who diverted tens of millions of dollars from the American government, earmarked for the war effort against the Communists, into his own pockets, and the thief who stole China's treasures. During the Sino-Japanese War, he was so obsessed with defeating the Communists that his own military officers had to kidnap him and threaten him with execution before he agreed to engage the Japanese.

When Chiang Kai-shek and his Kuomintang loyalists—including my grandparents and their young children—retreated to Taiwan in 1949, they intended to regroup and organize as a "government in exile" for the inevitable failure of Mao's grand social experiment. "The sky cannot have two suns," Chiang told an aide. Chiang, of course, underestimated Mao's deftness as a nation builder. As Mao created a country of peasants with no ties to any historical or foreign influences, the thread of Chinese history that gave rise to the May Fourth generation continued with the Chinese enlightenment in exile. As a result, this tiny island became the world's repository of Chinese culture.

But the Taiwan that I reveled in didn't just spring forth fully formed. While the Kuomintang cast Mao as a despotic thug, Chiang was the one with ties to crime syndicates, and the Kuomintang was stricken with corruption. The Chiang-led government in Taiwan could be as brutal as Mao in purging dissent. Thousands of Taiwanese were killed, imprisoned, or disappeared in the "228 Massacre" (a Tiananmen-like crackdown on protests against carpetbagging Kuomintang officials in Taipei on February 28, 1947) and the "White Terror" (the forty years of martial law and suppression of political dissidents) that followed. As recently as 1995, it was taboo to even

speak of the 228 Massacre in Taiwan, which might have explained the pitch of my parents' after-dinner discussions.

That same year a tsunami of protests spurred the government to apologize, erect a monument to the 228 victims, and enact political reforms that led to the island's first direct presidential election, in 1996. Then in 2000 the opposition party, known as the Greens to the Kuomintang's Blues, crushed the incumbents by an almost two-to-one margin, leading to the first peaceful transfer of power in five thousand years of Chinese history. The result was an atmosphere where the right to vote was cherished and voter turnout approached 80 percent.

In 2011 Taipei opened the 228 Memorial Museum, in the 228 Peace Memorial Park, located on a wide, quarter-mile-long road that was once called Long Live Chiang Kai-shek Road but was later re-named after the Ketagalan aborigines who originally inhabited the Taipei area, to "celebrate liberation from authoritarianism." The museum's purpose seemed to be both "never forget" and "celebrate freedom," two phrases that appeared frequently in the exhibitions.

Taiwan took pride in confronting its ugly history and in having built a society that blended the best of traditional Chinese culture with new Chinese ideals, and I was proud of them for it. Whenever the topic of the mainland came up, the Taiwanese I met sighed and politely said that Taiwan had been a mess twenty years ago, too, but look at where it was now. But it was increasingly looking as if the mainland's culture would subsume Taiwan's and not the other way around. After developing independently of mainland China for so many decades, China's economic might had made the two governments cozier. Travel restrictions had been lifted for Chinese travelers, airlines could fly directly between Taiwan and China, and mainland brides were in vogue on the island. After decades of holding on to the Wade-Giles romanization system as a matter of cultural pride and national independence, Taiwan finally relented to mainland Chinese

pressure and adopted pinyin as its official system in 2009, a move that angered many citizens, who took it as another step in Taiwan's assimilation into China.

AT SAN YI PO's insistence, I checked out of my hotel and moved my things into her spare bedroom, which was anything but spare, with boxes piled to the ceiling. Once I was settled, San Yi Po told me that she had found a shoebox with a small stack of black-and-white photographs. The one box was all she could find. "Oh, I've thrown away so many photos," she said. "They wore out, so I tossed them."

Many of the photographs in the shoebox were pretty worn out themselves, and San Yi Po couldn't always remember where they had come from or who their subjects were. But they provided some of my first real glimpses of my family's history, including my grandmother's early life. The oldest were a group of photographs of the Rulison school campus from the 1930s before the war: San Yi Po and classmates whose names she couldn't recall relaxing on a green, or sitting on a long brick walkway lined with trees and manicured lawns, the portico of one of the school buildings peeking from neatly trimmed hedges. A young boy and girl standing in front of a beautiful neoclassical building with arched columns, which could have come straight from the campus of an American school of the same period. A ghostly group of girls wearing white dresses, white leggings, and white flowers in their hair, their images faded to the point of transparency, performing outdoors on the Rulison campus. A tiny, blurry photograph of what appeared to be my grandmother in high school, dressed for a school production in an elegant white Chinese gown and holding an open fan over her breast. Another thumbnail-size photograph of a smiling young woman who looked like my grandmother, wearing a traditional *qipao* with daisy print. Or it might have been San Gu. San Yi Po didn't know for sure.

We found a photograph of San Yi Po and Dai Chang Pu at their wedding, she in a white, sleeved dress and he in a three-piece suit, holding a fedora in his left hand. And a studio photo of my grandmother and grandfather holding my mother and Lewis on their laps, probably taken in Chongqing around 1945. Then a family picture of my grandmother, grandfather, mother, Lewis, and Richard standing in front of their small Japanese-style house in Taiwan during the early 1950s. San Yi Po's husband standing with Chiang Kai-shek on one of the islands in the Taiwan Strait in 1959. A few images of my grandmother, San Yi Po, and another Rulison alum with one of their former English teachers, a white-haired woman named Laura Schleman from Ohio, reunited in Taichung, Taiwan, in the 1960s. My grandmother wears a long *qipao* under a white cardigan with the top button fastened, looking preppy-Chinese. Finally, my grandmother in middle age, her hair swept up into a bun and wearing horn-rimmed glasses.

For the rest of the week, I explored Taipei during the day and after dinner sat with San Yi Po and Da Biao Yi in the living room to hear their stories. As the widow of a high-ranking Kuomintang officer, San Yi Po's loyalties were clear. In her recollections, the Kuomintang were the noble heroes, while the Communists were "red bandits," "ghouls," "thugs," or "bastards." The Communist sympathizers in the family were "traitors," and she gave dates, as most Taiwanese did, in "the *n*th year of the Republic of China." Unlike the older generation on the mainland, many of whom were nostalgic for the Mao years, San Yi Po preferred the current era of Communists. "Before, they were all gangsters and bullies," she said. According to San Yi Po, my great-great-grandfather was even more wealthy, educated, and generous than I had heard, a man who let his sharecroppers keep seven, not six, bushels of every ten. (By now, I had met enough Chinese descended from landowners to know that if every landlord was as kind and generous as their families remembered them—just as families of American

plantation owners always claimed their forebears treated their slaves well—the Communists would never have taken power.) As for his porcelain collection, well, it was as massive as it was peerless.

"My grandmother said you still have some porcelain from Jiu-jiang," I said.

"Not anymore," San Yi Po said. "If I'd brought any porcelain out with us, we'd be rich. It was antique and would have been worth a lot."

"You should have," Da Biao Yi said.

"But if we'd taken them, they probably would have broken," San Yi Po said.

"Well, you should've taken some small things, then," Da Biao Yi said. "That would have been worth it. You know how hard it is to find imperial porcelain from Jingdezhen now?"

"*Aiya,* we could barely even carry clothes!" she said, closing her eyes and rubbing her forehead with the palm of her liver-spotted hand. "How were we supposed to take porcelain?"

Da Biao Yi shrugged. San Yi Po leaned toward me. "There was a set of bowls, let me tell you, they were like glass, they were so thin and transparent," she said. "These bowls, you couldn't stack them or they'd break. They all had imperial seals on the bottom."

"Do you know what happened to all the porcelain?" I asked.

"The first time, when we returned from Chongqing, there was a portion of our things left," San Yi Po said. "The good porcelain, the furniture, most of that was gone. The second time, after the Communists, there was nothing. The house was gone, the field had become a workers' commune."

"How did you find out?" I said. By the time the Communists took Jiujiang, San Yi Po and her family had gone to Taiwan.

"Andrew's father, the first time he went back to the mainland, I told him, 'When you get back there, here is where this stuff was, and here was where that stuff was.' He found some people and tried dig-ging but didn't find anything. Nothing left at all. Even the house was gone. Just a vacant lot."

"Really?" I said. I couldn't imagine Uncle Lewis neglecting to mention having looked for the porcelain.

"He went by himself to Jiangxi. I told him what was where and where to dig. I joked with him, 'Don't worry about those plates and bowls. See if you can find the money.' Pei Fu was still alive then. He got her family, her son and others, to go dig. I drew him a map. Pei Fu took one look at it and remembered."

Then San Yi Po rolled her wheelchair away, switched on the television, and cranked it so loud the entire building probably heard it. She did this every night at eight p.m. on the dot, without the assistance of any timepieces, and would spend the rest of the night watching Chinese serials, inches from the television, until she fell asleep.

San Yi Po didn't think anything would come of my going back to Xingang to look for the porcelain, though she didn't discourage me. "Our house isn't even there anymore," she said the next day as we sucked on brown sugar lollipops with sour plum centers. "How do you expect to find anything when it's all been changed?"

I asked if she could describe any of the buried objects in more detail. She couldn't, but repeated, "It was all from the imperial kilns in Jingdezhen."

"How did Grandfather get it?" I said.

"My grandfather's middle son worked in Jingdezhen as the county commissioner," she said. I found it curious that she didn't just say her father, but I had her write down his name.

"Those kilns used to make imperial stuff, and they'd let him have the leftovers," she continued. "The six girls living at home all got a set of porcelain. It was mostly Qing, some Republican, some others. We never really used it."

"But you don't remember what it looked like?"

"How can I remember all the stuff in there?" she said. "I don't know. But the ground was completely full of porcelain when we

buried it. Big cisterns, small cisterns, little figures. Just one dining set might have a hundred pieces."

"Do you think there's anything left in that hole?"

"You can't even locate the hole! The house, the land, it's all been changed. The Communists used the house to run a cotton plant and a pig farm. It's all gone.

"What you should really do is try to find that villa on Lushan," she continued. "That's worth something, and if you found it, we might be able to get it back."

I had heard of Lushan only as a resort for foreign missionaries and Kuomintang elite. Did our family really have a villa there? Who had bought it?

"Your grandmother's family was the big landowner," Da Biao Yi said. "They had money. Why wouldn't they have a house on Lushan?"

San Yi Po said that it had been her father, Ting Geng, who bought the house, and she described it with all the vivid detail that her recollections of the porcelain lacked. The villa was across the creek from Chiang Kai-shek's residence—known as the Meilu Villa and technically belonging to his wife, Soong Mei-ling. Two roads ran on either side of the creek, He Xi Lu and He Dong Lu (West Creek Road and East Creek Road). The house had two floors and four bedrooms, along with a living room, a dining room, a library, and a servant's room. Outside was a flower garden. "The Chiangs were on He Dong Lu, we were on He Xi Lu," San Yi Po said.

"Have you been to Lushan yet?" Da Biao Yi asked me.

"No."

"Then hurry and go see if it's still there!" Da Biao Yi said. "Soong Mei-ling's house is still there, I know that. Our house was across from hers. Just find He Xi Lu and see if it's there."

I promised that I would try. "If I wanted to see the kind of porcelain your family used to have, where could I see it?" I said.

San Yi Po shrugged. "Maybe Jingdezhen would have it," she said. "But even in Jingdezhen you can't see what they used to have."

✺ ✺ ✺

BETTER YET, I could go to the National Palace Museum. Built into the mountains north of Taipei, the sprawling NPM was home to the world's preeminent collection of antique porcelain. The serenity of the setting ended at the main entrance hall of the museum, thronged with noisy tour groups from the mainland. As I stood in line to buy a ticket, volunteers ran from one knot of shouting mainlanders—far louder than any museumgoers I'd ever seen and easily identified by their volume, their smell, and the behavior of their children—to another, holding up signs bearing reminders to keep their voices low and refrain from taking photos. One volunteer told me this system was intended to avoid confrontation, but it didn't make a big difference. "People who don't care about proper behavior aren't going to care about these signs," she said.

I spent the day gazing at the porcelain displays, arranged chronologically and accompanied with informative English texts. I walked from early earthenware to the subtle monochrome Song wares to the early blue and white of the Yuan, through the beginning of color in the Ming to the explosion of vibrant colors and exotic styles of the Qing, wondering if my great-great-grandfather had owned any similar objects.

There were actually two Palace Museums, one in Taipei and one in Beijing, both claiming to be the original institution. In the nineteenth century, as reformist Chinese scholars traveled to the West, they became exposed to the idea of museums as civic centerpieces. The museum as an institution for the public to appreciate hitherto private collections of cultural artifacts had great appeal to Chinese literati like my great-great-grandfather, with their long traditions of treasuring antiquities and their reverence for education.

After the 1911 revolution, though there was no royal family residing in the Imperial Palace, there remained the issue of who the imperial collections belonged to, what they signified politically, and

what to do with them. The continued presence of the abdicated "last emperor" Puyi fostered the possibility of a return to dynastic times. So the impetus for the Palace Museum, to be housed in the Forbidden City, was as much about occupying palace space to thwart any restoration of the monarchy as it was about preservation or culture.

With the creation of a museum came the challenge of filling it. The royal collections were scattered all over the country. Puyi, the abdicated royal family, and the court eunuchs who resided in an area of the Forbidden City had continued to regard the collections as their personal property and they regularly filched items, either by claiming to send out objects for repair or presenting them as payment. In 1913 the imperial family even tried to sell the entire palace collection, "including pearls, bronzes, porcelain, etc.," to J. P. Morgan for $4 million. But Morgan died just a few weeks after his staff received the telegrams, and the collection remained in Beijing. In 1923 Puyi announced an inventory of the Qianlong emperor's collection, sending the eunuchs into a panic. The building housing the collection was suddenly and conveniently burned to the ground, and only 387 items were recovered from the 6,643 inventoried. Puyi expelled one thousand eunuchs, who opened up antique shops outside the front gate of the Forbidden City, and their counties of origin were suddenly flooded with imperial antiques.

After Republican officials converted the Forbidden City's halls into museum space, they put a stop to the thievery. Over the next few years, officials were able to recover more than 200,000 objects (including forty-three live deer) from the various royal collections and move them to Beijing. As the collection continued to grow, the staff also began to address the preservation and conservation of antiquities, the preservation and restoration of the buildings of the Forbidden City, and academic research and publication. The Palace Museum opened its doors to the public in 1925 and became so entwined with national identity that when Chiang Kai-shek assumed power, he appointed himself to the museum's board.

The bifurcation of the two Palace Museums, like my family's, began during the Second Sino-Japanese War. As Chiang's government focused on exterminating the Communist threat, a matter complicated by powerful warlords, corruption, and crippling self-interests (a trio of Chinese legacies that survives to this day), the Japanese attacked Manchuria in 1937, an area in northeastern China they envisioned as their future breadbasket. China offered little resistance while the Japanese rolled inland, taking cities with ease and prompting my great-great-grandfather to bury his porcelain and flee.

In Beijing, Chiang Kai-shek initiated a similar but far grander endeavor, ordering the Palace Museum's staff to box up more than one million pieces of priceless porcelains, jades, scrolls, bronzes, furniture, and—significantly—thrones for clandestine shipment to Nanjing, the Republic of China's capital, for safekeeping; other items were shipped to the Library of Congress in Washington, D.C.

This was just the beginning of a six-thousand-mile, sixteen-year odyssey that saved China's *guo bao,* or national treasures, from the Japanese, the most extraordinary art preservation effort in Chinese history. With no facility large enough to store the nineteen thousand wooden crates in Nanjing, the collection then traveled to Shanghai. After the Japanese took Shanghai, the collection was separated into three batches that would take different routes west with a military escort. Over the next decade, the dispossessed collection of China's most valuable art was in constant motion, traveling on trains, trucks, steamboats, hand-towed barges, and the backs of laborers, often just a single step ahead of Japanese bombs, while also contending with floods, warlords, and bandits. It took refuge in bunkers, caves, temples, warehouses, and even private homes. Elderly residents in a host of rural Chinese villages who might never have traveled more than twenty miles from their birthplaces had childhood memories of seeing ancient paintings, scrolls of calligraphy, and books when staffers aired them out on sunny days.

As the story goes, not a single item of the collection was lost or damaged, which speaks to the collective effort of its protection, as well as its cultural significance. But the elegance of that claim, like San Yi Po's rose-colored memories, was probably more mythology than fact. Since 1991 a joint Sino-American team of archaeologists had been investigating the area around the ancient Song dynasty capital of Kaifeng for predynastic Shang cities. (The Shang were the ones with the oracle bones.) That area also happened to be on the route that one batch of Palace Museum objects took through the Yellow River valley in 1938. On the final day of one recent dig season, a farmer showed up to report the appearance of imperial ceramics in his fields. The archaeologists didn't have time to make a full investigation but surmised that the museum trucks had rolled through Henan province the same year the Japanese had gained control of all of northern China. Chiang Kai-shek, in what was described as "the largest act of environmental warfare in history," dynamited levees on the Yellow River, creating a massive flood that he hoped would stymie the Japanese advance. The flood succeeded in slowing the Japanese but also destroyed thousands of villages, ruined huge swaths of farmland, and created several million refugees. By the Kuomintang's own count, nearly a million Chinese drowned as a result of the flood. The archaeologists in Kaifeng surmised that it was entirely possible that the floodwaters might have also overturned some of the museum trucks, spilling their goods into the fields. And given the chaotic circumstances, some of those treasures might have been left where they fell and remained silted over for decades, just another layer of the local history that stretched back to the beginning of China.

The three Palace Museum shipments eventually rendezvoused in Sichuan province, near the wartime capital of Chongqing. After the Japanese surrender in 1945, they made the trek back to Nanjing, but the civil war between Chiang's Nationalists and Mao's Communists had recommenced almost immediately. In 1949, as Chiang was

planning the Kuomintang retreat to Taiwan, he called the treasure trucks back to Shanghai, where he cherry-picked more than 100,000 of the collection's finest (mostly jades and porcelain, which had the best size-to-value ratio) to bring with him, along with most of the nation's gold and silver supply.

Under the life-size portrait of Chiang Kai-shek in the National Palace Museum's library building was an English inscription that explained Taiwan's version of the events: "Under his command, the treasures of the Palace Museum were rescued and shipped to the southwestern part of China. During these tumultuous years, they were saved from war destruction. In the aftermath of the Chinese victory, the insurgent Communists began to create internal strife. The cultural artifacts were therefore shipped to Taiwan, under the direction of Chiang Kai-shek, to protect them from the annihilative reign of the Communists, especially from their catastrophical 'cultural revolution.'"

The Communists viewed Chiang's act as plunder, and the collection's value, both monetary and symbolic, remained a flashpoint for the Chinese identity. Though in 1991 Taiwan declared that the Chinese Civil War was over, the combatants have never signed an armistice or peace treaty. The many acts of aggression by China since 1949—shellings, naval blockades, incursions of Taiwan's offshore islands, and missile tests in the Taiwan Strait—indicating its willingness to go to war rather than lose Taiwan had just as much to do with what was in the NPM in Taipei as it did with politics. In dynastic China, ownership of the imperial porcelain collection had conferred the right to rule, and so long as it remained in Taipei, Chiang's government could claim that it, not Beijing, was China's capital.

THE MORNING I left Taipei, San Yi Po was up early, and she told me one last story. When China finally opened up in the 1980s, she went back to Xingang to find my great-great-grandfather's house. While

there, she was invited to meet with a local party official in Jiujiang. "He was very *tongzhan*," she recalled. That is, he was welcoming of overseas Chinese returning to the mainland.

"If you come back, we can give you lots of things," he told my grandaunt. "Many things for you to invest in. Just complete some applications."

"But my family's house, it's all gone," San Yi Po said. "Our things are gone. You've built on our property. What can I possibly apply for?"

"Oh, we have a lot of land. Just fill out some paperwork, and we'll give you some other land."

San Yi Po considered the proposal.

"Say, how long have you been away?" the official asked.

"How long have you all been here?" San Yi Po snapped. "That's how long I've been away."

The official frowned. "Well, if you add up all the years, that's a lot of tax that you would owe on the land," he said. "If we gave it to you, we'd have to charge you for the taxes."

"I couldn't believe it," San Yi Po told me. "I told him I'd have to go back to Taiwan and check on some things, see if it would work. And then I got the hell out of there. What do I want their land for, anyway?"

She pulled a pair of silver coins from her shirt pocket. "Here," she said. "A souvenir."

I tried to read the script on the obverse side. "Year three of the republic—"

"Republic of China, third year!" San Yi Po said.

I had mistakenly read from left to right instead of right to left. The coins had been minted in 1914. These were silver dollars that my great-great-grandfather had buried, recovered, and given to San Yi Po, who carried them with her, along with about twenty others, from the mainland more than sixty years ago. She had given them away as gifts, until these two were all she had left.

"Been almost a hundred years," San Yi Po said. "In the thirties we'd change one coin for 360 bronze pieces. They were worth even more before. You could buy a hundred pounds of rice with one coin. We buried a big jar of these in Jiujiang, next to the porcelain. One or two thousand coins in there."

San Yi Po instructed me to hold them lightly between my fingertips and knock them together, an old trick to determine the authenticity of silver. Other metals made a dull jangle, but silver would ring clean and pure. I balanced a coin on each of my middle fingers and brought them together. They produced a crystalline, high-pitched chime, as a sparkle would sound, that reverberated through the room. Proof.

[9]

END OF PARADISE

Y GRANDMOTHER GRADUATED FROM GINLING WOMEN'S College with a chemistry degree in June 1937, just six months before the Japanese would occupy Nanjing and begin the Rape of Nanking. The afternoon of the graduation ceremony, her entire class served as bridesmaids in a classmate's wedding. They wore custom-made light green *qipaos* and daisy chains in their hair and split into two lines that the bride walked between. The class had pooled their money to buy a set of Jingdezhen porcelain and charged my grandmother with ordering the gift, having it inscribed in Jiujiang, and sending it to the newlyweds. But by the time the porcelain was ready to mail, the war had begun, and my grandmother, in a hurry to leave, left the set at home in Xingang. She never found out if her family mailed the gift for her, or what happened to her classmate. Many years later, once my grandmother was in Taiwan, she cleared her conscience by donating a sum of money to Ginling in the name of the class of 1937.

The Rulison school wanted my grandmother to return to Jiujiang and teach, but she had gotten used to her freedom. In spite of the war, missionary schools all over China were hiring, and Ginling graduates were in high demand, especially one with a minor in education like my grandmother. Her parents were long dead, the age difference with her sisters had prevented her from developing a close bond with

them, and she had no interest in living anywhere near the thumb of her grandfather as an adult. Eager to explore a new part of China, and still angry at her grandfather for preventing her from going to medical school, she accepted a job with Union Normal School for Girls in Guangzhou.

By then Republic of China president Chiang Kai-shek was waging battles against the Japanese throughout northern and central China. The south, however, remained relatively peaceful, and my grandmother wrote back to Xingang that she had arrived safely in Guangzhou. But just a few days later, the Japanese began bombing the city, targeting transportation and military assets but hitting schools and missions, too. The Union leadership moved the institution into the countryside and rented an abandoned school, but less than a month later the Japanese began to use the school as a landmark for lining up their bombing runs on the train station. Every day Japanese planes circled the school to orient themselves, flew off to drop a bomb, and returned for another pass as the terrified Union teachers and students took shelter in the basement, unsure if a bomb might also fall on them. The school moved again, this time to the neutral territory of Macau, a privilege not afforded to public Chinese schools, which stuck it out in the countryside and hoped for the best. The Union students and teachers crammed into rowboats, covered with tarps and launched at intervals to prevent drawing attention from the Japanese, and floated south to Macau.

While my great-great-grandfather made his harrowing escape to Chongqing, my grandmother remained tucked away in paradise. Macau's skies were uncluttered with bombers, its streets clear of soldiers, and Union had created a campus out of a group of vacant houses near the beach. Despite the war raging across the border, the school's laboratory remained fully stocked with chemicals and equipment. Everything my grandmother requested, including scripts for the drama club that she advised, could be procured. My grandmother taught chemistry and natural sciences, and her students scored well on

their college entrance exams; many of them went on to become departmental heads at various universities or physicians, fulfilling my grandmother's dream by proxy. After dinner she would descend the hill and spend the last bit of light walking the seaside. On weekends the teachers took in Deanna Durbin musicals at the movie theater.

My grandmother was introduced to a Hong Kong hotelier who sought an English and Mandarin speaker to tutor his children. Soon she was taking the ferry to Hong Kong during vacations and staying in the Metropole Hotel in the city center. In the evenings she would visit her old chemistry lab partner from Ginling. They would go out for a movie and ice cream or, if it was particularly hot that night, cool off by riding the ferry to Kowloon and back, chatting and watching the lights in Victoria Harbor.

My grandmother remembered her years in Macau as the most blissful period of her life. Then, in December 1941, on the same day as the attack on Pearl Harbor, Japanese forces invaded Hong Kong. The badly outnumbered British colony fought for more than two weeks before surrendering on Christmas Day. That cut off Macau's primary supply line. What little food that got into Macau became more and more expensive, until nothing came at all. My grandmother ventured out one day to buy some biscuits and had them stolen right out of her hand. A male teacher happened to be behind her and snatched the biscuits back. Bodies accumulated in the streets and on the doorstep of the Union campus. Rumors of cannibalism spread, and the school's *ayi*s made it a daily habit to go out and look at the carcasses. No one dared to go out at night. My grandmother began to think about making a run for it back to Chongqing.

At the time the Kuomintang was desperate for skilled manpower and enticed educated overseas Chinese back to the mainland with jobs, free housing, and free postsecondary schooling, plus a monthly stipend. My grandmother found a travel partner in another Union teacher, and they entered China through Guangzhou Bay, which was still a French territorial holding. From there they went through

Guangxi and Guizhou, walking, riding boats, and hitching rides with Kuomintang military trucks, sitting on top of sacks of rice and canned goods as dust kicked up by the tires covered them head to toe. They carried just a single large bag each, packed with clothing and food. My grandmother left everything else, including all her letters and an entire suitcase full of photographs, in Macau. They bivouacked in filthy roadside inns, wrapping themselves in their own clean bedding in a futile attempt to ward off critters, but were so exhausted that they slept through the bedbug attacks.

But that would be as bad as it got. And the coolies and porters who carried their bags treated them honorably. After four weeks on the road, my grandmother reached Chongqing. She bunked in a residence for returning Chinese until she found one of her former science professors from Ginling, who used to host pancake and milk breakfasts on the weekends for his students, and who arranged for her to live with another married couple. The professor also introduced her to the director of the education ministry, who saw my grandmother's chemistry degree and assigned her to the ballistics research laboratory in a munitions factory that had relocated from Nanjing.

The arsenal dated back to 1865, when a Qing viceroy set up the Jinling Manufacturing Bureau. In the aftermath of the Opium War defeats, a group of Qing officials argued for the adoption of Western weaponry and military technology. These "self-strengtheners" proposed opening arsenals and shipyards in each major port, and the Jinling Arsenal, as it became known, was soon making guns, shells, and even rockets. But the self-strengthening movement was concerned only with developing modern armaments, not social change, and like most of the last-gasp Qing reforms, it had a brief period of growth followed by a sharp decline. By the time the Kuomintang took control of the arsenal in 1934, its physical plant was so badly outdated that the new government had to start from scratch.

A supervisor at the munitions factory, believing that women should marry, especially in wartime, introduced my grandmother

to a metallurgist from the materials and testing department. He was tall, liked to eat peanuts and play basketball, and came from Hubei province, Jiangxi's neighbor to the northwest. They married about six months later. I'd asked my grandmother about her first impressions of my grandfather. "It wasn't as if I took one look and liked him or loved him," she said. "My professor said to not stay single, it's better if you're married, so I listened. I didn't marry him because I liked him. They just told me that being married was safer and more convenient. So we got married. Whatever."

During my grandparents' courtship, my grandfather's apprentice, a teenager named Chang Guo Liang, delivered the letters they wrote back and forth, walking about an hour between the two departments. Chang Guo Liang remained at my grandfather's side when the munitions factory returned to Nanjing after the Sino-Japanese War and when the family fled to Taiwan. As the ablest man in the group, he helped them out of plenty of tight situations and literally became part of the family. He lived with them for many years, and when he married, my mother and her brothers called his wife by the kinship term for "sister-in-law." Now in his eighties, he lived in Kaohsiung, on Taiwan's southern tip and the island's second-largest city, where my mother had grown up. Both my grandmother and San Yi Po had told me that he might still have a porcelain jar from my great-great-grandfather's collection.

FROM FAR FORMOSA

AS I HEADED SOUTH FROM TAIPEI, THE COUNTRYSIDE wrinkled into green folds. Soon I entered Taiwan's mountainous tea country. Chinese tea culture stretches back thousands of years, when emperors insisted that their tea be picked only by virgins who—for fear it would taint their crops—weren't allowed to eat anything smelly or spicy for two weeks beforehand. Mainland China's most famous tea region, Wuyishan, a range of craggy, fog-bound peaks in Fujian province, was described in a Tang dynasty monograph as having the perfect conditions for growing tea. Taiwan's mountains offered some of the same growing conditions as Wuyishan, and British entrepreneurs set up plantations on them during the nineteenth century with seedlings from Wuyishan's tea trees. As the story went, those seedlings developed unique characteristics in Taiwan that altered the processing slightly, which resulted in a distinctive flavor. "But you can't say they're different," one tea expert told me. "Their environment made them this way."

When the Japanese arrived in 1895, they codified the tea tradition, developing rituals around its brewing, serving, and drinking. Fifty years later the Kuomintang brought the remnants of China's tea culture; they might have lost the mainland, but they were going to preserve their history and traditions in Taiwan. Children in Taiwan

grew up hearing that they were the *fuxing de jidi,* or revival base, for Chinese culture.

While mainland China suffered under trade embargoes until 1971, Taiwanese tea became an important export. The *chayiguan,* or teahouse, appeared. Chinese teahouses were traditionally rest stops for travelers to eat, drink, and take in an opera performance, but Taiwan's were for cultured people. *Chayiguans* served high-quality teas, developed an etiquette for brewing and drinking tea, and perhaps most important, provided a place for political dissidents to meet when martial law was still in place.

When China opened and Taiwanese began returning to the mainland, they brought their tea—and their tea culture—with them. It was this tea culture, born in China and nurtured in Taiwan, that began the rediscovery of Chinese culture by the mainland and was inexorably linked to porcelain. The connection of tea with everyday life, including the vessels used to prepare and drink it, was the beginning of modern China's reacquaintance with its ancient traditions.

THE MAIN DOOR to Chang Guo Liang's apartment on the southern outskirts of Kaohsiung was open, and through the mosquito screen I saw him jump out of his chair, almost tripping as he ran to greet me, while a toy poodle mix yapped. Chang Guo Liang was a compact man with white hair, a large nose, and a pinched expression that made me think of a hare. He wore gray slacks, a red T-shirt, and socks with individual toes that gave him little purchase on the bare floor.

All his years in Taiwan had done little to affect his native Sichuan accent, which sometimes made him difficult to understand while we sat in his living room and talked. I had not learned of his existence until recently, but he knew all about me from my grandmother, whom he phoned regularly. His house was spare, the kind of concrete box that Chinese people furnished but never seemed to finish. A three-dimensional photograph of Jesus knocking on a door stood on

a shelf, a piece of embroidery that read "Always Rejoice" hung on the wall, and an old Mitsubishi sewing machine was tucked into the corner. Chang Guo Liang's twelve-year-old grandson, Stanley, slouched on the sofa and watched cartoons while he played a handheld video game.

It was late afternoon, still light enough for a stroll, so Chang Guo Liang changed into a collared shirt and slipped into silver and blue running shoes. We wound our way out of the mammoth apartment complex and headed toward a small river that Chang Guo Liang followed for his daily walks. He wanted to show me the old arsenal where my grandparents had worked. The surrounding area had been rice paddies and sugarcane fields when my grandparents first arrived, and much of it didn't appear far removed from those days. The rest had been colonized by major thoroughfares, new high-rises, shopping centers, and plastics factories. A frightening number of feral dogs roamed the empty lots.

Chang Guo Liang was born in 1925 in a village near Chongqing. His parents were porcelain merchants. He remembered Japanese warplanes bombing Chongqing in 1938 and the city burning for days on end. The movement of consumer goods effectively stopped after that, and although the family had no political leanings, Chang Guo Liang's father asked a family friend to get Chang Guo Liang a job in the arsenal where my grandmother worked; he would be safer there than in the army. He was assigned to my grandfather's department to do metallography—cutting material, polishing it, and then inspecting it under a microscope. Chang Guo Liang had only a middle school education, but he was bright and quickly picked up the names of the different alloys and how to test them. As my grandfather rose to become the head of the department, he brought Chang Guo Liang with him.

In 1947, two years after the Japanese surrendered, the munitions factory returned to Nanjing. From Chongqing my grandparents, their two infant children, and Chang Guo Liang boarded the Tian Xiang Lun, or "Heavenly Peace," of the Minsheng line, the largest

privately owned shipping company in China at the time, and steamed east on the Yangtze. Chang Guo Liang remembered the wind sweeping veils of sand from the tops of the cliffs as they passed through the Three Gorges and Yangtze River dolphins flipping and rolling in the ship's wake near Dongting Lake. They stopped in Jiujiang to buy household items, but the water was low and a rowboat had to transfer them to shore. My grandmother, pregnant with Richard, was able to see San Gu, Pei Ke, and Cong Ji, who were all at Rulison in the city, but didn't make it back to Xingang to visit her grandfather. By the time they returned to the ship, the weather had changed; the waves swelled and their caps turned white. Docking the rowboat next to the ship for reboarding was a dangerous maneuver that risked being smashed against the hull or carried downstream by the swift current. Somehow Chang Guo Liang managed to hook the rope with a gaff and saved the day.

My grandparents lived in Nanjing for less than two years before Chiang Kai-shek sounded the retreat to Taiwan. Everyone rushed to leave before the ports closed. My grandparents, their three children, and Chang Guo Liang arrived in Shanghai in the middle of winter and moved into a ramshackle dormitory made of bamboo and mud near the pier in Wusong, the site of China's first railway. Much of the mud had fallen off, and when the wind blew, snowflakes swirled in their room. Without running water or a stove, Chang Guo Liang trudged thirty minutes past frozen ponds and streams and dead automobiles to fetch hot water, his hands numb despite wearing two pairs of gloves.

While my grandfather's unit waited for its boat, my grandmother took the children to stay with an old Rulison classmate who had married a high-ranking customs officer. Then one day my grandfather appeared and told them to get their things; the boat was leaving. Each person was allowed two pieces of luggage. My grandmother left a few cases of belongings with her classmate, who in turn gave my grandmother a gold ring for safekeeping. My grandmother's belongings

were all taken by the Communists, and the classmate never got out of China, suffering greatly during the various movements against intellectuals and elites, but my grandmother managed to return the ring after China reopened.

The family boarded the ship on January 2, 1949. Richard celebrated his first birthday on the boat. At the mouth where the Huangpu joined the Yangtze, they passed the wreckage of the *Jiangya,* sunk a month before by a Japanese mine and claiming more than two thousand lives. While my grandmother and her family stayed in a passenger cabin, Chang Guo Liang slept on deck with the rest of the single men. He wore as many layers as he could fit, and it was still cold. He got seasick. "Nothing was convenient," he said.

My family did manage to bring with them a crate of Jingdezhen porcelains, perhaps bought in Jiujiang during the shopping trip on the way to Nanjing. My mother remembered seeing the wooden case in the closet in Taiwan when she was young, stacks of blue and white plates and bowls and covered jars for salt and fermentation. Over the years the pieces broke or got lost. None of them survived.

The ship sailed for three days before landing in Kaoshiung. Everyone who had been shivering with cold in Shanghai stripped to their undershirts to cope with the tropical climate. As they entered the harbor, they could see farm girls standing on the pier, dressed in pointed hats and wooden clogs. They lived in tents for a month, subsisting on moldy brown rice, eaten out of government-issued metal bowls. "It was so *can*," Lewis once told me, using a word for "miserable." Part of the poverty stemmed from Chiang Kai-shek's policy of destroying resources instead of moving them to Taiwan; he didn't want to leave anything for the new Communist regime, even if it meant that his loyalists on the island would suffer. "God, he was such a son of a bitch," Lewis said. "I fucking hate Chiang Kai-shek."

Lewis was originally supposed to stay on the mainland. My grandfather thought Lewis was too difficult a child and wanted to leave him with Pei Sheng, but my grandmother insisted that the family

stay together. (Later, during the Cultural Revolution, when Taiwan was awash with images of the Red Guards running amok, my grandmother would joke, "Thank God we brought Lewis with us. Otherwise he'd have been the leader of the Red Guards for sure.")

In Kaohsiung, there wasn't enough housing to accommodate everyone coming from the mainland, and the family squeezed into a three-room house that they shared with another couple. Once new housing was built, my grandparents' job grades were high enough that they were able to move out into their own place.

During a bout of tuberculosis, my grandmother turned full bore to Christianity, which led her to leave the armory to raise her children full time. To make sure they didn't suffer through the same deprivation as she had, she sold off her jewelry to pay for their food. All the cookies—baking appealed to her chemistry background—and jams that they couldn't find in Taiwan, she made from scratch, using the fruits and vegetables available. When Richard got older, he used to ask her why he couldn't find the tomato jam from his childhood in any stores. Once the children were grown and attending college, my grandmother accepted a post at the Ginling Girls' High School in Taipei, founded in 1956 by alumnae of Ginling College.

When the Kuomintang first arrived in Taiwan, everyone was preoccupied with counterattacking the mainland and assumed a victorious return was imminent. As China suffered through the disastrous Great Leap Forward, Chiang Kai-shek saw his opportunity to retake the mainland. But he had lost international support, particularly from the Americans, and after a series of defeats in skirmishes with the Chinese army, he scrapped his plans. "If the Americans had given their okay, we'd have been victorious at that time," Chang Guo Liang said. "We'd have been back for decades."

Chang Guo Liang was desperately lonely in Taiwan, living first in the singles' barracks on the army base, then with my grandparents, and then in another series of homes. But with all lines of communication broken (due as much to Taiwan's policies as China's), it was difficult to

know what friends and family were going through on the mainland. Occasionally a letter would get smuggled through Hong Kong, but from 1949 until the 1970s, when mail service was normalized, families remained in the dark. Chang Guo Liang gave up hoping that he would ever go home and married a *bendi ren*, or "native" Taiwanese.

We took a right at a newly built administration building and emerged onto a wide intersection. "This used to be just a wooden bridge," Chang Guo Liang said. On the other side stood the arsenal, encircled by a concrete wall topped with razor wire. An old water tower rose up from the compound. The arsenal was still in use, Chang Guo Liang said, though I saw no activity, only a few military trucks and a treadless armored vehicle. My family, along with Chang Guo Liang, had lived inside those walls when they first arrived in Kaohsiung.

Clouds knitted on the horizon, so we returned to the apartment, where Chang Guo Liang's wife had prepared a dinner of pork meatballs with soy sauce and tofu, mustard greens, scrambled eggs with tomato, cabbage, and winter melon soup. We ate in front of the television, while Stanley watched cartoons and ignored his grandfather's exhortations to eat more.

Chang Guo Liang finally returned to the mainland in the late 1980s, a few years after China began allowing family visits. A letter sent to his old address in Sichuan province sat in the village until someone happened to recognize the name and deliver it to Chang Guo Liang's younger brother. Though his family house had been torn down, Chang Guo Liang still made annual trips to China. I asked him if he thought of himself as Taiwanese or Chinese.

He didn't answer immediately. "I think . . ." he began, "it's all the same." He laughed. "Taiwan's fine, the mainland's fine. In my heart, I think it's all one country."

THE NEXT MORNING Chang Guo Liang and I rode the bus into the city to see the lane where my mother, Lewis, and Richard had

grown up. We walked up a wide, leafy boulevard and turned left into a narrow side alley. Once lined with arsenal employee housing, much of the lane had been redeveloped with low-rise flats. A new six-story apartment building stood where my grandparents' house once had. At the end of the lane, a few of the original employee houses remained, one-story, fenced by brick walls, with corrugated metal roofs.

Chang Guo Liang recognized a man his age and had a quick conversation with him. I looked up and down the lane, feeling no special connection to it, perhaps because my family had not felt one either. I didn't remember anyone making trips back to Kaohsiung or even speaking about it with much fondness. My mother had gone back to Taiwan only once or twice in my lifetime.

On the way back to Chang Guo Liang's apartment, I asked him about the porcelain jar. He never met my great-great-grandfather and couldn't remember my grandmother or any of her sister-cousins talking about him. He didn't know the story of the buried porcelain and wasn't sure what jar my grandmother was talking about, except that he didn't have it. I supposed it was probably like someone asking about a spoon or a sweater or some other utilitarian item left with him half a lifetime ago. Nor did he have any old photographs of the family. "Oh, we had so many photos, but when we moved, we threw them all away," he said. "It's such a shame. And the ones we kept, we can't find them anymore."

WHEN I WAS in Shanghai, I heard a Taiwanese businessman explain the cross-strait relations between China and Taiwan. There were parents with a child, the businessman said. When the child was born, the parents were too poor to take care of him, so they put him on the street and hoped that someone else would take him. And many countries, with abundant culture and resources, did just that. The child grew into a bright and talented young man, full of potential. By then

his birth parents had grown very rich and decided they wanted the child back. But the child thought, *Wait a minute. You left me by the roadside in a pile of shit, and now you want to tell me what to do?* We came from the same family, the businessman said, but we've taken very different roads.

In the years following the civil war, it seemed that Taiwan based its identity on whatever the mainland wasn't. Communism versus capitalism. Cultural Revolution versus cultural protection. Traditional characters versus simplified. Wade-Giles romanization versus pinyin. Every aspect of daily life could be parsed to oppose the mainland. Even now the Taiwanese insisted on calling their metro system the *jie yun,* or "rapid transit," instead of the mainland term *ditie,* or "subway." Whatever the motivations, it was heartening to know that Chinese people could achieve such progress but also disappointing that it was limited to Taiwan.

When Chinese on the mainland brayed about recapturing China's past glories, I heard insecurity. When they mentioned China's five thousand years of history and culture, I saw a long line of failures and missed opportunities. It was easy to blame these failures on China's feudal system, in which all power was concentrated in one man who was more interested in maintaining that power than in developing his country. Or on China's history of xenophobia. But in actuality, reformist emperors did exist, and China did study the West. The problem was those reformers didn't last long, and unlike the Japanese, who studied the whole Western knowledge system as they modernized, the Chinese focused on expediency. They relied on missionaries to make timepieces or scientific instruments, and when the missionaries left, so did the knowhow, and the Chinese could only make copies rather than innovate.

Instead of practical technologies, the Chinese invested in pondering the principles for ruling a country—Confucianism. But when the country abandoned the imperial exam system in 1905, its

philosophical foundations became irrelevant, and so did its economic base of agriculture and taxes. Those systems didn't modernize to keep pace with a changing world, so while the West rose, China languished.

In a roundabout way, I was basically pondering the "Needham question." Joseph Needham, the eminent Cambridge biochemist, polymath, polyglot, and polyamorist who was a better friend to China than I could ever hope to be, crisscrossed China during the Sino-Japanese War on a friendship mission to provide moral and material support to Chinese academic and research institutions, and along the way he recorded the whole of China's intellectual history. Upon returning to England, he embarked on the landmark *Science and Civilisation in China* book series attempting to catalog every invention or idea that had ever originated on Chinese soil.

As Needham studied the endless ways in which the Chinese had demonstrated inquisitiveness, inventiveness, and creativity, he couldn't help wondering why, for all China's scientific accomplishments, modern science, for instance, had not developed in China. Why had this tradition of achievement all but stopped in the Ming dynasty, and how could China have been so poor and backward for so long?

Needham postulated many reasons, such as China's reliance on an ideographic language system, its system of governance, and its geography, but he died in 1995 without finding his answer. Other scholars had put forth their own theories—one prevailing idea was that the Chinese just stopped trying—but recently a backlash had developed. One of Needham's collaborators, University of Pennsylvania sinologist Nathan Sivin, was a particularly eloquent critic, writing, "It is striking that this question—Why didn't the Chinese beat Europeans to the Scientific Revolution?—happens to be one of the few questions that people ask in public places about why something didn't happen in history. It is analogous to the question of why your name did not appear on page 3 of today's newspaper."

Perhaps it was only natural for me to speculate. As I unearthed pieces of my family's history and tried to weave them into a coherent narrative that I could follow back to the porcelain, I was also creating a new version of it. I disturbed the long-buried memories of my relatives because I hoped these shards might yield some unified truth. But there was no end to trying to know what happened to my family's buried treasures, just as there was no end to speculating about China's unhatched scientific revolution.

In the *Tao Te Ching,* Lao Tzu wrote, "We shape clay into a pot, but it is the emptiness inside that holds whatever we want." No matter how hard I tried to project something into the emptiness inside my family's porcelain—a goal, a heritage, a solution—it remained empty. Just as no matter what explanation I gave for China's miscarried possibilities, they remained unborn. Until we knew what had been, we were free to write what might still be. To seek was to have purpose. To wonder was to breathe life into possibilities.

For all Taiwan's comforts, I was eager to return to the mainland. I missed its urgency and dynamism—even the confrontation. Perhaps because Taiwan had spent most of its modern existence looking at the mainland with longing, its cities embodied impermanence; Taiwan wasn't just a government in exile, it was a people and a culture in exile. Sinologists and archaeologists could bemoan the current state of affairs on the mainland until they were hoarse, but they wouldn't stop heading there, and neither could I. As one anthropologist in Taiwan told me, "China has it ALL. It's where the things are."

CITY ON FIRE

I WOUND UP IN JINGDEZHEN BY ACCIDENT. WHILE ON A long weekend trip with some friends to Huangshan, declared by Ming dynasty scholar Xu Xia Ke (same Xu as my Hsu) as a mountain without peer and where the SMIC vice-president had nearly died of a heart attack, I looked on a map and saw that Jingdezhen was less than one hundred miles away. Having heard so many people talk about it in fantastical terms, and having felt their disapproval when I told them I had not yet visited, it seemed only right to take the short train ride to the origin of my great-great-grandfather's porcelain. I left my friends at some hot springs midmountain and hailed a taxi to the train station.

We sped past jagged peaks and long tunnels, the only car on the highway, which the driver said was new and greatly reduced travel times to and from the mountain. At the train station, map vendors, restaurant hawkers, and pedicab drivers accosted me as soon as I exited the taxi. I fended them off and bought some fruit and a *dan bing*, a spring onion crepe fried with a beaten egg, from one of the food stalls on the square. Though the station was located in Huangshan, most of the storefronts around the plaza claimed to be in Tunxi, and I asked the proprietor about the discrepancy.

"Less than ten years ago this town was called Tunxi," he said. "But someone in the provincial government decided to change it to

Huangshan. They wanted more tourists, and Huangshan is much more recognizable."

I spent the train ride facing a thin, manic young man with a spiky haircut talking nonstop to his seatmate, a placable man in his forties or fifties who looked to be an uncle or workmate. The younger guy's speech was drenched in *ma des*, a filler word equivalent to *fuckin'*, as in, "That fuckin' bitch at the fuckin' train station was getting on my fuckin' nerves, so I told her to fuckin' shut up." The young guy asked what I was doing on the train and how much I'd paid for my ticket.

"Twenty-five *kuai*," I said, using the monetary term with a meaning similar to "bucks." About $3.50.

"That's a fuckin' lot," he said. "Too fuckin' much."

The train pulled into Jingdezhen past midnight. I followed the passengers out of the station, where they seemed to evaporate into the hazy night. I crossed the deserted street to look for the hotel that I had booked last minute from Huangshan, selected for its proximity to the train station. A woman appeared from an unlit doorway. "I've got girls, mister, very young, very beautiful," she said. "Seventeen years old."

THE NEXT MORNING I rode the elevator to the lobby of the Bandao International Hotel, some attempt to build business-class accommodations for businessmen who never came. The receptionist and security guard were the same as the night before; when I entered, they were chatting about where they dreamed of traveling (she, New York and Paris, and he, Tibet) while a bat circled overhead. The only signs of porcelain were the two tall vases lurking behind high-backed chairs in opposite corners of the lobby.

I had a backpack full of dirty clothes and a phone number for something called the Pottery Workshop, which a gallerist in Shanghai had given me. If I wanted to know about Jingdezhen and porcelain, the gallerist said, the Pottery Workshop was a good place to start.

But the hotel employees didn't recognize the Pottery Workshop, and I didn't know what it was called in Chinese, so I decided to walk to People's Square, which formed the center of many Chinese cities.

The hotel doormen argued over the best way to get there. "My way is faster," one said.

"His way exposes you to the sun the entire time," the other said. "My way has trees."

I took the second doorman's advice. Though Jingdezhen lies about fifty miles south of the Yangtze River, its hot and humid summer climate shared the same characteristics as the trio of river valley cities—Chongqing, Wuhan, and Nanjing—that earned themselves the moniker of China's "Three Furnaces." I walked north through the sopping heat along a shaded street of small storefronts, including scooter retailers, restaurants, fruit stalls, and two sex-toy shops. For a city synonymous with one of China's most beautiful creations, Jingdezhen wasn't much to look at, a third- or fourth-tier city in a poor province. The architecture consisted of monotonous variations on a cube, often clad in sanitary tiles caked with water stains and dirt. The refuse on the streets, the dust and smog and sweat choking the air, and the traffic noise made Shanghai seem like Switzerland. One of the few attempts at beautification were the streetlights and the crosswalk signals encased in columns of blue and white porcelain. At the southern edge of People's Square loomed a Walmart the size of a football stadium.

Across the street from the Walmart, construction crews worked to clear an equally monstrous tract of land next to an open-air ceramics market and a shopping mall, each stall offering the same cheap, de-caled vases, dinnerware, and tea sets. It was difficult to overstate just how ugly it all was, loud colors and clashing styles as unsubtle as their surroundings. Anchoring People's Square was a concrete tower connecting four pedestrian bridges, painted to look like blue and white porcelain.

I phoned the Pottery Workshop, obtained the address, and hailed

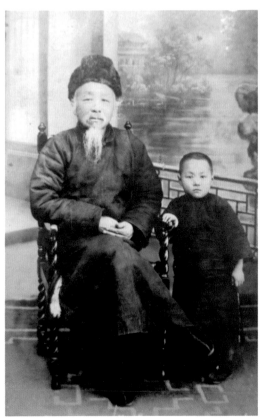

Liu Feng Shu with either Liu Cong Ji or his older brother Liu Cong Jia, at a Jiujiang studio during the 1930s before the family fled Xingang. This is the lone photograph I have of my great-great-grandfather, discovered among San Gu's possessions after she died in 1998.

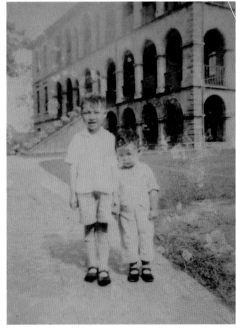

Liu Cong Ji and Wu Yi Po on the Rulison campus, circa 1937.

Undated photograph of Liu Pei Sheng, my Si Yi Po. She sent this photo to Fang Zhen Zhi in 1946 when they were courting, and he has managed to hold on to it ever since.

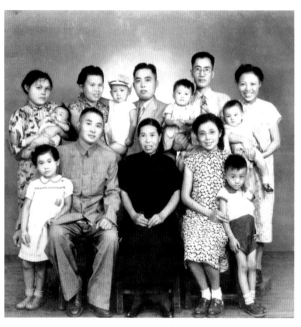

My grandmother (back row, right) with assorted family members at San Gu's engagement to Kuomintang officer Guo Wen Can in the summer of 1948. She would not see many of them again for nearly 30 years. Adults, front row, left to right: Guo Wen Can, San Yi Po's mother (Lady Cai), San Gu; back row, left to right: Si Yi Po, San Yi Po, Dai Chang Pu, my grandfather Zhang Xi Lun, and my grandmother Liu Pei Jin.

My grandmother holding Richard, circa 1952, about a block from the family house in Kaohsiung, Taiwan.

Fang Zhen Zhi in Moscow during his years as a visiting scholar from 1957 to 1959.

San Yi Po's husband, Dai Chang Pu (back row, left), with Chiang Kai-shek (front row, center) on Jinmen Island, circa 1960. As a high-ranking "political warfare" officer, Dai Chang Pu's responsibilities included rooting out Communist sympathizers inside Taiwan's military.

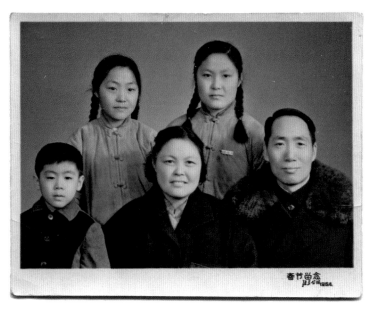

Si Yi Po and Fang Zhen Zhi with their family in Beijing in 1964, while Fang was on furlough from his top-secret work developing China's nuclear capabilities.

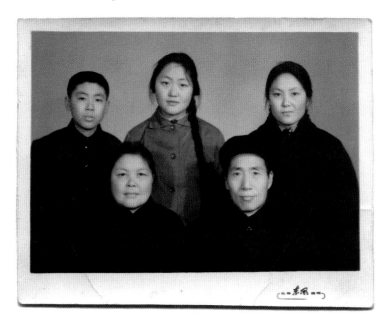

Si Yi Po and Fang Zhen Zhi with their family in Beijing in 1969 or 1970. The eldest daughter, Fang Wan Ling (back row, right), had just returned from three years of "reeducation" in Yanan.

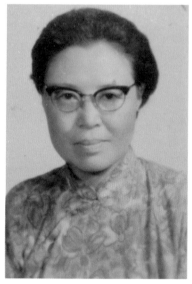

My grandmother Liu Pei Jin in the 1960s, perhaps when she was serving as dean of students at Ginling Girls' High School in Taipei, Taiwan.

My grandmother at Ginling College in 2002, the only time she returned to her alma mater. She had contributed money toward the construction of a new building on campus; her name appears with other donors on the plaque behind her.

Left to right: Me, my brother Fong, Ramey Ko (a cousin), and Andrew in Dallas in the summer of 1985.

The SMIC headquarters in Shanghai. Beginning in 2000 as a cluster of trailers on a tract of farmland, the company has since grown into an international manufacturing giant boasting some of the most advanced technology in China.

After Xingang suffered a massive flood in 1954, the village reassembled itself on higher ground. This is one of the few older houses remaining on what had been Xingang's main street, at the end of which stood my great-great-grandfather's estate.

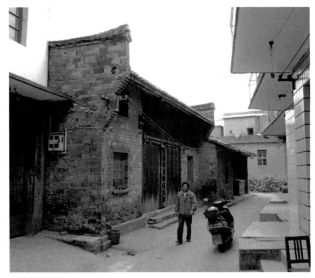

Much of the farmland in Xingang along the Yangtze River that my great-great-grandfather once owned has been sold off for development. This billboard on one of his former fields offers a glimpse of Xingang's future.

On the way to visit the grave of Liu Pei Fu (my grandmother's middle sister and my Er Yi Po) near the Chen Jia Ba Fang village. From left: me, Chen Bang Ning, Wu Yi Po, San Yi Po's son-in-law, Uncle Lewis, San Yi Po's two daughters, and Aunt Jamie.

Uncle Lewis paying his respects to San Gu in the relocated family cemetery. The gravestones are modern, and whether they are paired with the correct remains—or any remains at all—is a matter of faith.

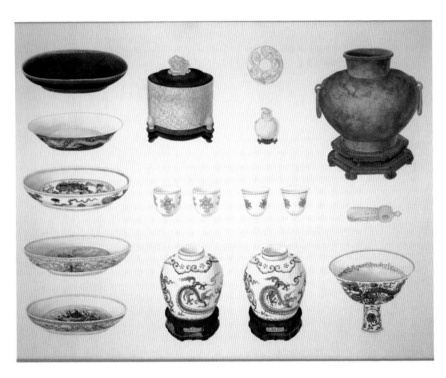

Commissioned in 1728 as a kind of pictorial inventory of emperor Yongzheng's favorite antiquities from the imperial collection, the 60-foot-long handscroll Guwan Tu, or "pictures of ancient playthings," depicts about 250 assorted objects with such detail that corresponding physical objects have been identified and experts still rely on it to verify antique porcelain and other collectibles. © *The Trustees of the British Museum*

a taxi. We drove through the winding, chaotic city center and then made a right onto a boulevard with antijaywalking railings running all the way down both sides. We passed a man standing over a sidewalk trash bin, squeezing the blood out of a headless snake, its body still coiled defiantly around the man's arm. Tall brick smokestacks began to appear above the houses, and the driver aimed for a pair on our left. He told me that there was a saying in town that someone in every family was involved in porcelain and he estimated that there were probably thirty to forty thousand workshops just in our immediate vicinity, though all I could see were crumbling houses. As we approached the pair of circular chimneys, hunched-over old men began appearing on the roadside, pushing handcarts loaded with ceramics to and from the kilns that I still could not see.

The driver dropped me off at the main gate of a 1950s-era factory. I walked in and found the Pottery Workshop's office, on the second floor of one of the larger buildings. In the office the woman I had spoken with on the phone asked if I could speak Chinese. "Yes," I said.

"Well, why were you making me speak English, then?" she said. "So what kind of tour guide do you want?"

"English would be better," I said.

"English would be better," she muttered as she dialed someone on her phone.

A minute later an attractive young woman with a dash of freckles across her nose walked in and introduced herself as Jacinta. She wore skinny jeans and a fitted plaid top, and her chocolate hair was cut in a bob. I figured her for Japanese, but she was actually from the Shanghai suburbs and a fourth-year student in ceramic arts at the Jingdezhen Ceramics Institute, a large four-year university in town. She spoke impeccable English with an American accent, using words like *dude* and *pain in the ass*. I was amazed to learn that she was completely self-taught, mostly from watching American television series, movies, and teen soap operas.

Jacinta seemed puzzled and somewhat suspicious about my

presence. To express an interest in porcelain without also being an artist struck her as odd, and I disappointed her when I failed to recognize the principles—minor celebrities in the ceramics world—behind the Pottery Workshop. Founded by a Hong Kong artist, the Pottery Workshop was an effort to reestablish a modern creative industry in Jingdezhen, offering artist residencies, manufacturing designs, and selling its own line of wares. It hosted weekly salons by visiting artists and a Saturday-morning market for JCI students to sell their work.

Jacinta dutifully showed me around. After seeing the studio spaces, resident accommodations, and an array of kilns—electric, soda, wood burning, and an environmentally friendly "smokeless" kiln designed in Japan—we walked up the road that ran the length of the factory. The entire plant had once been China's national sculpture factory, and clustered around the Pottery Workshop's properties were studios and workshops still being run by local artists and craftsmen. Small shops had taken up the square, garagelike spaces lining the road, their storefronts crowded with the products they specialized in: vases, bowls, and figurines of Buddhas, goddesses, and Mao Zedong. Lean, shirtless men, all bone and ropy muscles wormed with veins, ferried pieces in various stages of production on handcarts. Playing cards littered the street; the porters used them as shims to level the pieces on their carts.

We arrived at a warehouse that the Pottery Workshop had rehabilitated into a large, airy work and lecture space with concrete floors and a high, slanted, churchlike roof, dubbed "Two Chimneys" for the twin spouts that rose up behind it. Contrasting the Pottery Workshop's sleek, modern aesthetic, the sagging wooden shacks surrounding Two Chimneys housed dirty studios appointed with scavenged furniture; even the chimneys themselves had been cannibalized, filled with junk or hanging laundry.

What I had seen so far of Jingdezhen looked nothing like the bucolic village of ascetic artisans I had imagined. Jacinta said I was naïve. Though Jingdezhen was indeed the mecca of porcelain, it had long since lost its cachet, having lapsed into churning out derivative,

low-quality ceramics for low-end markets. Decals and electric kilns had replaced hand-painting and wood-fired kilns. As China industrialized, ceramics had followed the same model as light manufacturing: everyone cutting corners as they tried to squeeze out tiny profits from even tinier pieces of the market. Artistry was an anachronism. Intellectual property was a joke. That Jingdezhen still managed to produce ceramics at all was a triumph in itself.

Jacinta had studied ballet for seven years as a child and aspired to become a professional dancer but wasn't accepted into the state ballet school. She learned to draw when she decided to pursue becoming a makeup artist but didn't get into the school for that, either. So she applied to the JCI, thinking she might develop an affinity for ceramics. "But I'm not cut out to be an artist," she said. "I'm not crazy enough, or narcissistic enough. I'm not being modest. I sort of suck at ceramics."

Jacinta struck me as a kind of kindred spirit, too Chinese for some things and not Chinese enough for others. When she asked again what I was doing in Jingdezhen and why I was so interested in porcelain, I felt that I could trust her with the story of my great-great-grandfather's porcelain and the relative who had supposedly served as an official here, which perked her up. She wasn't very clear about the city's history or where I might find any records of the porcelain my great-great-grandfather had obtained from here, but she urged me to talk to the Japanese artist who managed the Pottery Workshop, who had done his own research on the topic. And she persuaded me to stay through the weekend for the lecture and the market, where she said I might meet some people who could help answer my questions.

I SPENT THE next few days wandering around the city in the August heat. On the corner of one large intersection near the university, seamstresses had set up a row of manual sewing machines. Across the street a little boy squatted before a hardware store, pushing a long

shit out from his open-crotched pants. I ate noodles and pork buns from squalid, fly-infested holes in the wall. Even the drivers seemed too lethargic to bother honking as much as usual. Then I heard about an ancient kiln museum on the other side of town and hired a taxi to take me there.

The museum was more like a re-created porcelain village, in a wooded area on the other side of the Chang River that sliced through Jingdezhen and that had for centuries served as its lifeline to the outside world; now people and goods moved via roadways, railways, and the small airport with thrice-weekly flights to Shanghai. I appeared to be the only visitor and had to wake a napping employee to buy a ticket and hire a guide. My guide appeared, looking as if she too had just woken from a nap.

She gave her name as Zhang, and we began the tour at the throwing, painting, and glazing demonstration. As we entered the small courtyard, three ancient men roused themselves into action, like life-size coin-operated automatons. Moving with detached precision, one of them stuck a wooden staff into a nock on the edge of his throwing wheel and spun it up to speed. He slapped a lump of clay onto the wheel and expertly pulled a bowl from the clay in a few seconds and placed it on a plank to dry. The next man took a dried bowl, centered it on a wheel, gave it a spin, and painted circular designs on it. The last glazed a painted bowl not by spraying it but by dipping it into a barrel. In their bamboo work enclosures, they looked like prisoners.

That would be the most interesting part of the tour, the rest of which consisted of visits to nonmoving displays of kilns and ceramic materials. Zhang recited her script and mostly thwarted my attempts to ascertain the authenticity or age of the things we looked at. There was only one structure, from the Ming dynasty, for which she could definitively state its era. Each area had its own gift shop, and Zhang made sure I browsed every one of them before signing a paper at the cashier to confirm that she had brought her visitor through.

Our final stop was a temple manned by two bored-looking

monks, who discreetly tucked their mobile phones into their robes when I entered. Even the temple had a gift shop, and Zhang passed me off to the young woman who worked there. She was more patient and friendlier than Zhang and explained to me that the temple was in honor of Tong Bin. Born in 1567, Tong Bin had been a precocious child and demonstrated an early aptitude for pottery. He quickly rose to become a master-level kiln master. Then the emperor demanded some especially large *long gangs*, or dragon pots, from the kiln. Tong Bin worked for fifteen years without producing a satisfactory *long gang*. Porcelain making at that time was far from precise, and the failure rate was high. The emperor grew impatient and dispatched a heavy-handed supervisor to Jingdezhen, where he declared that if the *long gang* could not be made, everyone involved with the kiln would be killed. There was only one *long gang* left to be fired, and when it was put into the kiln, Tong Bin jumped in with it. Because of his sacrifice, the firing was successful and the kiln was spared.

I frequently heard this kind of martyr story in China. The creation of bloodred glaze was attributed to a farmer's daughter who jumped into the kiln. A mountain retreat near Shanghai named Moganshan was named for a pair of star-crossed lovers, Mo Ye and Gan Jiang. Gan was tasked to make a sword for the emperor and continually failed until Mo sacrificed herself by jumping into the cauldron of metal, which allowed Gan to forge a sword that exceeded the emperor's demands.

"What is it with all these suicide stories in China?" I said.

The woman laughed. "Yes, there are lots of these types of stories," she said. "But it's not just China. What about Romeo and Juliet?"

ONE EVENING AT the Pottery Workshop's coffee shop, perhaps the only place in town to get a decent espresso and a gathering place for the tiny expat population of English teachers and ceramists (often

one and the same), I was introduced to the workshop's director, ceramic artist Takeshi Yasuda, a stocky, balding man with a thin corona of gray hair. He wore baggy shorts, a white, sleeveless shirt, and technical sandals with curved rubber soles. His face was a composition of circles—a round forehead, round cheekbones, round jowls, and round tortoiseshell eyeglasses. Takeshi was married to an English ceramic artist and was on faculty at the Royal College of Art in London. He had not lived in Japan for so long that his niece told him that he spoke a very strange kind of Japanese.

"Jingdezhen was not where porcelain was invented," he told me as he made me an Italian-style cappuccino. "But all the innovations after that took place in Jingdezhen."

I sat at a glass-topped table displaying blue and white shards that Takeshi and others had picked up around the city and at the weekly antiques market, where I was told 99 percent of the intact pieces were falsely aged but the shards, which ranged in price from 20 to 300 RMB, were real. On the walls and shelves sat modern ceramics for sale, including some of Takeshi's recent work, delicate pale green teaware with *wabi sabi* imperfections—an indentation here, a pinch there, an overlapping seam—formed from hands guided by a considered spontaneity. The thinness of the vessels interacted with gravity in the kiln, creating sagging bodies and warped lips that gave the impression that they were still spinning on the some invisible wheel, on the verge of deformation. They were so unlike the vast majority of wares in Jingdezhen's stores, and very beautiful.

While Takeshi prepared my coffee, I studied the ancient fragments of bowls, dishes, and vases in the table displays. Fired anywhere from fifty to five hundred years before and smashed for some imperfection, their curved surfaces remained glossy and held thumb-size flowers, animals, and figures in domestic scenes, some complete, some severed. I found them even more captivating than what their former wholes must have been. Takeshi set down my cup, and I experienced a flash of disorientation as the café dilated back into view. "In Chinese

culture, porcelain was the most important cultural item and also the most exchanged item with other cultures," he said.

Throw a dart at a map of China, and it will probably land somewhere with an interesting porcelain history. The operative word here is *history*, for most of China's famous porcelain cities had the connections to their glorious pasts broken long ago. The celebrated teapot clay in Yixing was mined out. Longquan, where celadon glaze was invented, managed to obtain UNESCO heritage status in 2009 but for "intangible" culture—every ancient kiln site had been destroyed. The giant-scale porcelain manufacturing in newly industrialized cities like Dehua relied on imported materials. Just one city's kilns had never been extinguished: Jingdezhen's, the buckle in China's shard belt.

The Chinese have two words for ceramics, *taoci* and *ciqi*, which approximate as "pottery" and "porcelain" respectively. Pottery making in China dates back to the Neolithic, and the Chinese achieved high-fired glazed ceramics in the late Shang dynasty. Porcelain, roughly defined as translucent white clay body composed of kaolin and china stone and fired above 1,200 degrees Celsius, probably first appeared during the Tang dynasty (618 to 907), though its originator remains unknown; for all of China's firsts, the inventors or discoverers were seldom recorded.

Porcelain soon became China's most famous, most enduring invention. As early as the Tang dynasty, cargo ships loaded with porcelain sailed west for the Middle East, where middlemen would transfer the wares to Europe. For the Chinese, porcelain wasn't just a sanitary material, dinnerware, or a hobby. Porcelain was as central to the Chinese identity as the Yangtze River, the bones to the Yangtze's blood, and it was no accident that the material became eponymous with its country of origin. Porcelain touched every member of Chinese society, from peasants' rice bowls to the imperial family's massive collection. Porcelain formed the basis of China's mythology and morality tales and fueled its economy, including the golden age of the Ming

dynasty, which boasted the world's largest economy. There was simply no Western analogue to the breadth and depth of porcelain's infiltration of Chinese art, industry, and culture, though the automobile in America comes somewhat close.

Jingdezhen was established in 1004 by the Song dynasty emperor Jingde as China's original factory city, achieving what alchemists had labored after in vain for centuries: to turn dirt into gold. Far from the quaint, pristine old China of the Western imagination, each area of this bustling artistic and industrial hulk was dedicated to one part of the porcelain-making process, from sourcing clay to packaging finished goods, and everything was done by hand. Entire neighborhoods of craftsmen spent their working lives mixing one glaze, throwing one shape, or applying a single brushstroke. Even the porters, moving the pieces through the city on bamboo yokes or handcarts, specialized in the items they transported. This narrow division of highly skilled labor, along with the area's unique *terroir*, allowed the Jingdezhen appellation to monopolize the market for the better part of a millennium.

According to one enduring local myth, Jingdezhen was the birthplace of the term *china*. For centuries, the city was known as Chang Nan, or "South of the Chang River," which provided its critical supply link; porcelain boats rode the Chang to Poyang Lake and Jiujiang, from which they accessed the Yangtze. Chang Nan manufactured the first Chinese porcelain for export, which had that name stamped on their bottoms. Western tongues approximated these wares' place of origin as "china," and the city's name became synonymous with its product. Jingdezheners also liked to boast that the city escaped bombing during the Sino-Japanese War because Japanese pilots mistook the scores of tubular kiln chimneys for antiaircraft guns and figured it best to give the place a wide berth. (More likely the city wasn't bombed because it served no strategic purpose.)

The Song dynasty—vibrant, prosperous, and renowned for its culture and diverse artistic tastes—was also very corrupt. The state

weakened to the point that it lost its northern territories to the Jin and had to regroup in the south. Eventually Kublai Khan—grandson of Genghis—and the Mongols conquered all of China and launched the Yuan dynasty. The subsequent destruction of other major kilns left Jingdezhen as the beneficiary. The Mongols didn't have the same appreciation for the finest Song ceramics—the seafoam of *ge* celadon, the milky turquoise of *ru* ware, or the copper flambé of *jun* ware. White was the sacred color for the Mongols, and the closest producer of white ceramics was Jingdezhen.

The Mongolian occupation was the most critical to Jingdezhen's history. For centuries Chinese potters had battled gravity, trying to prevent a clay pot from collapsing during the firing process. The solution was finding the right material, and only high-quality porcelain stone—crushed into powder and reconstituted with enough water to make it malleable—could withstand the 1,250 degrees Celsius required to vitrify it into porcelain without deforming. Meanwhile the lowest melting point of glaze was just below 1,200 degrees Celsius, which gave potters a very narrow temperature range in which both a ceramic body and glaze would behave as desired.

The discovery of massive kaolin deposits in a mountain near Jingdezhen during the Yuan dynasty changed everything. Mixing kaolin into clay raises its firing temperature (improving yield) while also allowing potters to conserve precious porcelain stone (improving production) because it can comprise half of the clay body and maintain its structural integrity even when eggshell thin. And it wasn't just the presence of kaolin that made Jingdezhen's clay unique; it was also the specific properties of that kaolin, right down to its molecular structure. While in Jingdezhen, I met a geologist from Montana who had traveled there to study its ceramic materials and who told me that both the size of its clay particles and its impurities could not have been more perfectly suited for making pottery. "The materials are absolutely unique here," he said. "A gift from heaven."

Perhaps of most interest to the ruling Mongols, kaolin increased

whiteness, and in 1278 Kublai Khan established a government bureau in nearby Fuliang, the county seat, to control the supply of materials. The idea behind that bureau—a government-supervised kiln in Jingdezhen—lasted until 1949, and if its records survived, they might hold information about the relative of mine who supposedly worked in Jingdezhen.

By the Yuan dynasty, the network of foreign traders in China was well established. While Chinese tastes still ran toward subdued monochromes, Middle Eastern and Persian markets favored boldly painted porcelains. The Persians already knew that cobalt pigment could produce vibrant blues, but they could produce only low-quality ceramic bodies. The Yuan court, seeking to increase its export revenues, hit upon the idea of using Persian cobalt to decorate Chinese porcelain. The resulting snow-white porcelain painted in rich blues created a sensation, and Jingdezhen's blue and white wares were shipped across the world.

As the Yuan gave way to the Ming dynasty in 1368, marking the restoration of native Chinese rule, Jingdezhen maintained its preeminence. The conquering Ming emperor Hongwu consolidated the legitimacy of his rule in part by ordering new vessels for the various ceremonies, rites, and sacrifices to gods and ancestors prescribed since high antiquity. But instead of gold, silver, or bronze, he insisted that all the sacrificial objects be made of porcelain. Subsequent Ming emperors established the official imperial kiln in Jingdezhen, where the quality and quantity of production were held to exacting standards; a production run of a thousand identical objects might yield just a handful of acceptable ones to send on to Beijing. Official wares began bearing the emperor's reign mark—now one of the first things experts check to determine the age, authenticity, and value of antique porcelain.

With the Manchu-led Qing dynasty came the apex of Chinese porcelain. The Kangxi, Yongzheng, and Qianlong emperors took personal interests in porcelain production, partly out of a tradition of

patronizing the arts and also partly to assimilate into Han Chinese culture. The result was an unparalleled explosion of high-quality techniques, glazes, and forms. Western influences also began to seep into porcelain. Missionaries had brought painted enamelware to China during the early Qing, and Kangxi fell so deeply in love with it that he all but forced missionaries—Guiseppe Castiglione being the most prominent—into imperial workshops to train and supervise painters. Jingdezhen continued to produce the porcelain bodies, which were decorated and finished in Beijing.

At its peak in the Qing dynasty, Jingdezhen hummed with densely packed houses, crowded streets, and temples built by merchants and boatsmen seeking favor with the gods. Its one million inhabitants (about the same number as today) quarried deep into the surrounding hills for porcelain stone and clear-cut the forests to feed the thousands of kilns burning around the clock. Jingdezhen's chimneys not only defined its skyline, the same way church towers rose above the rooftops in European cities, but also served as its nuclei. The chimneys were why transporters hauled materials over great distances from the forested hills into the workshops, and why the clay passed through a horde of processors, throwers, trimmers, carvers, painters, glazers, retouchers, and others on its way to the kiln (the saying in Jingdezhen was that a dozen hands touched each piece from start to finish), where it vitrified under the watchful eye of the kiln master, perhaps the most alchemical of the ceramic specialists. Once the kiln was packed and sealed, it consumed a nonstop diet of pine billets for more than a week to reach temperature, which the kiln master, without the benefit of thermometers, determined by watching the color of the flames, observing the luminosity of the saggers (the clay containers in which the ceramics were fired), and spitting on the bricks. It took four days for the kiln to cool, after which workers still had to wrap their hands and bodies in protective layers of wet cloth to extract the saggers, and opened them to see if the firing had been successful.

When the kilns turned from wood to coal, their chimneys—still the tallest structures in town—emitted a foot's worth of soot annually. The eighteenth-century French Jesuit priest François Xavier d'Entrecolles (one of many missionaries who traveled to China to uncover its porcelain secrets) wrote that at night "one thinks that the whole city is on fire, or that it is one large furnace with many vent holes."

Over the centuries Jingdezhen's kilns developed glaze that could show mixed colors and graduations within the paint. They invented twice-fired *doucai* colored wares and polychrome enameled *wucai* pieces. Lead arsenic created pink, which allowed for the depiction of peaches, an important achievement as the peach tree was soaked with historical and cultural significance. "All these inventions are extraordinary inventions," Takeshi said. "And all these decoration and material technologies were done here in Jingdezhen. It's the most amazing thing."

While Jingdezhen rose, European scientists remained baffled over how to produce porcelain. Some believed that it was formed when falling stars struck the earth. Others theorized it was made of crushed eggshells or a special fish paste left to ripen underground for one hundred years. Throughout the sixteenth and seventeenth centuries, Europeans journeyed to China to discover porcelain's arcanum, but no matter how hard they tried, they couldn't reproduce the translucent material that was "white as jade, thin as paper, bright as a mirror, with the sound of a music stone [when struck]." Until the eighteenth century, the disparity between the Chinese and Western ceramic industries was as stark as that between China and the West in the centuries that followed.

The savior came in an unexpected form. Johann Böttger was a Saxon charlatan who claimed to have successfully produced gold from base metals. His boasting earned him an audience with Frederick I, who demanded he make good on his claims. Böttger escaped, only to be "rescued" by the king of Saxony, August the Strong. August

believed Böttger could solve his treasury's woes and placed him under protective custody until he produced gold. In Dresden, Böttger faked his way through alchemical procedures until a sympathetic court scientist suggested he search for a way to produce the next best thing to gold: porcelain. He began experimenting with different clays and, because he wasn't completely unskilled, designed a kiln that could reach 1,300 degrees Celsius. Judging by the sign he hung outside his workshop, which read, "God, our creator, has turned a gold maker into a potter," he worked grudgingly.

In 1708 Böttger happened to receive a shipment of hair powder, which he assayed as both a natural substance and having an unusual weight. It was kaolin. Following the successful firing of porcelain, Böttger's laboratory relocated to Meissen in 1709, and Meissen porcelain hit the market in 1713, a harbinger for the rise of companies like Wedgwood and the end of China's prosperity.

During the late Qing, as subsequent emperors lost interest in porcelain or became too busy with trying to hold their empire together, the kilns were entrusted to local authorities, and imperial styles declined. Except for brief periods of renewed interest, such as the garishly colored sets of tableware and boxes that Cixi commissioned for her birthdays in 1884, 1894, and 1904 during her reign of excess, the imperial kilns faded.

In 1949 the new Communist government began consolidating Jingdezhen's kilns into ten nationalized factories, each specializing in a certain type of ceramics: the Shi Da Ci Chang, or Ten Great Factories. One made blue and white, one made on-glaze painted pieces, one made sculptures, one made oversize pieces, and so on. The factories were overemployed, saddled with bureaucracy, and wages were modest, but the jobs were secure and everyone "ate from the big bowl of rice."

The Ten Great Factories all failed after privatization in the 1990s, destroying the local economy and hollowing out the company town's core industry. Employees were let go or forced to take

early retirements. (One local told me some factory retirees received a monthly pension of 160 RMB, about twenty dollars.) Some of the factories were too bankrupt to pay owed wages and gave porcelain as severance. But as they said in Jingdezhen, you can't eat porcelain, and downtown filled with people selling surplus porcelain from handcarts. The empty factories fell into disrepair, their inventory piled outside and overtaken by vegetation. A popular site for Western artists to visit was a defunct plate factory, with seemingly endless stacks of unwanted plates left behind the buildings, perhaps all the more remarkable that they remained undisturbed in a country where nearly everything was scavenged. Porcelain manufacturing has relocated to the coast, where it relies on machines and has become notorious for lacking creativity, quality, and respect for intellectual property. Jingdezhen's factories lie in ruins, the once-great porcelain industry now consisting of a fragmented assortment of individual workshops and kilns manned by aging former factory employees who continue the ancient handcrafted traditions both out of stubbornness and for lack of a better alternative.

Meanwhile the political cadres posted in Jingdezhen often come from elsewhere, with their eyes on the next rung on the party ladder, so they aren't particularly interested in Jingdezhen's porcelain history or its affairs in general. The development that occurred in Jingdezhen—the new roads, the Walmart, and the wrapping of streetlights in blue and white porcelain—was funded by the central government, and the local government seems preoccupied with grandiose projects, such as building oversize (and vacant) apartment complexes, often ruining ancient kiln sites in the process, or establishing heavy industry like the Sikorsky helicopter plant or Suzuki factory. Huge billboards both advertise and veil the construction taking place behind them, projects with names like "Regal Mansions" and "Upper East Side JDZ," and advertising copy such as "harmonious imitating nature's godliness symbolism." Plenty of these projects never finish once the government and developer have

made their money, leaving the city dotted with cavernous multistory concrete shells.

Or the local government constructs boondoggles like the China Ceramic Museum. Reclining atop a mountain miles from any historically significant ceramics site and served by a 200-foot-wide traffic artery at least 150 feet wider than necessary, the museum was initiated as a showpiece for former president Jiang Zemin's 2004 visit to his ancestral home in northern Jiangxi. But once Jiang came and went, work on the museum essentially stopped, leaving an impressive glass and steel facade and little else. The museum's vast window frames remain empty, water damage has created long fissures in the walls, and rusting, peeling trusses arch overhead. The concrete floors are still tracked with cemented footprints and studded with jagged ends of rebar. In some wings, staircases descend into dirt and weeds. The only area of the museum that seems complete is the hall dedicated to photographs and paraphernalia commemorating Jiang Zemin's visit. The museum still has no expected opening date, no plan, no curatorial team, and not a single item in its collection. "It's very Chinese," Takeshi said. "They think you can build anything, even culture."

That was the Jingdezhen that Takeshi and the Pottery Workshop were fighting against. When he was younger, Takeshi had spent a decade in Mashiko, a Japanese ceramics village, where he watched all the old master craftsmen disappear. While in England, he had seen the extinction of its country potters. The same was happening in Jingdezhen, he said. "You can see this town is going to change very quickly in the next ten to twenty years, unless these trained people in ceramics change their products to what makes sense in modern society," he said. "That's how Jingdezhen survived a thousand years. The most important tradition is that the industry changes with society. I'm not a museum guy. That's not how to preserve tradition. That's how I see traditions die."

For now, Jingdezheners can still claim that the city's kilns have

never been snuffed out. While other porcelain cities came and went, Jingdezhen's kilns fired through dynastic upheavals, wars, and disastrous national policies, leaving behind a stories-deep layer of topsoil so saturated with old kilns and shards that it glitters.

UNTIL I SAW those shards in the Pottery Workshop's coffee shop, I had seen no indication of such abundance. The Jingdezhen I had experienced appeared paved over and far removed from its ancient past. But the shards ignited a longtime impulse, the same one that compelled me to spend hours sifting through my Legos for the right piece, to steal baseball cards, to interview twice as many people as I needed to for the perfect nugget of information, to scour classified ads for classic tennis racquets. And the shards offered the chance to collect not only old, real Chinese things but also objects that could have come directly from my great-great-grandfather's time and beyond. The attraction was so powerful that I never questioned my desire.

I asked Takeshi where I could find some for myself. Everywhere, he said. Historically important kiln sites were still being discovered all the time. He had once gone to visit a site outside of the city, where a road was being built atop a huge Song-era kiln. "It was ten meters deep, freshly dug, and some pots looked like they were put there that day," he said. "Amazing! There were more pots and saggers than soil, and it was all nine hundred years old! This was during the dragon kiln period, so every firing had tons of discarded material."

Even Jingdezhen's waterways were plaqued with shards, since anything broken during transit or loading was summarily tossed overboard. Most residents above a certain age could remember when the Chang River ran so clean, they could read the characters on the shards lining its bottom, in such quantities that they had to wear shoes when swimming to protect their feet from getting cut.

But like any beginner, I still couldn't see what I sought, until one evening before I returned to Shanghai. Just beyond the layer of new

development ringing People's Square, I happened upon a construction site where workers had dug a long trench about eight feet deep through a historic neighborhood. An equally long pile of earth stretched along the trench. The sun had settled at a languid position in the sky, dimming its heat, and residents had emerged from their shady refuges. Dozens of men, women, and children stood in the ditches, chipping away at the walls with hand tools. Others clutched old rice sacks and walked meandering search patterns over the removed soil. I went over to see what they were doing and realized that the soil was studded with blue and white shards, and the walls of the trench were composed of layer upon layer of shard deposits.

Once I saw these first shards in situ, I began seeing them everywhere, as clear as stars in a night sky. They seemed to multiply before me, a carpet of blue and white fragments stretching from my feet to the horizon.

I walked over to the trench and picked up a few blue and white fragments. It was technically illegal to dig for porcelain shards, but the city supposedly looked the other way when it came to combing through the disturbed soil of construction sites. And there was no shortage of construction in town. Entire neighborhoods of kilns and houses, some of which dated back a thousand years to the Song dynasty, had been clear-cut for a new shopping center, apartment complexes, and a five-star "luxury" hotel. (Every time one of these was built in China, a Communist received his wings.) Takeshi had told me that an archaeological team might make a survey of a potentially important site, but most of the time they couldn't be bothered because there were just too many ancient kilns to inspect them all. But what was bad for preservation was great for shard hunting. Every morning before the machinery started up, people flocked to the construction sites with trowels and picks, and they came back in the evenings after the workers knocked off.

A woman in dirty clothes appeared from the other side of the pile, holding a sack and a handpick. "Are you looking for shards?" I asked.

"Yes."

"Do you sell them?"

"Are you interested in buying?" she asked.

"I might be."

The woman made a quick scan of the area and squatted down to show me what she had picked. "Well, take a look, then," she said, showing me fragments of what she claimed were Ming dynasty bowls. They were so lustrous, and the painted blue on them so sharp, that I had trouble believing they were three hundred years old.

"Are you sure these aren't Republican?" I said.

"Look at the glaze," she said. "Look at how much higher quality it is. That one you're holding, that's Republican."

I tossed away my shard. She seemed to know what she was doing, so I asked if she could take me around to look for shards. "No, I don't have the time," she said, and moved away.

IT TOOK ONLY a few days for me to see that, for all its rudeness, Jingdezhen was one of the most vibrant, dynamic, and unique places in China, as well as one of its most threatened. So many lines of Chinese history intersected here, including my own, and those lines remained intact—for the moment. I returned to Shanghai still wanting to know if San Yi Po's father, Ting Geng, had really served as the *xian zhang*, or county commissioner, of Jingdezhen. And how he had acquired porcelain for my great-great-grandfather. And I wanted shards. But Jingdezhen's tension between past, present, and future was so urgent and intoxicating—and real—that instead of just returning for another short trip, I decided I needed to move there.

I had to extract myself from Shanghai. Once I used up my vacation days at work, I applied for a leave of absence. Richard didn't object; the tenor of so many family interactions depended on felicitous timing. Whether it was my being Richard's nephew, or how little I

would be missed, I was approved for my leave. I returned to Jingde-zhen in October.

To help me find an apartment, Jacinta, from the Pottery Work-shop, introduced me to her friend Maggie Chen, a Japanese major at the JCI and Jingdezhen native. There wasn't much housing to choose from—returning JCI students had snapped up all the cheap apart-ments close to campus. I thought my requirements were modest, a Western toilet and a shower, but many Jingdezhen residents only had running water for a few hours during the day, filling buckets every morning to last them the day, and Western toilets were rare. Still, Maggie didn't stop trying, and I couldn't believe how determined she was to help. She shook off my gratitude. "Don't worry about it," she said. "I've got time, so I'm happy to help, and who knows, maybe you can help me down the road. Besides, you're Chinese. If you were a *laowai*, I probably wouldn't have agreed."

After about a week, Maggie found an apartment for me, on the top floor of a five-story building near the JCI. The only catch was the landlord, Ms. Zhang, a friend of her mother's. Ms. Zhang had once been rich, owning several apartments in Jingdezhen, until some ten-ants skipped town with a lot of her money. Then her husband ran off with another woman, leaving her to raise their daughter alone. Those experiences had left Ms. Zhang a paranoid, insistent middle-aged woman with a face tensed in a permanent grimace. She was *luosuo* in its purest, pain-in-the-ass sense.

Most of the apartment's lightbulbs had burned out, but when Maggie asked if she would replace them, Ms. Zhang said that it wasn't convenient for her to do so. "This is plenty of light," Ms. Zhang said. "You're not going to do anything in this living room except sit around anyway. What do you need so much light for at night? Just go to sleep."

We got nowhere, but I took the apartment. I soon discovered that the toilet tank leaked and the hot water from the shower nozzle ran at a trickle. A handyman told me there was nothing he could do, so

I took cold showers for a while and, when the nights turned chilly, knelt in the tub with a bucket and a kettle of boiled water. When I brought it up with Ms. Zhang, she said, "The shower is fine. How much are you going to bathe in the winter anyway?"

There was nothing I could say about the apartment that would make Ms. Zhang concede anything was wrong. China is too often a country of *chabuduo*, literally "not far off" and essentially "good enough." "You ordered a cup, right? Well, here's a cup," a potter might say. "But it's not the cup I ordered," the customer might protest. "Ach!" the potter replies with a dismissive wave of his hand. "*Chabuduo*." The reaction to broken things or systems isn't to repair or replace them but to modify one's expectations. In some ways, this is a hallmark of Chinese adaptability, but I just saw parsimony and laziness. Even Maggie's advice when I complained about Ms. Zhang's *luosuo*-ness belied the very mentality that I couldn't stand. "You have to get used to it," she said. "She's the same age as your mother, probably, so you better learn how to take it."

DURING THE WEEKEND student art market, I caught up with Caroline Cheng, the founder of the Pottery Workshop, painting vases in her studio. Despite being Chinese, growing up in Hong Kong, and having trained in ceramics, Caroline had never heard of Jingdezhen, or even been to China, until 1998, when a Canadian artist gave a lecture on Chinese ceramics at her Hong Kong ceramics studio. She went to China that same year, touring Yixing, Jingdezhen, Xi'an, Shanghai, and Beijing. "My god, I was blown away," she said. "Ceramic art in China was like from Mars. It was nothing like the Western work I'd ever seen."

For however *cha*, or substandard, present-day Jingdezhen is, it was even more filthy and run down back then. Only the central arteries were paved, and none of them had streetlights. The entire city worked and lived on the sun's schedule, and nights were nearly pitch black. The only flight into the city departed from a military airport in Beijing.

People's Square was a garbage-strewn soccer field where farmers ped-
dled shards, and every day at four p.m. the coal-fired kilns started
belching black smoke. The JCI was in a state of disrepair. But Caroline
saw, tucked away in the failed factories and old neighborhoods, expert
craftsmen, unique materials, singular products, and peerless work-
manship, all with no thought whatsoever given to design, and came
to the same conclusion as I had during my first visit. "It was very dirty,
very ugly, and very interesting," she said. "I fell in love with it."

She grew determined to save the city. When she met Takeshi Ya-
suda, who would become the Pottery Workshop's general manager, in
2004, she laid out her vision. "I love Jingdezhen, you love Jingdezhen,"
she told him. "And we want the whole world to know about it, to let
people come work with local artisans and craftsmen, have a cultural
exchange, and help young artists."

Takeshi told her that they would need three things to get foreign
artists to travel to Jingdezhen: a clean bathroom, a good cup of cof-
fee, and wireless Internet. While Caroline toured prospective sites in
Jingdezhen for the Pottery Workshop, she immediately saw the po-
tential of the former national sculpture factory, one of the Ten Great
Factories. Established in 1956 as the national center for sculpture, the
Sculpture Factory produced religious figurines and animals for both
domestic and export markets until the Cultural Revolution, when it
was ordered to destroy all the figurines, including their molds and
designs. The factory survived by making politically neutral animals
and ceramic molds for industrial gloves; one small workshop in the
Sculpture Factory continued to make the glove molds, and the stacks
of old molds that looked like severed white arms were popular souve-
nirs for foreign visitors.

During the Cultural Revolution the factory also produced many,
many sculptures of Mao, another tradition that continued in the cur-
rent workshops. One afternoon I followed a beaten path through tall
weeds to a courtyard flanked by dilapidated wooden sheds. I peeked
into one of them and saw three rows of waist-high sculptures of Mao

standing with his right hand in the air and "Long Live Chairman Mao" on the base. The man smoothing out the bases introduced himself as Luo Sifu (*sifu* meaning "master" and used to address drivers, craftsmen, and other vocational workers). "These were ordered by a French artist," he said. "He comes here every year. This time he ordered one hundred."

"Do you make Dengs?" I asked.

He shook his head. "I did once, but you can't sell them," he said. "Deng made a lot of changes that my grandparents' generation wasn't used to, so they're not as warm to him. They don't buy him here, much less abroad. But everyone recognizes Mao."

"You must be doing pretty well, making such a big order for a foreigner," I said.

"We don't make shit," he said, keeping his eyes on his work. "It's the interpreter who makes all the money. They give a high price to the artist, and we make what we make."

Luo Sifu had started in the Sculpture Factory in 1980 as an eighteen-year-old apprentice to his parents. He took over the workshop after three years when his parents died or, as he put it, "went to play mah-jongg with Mao." "When my father was making these, it was very serious," he said. "You had to be careful where you put them, definitely not on the floor. And if you fired one wrong, you couldn't smash it. You had to get rid of it very carefully—otherwise people would take it as a political statement."

The exact date of the Ten Great Factories' demise varied. Lifelong Jingdezhen residents stated years from the late 1980s to the late 1990s. I often wondered why I got such different answers for such a cataclysmic event that happened within my lifetime. It used to be that objects weren't considered old unless they were a thousand years old. But the speed of China's growth, hurtling exponentially faster away from its history, seemed to compress time, and now twenty years seemed aeons ago.

Whenever it collapsed, the Sculpture Factory employees retreated

to small workspaces in the factory. Because of the unique nature of its work, the Sculpture Factory had resisted many mass-production techniques, leaving a dormant ecosystem of glazers, throwers, kilns, and other specialists all within a stone's throw of one another, just waiting for a keystone species to support. The arrival of the Pottery Workshop completely revitalized the Sculpture Factory. Mold makers and glaze mixers moved in. A tool shop opened. Artists from across China migrated to the Sculpture Factory just to be near the Pottery Workshop—studio space was scarce and fiercely contested. The porters who were once on the verge of extinction could now make four thousand RMB a month, more than a taxi driver.

This was how Caroline envisioned saving Jingdezhen, by reconnecting it with artistry and helping it make the right product for its time. But for all the contributions the Pottery Workshop has made in reinvigorating the porcelain ecology, old habits die hard. The local craftsmen, skilled as they were, remain extremely entrenched in their practices, and many of the foreign artists visiting Jingdezhen who completed residencies in Japan and Korea regard the habits in Chinese workshops with a mixture of amazement, disapproval, and annoyance. In Japan, artists are stereotypically obsessive in everything they do, setting out a white towel on which they line up their shiny tools and throwing away work that doesn't meet stringent standards. When artists aren't working, they are cleaning. In Jingdezhen, the workshop floors are littered with debris, the craftsmen are fast and messy, makeshift tools are the norm, quality is hit or miss, and there is little urgency to meet deadlines. A Peruvian artist told me she turned the entire city upside down looking for a measuring cup and came up empty. And in all her years of hosting lectures by visiting artists, Caroline couldn't recall a single local student asking why someone made something. "All they're interested in is how they can make the same thing," she said.

❧ ❧ ❧

I WENT TO FIND Fu Sifu, a local potter I had met on my first trip to Jingdezhen who'd told me he would take me shard hunting. His studio was in the Lao Chang, or Old Factory, which, despite its name, was neither old nor a factory. A few minutes' walk from the back gate of the Sculpture Factory, the Lao Chang was a collection of residences and workshops built in the 1990s during the rise of privatization and the decline of the national factories. The itinerant population of independent craftsmen renting the workshops churned out everything from small jars and vases to huge hand-rolled tiles, all seeking to make enough money that their progeny wouldn't have to do the same.

I walked up the Lao Chang's main road, lined with oozing heaps of trash so putrid I felt I might get sick just looking at them. Wild mutts with elongated bodies and folded, triangular ears rooted through the trash. I narrowly missed stepping into a maggoty pile of chicken feathers and entrails, having smelled it milliseconds before I set my foot down. Not far from the garbage piles, freshly thrown and molded clay bodies congregated along the defunct train tracks cutting through the Lao Chang, drying in the sunlight and giving perch to butterflies and dragonflies. A Chinese art professor who had done his MFA in Illinois told me that this contrast between ugliness and beauty was what made the Lao Chang his favorite place in Jingdezhen, as well as the most representative of modern China.

At Fu Sifu's studio, I found only his parked scooter. After a while Fu Sifu showed up, wearing short athletic shorts and a tank top, displaying the characteristic build of someone who wrestled with clay for a living: muscular arms and shoulders, thin waist, and strong quadriceps, which were used to brace the elbows when sitting at the throwing wheel. He rolled up the overhead door and showed me his studio. On a small platform sat a motorized throwing wheel. In the other corner was a stool and glaze gun. Most of the shelves were taken up by his cups. Packs of clay were stacked on the floor. Fu Sifu was the rare potter in Jingdezhen who handled the entire process himself, until the piece was ready for the kiln.

"It's very nice," he said. "When I feel like making something, I make something. When I don't, I do something else." He hopped onto the platform and sat at the wheel. I watched him pull a few bowls, leaning into it with his head slightly cocked and nodding, as if listening to a beat only he could hear. He seemed to navigate the clay by feel rather than by looking at it. After every bowl he looked up, the trance broken, and smiled. "It's really not that difficult," he said.

I jumped onto the back of Fu Sifu's scooter, and we drove to a neighborhood in Jingdezhen's old center, across the street from the Walmart, the Shiba Qiao (Eighteen Bridges, for the ancient network of waterways and crossings that no longer exists). There is an old saying that Jingdezhen consists of ninety-nine neighborhoods, though Fu Sifu said few people know about them anymore, or can locate them, so much has been cut down for new construction. Within these old neighborhoods, the craftsmen are fiercely protective of their trade secrets, passing down their knowledge only to direct descendants. This secrecy, Fu Sifu said, explains why China is so slow to change or innovate. "No one will say, 'Hey, you do this well, and I do that well, so let's work together,'" he said. "They all work alone thinking theirs is better than everyone else's. That's why you have so many small shops doing the exact same thing."

We carried rice sacks and walked through the marketplace and into the old houses, through the thirty-foot-long remnant of what had once been a long lane with houses on each side, and out to a pair of small dirt piles next to a new foundation. Trash and pottery shards piled against the houses that remained. A man urinated in the other corner. "Look at this," Fu Sifu said of a half-destroyed, double-layered wall insulated with pieces of brick. "Many generations of people lived here. All gone now." He rooted through the dirt and collected a few pieces of pottery. "You can clean these off, and they'll look really nice," he said. "There won't be any more in the future."

While I scanned the earth for shards, Fu Sifu continued to admire the wall. He pointed to the bricks, dark and glossy with the iridescent

isobars of an oil slick. Over Jingdezhen's thousand years of history, wood-burning kilns had fired nearly all its wares. And when these kilns were fired, their entrances were blocked up with a wall of bricks. Those bricks became glazed when the flying ash stuck to and melted on their faces. After a few uses, the vitrified bricks were discarded and scavenged as building materials. Once I began to notice them, the entire old city appeared to have been constructed from these bricks, glinting like obsidian.

"You don't have to dig for shards," Fu Sifu said. "Just pick off the surface. You can find plenty of things that way."

"What do you look for?"

"Pieces with flowers, designs, those are worth it," he said. "Value depends on the person. If you feel like it, pick it up. Wah! Look at this." He extracted the base of a *fencai* overglaze painted bowl with a Kangxi reign mark. "This is really rare. This is worth money."

As recently as fifteen years ago, these shards were as useless as they were plentiful. Everyone knew that the city government's offices sat atop an old imperial kiln, but no one had much interest in its artifacts. But as the Chinese economy gained strength, and its people grew more confident and nationalistic, native traditions became valuable again. Suddenly antique porcelain could fetch millions, and so even shards found a market. When the city government vacated its old offices, residents flooded the site with picks and shovels, overwhelming the city's ad hoc preservation efforts. Locals even set up small stores near the site just so they could sneak over or dig tunnels under the hastily erected wall at night. Eventually the city razed all the buildings around the site and turned it into a museum.

Fu Sifu dropped the Kangxi shard into his bag, and we moved through more construction, scrambling up a large pile of excavated dirt that had sat long enough to have formed a hard crust. Fu Sifu had grown up around here, and despite the sound of hammers and power saws filling the air, just enough of the old neighborhood remained for him to orient himself. "There used to be all these little streets

here, but they're gone now," he said. "It was all connected, all the way to that chimney." He pointed to a turret far off on the horizon. We peered into the pit that the hill we were standing on had come from; the walls were layer upon layer of collapsed kilns and shard beds. The rounded forms of broken teacups looked like clutches of fossilized dinosaur eggs. "Those shards two meters down, they're about a hundred years old," he said. That was only halfway to the bottom. "And there's even more under there."

We walked to the street where Fu Sifu had lived until he was eight years old, formerly anchored by a lively market that Fu would buy rice from for his family. His parents and grandparents had worked in a porcelain factory making dinnerware. "It was better than being farmers," he said. "They had work, they had food—what else do you need?" He considered it fortunate that his mother had taken an early retirement from the factory and received a full pension that helped to support the family when the factories died. After he finished school, he sought out a master to teach him how to throw, and he had been working in ceramics since 1998.

Now Fu Sifu's old street was completely flattened, except for three sagging wooden houses. Some of the old signs indicating the names of the neighborhoods still hung at the heads of the remaining alleys, all but drowned out by electrical wiring and modern signage. A brick wall bore the faded remnants of a political banner: *Executing the one-child policy is the responsibility of young people!* We walked out to a street corner with two- and three-story tiled buildings. "This was one of the first areas they developed," Fu said. "When they built those buildings, there were tons of shards. They're under here, too, but you'll have to wait until they rebuild this street to find them."

As we circled back to his scooter, Fu pointed out the woodcarvings that still adorned many of the old doorways. The modern architecture was so visually noisy, it made seeing the historical buildings and houses difficult. But if I concentrated on shapes or textures—a curved eave, weathered wood, the telltale glint of kiln brick—they

still revealed themselves. "What happens to these old places?" I asked. "Do people preserve them?"

Fu threw up his hands. "If you were that poor, living in those circumstances, would you be interested in preservation?" he said. "You can't even fill your belly. How can you worry about preservation?"

When Fu Sifu dropped me off after lunch, we argued over the bag of shards. I wanted to divide them. He insisted that I keep everything. I relented, but when I dumped out the sack's contents in my room, I didn't see the *fencai* Kangxi piece that we had picked up, leaving me with an assortment of Republican-era fragments that I, despite being new to the game, had already dismissed as not old enough for my taste. I pawed through the shards again and again, but it didn't appear. I wondered if Fu Sifu had kept it and hoped that he had.

THE ONE THING about my apartment that I couldn't deal with was the cockroaches, which infested the kitchen and bathroom; I often had to scatter them out of the tub before bathing. I called Ms. Zhang to say that the situation was untenable. Maggie taught me the Chinese word for "cockroach," which was easy to remember since it was a homonym for "filth wolf."

Ms. Zhang came over to the apartment, complaining that she had never had a tenant as *luosuo* as me. I reminded her that I had accepted a litany of the apartment's shortcomings. "But there are tons of cockroaches," I said. "I see them every—"

"Cockroaches?" she repeated, laughing. "That's not a problem. They're completely normal here. We treat them like our children."

Maybe so, I said, but I was moving out. I had paid three months' rent and stayed less than two weeks, so I offered to let her keep the entire first month but wanted the last two back. Ms. Zhang refused, saying that it was my problem, not hers. I argued with her about it, because I figured if I couldn't get a fair deal from some *luosuo* landlady in Jingdezhen, what hope did I have trying to convince officials

to let me dig for my family's porcelain? I eventually got her to concede the last month and checked into a hotel, where I took one of the most satisfying showers of my life. A few days later I was introduced to an Australian artist who offered to let me stay in her apartment after she returned to Melbourne. She had managed to buy a two-floor unit in a new development not far from the Sculpture Factory and renovated it with Western bathrooms and even a full oven.

After I moved to my new lodgings, Lewis phoned to say he couldn't help me look for my great-great-grandfather's old house. "Why not?" I said.

"I talked to Grandma, and she made me promise not to," he said. "For political reasons."

"Political?" I said. "How?"

"Because she's afraid if I take you to their graves, people will see a rich American there and go dig up their graves."

So that was the "dangerous" reason why my grandmother had forbidden me from going to Xingang. "That doesn't sound political to me," I said.

"Everything in China is political."

I STARTED LOOKING for someone to help me research San Yi Po's father, the supposed former county commissioner, in the local archives and was introduced to Ding Shaohua, a twenty-five-year-old student at the JCI who had worked for a stint at the Pottery Workshop. I met him at a Korean restaurant in the jumble of shops across from the JCI, where he had already ordered a large bottle of beer, two glasses, and a bag of shelled peanuts. I liked him immediately. He wore a white dress shirt and had spiked his short hair up. He was guileless and curious and thoughtful, and while he spoke good English, it restricted his natural garrulousness, so we switched to Chinese, in which, thanks to the immersion in Jingdezhen, I had become fairly proficient.

Ding was born in Jiangxi but grew up in a suburb of Shanghai. He had been an uninterested student in high school and enrolled in the JCI for ceramics just to please his family—despite being known for its ceramic program, the JCI was something of a safety school—figuring he'd switch to another subject once he got to campus. But as soon as he saw how small the school was, how dirty the streets were, and how *tu*, or "unsophisticated" (*tu* literally means "earth" or "dirt" and forms the root for the insult *tubaozi,* or "country bumpkin") the professors were, from their clothing to their outlooks, he lost hope. And he wasn't allowed to change his major, either. Now he was about to graduate from the JCI with a ceramic arts degree that he didn't care about; he smashed all his work as soon as it was graded.

But during his first year at school, he met an older JCI student who was working at the Pottery Workshop as an interpreter. Once he saw the opportunities available to a skilled English speaker, he ignored his classes, avoided his classmates ("I just thought everyone there was sick, and I didn't want to catch it and get dragged down with them"), and devoted all of his time to improving his English.

He passed China's College English Test, a requirement for graduation and something employers increasingly look for in applicants, on his first try, despite not being able to study after eleven p.m. because that was when the JCI shut off the power for the night. Then he caught on with another outfit offering artist residencies and helped guide tours of China for visiting artists. Now he was trying to start his own travel service. He dreamed of working on a cruise ship.

Ding didn't know much about the archives but said he'd ask around for me. And when I mentioned my interest in collecting ancient shards, he told me he knew of an area outside town where I could find piles of them.

Ding arranged for a driver to take us to the shards, and I met him one morning at the entrance of the Sculpture Factory. We were joined by a local artist, Kai E, a small, trim woman with the patina of someone who had recently made the transition to mother. A native

of Hainan, the tropical island province in the South China Sea, Kai E had tried and failed to get into art school twice, after which her father told her she had to go to work. But she wanted to make art, so she came to Jingdezhen for the JCI's accounting school, thinking she could switch to ceramic arts. The school refused to allow it, so she dropped out and started her own ceramics practice. She was a complete autodidact, never missing a Pottery Workshop lecture, reading books, and studying shards.

Ding wore a green T-shirt that read, in English, "Being gay is not a choice . . . Hate is." I asked him where he got the shirt.

"The market downtown," he said. "What's it mean?"

I explained it.

"Ah, so it's about equality," he said, nodding.

Our driver, Qi Sifu, was born in San Bao, a valley in Jingdezhen's southern hills that had supplied clay to Jingdezhen since the Song dynasty. He had deep roots in that industry, and his family still operated water hammers in San Bao, smashing porcelain stone and processing it into bricks. He used to do it himself before he bought a van and started his car service.

Beyond the dusty, angular masses of Jingdezhen's industrial plants, we entered the countryside of rice fields and wooded foothills braided with alpine streams. Farmers coaxed water buffalo through verdant plots and graves dotted the rises. As much as I romanticized China's old cities, they had been dirty, crowded, full of dysentery. Then as now, the Chinese yearned for the clean air, fresh water, and solitude of the countryside. There was a reason for all the ghastly new houses in rural villages.

This entire area went by the name Nanshijie and had been the location of a quarry for porcelain stone, which was processed into a one-source clay. The clay fired extremely white, but without additives to firm up its bones, it could be used to make only small objects—cups, bowls, and teapots. This clay and the surrounding pine forests had once sustained hundreds of ancient kilns. Between the Song and

the Yuan dynasties, Jingdezhen's ceramics center relocated to Hutian, near the mouth of the San Bao valley, and began producing blue and white wares for export. It was closer to the river and obviated the laborious method of transport by horse or handcart on unpaved roads, and Nanshijie declined. Now, Qi Sifu said, people in the area mostly survived by mining coal.

We passed through the village of Liujiawan, which used to be home to an eponymous kiln. "This area, about thirty thousand square meters, is probably all shards," Qi Sifu said. "They fired from the Northern Song until about the middle of the Song dynasty, maybe a hundred years." Those days the yield hovered around 30 percent. "These mountains are full of shards," Qi Sifu said.

Qi Sifu honked at everything that moved: men, women, children, scooters, dogs, cats, and chickens. The ride took us longer than usual, having to slow through construction areas where a new highway was going up to connect the villages with the city. As the valley narrowed, a stream banked alongside us for a stretch before giving way to a set of narrow-gauge rails, for the coal train that ran from Jingdezhen to parts unknown. Then the valley widened, and we drove along a flat expanse of green fields that stretched to hills on the horizon. Qi Sifu veered onto a small road and then turned up a thin driveway. He parked in front of a mud hut, next to which rose a new multistory house with tiled walls and metal railings. Opposite the mud hut were undulating mounds of shards so large that it took a moment for my eyes to adjust to the scale. The piles closest to the house had crevasses deep enough that people disappeared when they descended into them. Elsewhere swaths of vines, sesame blossoms, wildflowers, and small trees had taken root. Qi Sifu said plants grew well on shards because of all the ash and aerated soil.

"*Oh, wah!*" Kai E said, leaping out of the car. This was her first time seeing the shards, despite having lived less than an hour away for many years. "Let's start picking!" She ran onto the piles and stooped

to pick a few shards around her feet. "*Wah*, they even have designs on them!"

Qi Sifu, having grown up kicking shards and now ferrying visitors to see them, appeared bemused and slightly embarrassed by Kai E's unbridled desire. "There are lots with designs!" he said. "Most have them. They aren't worth much. Not worth picking up."

"*Wah*, this is so different from the market," Kai E said. "It's like you've returned to the Song dynasty. I wish I could move these piles back home with me."

Kai E disappeared over the hills, occasionally sending up a "*Wah!*"

"People come here to pick shards all the time," Qi Sifu said to me, as if confiding with a fellow parent. "They sit with a stool and just look for pieces."

As I climbed over the shifting piles, picking up pottery fragments that caught my eye, I was possibly the first person to handle them in a thousand years. Glinting among the earth tones of the saggers were shards of celadon in pale blues and greens and yellows, molded or incised with subtle but elaborate floral patterns, billowing like the clouds their colors recalled. The saggers had broken away like eggshells, by nature and by hand, to reveal the shiny, malformed embryos they contained. Orange and red dragonflies buzzed about, taking rests on the shards. Tiny frogs splashed in the rainwater that had collected in upturned saggers. The ground, moist with dew, felt spongy. The only sounds were the clink of pottery, birds chirping, and distant roosters crowing. Then came a series of explosions from the highway construction. "China is developing right now," Ding said, laughing. "Too fast." Beyond the piles I could see a row of concrete monoliths, sections of the new highway awaiting installation. The government had already begun hauling away some of the shards to make room for the highway.

I walked back to the van with a handful of shards and joined Qi Sifu. He stood with his arms behind his back and weight on one leg,

aviator sunglasses taking up half his face. According to him, the area used to be even bigger, dozens of acres, and the pits we were exploring had all been dug by shard hunters. "The government ought to turn this into a tourist attraction, charge an entrance fee," he said. "That would be nice. But they don't care.

"My idea is to buy some land, move some of this over there, and put a replica kiln there, make it all like it was in ancient times," he continued. "And you could open a teahouse, a restaurant, people could look at the shards, have tea, a meal. If I charged just ten RMB per person, I'd never spend it all in my life. But I don't have the capital, and my *shenfen* is too small." *Shenfen* means "identity" and is the same word in the Chinese term for "identity card." It seemed that Qi Sifu's time driving for foreign artists had laced his entrepreneurialism with Western sensibilities, but without a bigger name, or a white face, his strivings were bound to remain incremental.

On the way back to town, Qi Sifu described how he had learned the clay trade from his parents and worked the water hammers for seventeen years until he saved enough money to buy his van. "I didn't want to do it anymore," he said. "The pay was too low. My salary still isn't great, but the life is better than doing clay."

"Doing clay," as Qi Sifu called it, is as dependent on the weather as farming, that bleakest of vocations in the Chinese mind. If the streams don't get enough rain draining into them to run fat and fast, the water hammers—stone hammers powered by water wheels— don't move, and clay isn't made. According to Qi Sifu, the method for making clay in the San Bao valley has not changed since the Song dynasty. His family bought raw porcelain stone that had been mined nearby, pulverized it into powder, and washed it in several water pits. The finest, purest particles form a kind of scum on the surface, which is skimmed off into piles with the color and consistency of *mantou* dough and then formed into *dunzi,* or bricks, destined for porcelain workshops.

Every month during the rainy season, with a quartet of hammer

mills going, Qi Sifu could produce about a hundred pounds per day. The year he quit, one ton of finished bricks fetched about 600 RMB, which meant that in one wet month of manual labor, he could gross a bit less than 1,000 RMB. Subtracting his material and hired labor costs, he took home about 500 RMB. During the winters the streams slow to a trickle and the work stops. Of the forty or so families that were making clay when Qi Sifu was young, a number that he said had not changed since the Song dynasty, only five or six remained.

Qi Sifu pulled over to show us the remnants of a Song dynasty bottle workshop. The highway was scheduled to run right through the site, and a clearing large enough to accommodate an eighteen-wheeler's turning radius had been cut into the hill. From the road, there were no indications of a former kiln; the broken saggers that covered the hillsides looked like scree.

Unlike at the shard piles, it was difficult to envision the original landscape here. A football field's worth of material had already been trucked away, yet the perimeter of the clearing was still crowded with ceramics. Qi Sifu pointed out where a dragon kiln had crawled up one hill, now a terraced trench of reddish earth. I climbed up into the kiln's old belly and immediately found a broken spout. Only the outer layer of the dragon kiln's bricks remained. The interior bricks, which would have been glazed, had all been scavenged. From my perch, I could see three cars with tinted windows on an outcropping on the other side of the road, parked together as if in conversation. I wondered who they were and if they were watching us.

"I remember I came here last year—it was still more complete," Ding said. "Next year it'll be gone."

"They couldn't have put the road a little this way or that?" I said.

"They don't think like that," Qi Sifu said. "There are too many of these old kilns. They've already saved Hutian, the ancient official kiln. That's enough for them. They can't save everything."

The entire route back seemed to pass through Song or Five Dynasties—era kilns. Every mile or so Qi Sifu would point out another

one, a few thousand square meters in size but usually unnamed and distinguished only by the wares that it produced. Even speeding by in the van, I could see the layers of shards exposed by rain and erosion.

We looped through town and then back up the San Bao valley to see Qi Sifu's family's hammer mill, which he now rented out. "Before I started driving, when I was working here, I hated it when people came to look," he said. "It was such bitter work, and I didn't like feeling like I was performing for these artists or videographers or television stations, who'd show the film and talk about how my life was so bitter. But I changed my mind. Now I wish for more people to see this, so they can see the history, see how hard they work, what goes into it. You have to have this environment to do this, and only this environment."

One of the laborers, shirtless and with a receding hairline, was breaking down a pile of porcelain stone into smaller pieces with a mallet. Under the tiled roof of the mill, amid the arrhythmic thud of the hammers and the creak of turning wheels, his wife stood at a table made from a split tree trunk, forming clay *dunzi*. Balls of clay rested on the rafters like *boules* of bread. She scooped a lump from the pile on the table, kneaded it a few times, slapped it into a wood frame, and sliced off the excess with a wire strung on a bowed twig, which she returned to the pile. She disassembled the frame, extracted the *dunzi*, and added it, on its long edge, to the grid of curing bricks behind her. Then she reassembled the frame and began the process again.

There was a second pile of rocks, next to which lay a large, overturned stone base, from a column or statue, with a carved face. "What's this?" Qi Sifu asked.

The man didn't know. "A businessman just asked me to process them," he said.

"Where's it from?"

The man shrugged. "Nearby," he said. "We're going to make clay from it."

Qi Sifu knelt to inspect the base. "This is an ancient stone arti-
fact," he said. "You've already picked off some of the carving." He
stood, shaking his head. "That's too bad."

DING DID SOME looking into the archives and reported back con-
fused. San Yi Po claimed that her father had been Jingdezhen's *xian
zhang,* but Jingdezhen had always been a *zhen,* an administrative unit
akin to a town, not a *xian,* or county. So the man in charge of Jingde-
zhen would have been a *zhen zhang,* not a *xian zhang.* Fuliang, where
the Yuan had established the first government bureau, was the *xian.*
Perhaps San Yi Po had mistakenly conflated Jingdezhen with Fuliang.
I hoped a trip to Fuliang would make things clear.

Looking north as we crossed the Cidu (Porcelain Capital) Bridge,
the river curved east, exposing green, unpopulated hills. To the south,
squeezed between the serpentine bend of a new thoroughfare and
the west bank of the river, were two of Jingdezhen's oldest remaining
streets, one dating back to the Ming and the other to the Qing, nar-
row lanes paved with stone slabs and lined with houses built from
kiln bricks or wood. Down the center of the lane ran an aqueduct,
covered with old stone tiles, smooth as river rocks and dipping in the
middle, the result of hundreds of years of handcart traffic.

In my great-great-grandfather's time, those streets led to one of
the major wharves of Jingdezhen, bustling with businesspeople, cus-
tomhouses, hotels, and markets. The Sanlu Temple, at the head of
the lane, watched over a flotilla of merchant ships docked along the
river, loading porcelain that would move downstream to Poyang
Lake, the customs port of Jiujiang, and then on to the Yangtze, from
which it would disperse all over China and the world. My great-great-
grandfather's collection likely passed through this very lane on its
way to Xingang. Now all that remained of the old docks was a half-
exposed stone ramp emerging from the water.

The ride to the Fuliang Gu Xian Ya, the ancient county government office, was shorter than I expected. Ding directed Qi Sifu past the turnoff for the tourist area and to the back of the adjacent village to avoid paying an entrance fee. We walked up a path, between houses, vegetable plots, and fruit orchards, and emerged at a 150-foot red pagoda, built during the Song dynasty atop a Tang dynasty temple. The women fanning themselves inside the pagoda told us there was nothing to see, so we walked on. Ding stopped to peer at the crumbling walls of a house built from stone and kiln bricks. "They tore down these houses after Liberation because they knew wealthy families hid gold and valuables in the walls," he explained. "Liberation" was the mainland term for the events of 1949. "So I'm always interested in checking the holes in these walls."

Now as then, a wall encircled the government complex at the center of Fuliang. Ding and I veered into the old cornfields outside the walls, looking for a place to enter. "There are shards everywhere!" he exclaimed. We studied the ground but couldn't figure out where they might have come from; Fuliang had been an administrative and supervisory bureau, not a production center. "Oh, look," Ding said. He picked up a coin with a square hole. It could have been anywhere from a hundred to a thousand years old.

There wasn't any getting around the wall, so we returned to the main gate of the magistrate's office, guarded by a thousand-year-old osmanthus tree and a crumbling brick wall under a metal awning that a sign indicated had once been a Song dynasty pavilion. I paid the entry fee while Ding waited at the gate. In the ceremonial hall, a woman operated a booth where visitors could have their photographs taken wearing Qing dynasty garb. I walked through every hall and room in the complex, realizing bit by bit that there was no archival material on site, yet never completely giving up on the idea.

On the way out, I paused in the ceremonial hall, where the names of all the Fuliang magistrates from the Tang dynasty through the Republican era were posted—some of the only historical information

the place seemed to have. If my relative had been the *xian zhang*, his name would have been up on the wall. But I saw only a handful of Lius listed for the possible dates he would have served, and none of them were from Xingang or had the correct generation name.

I struck up a conversation with an older woman hanging out in the hall, fanning herself. She introduced herself as Mrs. Chen and said that she had come to Fuliang from Jiangsu with her parents when she was twelve. The ceremonial hall had functioned as an elementary school from 1954 to 1978, and she had attended in the 1960s. She called my attention to the rafters, where the beams still bore banners that had been posted during the Cultural Revolution, proclaiming slogans like "Long Live Chairman Mao" and "Defeat the American Imperialists." After the school moved to a new location, the hall had been a fruit market and a sweets factory, among other things. It became a tourist spot about ten years ago, and all the buildings had been rebuilt in the past couple of years. The actual Fuliang archives that I sought were long gone, but Mrs. Chen didn't know where they went.

The woman working the photo booth beckoned for my camera and offered to take a few pictures, posing me and Mrs. Chen at the magistrate's desk. I thanked her and held my hand out for my camera.

"That'll be ten *kuai*," she said.

What could I do? I paid her ten *kuai*.

JINGDEZHEN WASN'T just full of ancient shards and ugly modern wares. Occasionally authentic, complete antique pieces could be found at the weekly market near the Shiba Qiao area, though it required wading through an acre of fakes. On the way back from the Song dynasty shard piles, Kai E overheard me talking about going to this market and insisted that I take along her husband, a painter and a market regular, to protect myself from getting ripped off.

I met Huang Fei, just as small as his wife, with a round forehead

and large, elfish ears, at the entrance to the market just after dawn. The empty streets were quiet, so I heard the market before I saw it: the chimes of shards pouring out of fifty-pound rice sacks onto blankets or bare concrete.

Huang Fei came from Fengcheng, a village about a hundred miles southwest of Jingdezhen. His grandparents had been landowners, having made their money in the leather trade. His great-grandfather committed suicide during the land reforms following the 1949 Communist takeover. His grandfather was sold out to the Communists by a younger brother, jailed for eight years, and sent to work on a farm when he was released. Without any means to care for his family, he had to send Huang Fei's mother away to be raised by another family. Huang Fei had always liked to draw, which wasn't much use in the countryside, and had known of Jingdezhen only as the city with the strange name. In 1994, with only a middle school education, he came to Jingdezhen on the advice of an "uncle" who had just set up a factory making reproductions. "Before, I had no impression of porcelain at all," he said. "It was just cups and bowls to us—what was so interesting about that? But then I got here and started falling in love with porcelain."

At the reproductions factory, Huang Fei was put in charge of glazes and taught to paint. He had no qualms about copying. It didn't even register with him. Orders were coming in, and he had to meet a quota every month. "I came from the countryside and got to paint," he said. "I was happy with that."

Four years later he happened to meet the same Canadian artist who had introduced Caroline Cheng to Jingdezhen, and invited him to his factory for a tour. The artist told Huang Fei that what he was doing wasn't painting but copying. That the rebuke came from a *laowai* made its sting worse. "I was really uncomfortable when he told me that," Huang Fei said. "So I left and found a blue and white painting teacher. Then I saw all the possibilities, *doucai, fencai,* while

so many people were just doing the same thing over and over." To describe his departure from the reproduction factory, Huang Fei used the term *chulai,* or "come out," rather than the more common *likai,* or "leave." I wondered if Huang Fei would really have left if not for a foreigner's nudge, if that had really been the climax of his awakening or simply the inception, to which he had appended certain realizations in hindsight. Stories are told linearly, but life doesn't unfurl that way.

He and Kai E had recently opened their own gallery, sometimes selling their work for thousands of RMB. In the back, Huang Fei kept the collection of antique porcelain he had found at the market. "People have been saying that Jingdezhen is dead since I got here," he said. "'This place is broken, there's no future in porcelain,' they said. But every month I'd see people putting out new things, so the tradition is still here."

The biggest change he had observed over the past few years was the influx of foreigners. His gallery, as well as many others on the same street, owed its existence to Caroline Cheng. "Without her, this place would be so *kepa,*" Huang Fei said, using a word meaning "horrible" or "terrifying," the same adjective one would use to describe a scary movie or gruesome crime. "I often compare Jingdezhen to this beautiful old house that was just festering and molding away, and then Caroline came and knocked open the windows and let all this light into it, totally changing it. Before her it was *an wu tian ri*"—a *chengyu* meaning both "complete darkness" and "a total absence of justice"—"and now it's alive again."

We turned a corner, and the bazaar unfolded. It wasn't yet seven a.m., but the square was already foggy with the cigarette smoke of browsers and vendors. In the workshops surrounding the market, men sawed and hammered wood into frames for shipping vases taller than me. Chickens stepped through the shards on display. Women wheeled food carts around, squawking singsong, prerecorded advertisements through megaphones: "Dumplings! Roasted yams!

Mantou!" Caroline had told me that when she first went to Jingde-zhen, the inventory of shards being sold seldom changed; there was hardly any construction turning up fresh soil for people to scavenge. Now one could gauge the city's projects based on the new shards showing up at the markets.

Huang Fei and I walked through the rows. The idea was to *jian lou,* literally "check for leaks," or gather the things that had slipped out of someone's net or bag. In other words, someone is always going to lose money on a transaction, and so better the vendor than me. There is a saying in Jingdezhen that, unlike gold or jade, porcelain has no price. Gold and jade are commodities with agreed-upon values. But porcelain depends on what one is willing to pay for it.

I saw Song celadon shards from Nanshijie, delicate blue and white fragments of teacups, chunks of cisterns, saggers glazed in lustrous purples. I had been told that although most of the shards in the market were indeed ancient, few were imperial, because the former imperial kilns were off-limits to hunters, and those vendors who did have imperial shards usually knew what they had. The majority of the shards with imperial marks on their bases were from much later periods, when emperors were too occupied with court intrigue, foreign incursions, and domestic unrest to care if a civil kiln misappropriated the royal seal, and the reign marks were applied not to trick customers but as homages to great periods of Chinese history (which is why Qianlong, Kangxi, and Yongzheng are such popular marks).

Beyond the shards lay blankets covered with old-looking, intact porcelain of all shapes, ages, and sizes. I had been warned that 99.9 percent of such items in the market weren't what they purported to be. But that sliver of possibility of finding an authentic antique, something my great-great-grandfather might have owned, kept me searching, and I was determined—or desperate—enough to sift through all the fakes.

Fake Chinese antiques aren't a new phenomenon. Already in 1712

Xavier d'Entrecolles wrote that Jingdezhen potters had perfected the "art of imitating old porcelain being passed for being three or four centuries old or at least of the preceding dynasty of Ming." Copying was a Chinese tradition. The Yuan copied the Song, the Ming copied the Yuan, and so on. There was never any sense in ancient China that copying was a violation. They called it "standing on others' shoulders to reach new heights."

"All this copying, faking, lying to people—it's a very ancient attitude," Huang Fei told me. "They think if you can't pick out the fake, it's your fault. You're the one with no education, no culture. And if you're stuck with a fake, you'll hide it away because you don't want people to know you were taken. As long as people are involved, you'll never cut out the problem. But with art, if you have real and fake, it's more fun. Without fakes, it's like a grocery store with determined prices. How interesting is that?"

To Huang Fei, it was all part of a game. Perhaps there is a reason the Chinese say they "play" porcelain instead of "collect." "Sometimes we see people spend lots of money on a fake, we won't say anything," Huang Fei said. "Consider the loss their tuition. Everyone pays it."

In fact, when I polled Jingdezhen students or locals about must-see places in town, they often mentioned the Fang Jia Jing neighborhood (named for the Fang family but fittingly also a homonym for "to imitate") near the railroad station, a whole village of workshops devoted to reproducing ancient ceramics. The entire history of China's ceramics can be found in the Fang Jia Jing's rows of shops selling Yuan blue and whites, Qing enamelware, or Ming *meipings*, every single one counterfeit. There is nothing secret about what happened in the Fang Jia Jing. The narrow alleys echo with the chimes of pumice stone working over porcelain to dull their finishes, after which vendors brush on thin brown paint and refire the pieces at low temperatures to achieve an aged tint. Counterfeiters set wares on a layer of rice husks to impart the faint red that was prevalent during the

mid–Ming dynasty. And knead clay by foot, to add large air bubbles into the bodies so they would weigh the same as those created before machine mixing. And research clay, glaze, and firing recipes to match the methods and materials of previous centuries. Persian cobalt used in blue and white Yuan wares, for example, has high iron and magnesium content that results in iron spots where the glaze pools. They scavenge kaolin from the same mines that had supplied it for the original they are copying. They tumble objects in mud to study where wear and dust collect. Or they might build a new body onto an authentic base, which is why bases command the highest prices for shards. Some vendors even sink new objects into the sea to cover them with barnacles so they can pass them off as recovered shipwreck items.

"We don't use 'real' or 'fake' with these things," one student told me. "We use 'old' or 'new,' or 'copy.' It's only fake if it's not porcelain. They're real. They're just not the original ones. And only one person can own the original one. What about the rest of the people?"

Recently the Chinese have begun to use a new word to describe faked or copied products: *shanzhai*. Literally, *shanzhai* describes a fenced place in the forest, or a fortified mountain village. Metaphorically, it recalls mountain bandits, Robin Hood–like characters who evaded or opposed the authorities (acts that, given the famously corrupt Qing court, gained them the moral high ground) and stole from rich Mandarins. The idea of *shanzhai* has since spread to become a philosophical term for "rebel innovation."

So if an entire nation of people don't think something is wrong, then is it? It made me wonder just what was real, what were those objects I sought, and what their value was. How would I know the difference between my great-great-grandfather's collection and a bunch of fakes? Not only had this stream of reproductions, like the rest of Jingdezhen's history, never been cut—*I fake, therefore I am*—but they also represented some of the city's highest-quality and greatest expertise. I

recalled Takeshi's advice to me about the antiques market. "The most important question you should ask is not 'Is it real?'" he said, "but 'Is it beautiful?'" Given the ends to which the counterfeiters pursue authenticity, and how that keeps alive Jingdezhen's ancient traditions, it *is* kind of beautiful.

As we walked through the market, Huang Fei bought a ginger jar, a Song dynasty cup, and a bowl melted into a sagger. All the shard hunters were right about seeing a critical mass of ceramics. Despite all the items in the market, I had spent enough time looking at porcelain to roughly group them into periods and types, patterns of a larger tapestry. I started looking for interruptions in the pattern, and on our way out of the market, my eye caught something that didn't belong: a large envelope adorned with crossed Kuomintang and Republic of China flags and official script and seals. Huang Fei and I immediately picked it up. "Jinling Museum Collection," read the text, written right to left. Huang Fei turned the envelope over. A paper seal had been applied over the flap and read, "Republic of China National Palace Museum, Republic of China Nanjing Provisional Government." Below that was a faded red stamp from the ministry of the interior.

The seller told us the envelope was one hundred RMB. "What's inside?" I asked.

"Beats me," he said. "What's it say on it?"

According to the information on the envelope, it was an official packet from the collection of the National Palace Museum containing a piece of calligraphy by an early Qing dynasty scholar. Was this part of the National Palace Museum's collection that Chiang Kai-shek had tried to keep from the Japanese, which might have explained why an ancient poem had been folded up into an envelope? If imperial porcelains could wind up in fields near Kaifeng during the frantic move, it seemed perfectly reasonable for a small envelope to find its way to a market in Jingdezhen.

"Can we see if there's actually anything inside?" I asked.

"You can if you buy it," the seller said. "You can do whatever you want with it after you buy it."

Huang Fei and I had a quick, hushed discussion. "What do you think?" I whispered. "Could this be real?"

He examined the envelope, picking at the folds and seals to see if it had been artificially aged. "It might be," he said. "This is a famous calligrapher. Even I've heard of him. But I don't know anything about calligraphy. And I'm not sure about this envelope. It could be fake."

For a hundred RMB, it seemed worth the risk. We each put up fifty RMB and agreed to split any possible proceeds equally. My heart raced as we walked around the corner, and Huang Fei phoned a friend who was a calligraphy expert to tell him we had something for him to inspect. Unable to wait, Huang Fei opened the envelope. Inside, we found a two-foot square of heavy, gold-flecked paper stained the color of tea that unfolded to reveal a calligraphed poem. It could not have looked more fake. We had been taken. Huang Fei tore apart a corner of the envelope, and the interior seams were bright white, which he said proved that the envelope had been artificially stained. He called his friend to say we weren't coming after all. We vowed not to tell Kai E about this. "That's our tuition for the day," Huang Fei said. "Don't worry, I've paid a lot of tuition in my time. That's the lesson—if you don't know what you're looking at, don't buy it. Even if it's only ten RMB, you're wasting that money."

ONE EVENING, as I sat with some friends in a bar in the Sculpture Factory's courtyard, two women dressed in vacation chic walked in, and the taller one ordered a beer in the unmistakable accent of an ABC. Edie Hu was the Chinese ceramics specialist at Sotheby's in Hong Kong, on her annual retreat to Jingdezhen to decompress in a Pottery Workshop studio and work on her burgeoning ceramics hobby. We were about the same age and had similar experiences with

our Chinese-ness, and she offered to host me if I ever felt like attending an auction in Hong Kong.

We kept in touch and I eventually had saved enough for a trip. The Sotheby's offices, on the thirty-first floor of the Pacific Place tower overlooking the sparkling waters of Victoria Harbor, felt light-years from Jingdezhen, yet many of Jingdezhen's finest creations passed through here on their way to new owners. In the conference room, Edie brought out a selection of the best lots from the upcoming auction season. I was surprised to see her carrying the pieces—worth millions of dollars—in her bare hands. "I do worry sometimes about tripping or bumping into someone and dropping a priceless vase," she said. "So I hold them really close." When she walked around the office, she tucked them in the crook of her elbow like a football and kept her free hand ready to cover the exposed part or stiff-arm an inattentive colleague; women in the ceramics department also weren't permitted to wear heels.

Edie's grandfather had grown up in a wealthy banking family in Shanghai. Like my great-great-grandfather, he collected porcelain and lots of it. "During the twenties and thirties, you had access to really nice stuff," Edie said. "The Qing dynasty was falling, so you could go to Beijing and buy imperial porcelain from the eunuchs— that's how some of the great European collections got formed. My grandfather liked to buy monochromes, and in pairs, and he had to buy something every day."

During the civil war Edie's grandfather moved to Hong Kong, entrusting the Shanghai Museum with most of his porcelain collection. He intended to return for it but never did, and the new Communist government wasn't interested in repatriating the belongings of landed gentry. Edie's father left Hong Kong to study engineering at Stanford and settled in the Bay Area, where Edie was born and expressed the family's porcelain gene. She graduated from Wellesley with a degree in art history and obtained a master's degree in Chinese art and archaeology from the University of London before going to work at the

Shanghai Museum, the National Palace Museum in Taipei, and then Sotheby's. "We had some of my grandfather's pieces at home, and as I got older, no one in my family could tell me anything about them," she said. "My dad wasn't interested at all, probably because he saw how my grandfather was so obsessive, always telling my dad to be careful around his things." Her grandfather had good reason. In 1985 one of his Ming dynasty goldfish jars became the first porcelain object to break the $1 million barrier at auction.

We started in the Ming dynasty with one of the "star lots" of the upcoming auction, a fifteenth-century double gourd flask made during the emperor Xuande's reign. Xuande was one of the first emperors to put reign marks on his porcelain, and his pieces were known for having a smooth clay body and tiny bubbles in the glaze, like the pebbling of an orange peel. Next, Edie brought out an extremely rare vase from the emperor Chenghua's reign, designed with plantain leaves and floral motifs. The white was more intense, and the glaze was tighter, without the bubbling of the Xuande era. The reign mark had been defaced, but that didn't affect the price, Edie said, which was estimated at 15 to 20 million Hong Kong dollars (2 to 3 million U.S. dollars). "The marks that matter are Qing dynasty ones," she said. "With a Qianlong or Yongzheng mark, you can ask for premium prices. Without them, it's just called 'Eighteenth Century.' "

Perhaps because he was too devoted to his porcelain, Chenghua wasn't a very good emperor. He had a domineering first wife, nearly twenty years his senior, who was so paranoid that she forced abortions or poisoned the mothers of Chenghua's other children. Somehow one son managed to stay hidden for almost six years before Chenghua even knew of his existence, and he became Chenghua's successor, the emperor Hongzhi. Hongzhi, a precocious child and brilliant student, lowered taxes and instituted transparency in government. Instead of killing corrupt officials and their families, he arranged for their safe passage home after their dismissal. He sought to end the practice of castration and the institution of eunuchs, and he redistributed

the properties of deceased eunuchs to victims of flood, drought, and other natural disasters. He was also the only monogamous emperor in Chinese history, ensuring a clean, smooth succession. Unfortunately, his son turned out to be a reckless ruler who, despite spending most of his short reign smothering himself with drink and prostitutes, managed to undo just about all his father's accomplishments before he died at age thirty.

By the end of the Ming dynasty, porcelain decorations had become loose, and the paint became stiffer, more mechanical. Porcelain quality—attention to detail, creativity, and technology—picked up again in the Qing, during Kangxi's reign, and remained high until Jiaqing. The country was flush, the emperor poured money and resources into the industry, and craftsmen experimented relentlessly. Then porcelain declined during the Opium Wars and never recovered. Some high-quality pieces were made at the end of the Qing dynasty, notably under Cixi's rule, but most were neither remarkable then nor highly collectible now. "You can see the rise and fall of China in the quality of the ceramics," Edie said.

Most of the lots that Edie showed me had one or more old catalog stickers on them. The stickers had discolored and frayed over the decades and disrupted the otherwise pristine surfaces of the objects. "Do you remove them before the auction?" I asked.

Edie's eyes widened. "Oh, no," she said. "Some of these stickers are worth thousands of dollars in themselves. They're one of the most important ways of proving provenance, showing that they belonged to an important or well-known collection. People try to reuse them or fake them all the time."

The last piece Edie showed me was a blue and white Ming dynasty tankard about seven inches tall, scheduled for a Paris auction. It had been purchased at a flea market in France. The diaspora of Chinese antiquities often followed the foreign troops that were stationed in proximity to royal abodes. The French and English ransacked the Summer Palace during the Second Opium War, and during the Boxer

Rebellion eight foreign legations had troops inside the Forbidden City. The Germans were closest to the hall of portraits, which was how many of China's best paintings ended up in German museums and collections. The French were stationed near the hall where the imperial seals were kept, so imperial seals sometimes surfaced at markets in Paris or Lyon.

"The woman at the market was asking for something like one hundred twenty euro, and the guy who bought it bargained it down to sixty euro," Edie said.

The tankard, listed in the catalog at 150,000 euro, would end up selling for 720,000 euro. It amazed me that despite so much demand and such readily available information, pieces like this could still appear. One of the most popular items for Jingdezhen's porcelain imitators to reproduce was a white ovoid Qing dynasty vase adorned with pastel-colored *famille rose* peaches on a branch. Made during Yongzheng's reign, the original vase wound up in the possession of the American ambassador to Israel, who used it as a lamp base for fifty years. When the Sotheby's experts received a photograph of it—with lampshade and all—in the early 2000s, they rushed a team to New York, where the vase sat unprotected in the owner's home. The shape was rare enough—they knew of only four in the world, and those were all blue and white; one with delicate pinks and vibrant greens was too rare to dream about. Thankfully, the seal on the base had not been drilled through, and the vase sold in Hong Kong in 2002 for $5.3 million to Alice Cheng, heiress to a soy sauce fortune, longtime Sotheby's client, and mother of Caroline Cheng of the Pottery Workshop.

Stories like these are why auction houses scour the globe for new supply, and they sustained me every time I wondered if perhaps my family had been right, that it was foolish to think that I—illiterate, limited in vocabulary, without *guanxi*—could recover objects that had been buried three generations ago in a land where time passed

like dog years. "One antique dealer I know doesn't believe in these miracles, but I still do," Edie said. "They're out there."

In November 2010 a small London auction house, Bainbridges, offered a Qianlong-era vase with reticulated double-walled peekaboo sides revealing a smaller vase nested inside. The sellers claimed to have discovered it while cleaning out a dead relative's attic and ascribed its provenance to an "adventurous uncle" who had been in China during the Opium Wars. They happened to see a flyer for Bainbridges and consigned the vase for auction. Bainbridges' appraiser valued it between $1.2 million and $1.8 million. At auction, the sale went on for half an hour until the hammer came down for an anonymous Chinese buyer bidding by telephone. Taxes and the requisite buyer premium brought the final price to more than $80 million, the most ever paid for a Chinese antiquity.

Chinese interest in its own antiques began only recently. Until the 1980s little got into or out of China. People had no use for imperial porcelains, and the country wasn't far removed from an era when it was dangerous to own anything besides utilitarian ware. Only once these items found their way to foreign collections did they become important symbols of China. "It took someone else to appreciate them to show that they were beautiful," Edie said.

Now, spurred by nationalism and economic prosperity, the Chinese nouveau riche are fierce competitors for imperial porcelains. For many Chinese, winning auctions is an act in service of their country, repatriating stolen objects and a step toward undoing the humiliations that China suffered at the hands of invaders and would-be colonists. Sometimes it isn't clear if the Chinese are more interested in owning their own art or in just keeping it away from the West. In 2009 an adviser for China's national treasures fund placed the winning bid on two bronzes at a Christie's auction and then refused to pay, just to sabotage the sale.

The Christie's and Sotheby's auctions in Hong Kong, long a preserve

of stiff-upper-lipped expats, are overrun by armies of wealthy main-
landers with identical buzz cuts, leather loafers and man purses, long
pinkie nails, and jade bracelets. Chinese auction houses have jumped
into the game. Even the People's Liberation Army is involved with
an auction house. These Chinese auctions are the new Wild West.
Nonpayment is so endemic that at some mainland auctions employ-
ees run up to the winning bidders as soon as the hammer goes down,
to make them sign a promissory note, but even that doesn't always
work. One recent auction treated attendees to the absurd scene of an
employee chasing a winning bidder through the salesroom with pen
and paper. "They just don't give a shit," Edie told me. "They think
that all these years they've been dumped on by the West and by their
own government, and now finally, now that they have money to buy
stuff, everyone is going to kiss their ass." The laws literally don't apply
to many delinquent Chinese buyers, who have friends in the govern-
ment to protect them. As for that $80 million Qing vase, less than six
months after Bainbridges sold it to a Chinese buyer, the auctioneer
canceled the sale for nonpayment.

One common tactic buyers use to worm out of paying is to dispute
an item's authenticity. As there are no widely used scientific methods,
the age and authenticity of a piece is determined by an expert's brew
of knowledge, experience, and feel. But there isn't exactly an uproar
for any improvements. Too many people stand to benefit from a ques-
tionable piece's inclusion in an auction. So even "genuine" objects
with long, detailed provenances become such on the faith of their
owners, appraisers, and prospective buyers—a kind of reality by con-
sensus. The director of international operations for China's largest
private auction house told me that the faking in China is so pervasive
that houses resign themselves to knowing that about 30 percent of
their lots are fakes. "What's real, in the end?" he said. "If my boss
says something's an obvious fake, but nine other people say it's real,
should he refuse to put it in auction?"

If independent experts can agree on a piece's inauthenticity,

Sotheby's will cancel the sale and refund the money. The disputed objects get stashed at the office until the next wave of pieces come through, and are then moved to storage. If no one claims them, they become study pieces for authenticating other items. The Sotheby's storage facility is full of unclaimed or unpaid-for pieces, an entire collection of expensive antique porcelain mired in limbo until someone acknowledges a piece's existence by making good on the sale. Some of the orphaned lots disappeared into storage for so long that the storage fees owed for them outstripped their value.

And if even experts can't distinguish between the counterfeits and the authentic antiques, I wondered what good it was to have the "real" thing. How sure could I be that the priceless porcelains on display at the National Palace Museums were authentic? What if my grandmother still owned a vase that she claimed to have belonged to my great-great-grandfather? Would I have believed her? Would that have been enough for me? Why did I insist on seeing everything for myself?

Caroline and Takeshi were right. Preserving history doesn't mean saving historical things. What keeps art, and history, alive is the continuation of making, seeking, and transferring information. There aren't enough vases in the world to contain one family's past, much less the constellation to which it belongs. And finding my family's porcelain would no better preserve its history than herding old craftsmen into a bamboo cage for tourists to watch. I still wanted to find the porcelain. But I began to understand that first I had to reconnect with the remaining links to my family's history. Unlike Jingdezhen, however, the surviving members of my family could not live forever.

I GOT TO KNOW Caroline well enough to ask her for advice on digging for my family's porcelain. She told me to find Jiang Yi Ming, the director of the ancient ceramics research center near the Long Zhu Pavilion in Jingdezhen. The research center had official permission

to make digs, she said, and might be persuaded to help me. I hurried down to the research center, but the cleaning ladies at the doorway told me it was closed and shooed me away when I tried to ask when it would reopen. I retraced my route back to the five-story Long Zhu Pavilion, which I had seen many times but not yet visited. The pavilion had been one of the nerve centers of Ming dynasty Jingdezhen, and as recently as 1989 piles upon piles of imperial shards covered the area. A visitor could have collected as many rare imperial copper red fragments as he could carry.

Now bricks and sheet metal walled off the grounds to discourage shard hunters, and I had to buy a ticket to enter. The earth was spongy with ceramic material, a mélange of spacers, saggers, kiln bricks, tiles, and shards loosely bound by soil. Somehow this porous substrate managed to anchor two immense camphor trees, which the docent told me were three hundred years old. Other than the groups of men on the grounds playing cards and smoking, I was the only visitor.

The pavilion had been turned into a museum, though only the odd-numbered floors were open. But the display cases ringing the small rooms showed a good selection of Ming dynasty pieces from the Hongwu, Yongle, Xuande, and Chenghua eras: large blue and white vessels and chargers, fine copper red bowls and stemmed cups, small *doucai* cricket jars, and celadon *meiping* vases. The majority had been glued back together from shards, and there was a wonderful photograph of four men squatting over a shard-strewn courtyard in the ancient ceramic research center, pawing through the pieces in search of the right ones to complete the large, three-dimensional jigsaw puzzle behind them: a blue and white cistern adorned with a dragon.

These objects on display, despite their visible imperfections and blank fillings where replacement pieces couldn't be found, which might have been cobbled together from any number of different originals, captivated me. They weren't representations of history, they *were* history, five-hundred-year-old visitors unearthed from beneath

my feet, and in their travel to the present, they carried not just their own history but also mine. They were artifacts not just of their time but also of the time *between* us. These shards were what I dreamed of finding, just as much as my great-great-grandfather's complete collection and certainly more than the imperial antiques in museums or auctions.

I love shards because they are as permanent as anything can be in China. Houses can disappear, textiles can disintegrate, and vases can be smashed. But no matter how much Jingdezhen and other former porcelain capitals build over their ancient foundations, shards will remain, and even if they manage to remove every last one of them, they will endure, somewhere. My great-great-grandfather's porcelain might not be where he left it, or how he left it, but there was comfort in knowing that some things cannot be erased. And maybe those shards hold kernels of all the things that China has lost and could, over time, reanimate them.

The next morning I returned to the research center, a well-preserved Ming-Qing dynasty house with ivy-rimmed white walls and a large courtyard—the government always managed to get the best buildings. Groups of shards and saggers covered the courtyard and interior porch. Also on the porch were two men and a woman sitting on benches at a wooden table, a laptop computer and papers spread before them.

"What do you want?" one of them asked.

"I'm looking for Mr. Jiang," I said.

"There is no Jiang here," he said.

"Really?" I explained that I was visiting from America and had some questions about porcelain, emphasizing that Zheng Yi, Caroline's Chinese name, had told me to come find the director, a Mr. Jiang Yi Ming.

"Yes, I know Zheng Yi," said the other man, wearing denim shorts and a striped polo shirt and looking much friendlier than the first man. "But there is no one by the name of Jiang here."

"Oh, well, sorry," I said.

I left and sat outside by the entrance for a while, trying to think of what to do next. The man in the polo shirt came out to buy cigarettes. "Excuse me," I said. "This is the ancient ceramics research center, isn't it?"

"Yes, yes," he said. "But we told you, there is no Zhang here."

They had thought I had been saying "Zhang" the whole time. "No," I said. "I'm looking for a *Jiang*."

"Oh, Jiang!" the man said. "Yes, he's here. He was the tall, thin guy at the table. Follow me."

Mr. Jiang didn't look happy to see me but gestured for me to sit down once I invoked Caroline's name. Just as I was about to tell him the story of my family's porcelain, his phone rang. "I'm sorry," he said. "I've been called to a meeting. Maybe next time."

"Can I come back later today?"

"Sure, come by later."

"What's convenient for you?" I asked. "I'll work with your schedule."

He didn't answer, clearly not intending to make an appointment with me. I stared at him while he squirmed. "Uh, maybe eleven a.m.," he said finally.

"Great," I said. "I'll wait for you."

We stood. Mr. Jiang was half a head shorter than me and not particularly thin. "Well," he said, "maybe we can walk and talk."

He strode toward Zhushan Road, moving faster than I had ever seen a Chinese person walk, while I tried to keep up and ask about the possibility of digging. I wasn't even sure if he was listening until he said, "You can't just go digging willy-nilly."

"I know, that's why I'm asking—"

"We can't, either," he said. "We have to go do a careful investigation first. There are too many of these stories like yours. I suggest you go to the archives first, learn about your family, find the burial site,

and find out about the site. Then come back. There are just too many of these stories."

"There might have been imperial pieces," I said, hoping that might get his attention.

"Go to the archives," he said, shaking his head. "Just so many of these stories."

"How do I check the archives?" We arrived at the Imperial Kiln Museum.

"Check the Jingdezhen archives on Lian She Road," he said. "Everyone knows where it is." He practically sprinted through the entrance of the museum.

When I found Lian She Road, a woman directed me up to the lotus pond at its terminus. At the pond another woman pointed to a dilapidated building across the street. "It's that way," she said. "See if they're still there."

They were not. The building's roof had caved in, and its double wooden doors were padlocked. A motorcycle taxi driver waiting for a fare told me that the archives had outgrown the building and moved two years ago to Xinqiao, just east of the old city. I cursed Mr. Jiang and hired the driver to take me to the new archives, a narrow, six-floor concrete box near a tangle of train tracks. I wandered the floors until I ran into a man who told me to go to the fourth floor. All the doors along the hallway were closed, but I heard what sounded like a meeting behind the last one. A small man with a wide mouth eventually emerged. I introduced myself, and he invited me into his office. We sat on bamboo chairs, his feet swinging a few inches above the floor. His name was also Liu, but he was not from Jiujiang. "If you know this relative's name, we can look it up, sure," he said. "We'll just check all the Fuliang records of *xian zhang*. It should be easy. Come back tomorrow morning, and we'll look it up."

Back at the Sculpture Factory, I recounted my experience at the research center to Ding. He didn't seem surprised. "So they weren't

interested in helping," he said. "But I guarantee if you'd had a *laowai* face, they'd have been willing to help."

I returned to the city archives the next day, hoping to finally resolve the mystery of my great-granduncle, Ting Geng. Instead Mr. Liu said, "We can't look this up. We only have post-Liberation records." I didn't bother asking why this contradicted what he had told me the day before.

"Have you gone to Fuliang yet?" he asked. "Fuliang has all the pre-Liberation records. They can look it up for you very easily. Let me make a call for you." He phoned the records department in Fuliang and had a short conversation. He handed me a name, phone number, and address. "Go find Mr. Chen," he said. "He's expecting you."

I went back to Fuliang, but this time to the archives, housed in a monumental tile-covered building with a slight curve in the middle. In the foyer hung two tile landscapes, under which a group of disinterested guards had gathered. I strode past the guards and up the stairs, where I found Mr. Chen.

Mr. Chen looked through the *xianzhi,* or county history. It was full of gaps, skipping entire decades. "Nope," Mr. Chen said. "There are some other Lius, but no one named Liu Ting Geng."

"What if he wasn't a commissioner but a minor official who worked in the government?"

"That's not in here. I can't look that up. If he did any important work, it may have been recorded—you could check the Qing records. But if he was just a regular guy, it wouldn't be recorded."

What was I expecting? A proper archive with acid-free paper and white gloves? Instead, I got a few minutes to glance through a book published in the 1990s. Mr. Chen brought me tea in a plastic cup so thin it seemed ready to melt. He stepped out to have a smoke, leaving me to flip through the history book, which contained mostly census information and mostly from after 1949.

Mr. Chen stepped back into the room. "Hey, tell you what, I'll try to look through the Liu family history for you," he said. "I've looked

through a lot of them but never Liu. If I find anything, I'll let you know." We exchanged contact information, and I left him the names to look up. "You can't rush these things," he said. "If you were in a hurry to find them, you couldn't do it. These things take time. But I'll see what I can find." I never heard from him, but it was exemplary treatment from a bureaucrat.

FALLING LEAVES RETURN
TO THEIR ROOTS

Y GREAT-GREAT-GRANDFATHER WAS ALREADY IN HIS seventies when he arrived in the wartime capital of Chongqing with his family in tow. They had survived a months-long journey of nearly one thousand miles from Xingang, and his bucket of silver was empty. Fortunately San Gu was already in Chongqing with Rulison, and Liu enrolled Pei Yu and Pei Sheng in school. As relatives of a faculty member, their tuition was waived, and San Gu covered their room and board.

The principal of Rulison's brother school, Tong Wen Academy, which had also retreated to Chongqing, invited Liu to teach Chinese classics, providing him with a small income. And despite her differences with her grandfather, my grandmother regularly sent money, shoes, and clothing from Macau. Her school provided room and board for its faculty, leaving teachers to invest most of their paychecks in gold, jewelry, or British pounds, but my grandmother forwarded the bulk of her salary to her grandfather.

As the war ground on, Liu's middle son, Ting Geng, also died of tuberculosis, leaving my great-great-grandfather with only one living son, the estranged Ting Gong. The granddaughters began finishing high school. This life of exile and dependency didn't suit a proud Confucian like my great-great-grandfather. With two dead heirs and

pennies to his name, he risked becoming a *liulang*, a drifter, if he stayed in Chongqing any longer. He had begun plotting his return to Xingang almost as soon as he got to Chongqing, scouring the papers for news about the Japanese and chatting up new arrivals for information.

He made his way back east as incrementally as he had come, dropping off Pei Ke and her mother in Guizhou with Pei Fu, arranging Pei Yu's marriage to Dai Chang Pu, and leaving Cong Ji with his father, Ting Gong.

Sticking to waterways, he hired small boats until he finally reached Poyang Lake, still patrolled by the Japanese. He slipped into the lake at night and made for the opposite shore, but then saw a bright light on the water. Thinking it might be a Japanese boat, he told the boat master to turn around and hide in the reeds. But the light didn't move, and so they edged back into the lake, following the path illuminated on the water. They continued slowly until they reached a small temple with a single burning candle. A short distance beyond the temple, he arrived home. A few days later, when he went back to look for the temple that had guided him, he couldn't find it. My great-great-grandfather wasn't a religious man, but that night he felt as if Guanyin, the goddess of mercy, had pointed him home, and from then on he would tell people that if their hearts were right, the bodhisattva would protect them.

Liu found the outer wall of his estate, along with some of the satellite dwellings on the edges of the property, almost completely destroyed, the bricks scavenged by neighbors to build their own structures. But the house itself remained sturdy. The roof was intact and the front door was closed as tightly as when he had left; but when he went around to the back entrance, he discovered that it had been opened and the contents of his house ransacked. He learned that the Japanese had occupied the house and used the yard as a drilling area.

He set about rehabilitating his house and reclaiming his fields, which his sharecroppers had continued working in his absence. When he reckoned it was safe enough, he sent for Ting Gong's wife and Pei Ke, the youngest of my grandmother's cousins. One day Japanese officers paid him a visit. They urged him to *chu shan,* or leave his hermit mountain and come out of obscurity to take a government position, to collaborate with them. "I've got one foot in the grave," he said. "I can't leave my mountain. What would you have me do?"

"Help us maintain order."

"You have your country, and I have mine," he said. "I'm not going to be able to do your country's work for you."

"It's your society," they said. "You're not working for our country. You're maintaining order in yours."

"We have very good order," Liu said. "We're very harmonious. Our people are not the ones committing crimes."

Later the Communist guerrillas descended from the mountains to ask him for help. "I'm seventy!" Liu said. "I don't understand military organization or strategy, I don't know how to fire a gun, I can't keep up with you when you run. Wait until I fix everything up and have a harvest. Then I'll provide some supplies. This I can do for you."

Then the war ended, the Japanese retreated, and my great-great-grandfather slowly rebuilt his life and wealth with Old Yang's help. He collected harvests and rent from his farmers again. The Communists were still around, making trouble, but my great-great-grandfather figured it was only a matter of time before they were defeated.

For now his postwar life was peaceful. Four of his five granddaughters were married. His remaining son, Ting Gong, had a good job in Nanchang. His only grandson, Cong Ji, graduated from Tong Wen and went to Nanjing for college. His youngest daughter, San Gu, had come back to Jiujiang with Rulison, where Pei Ke, his youngest granddaughter, attended school. He even saw the bright side of Ting Gong's mistress; it allowed Ting Gong's wife to stay in Xingang to help care

for him. His experiences during the war had left a lasting impression. Whenever neighboring families expressed disappointment over the birth of a girl, he would always try to correct them. "Girls are good!" he'd insist. "During our family's time of greatest suffering, it was our girls who took care of us."

ALL DEATH IS A HOMECOMING

FTER A BRIEF AUTUMN, THE WINTER IN JINGDEZHEN WAS as cold and damp as the summer was hot and humid. Making ceramics in such conditions was difficult—throwing cold clay was a nightmare, and finished bodies took forever to dry—so the city's workshops went into hibernation. Few of the shops and restaurants heated their spaces or even closed their doors; the proprietors simply bundled themselves up and slurped hot tea. Even my luxury apartment was so poorly insulated that standing directly in front of the heating unit did no good. I was almost relieved when my aunt Scarlett, Richard's wife, called from Shanghai to report that my grandmother had gone to the hospital and that I should come back as soon as possible to pay my respects.

Returning to Shanghai was disorienting because it felt so different not just from Jingdezhen but from the Shanghai that I had left just a few months before. The taxi ride from the Shanghai Hongqiao airport to the Zhangjiang living quarters was nearly silent—the city had begun to issue fines for honking—and the newly completed elevated freeway above Longyang Road made the trip a snap. There were more strollers on the streets, and more people stood to the right on escalators. The trappings of wealth were obvious and increasing, and construction projects had left more and more areas with the anodyne internationalism of an airport shopping zone. I couldn't help

feeling a pang of nostalgia for the coarseness of "old" Shanghai and the specificity of all the things—the street food alleys, the pajamas on the street, even the laundry hanging in the trees—that I used to find backward.

I noticed more local—or sea turtle—Chinese in what used to be expat havens, and why shouldn't they? It was their country. The corrections extended to the reappropriation of the very expat havens themselves, with the opening of wine bars, bistros, and coffeehouses by Chinese, for Chinese. On the way back to the Zhangjiang living quarters, I snapped—in English—at a young guy cutting in front of me in the taxi line, and he responded in English.

While I was in Jingdezhen, the ruling in the SMIC trial came down. A California jury found the company guilty of misappropriating sixty-one of the sixty-five disputed technology items. As part of the settlement, the company paid TSMC $200 million as well as stock and warrants worth about a 10 percent stake in the company, making TSMC one of the largest minority shareholders. Richard resigned. I was still on the company rolls, and the company could terminate my employment, which would cancel my visa, but I hoped that it would be a low priority in the reorganization.

The next few weeks Andrew and I, joined by my brother, Fong, a government lawyer in Washington, D.C., visited our grandmother in the afternoons at the First People's Hospital in downtown Shanghai. My grandmother had her own room on one of the top floors, accompanied by a rotating cast of family members and nurses. Sometimes she seemed almost sheepish, as if she might have overreacted. Other times she appeared to be in great pain, her face contorted with fear and panic, uttering soft moans as doctors hovered around her. It was my first time seeing a relative on her deathbed, and the smell of must and iodine clung to me when I left the hospital. Andrew and I often headed straight to the nearest bar after our visits.

Too charged to cram ourselves into a taxi, we usually walked back to the subway station, wandering through what remained of

the International Settlement's old alleys and stately buildings. I had spent little time in this area north of Suzhou Creek, where many of the neighborhood's smaller streets had not yet been redeveloped, and if I directed my gaze above street level, I could see pockets of Shanghai's colonial history. The General Post Office Building, built in 1924, with classical columns and Greek gods on its baroque clock tower. The imposing art deco Broadway Mansions hotel from 1935, cubist setbacks on its shoulders. The Flemish revival Russian consulate building, and the Victorian Astor House hotel. To reach the Bund, we crossed the Waibaidu Bridge, an all-steel camelback truss bridge dating back to 1907 that looked like it had been transported from the Chicago River. These were the same things my grandmother would have seen when she brought her family through the city on their way to Taiwan in 1949.

Dawn broke over this part of Shanghai, light schooling into the northern bend of the Huangpu and running upriver. Despite its reputation as a twenty-four-hour city, Shanghai does sleep, as I saw during late nights that stretched into the morning, the dim, empty streets overtaken by a spiritlike condensation. The fog wandered until the sky turned cerulean and the Huangpu ran gold, as if full of the money that the Chinese so feared would leak from the riverfront properties that the doors of the newly reopened Peace Hotel facing the water remained locked at all times. And when the fog burned away, changing state, as my grandmother soon would, as the buildings on my path from the hospital surely would, it lived on as an ever-shifting memory.

When my grandmother's body began to fail, Andrew and I made our final visit, and for all the practice I had speaking Chinese in Jingdezhen, I didn't know what to say. My grandmother was conscious and lucid but had trouble speaking. Scarlett leaned into her ear and told her that we had come to see her, and then left the room.

My grandmother whispered that she was glad to see us and that she hoped we would be good sons and Christians. I searched for

something to say, a return to my monosyllabic childhood conversations with her.

Finally Andrew cleared his throat. "Grandmother, thank you for all that you've done for us, helping raise us and taking care of us," he said, his voice catching. "Please don't worry about us. We will all be fine. Huan and Fong are smart, good-looking guys, and they'll have no problem finding girlfriends. And I've got a girlfriend, so you don't have to worry about me." His eyes welled, but he continued with a farewell more eloquent and heartfelt than I ever could have managed. My grandmother closed her eyes and nodded. We squeezed her bony shoulders. She passed away a couple of days later.

When the family gathered one night to make funeral arrangements, I demonstrated my exquisite sense of timing by recounting my progress to Richard. "If I can figure out the exact location of the porcelain, how do you think I would go about trying to dig for it?" I asked.

"I have no advice for you!" Richard shouted. "And when was the last time you listened to my advice, anyway? There's nothing there! Grandma said so."

"I know what Grandma said. But San Yi Po said it could still be in the ground. And she said that you, or Lewis, or my mom, if one of you approached the government and told them that the family used to live there, they would be willing to work with you on it. So I'm just asking if she's telling the truth."

"She's oversimplifying," Richard said. "Maybe it's there, maybe it's not. Grandma wanted that history to stay buried. She had her reasons."

When I told Lewis about this exchange, he told me that it would have been a snap for Richard to buy our family's old property. "When the Jiujiang government was treating him like a god, very eager to partner with him on a project, he could have bought the old property back for ten thousand dollars," Lewis said. That was less than my family would spend on my grandmother's gravesite. But the opportunity had passed.

While my family navigated the state funeral monopoly, one of Richard's business partners put me in touch with Zhang Songmao, who claimed to have amassed the world's largest collection of 7501 porcelain, made in Jingdezhen by the state ceramic research center for Mao's personal use and considered by some as the last imperial kiln in China.

I met Zhang at his factory in the Western outskirts of Shanghai. He was sixty years old, short and slim but with a round belly, dressed in Converse sneakers, gray jeans with the cuffs flipped up, and a fitted, shiny black patterned shirt. He had a man purse tucked under his arm and a half-smoked cigar in his left hand. Inside the office building, he had his porcelain displayed in cases on all three floors. The walls in the atrium were covered with enlarged copies of press coverage and exhibitions of his collection.

Born in 1950, Zhang grew up during the Cultural Revolution and earned an engineering degree. When China first relaxed its economic policies, he and some friends pooled their money to start a technology company. "That was hard work," he said. "There were no venture capitalists then, banks weren't lending to nongovernment projects, and the government wasn't backing regular people. We had to fund it with our own hands." He eventually built a string of successful companies and made his fortune from television chips. A few years ago Zhang decided to become the preeminent collector of Mao porcelains, approaching his hobby with the competitiveness of a businessman who had scrapped his way to a fortune.

"I started with stamps, then coins, and once I had some money, I started collecting porcelain," he said. "But then I thought, 'Well, what can I collect?' There are already people with great Yuan blue and white collections, museums in Turkey and Iran have tons of them . . . you can't compete with them. And then Ming and Qing porcelain, I'd never be one of the best in those. But with Mao porcelain, I can have the best. What's the point of collecting if you're only second best?"

Zhang led me around the different floors, and then we entered an inner sanctum where his best pieces were displayed. His assistant walked in and out of a storage room, showing us Qianlong-era watches, bronzes, paintings, and more Mao ware. "I started collecting Mao ware because it's part of China's porcelain history," he said. "The tradition was passed from Song to Yuan to Ming to Qing, and then what happened? The history is incomplete without the Mao ware."

In 1975, while Mao's Red Guards were destroying every vestige of ancient China that they could find, the ceramics research center in Jingdezhen received an unusual order. The order, given in a secret document numbered 7501, was to produce a set of fine porcelain expressly for Mao. In almost identical fashion to the despotic emperors whom Mao's revolution had intended to snuff out, the best kilns in Jingdezhen were conscripted to fire thousands of pieces, accommodating requirements such as using lead-free glaze and the bowls needing to have covers, because the Chairman often ate in a different place from where the food was served. The craftsmen worked under military guard and the threat of imprisonment—or worse—if they failed. The pieces were decorated with plum and peach blossoms and, in a classic example of pointless Chinese one-upmanship, fired at 1,400 degrees Celsius, rather than the 1,300 degrees at which imperial porcelain was fired.

Mao's advisers picked the best, assembling two 138-piece sets of tea ware, brush holders and cleaners, ashtrays (Mao was a chain smoker, a fact that people often gave to explain why so many Chinese also smoked), and tableware. The rest were put into storage—in violation of the order to destroy the remainders—and given as gifts to institute employees during the Lunar New Year.

After Mao died, the wares remained something of a Jingdezhen secret. But during the late 1980s or early 1990s—no one could tell me for sure—a Singaporean collector caught wind of the items and spent a year scouring the city for pieces. He cleared out the JCI's storerooms

and went door to door asking institute employees for their collections. After he had made off with the Mao ware, he boasted that he had all the Chairman's old porcelain. That angered enough of the nascent Chinese middle class that a group of them descended on Jingdezhen and made it their patriotic duty to discover what the Singaporean might have overlooked. Domestic collections formed, and efforts began to repatriate 7501 wares that had gone overseas.

I asked Zhang if he ever felt uncomfortable, collecting pieces from a time during which so many people suffered.

"Not at all," he said. "I don't think about it in political terms. Look, I suffered during the Cultural Revolution, too. But it wasn't all chaos. There was also a lot of *kuaile*"—contentedness. "These pieces remind me of my youth. To me, Mao, the Cultural Revolution, it was all just part of history. I long ago stopped thinking about whether or not it was good or bad."

In 1996 the first major auction of Mao ware was held in Beijing, where eighty-nine pieces—all leftovers—sold for nearly nine million RMB. A government trading company purchased all but one of the pieces, spending seven times the estimated value to beat out rival bidders. A real estate entrepreneur won the remaining lot, a lidded bowl, and only to "make mischief" because he thought it was unfair for the quasi–government entity to hoard everything when so many people had come out for the auction. And with the market came the counterfeiters; I had met one man in Jingdezhen whose parents had worked at the 7501 research center and who now ran a workshop in the Sculpture Factory churning out reproductions.

My grandmother's leaves never made it back to their roots. She was buried on a freezing winter day in a cemetery for overseas Chinese near Suzhou, on a hill cleared of orange trees, overlooking a lake. During the funeral the pastor spent about thirty minutes

yammering about his personal conversion story, nothing to do with my grandmother's life, while I fantasized about pushing him down the hill. On the gravestone, where my grandmother's descendants' names were carved, according to Chinese tradition, they wrote the characters of my name wrong.

NANJING

MOVED BACK INTO THE LIVING QUARTERS AND BEGAN transcribing the recordings I had made of my grandmother, cringing at how much my poor Chinese had limited our conversations on the early tapes. I often caught myself pausing to write down follow-up questions and lamented my fluency having come too late. To replenish my coffers, I found a job teaching academic English in a college-prep program for wealthy Chinese students.

UNABLE TO TRAVEL FAR, I decided to pay a visit to Ginling College in Nanjing, a short train ride from Shanghai. I'd heard that alumnae in their seventies and eighties held monthly meetings and thought I might find some of my grandmother's classmates. Hemmed in by mountains and by the Yangtze, topography limiting its sprawl, Nanjing was known until the Ming dynasty as Jinling, or "Gold Hill," referring to the mountain guarding its backside, though the "hill" can also mean "mound," "tomb," or "mausoleum," as the Chinese preferred to bury their dead on elevated locations and above ground. The classical name Jinling is still very much in use by literati and advertisers alike, adorning the signs of businesses seeking to exploit nostalgia or invoke the triumphs of imperial China. There are few Western equivalents to this interchangeability, though referring to the modern-day region of Laconia as "Sparta" might come close.

Nanjing is one of the oldest cities in China, having served as the capital of Chinese dynasties going back nearly two thousand years, including the Kuomintang during the Republican era, and with Hangzhou and Suzhou it formed the Jiangnan cluster of municipalities with a long history of industry, culture, and education. The founding emperor of the Ming dynasty had ordered the encirclement of the city with more than twenty miles of muscular ramparts, fifty feet high, forty feet wide at their base, and about half that width at their crenellated tops. The walls took twenty years to complete and required hundreds of millions of bricks that were produced in five provinces and inscribed with the names of the local quality-control officials. I had become so inured to the destruction of Chinese antiquity, and consequently sensitive to any vestiges of it, that I assumed the gray walls, collared with green trees and seeping vines, were too well-preserved to have been the originals, but they were.

From the train station, I took the subway into town, by coincidence emerging near John Rabe's former home, a European-style villa with gray bricks and white windows. Rabe was a German businessman who worked for Siemens in China from 1910 to 1938. As the Japanese invasion of Nanjing became imminent in the winter of 1937, most Westerners fled the city. The two dozen or so who remained, including a Ginling College professor, organized the Nanjing Safety Zone, a trapezoidal area in the northwestern part of the city about the size of New York's Central Park and encompassing foreign embassies, church organizations, and schools, where Chinese citizens who weren't able to evacuate could seek refuge during the war. Rabe, a member of the Nazi Party, was elected the head of the Safety Zone committee, with the hope that his Nazi credentials would carry weight with the Japanese.

Chiang Kai-shek refused to surrender the capital but fled for Chongqing while tasking a rival general to defend Nanjing. This perceived abandonment of his countrymen earned Chiang the lasting

enmity of mainland Chinese. For the overwhelmed defenders, military tactics quickly gave way to a frenzy of self-preservation. Fleeing Chinese soldiers stripped off their uniforms and left them in the street, along with weapons, backpacks, helmets, even shoes—anything that might identify them as noncivilians.

For six weeks following Nanjing's capitulation, Japanese soldiers terrorized the city, burning, looting, and committing atrocities in what became known as the Rape of Nanking. Chinese prisoners of war and civilians alike—including women and children—were machine-gunned into mass graves, beheaded, bayoneted, or buried alive. Civilians were shot for the slightest indication of resistance or just because they, as Rabe wrote, "simply happened to be in the wrong place at the wrong time." Japanese soldiers raped girls as young as eight years old and women as old as seventy, many of whom died after repeated assaults. Those who survived were often penetrated with bottles, sticks, and bayonets before being summarily executed. Even pregnant women were targeted and stabbed in their stomachs afterward. Japanese troops forced families to commit incest, sons raping mothers and fathers raping daughters, before killing them all. The total number of casualties remains heavily disputed, with estimates ranging from a few hundred (as some Japanese claim) to 300,000 (the figure most often cited by the Chinese).

The twenty-two Westerners on the Safety Zone committee—missionaries, businessmen, or doctors armed with only their occidental features and a moral authority—worked around the clock to protect the refugees of Nanjing; sometimes they were literally the only thing between a civilian and certain rape or death. Despite their heroic efforts, they were too outnumbered to stop all the incursions by Japanese soldiers, who regularly flouted the rules and broke into the camps. Inside the Safety Zone they stole food and clothing, carried off civilians to execute, and "raped until they were satisfied," as an American surgeon serving at a hospital in the Safety Zone wrote to his family. Often a frantic civilian would find Rabe to report a

rape in progress, and the two of them would rush to the scene, where Rabe chased away the Japanese soldiers, sometimes physically lifting the rapist off his victim. The Safety Zone was credited with having saved more than 200,000 Chinese from slaughter. Ironically, the item that Rabe relied upon most to stop the genocide was his swastika armband.

I headed to the Nanjing Normal University campus, a large research institution that still went by its former moniker of a teachers' college and that had subsumed Ginling College. I entered at the university's main gate, a narrow, angular arch of blue tiles, behind which slivers of historic buildings—the corner of a curved tile roof here, a splash of red column there—peeked from behind stands of tall, old trees. Nanjing Normal University is a popular destination for studying Chinese, and groups of foreigners—Americans, Europeans, even Japanese—strolled the wooded campus. In my search for the alumnae building, I passed a memorial for Minnie Vautrin, the longtime Ginling professor who'd helped designate Ginling as part of the international safe zone and stayed in Nanjing while the rest of the school evacuated. In addition to feeding, clothing, and sheltering the refugees, Vautrin ran from one entrance to another, chasing off Japanese intruders.

At the three-story alumnae house, the front door was locked, so I entered through a side door and came upon thirty elderly women on plastic chairs in a conference room. A younger woman asked what I wanted. I explained that I was the grandson of an alumna and had heard about the monthly meetings and hoped to find some of my grandmother's classmates. "Oh, well, let me introduce you to Wang Laoshi," the woman said. "She organizes these meetings."

Wang Laoshi was a small, energetic woman in her seventies dressed in a floral print tunic, gray pants, and white walking shoes. They had just wrapped up the morning meeting, she said, and were about to break for lunch. Wang Laoshi insisted that I join them, so I followed their slow migration up the hill to the campus hotel. Recent

graduates of the reconstituted Ginling College, a constituent, and still female-only, school of Nanjing Normal University, had set up a few tables in the hotel's dining room. "These meetings don't happen elsewhere, and we don't know how much longer we will have them," Wang Laoshi said. "We're all getting old."

Lunch consisted of light fare such as tofu and wood ear mushrooms, steamed fish, and buns, and the alumnae spent most of the time imploring me to eat more, piling food and rice into my bowl. "Eat up!" Wang Laoshi said. "We're all grannies here. We can't finish all this food."

Most of the women who showed up at the alumnae gatherings had graduated after the Communist takeover in 1949; in 1951 Ginling was merged with Nanjing University. Wang Laoshi recognized my grandmother's name—she had contributed money toward the construction of a new building on campus—but had never met her. "We don't have anyone her age here," she said. "None of those classmates can come out anymore, those who are left. But I remember your uncle Richard. Your grandmother told him to come to Ginling to recruit graduates for his new company, and he came here one year and hired a bunch of them."

After lunch most of the group made their way back to the alumnae house to "rest" before heading home. Wang explained that the second floor was given over to residences for visiting alumnae, and on the third were rooms for visiting students or alumnae of Wellesley College, with which the new Ginling had a relationship. Students of Ginling's original sister school, Smith College, had rooms on campus elsewhere. Much of the first floor of the building displayed Ginling's history, with a special focus on former college president Wu Yifang. Born into a family of declining scholar-officials in 1893 in Hubei, Wu was educated at mission schools in the Jiangnan region and was part of Ginling's inaugural class of 1919. She went on to earn a doctorate in entomology at the University of Michigan and returned to China in 1928 to become Ginling's first Chinese president and was a beloved

figure to its alumnae. It was through the continued efforts of Wu, who never married and endured the Cultural Revolution (Wang would only say that she "suffered"), that Ginling College was reopened in 1987, two years after her death, as China's only women's college.

Wang introduced me to the rest of the women in the alumnae house, sitting placidly with straight backs and hands in their laps. They nodded and murmured approval over my interest in Ginling. One of the women asked if I could fix the ringer on her mobile phone. Eager to help, I fiddled with the phone for a long while, despite not being able to read the Chinese on her screen. One by one the women got up to leave, offering a chorus of polite excuses: We can't help, we're too young, we don't know anything, we're no use, we have nothing to say, you don't want to waste your time talking to us. Except for Wang Laoshi and me, only one woman remained, a shy woman named Chen Laoshi, who graduated the same year as Wang. They decided to take me for a walk around the old campus.

Although the historic campus appeared as if it had always been there, it wasn't even a hundred years old. Ginling College was founded in 1913, and its original campus constructed in 1916, on twenty-seven acres of rice and wheat fields and hills dotted with graves that a conglomerate of mission boards purchased piecemeal from the various owners. For most of the period of Western activity in China, foreigners constructed buildings in their native styles, importing the necessary materials to create faithful reproductions of European structures. Chinese architecture was regarded as "rotten" and backward, concerns about feng shui were dismissed as superstition, and objections that the erection of Western-style buildings all over China insulted the Chinese fell on deaf ears. Those magnificent Gothic, neoclassical, and art deco structures that I loved in Shanghai were seen as monuments not of integrity, efficiency, and modernity, as I saw them, but of oppression.

Western missionaries, unlike their commerce-oriented brethren, weren't only interested in extracting wealth from China and were

thus primed to be more sensitive to these unequal exchanges. The first attempts by American architects at sinicizing missionary buildings focused on the roof and simply capped four otherwise Western walls with a sloping roof and overhanging eaves superficially modeled after the ones in Beijing's Forbidden City but without their actual structural design. For the Ginling College campus and grounds, the school's president commissioned a Yale-trained New York architect named Henry Murphy, who had gained renown by successfully melding Chinese aesthetics with Western techniques in the construction of a medical campus in Hunan province—the Xiangya Medical School that my grandmother had wanted to attend. Murphy understood that Chinese-ness extended below a building's roof, too, and would go on to design buildings for Beijing University and the Nanjing government. For all the new ideas being introduced inside those buildings—sturdy, high quality, and reminiscent of Ming dynasty palaces—the buildings themselves were perhaps the most visible reminder of the possibilities in balancing Chinese history and tradition with Western progress.

Working with a shady local land buyer, Chinese architects, and Shanghai builders, Murphy oriented the campus on an east–west swale and placed the college buildings at the foot of the hills to shield them from cold breezes; since the college was closed during the hottest months, winter comfort was the priority. He secluded the dormitories at the west end, forming four corners of a quadrangle. To protect the students from rain and snow, he connected the dormitories and academic buildings with covered walkways. Other accents included ponds, artificial streams, arched bridges, and a traditional Chinese courtyard. As Murphy pushed for a local style throughout, the interiors had exposed ceiling beams and columns, ornamental lamps, and latticed screens.

The new Ginling College campus opened in 1923, ready to accommodate four hundred students. The reaction to the building was overwhelmingly positive, and the provincial commissioner of public works claimed that it was the first time foreigners had adapted

Chinese architecture to modern practices. A Ginling sociology professor summed up the aesthetic as "Chinese temples adapted to the use of Western science."

When my grandmother arrived on campus in 1933, the curriculum she studied was modeled after the elite women's colleges in the United States, and all classes except for Chinese language and literature were taught in English. Smith College donated thousands of dollars each year (including the entire cost of the social and athletic building) to its "Chinese sister" and sent more than a dozen graduates to Ginling as teachers, who wrote glowingly of the neatness and intellectual curiosity of their students. While the rest of the country swung from one ideological pole to another, Ginling's students were a robust hybrid of East and West, "having much more regard for family ideals, and more appreciation of the finer things in Chinese culture, while at the same time, they are not so narrowly nationalistic and also appreciate the best things in Western culture," as Ginling founder Matilda Calder Thurston reported.

Wang Laoshi and Chen Laoshi walked me down the hill toward the old Ginling quadrangle, following the slope of a creek bed that had long since been paved over. Wang's father was a real estate developer in Shanghai. Though a Buddhist himself, he sent his children to missionary schools, "because they were better in every way," Wang said. She was sent to one of the best, the McTyeire School, an elite school for girls that the Soong sisters had also attended. Attending Ginling was a foregone conclusion for Wang.

Chen's background was more modest, growing up in Ningbo, a former treaty port south of Shanghai on which the Japanese dropped fleas contaminated with bubonic plague during the war. Her father was a Qing dynasty *xiucai* who converted to Christianity. He had met Chen's mother at church. When Chen and Wang arrived at Ginling in 1948, there were approximately five hundred students. The next year, after the Communist takeover of the mainland, only about one hundred remained.

The foreign teachers stayed until 1950, and Wang and Chen still remembered them clearly. On weekends the girls would take them out to the markets and shops near campus, or celebrate a classmate's birthday, or take in a movie. Wang received an allowance from her family, while Chen worked in the library for spending money. Wang became a sociology major; Chen, a biology major. "If not for Liberation, I could have graduated in three years," Chen said. She didn't say what she had hoped to do afterward.

Not that it mattered much. Wang and Chen graduated in 1952, the last class to graduate from Ginling, and by then the government was making their decisions for them. They were sent to Anhui province to assist the government with the confiscation of property from landowners like my great-great-grandfather. Back in Nanjing, they became kindergarten teachers. Then, by dint of being missionary school graduates, they were brought to the university to help with translating documents. "I learned to type really well in middle school," Wang said. "I could do it without looking." They retired in the 1980s, refusing offers to work in the foreign language materials department, and went to volunteer at the Ginling College Library. "Look at the two of us," Wang said. "We graduated together, worked in Nanjing together, we're closer than sisters!"

We stopped at a small bluff behind the former 200 Building, home to the science department where my grandmother would have taken her classes. To our left was the 400 Building, a dormitory. Farther up the rise was Wu Yifang's old residence. "She took this small path down to her office every morning," Wang said. "It all used to be just hills and trees, and paper lanterns lit the path. It was so pretty."

Wu's old path was blocked with construction debris, so we wound our way down to the former Chapel and Music Building. "During the Cultural Revolution, we didn't go to church or worship," Chen said. "We burned our Bibles when the Red Guards came around to search our houses and confiscate contraband."

"*Aiya,* we burned so many things," Wang said. "All our school photos. We were afraid they'd be used against us." Wang had grown up in an elegant four-story house in a wealthy part of Shanghai, but during the Cultural Revolution the government took one floor after another until the family was left with only the fourth floor.

"I even burned my diploma and wedding photos," Chen said.

"It's such a shame," Wang said. "Because those are the very things we want now. But they're gone."

We emerged at the old campus, a grassy quadrangle ringed with hedges and a small sign reading, in English, "Beauty needs care, please do not step on the grass *yopian.*" Surrounding the quad were the original Ginling College buildings, nestled among trees as old as they were, and we faced the 100 Building, the central reception hall and gymnasium that also housed a social room where the students were allowed to receive male visitors. All the red pillars, the curved, overhanging roofs, and the ornate eaves recalled a smaller-scale Forbidden City. The buildings were all university offices now. A few were sheathed in bamboo scaffolding, undergoing repairs.

Wang had an appointment, and Chen needed to pick up some medicine from the hospital, so we said our goodbyes. Chen apologized for not being able to tell me anything about my grandmother. But I had learned plenty. I had always envied people who could rattle off their family histories—perhaps a quirk of Utah, where the Mormon Church had built the largest genealogy library in the world. Now, standing on the campus where my grandmother had studied as a young woman even younger than I was, her future yet to become my history, I could see that my family was not confined to my parents and three spectral grandparents. (My paternal grandfather died before I was born.) For a long time the disparate things about China in my consciousness—Marco Polo, the Ming dynasty, the wars, Mao, Tiananmen Square—and the few physical pieces of China I grew up with at home, remained as unremarkable as the furniture and about

as interesting. And even once I noticed them, the stories behind these things were just shapes in a dark room. But now their connections lit up like landing strips, showing me where I stood and pointing where I needed to go next.

I had not been a good grandson. My relationship with my grandmother fell far short of Confucian standards. But here at Ginling I felt the greatest attachment to her, as well as her absence. The decades-long trek that my family began in 1938 had splintered it, over thousands of miles and countless upheavals, and had so estranged some members that I had spent most of my life not even knowing of their existence. In a general way, I had been following my grandmother's life in reverse—America, Taiwan, Shanghai, and now Nanjing. But she had never gone home, living most of her adult life in exile, without completing her long march. I hoped that once I reconnected with the living members of her generation, once I made my way back to Xingang, I could both piece the family back together and finish her journey.

NORTHERN EXPEDITION

A<small>S I PREPARED TO MAKE ONE LAST PUSH FOR</small> X<small>INGANG BE</small>fore my visa, which SMIC had still not canceled, expired, I called Uncle Lewis and asked him about what San Yi Po had told me, that he had already gone to look for the porcelain. He had not, he said. Yes, he had traveled to Jiujiang a couple of times during the 1980s for work. Before the second trip, San Yi Po had even drawn him a map of the house, but he had not gotten around to look for the old family property, much less tried to dig.

Lewis often rushed me off the phone whenever I called him, but not this time. He recounted his miserable experience on the boat from Shanghai to Taiwan (he threw up a lot), my grandmother's stint as the dean of academic affairs at Ginling High School in Taipei ("The girls were very pretty, but their brains weren't good"), and speculated that San Yi Po had called her father a *xian zhang* in Jingdezhen because it sounded more impressive.

Contradicting another piece of San Yi Po's information, Lewis said that Pei Sheng, my grandmother's youngest sister in Beijing, *had* gone back to Xingang and might know something about the porcelain. San Yi Po had described her cousin as brainwashed on numerous occasions, and Richard had discouraged me from visiting Pei Sheng, whose kinship term for me was Si Yi Po, saying she had dementia, but I wanted to find out for myself.

"Good idea," Lewis said. "Let me give you Si Yi Po's phone number." He read it to me along with the number of one of Si Yi Po's daughters in Beijing. He also began to tell me about Si Yi Po's husband, a well-known scientist who had studied in the United States.

"Hold on," I said. "Do you have info for any other relatives?"

"There's another guy, Grandma's *tang di* in Shandong," Lewis said, referring to my grandmother's younger cousin. "His name is Liu Cong Ji. He lives in Jinan." That was the son of Ting Gong, the only male of my grandmother's generation, who would have inherited my great-great-grandfather's estate. He gave me Liu Cong Ji's phone number in Shandong province.

"And there's a person in Jiujiang," Lewis went on. "Grandma's mom's uncle's son, Tang Hou Cun. He was an engineer, younger than Grandma by about twenty years. He's been in Jiujiang his whole life. Give him a call, tell him you'd like to pay him a visit."

According to Lewis, Tang Hou Cun was also something of a poet and amateur historian and would probably be eager to help me. Lewis then instructed me on the Chinese phrases to use when I contacted these relatives. I was too busy trying to capture the sudden deluge of information to ask why my family released such valuable information at such random times or never thought to supply it in the first place. Not that there was any use in wondering. I was almost disappointed at how mundane it all was, leapfrogging me through time and space on the strength of a few mobile phone numbers. Little remained of the frontier China of my grandmother's youth, but navigating my family's psychology and social mores—that remained a heart of darkness.

MY INITIAL IMPRESSION of Beijing was that all the Olympic investment had paid off. The 2008 Summer Olympics had been touted as the capstone of China's ascension, when it would finally demonstrate that its software had caught up to its hardware. The effort put

toward upgrading Beijing's culture was as impressive as the construction of the Bird's Nest Stadium or the shuttering of nearby factories to ensure blue skies and clean air. Citywide etiquette lessons were initiated: signs discouraged spitting, driving violations were aggressively ticketed, and the eleventh of every month was "queue up" day, the number a pictorial representation of two people standing in line. But now that the world wasn't paying attention anymore, China didn't seem to be, either, and its finely crafted facade had been succeeded by its old habits. The monumental sport and hospitality venues erected for the games had already acquired the patina of dust that eventually claimed everything in China. Smog obscured the sky, the opening of subway doors sparked a feeding frenzy, and trash was someone else's problem.

Still, Beijing was the traditional home of the best schools and best students, which infused the city with an intellectual and cultural buzz that Shanghai lacked. At Si Yi Po's apartment complex just inside the gates of Beijing's University of Science and Technology, in the northwest quadrant of the city that was thick with science institutes, I stopped to telephone her of my arrival, and an elderly man on a bicycle buzzed past me. "Hey, kid, don't stand in the middle of the road when you're talking on the phone," he called over his shoulder.

Si Yi Po came down to receive me, dressed in a black embroidered Chinese top and pants, with black clogs, her short white hair tucked girlishly behind her ears. She was ten years younger than my grandmother and wore a ready smile. I followed her upstairs to her third-floor apartment and met her husband, Fang Zhen Zhi, a small, hunched-over man wearing large eyeglasses and gray slacks pulled halfway up his undershirt and open shirtsleeves.

Si Yi Po and Fang Zhen Zhi had lived about twenty minutes down the road in a cozy two-story flat, but that happened to be exactly where city officials wanted to build the Olympic Stadium. They weren't compensated but were offered replacement housing, for which they still had to pay another fifty thousand RMB to purchase.

They accepted the move without fuss, just the latest in a lifetime of dislocations.

Their new apartment had two living rooms, one for each of them, where they also slept, and a tiny bedroom for their live-in *ayi*. They put me in a bedroom on Fang Zhen Zhi's side, the only one with air-conditioning and which doubled as a storage room, full of Chinese books and a *Vogue* magazine from many years ago. I scanned Si Yi Po's room for porcelain and saw a plate commemorating their fiftieth wedding anniversary and a porcelain peach. Si Yi Po spent most of her afternoons on her side, watching Chinese opera on the television, which had been broadcast nonstop since the Olympics.

Si Yi Po's oldest daughter, whom like San Yi Po's daughter in Taipei I also called Da Biao Yi, arrived with her husband to take us to lunch, where I gorged myself on the most delicious Peking duck I had ever eaten, along with crispy chicken, fried tofu, clay pot beets, and durian and pumpkin puffs. Si Yi Po and Fang Zhen Zhi held hands during the meal. Fang Zhen Zhi picked out the chicken's brain with expert precision, and Si Yi Po asked the waitress to pack up the flower garnishes, which she said would look nice in a cup of water at home.

When Si Yi Po was four years old, the patriarch of the Shi family in Xingang, who ran the general store and post office and was a good friend of my great-great-grandfather's, asked for a marriage contract between Si Yi Po and his son, Shi Er Heng. Since the Shis were a prosperous family with good bloodlines, and Si Yi Po's parents had passed away, my great-great-grandfather agreed. But then came the war and the relocations—Si Yi Po and Shi Er Heng met only once, briefly, and the two families fell out of touch long before the children were old enough to consummate the contract. Si Yi Po and Shi Er Heng didn't speak or correspond and sometimes didn't even know if the other was alive.

During the war Si Yi Po finished high school in Chongqing and then went to live with my grandmother in Nanjing, where she helped take care of my mother and Lewis, and there she was introduced to an

industrious young man in my grandmother's department, Fang Zhen Zhi. Meanwhile Shi Er Heng had graduated from the Whampoa Military Academy and joined the Kuomintang army as a company commander. Just as my great-great-grandfather had predicted, the Shi boy had grown into a tall, sturdy, and very handsome man. He was also something of a playboy, and the news of his indiscretions reached Si Yi Po, who threatened to cancel the marriage contract and cause a major loss of face for his family. Shi Er Heng hurried to Nanjing to beg for forgiveness, and Si Yi Po granted it, as long as he didn't do it again. He left to join his company in Beijing, and within a month Si Yi Po heard he had already taken up with two different women. Si Yi Po wrote him a letter and told him the wedding was off. "I could overlook the past, but I have to be mindful of the present and the future," she told him. "We had an agreement, but you didn't honor your promise, so we're finished."

Si Yi Po published an announcement in the local newspaper that she had canceled the marriage contract. None of her sisters would have ever considered doing such an unconventional thing, and with that Si Yi Po's reputation for being the bravest among them was sealed.

In 1946 Fang Zhen Zhi asked my grandmother if he could take Si Yi Po to Anhui province to meet his parents. My grandmother said yes. The two of them returned from Anhui married. No one had any inkling they had been seeing each other, meeting at San Yi Po's house in secret while my grandmother was at work. A year later they had their first child. But Si Yi Po didn't tell her grandfather about the marriage or the child and didn't dare show her face in Xingang.

It was up to San Yi Po to report the broken contract to their grandfather. "She married a colleague of Big Sister's husband," she told him. "He's very outstanding. Big Sister introduced them." That was a bit of a fib, and when my grandmother found out about that, she got angry. "Why did you drag me into this?" she said.

"I had to do it," San Yi Po told her. "If I hadn't, it wouldn't have sounded right. How else was I going to explain it?"

"Did you have to say I introduced him to her?"

"Well, he's technically your colleague."

My grandmother needn't have worried. Their grandfather took the news about Fang Zhen Zhi in stride. "Well, if it's already gone this far, there's nothing to be done now," he said. "You tell Pei Sheng that I'm not going to blame her, and I'm not going to meddle. She can make her own choices. Her happiness is in her hands. Just tell her to come back. I'd like to see her."

Despite her grandfather's frequent pleas to come home for a visit, Si Yi Po always found an excuse not to go. I'll go back in a year or two, she told San Yi Po. My kids will be a little older and easier to travel with. And we can all go back together.

Si Yi Po's vivacity made it easy to forget that she had suffered a stroke a few years before. At first I didn't notice anything wrong with her mind. The first afternoon I spent with her, she seemed to have no trouble remembering details from her childhood, or stories about the family, or the trek to Chongqing, or her grandfather's porcelain.

"The ceramics in our home were given by others as well as bought by Grandfather himself," she said. "His students came to visit him every year at Chinese New Year and brought him gifts."

"Were they valuable?"

"They were all bought in Jingdezhen. Maybe there were some imperial porcelains, because Grandfather's students were mostly wealthy. They must have been valuable."

I asked if she knew what had happened to the buried porcelain.

"Maybe the Japanese dug them up," she said. "It was not by locals or anyone in the family."

"Are you sure the relatives didn't do it?"

"They wouldn't dare, because of the Japanese."

That seemed logical. If the house had been occupied by Japanese

officers, no one would have risked going into the garden to retrieve buried valuables, even if they had known where to dig.

Other times Si Yi Po's recollections petered out or swerved onto tangents upon tangents, sometimes all in the same sentence. In the middle of describing what her grandfather liked to eat, she would begin talking about neighbors in Beijing who committed suicide during the Cultural Revolution. Family members died and then came back to life. One day she would say that my great-great-grandfather wasn't interested in porcelain. The next, she would talk expansively about how much he loved collecting it and have no recollection of what we had discussed before. She didn't seem to know that my grandmother had passed away and believed so fully that San Yi Po was my grandmother that I stopped trying to correct her. She wasn't making up her memories, but they had unmoored from their original context and drifted into a mosaic with no beginning, end, or order. It wasn't all that different from my own uncertain understanding of how the fragments of our family history fit together, or what was real and what was imagined, and with fewer and fewer people to ask for the truth.

"When we went back, the Japanese were gone, but we needed to be aware of the Communists, so we buried the porcelains," Si Yi Po said.

"Again?"

"We didn't bury them all at first. We put them in the pigpen. Later we didn't think it was a good idea, so we buried them."

"That's during the Sino-Japanese War?" I said.

"Yes, that was during the war," she said. "The Japanese had surrendered. After the atomic bomb, the Japanese were no longer as vicious. So we buried the porcelains."

"Wait," I said. "I thought that as the Japanese were approaching during the Sino-Japanese War, your grandfather sent you all to Lushan, and at the same time, he buried the porcelain."

"Oh, that I'm not sure. I know he buried them but don't know

where. Your grandmother knows. The porcelains were buried in the same place as the land deeds."

"Why did your grandfather bury the deeds?" I asked.

"He thought once the war is over, the deeds and the land would still be ours."

"Which one? The civil war or the Sino-Japanese War?"

"Grandfather built two houses in Nanjing," she said, answering a question only she heard. "Then they were gone."

"What happened to the deeds and the silver dollars?"

"We don't know. No one asked about them once they were buried. Nobody was home, and they were taken from us."

IN CONTRAST TO Si Yi Po, Fang Zhen Zhi remembered events with impressive clarity. My family had not told me much about him, except that he had been a scientist and helped develop China's nuclear weapons program. One afternoon, after sitting through another of Si Yi Po's rambling monologues, I walked over to Fang Zhen Zhi's side of the apartment and asked him about his life.

He was born in 1918 in rural Anhui, one of China's poorest provinces. His great-grandfather had run a village *sishu,* and his grandfather had passed the first level of the imperial exam, but the revolution of 1911 ended his prospects as an official. Fang Zhen Zhi's father was a bright man but from a family too poor to afford schooling, and who worked as a traveling salesman, peddling knives, scissors, and porcelain in Yangtze River towns.

Fang Zhen Zhi grew up in a straw hut. He remembered hearing his father's pockets jingling with copper coins when he came home for the new year, after which his mother would take him by the hand and make a round of the surrounding villages, paying back what they had borrowed while his father was away. When he was six years old, he got malaria, and his mother interpreted his fever and chills as signs that he was possessed by a demon. She ordered him to run around

the courtyard where they processed the rice harvest until the demon left his body, chasing him with a willow branch to keep him running.

Then Chiang Kai-shek's Northern Expedition moved through the area, attempting to suppress the warlords and reunify China, and he remembered being terrified of the soldiers. "My generation had the impression in our minds of old China being invaded by other countries, domestic power struggles, warlords fighting each other, and Chiang Kai-shek's so-called unification, which fell short in reality," he said. He spoke clearly and slowly to make sure I could follow him. "It was nonstop war."

But Fang Zhen Zhi's father got to know some porcelain businessmen in Jingdezhen and built his own porcelain store, and then a small factory. Fang Zhen Zhi could finally attend school, starting in a *sishu* and then testing into a progressive middle school founded by a Qing dynasty scholar who had studied Japan's education system. He learned math, chemistry, and physics and woke up early every morning to recite English essays in the park across from the campus.

He passed the entrance exam for high school in the provincial capital just as the Sino-Japanese War began. The school moved several times to escape Japanese bombardment, setting up temporary campuses all over the province. In Wuhan, the Japanese came close enough that the students had to make a run for boats on the Yangtze, which took them to Leshan in Sichuan province, where Fang's family had relocated.

Feeling restless after his second year of high school, he decided to sit for the university entrance exams, just to see how much he could learn if he studied through his summer vacation. He learned enough to gain entrance to the engineering college at Northwestern Union University, a consortium of engineering schools that had relocated to Shanxi during the war. Not long afterward the Japanese leveled Leshan. Fang Zhen Zhi's father's business was ruined, and the city was strewn with charred bodies. One of Fang's father's employees had ignored the air raid sirens and remained in the store. The gold jewelry

he wore had melted on his body. Fang Zhen Zhi's father picked it off the corpse and gave it to the man's surviving son. Fang left for college before he even finished high school and graduated with a degree in metallurgy in 1943, after which my grandparents' materials research lab at the Jinling Armory recruited him. The lab needed four people but managed to get only two. "There was no freedom and it paid badly," Fang explained to me. But the lab was headed by a Harvard Ph.D., and that was enough to induce a bright, curious young man like Fang to take the job.

When the Japanese surrendered in 1945, many of the ordnance factories and armories wound down and waited for redeployment. Employees took advantage of the change to relax, checking in at work before heading off to one of the famous Sichuan teahouses. But Fang didn't want to spend his days idling in a teahouse; he wanted to *peiyang rencai*—develop his talents to develop the country. "The Japanese had left, but the Kuomintang needed development or else it wasn't going to last long," he told me. "All kinds of industries needed to be improved."

He heard that Tsinghua University was sponsoring Chinese students to study in America, so he started studying English. With no teachers or classes available to him, he got copies of *Reader's Digest* from the American consulate and read them cover to cover. He applied to study metallurgy, a concentration that accepted only two students from the entire country, and took the exam in August 1946. "I didn't dare think I would make it, but I figured it didn't hurt to try," he said.

In October his family returned to Anhui, and he moved to Nanjing with the armory. Then in December he received a letter of admission. He was approved to study abroad. His father sold a quarter of his inventory to pay for the steamer ticket and tuition and living expenses for one year in the United States. He married Si Yi Po, and one month after his first daughter was born, he boarded a boat for America.

A few weeks later he arrived at the Colorado School of Mines in Golden, Colorado. But he found the metallurgy department in decline, so he transferred to the University of Missouri School of Mines and Metallurgy in Rolla, where he found his academic nirvana. Advised by dynamic professors and free to indulge his intellectual curiosities, he became a scientific polymath, taking classes in atomic theory, X-ray analysis, atomic spectroscopy, and others far afield from his primary interest in aluminum and metal physics. In the summer he worked at a vegetable cannery in Minnesota, first operating a machine that sieved peas and then as a janitor, living with other Chinese students and Cuban field hands in a rickety dorm with wooden beds and no plumbing. He wrote Si Yi Po, followed the Kuomintang's war with the Communists in the *Overseas Chinese Daily*, and reported on his courses to my grandmother.

Fang Zhen Zhi was still in Missouri when Chiang Kai-shek sounded the retreat to Taiwan. My grandmother and San Yi Po urged Si Yi Po to go to Taiwan with them, but she had an infant child and Fang Zhen Zhi was still in the United States. Fang Zhen Zhi told her that if she wouldn't go to Taiwan, then she should stay with his parents in his remote hometown in Anhui, where the war wouldn't touch her.

As the Communists closed in on Shanghai, my grandmother's department was ordered to leave for Taiwan at once, and there was no time to notify Si Yi Po. She wouldn't have been able to get to Shanghai in time anyway. My grandmother wrote Fang Zhen Zhi that she was sorry she wasn't able to take Si Yi Po with her to Taiwan. Fang wasn't concerned. His parents would take good care of his wife, and as for the Communists, they were simply a change in leadership.

When Fang obtained his master's degree, his adviser recommended him to pursue a doctorate at the University of Florida. "But my wife and family were back on the farm, and they would have suffered," Fang told me. "What good would any success of mine be if they were suffering?"

In December 1949, shortly after the Communists declared victory, Fang Zhen Zhi returned to China aboard the *General W. H. Gordon,* a troopship carrying about a hundred other returning Chinese students. Upon arriving in Tianjin, he was offered an associate professorship at the prestigious Beiyang University, founded in 1895 as one of the country's first modern institutions of higher learning. The victorious Communists were recognized as having driven out foreign influences and reclaiming the country for the Chinese, and patriotic intellectuals like Fang Zhen Zhi respected them for it. The Communists were also contending with a brain drain that had left universities short on skilled teachers, and so they treated professors well and paid them good salaries, even better than government officials. Once Fang Zhen Zhi's university housing was prepared, he sent for his wife and daughter, whom he had not seen for nearly three years, and at the dawn of what they expected to be a bright new China, they were reunited.

As the Communists remade China, pragmatism was a guiding principle. University curriculums were based on the country's hardware needs, and Fang Zhen Zhi taught whatever was assigned to him, even courses in which he had no background. When the central ministry of heavy industry needed materials to build airplanes, Fang Zhen Zhi was ordered to organize a course on light metals to train four students how to extract aluminum oxide from low-quality ores. Somehow, between the papers he had collected from America on aluminum oxide, teaching materials in the Communist Party's branch office, and his own ingenuity, his students graduated. One became a senior engineer at an aluminum oxide factory and another became a university professor, teaching his own course in light metals. In a harbinger of what was to come, the two other students were deemed to have come from "bad" family backgrounds and were forced to find work outside of light metals.

In 1952 the university system was reorganized, and Fang and his family moved to Beijing, where his department had been incorpo-

rated into the newly established Beijing Steel and Iron Institute, one of eight (an auspicious number) institutes erected in the same area of the city. Fang taught metallography, X-rays, and metal physics, and the family lived in newly built residences with two floors, three and a half rooms, and a private bath and kitchen. It was luxurious by any standard, and they played host to a rotating cast of friends and relatives.

It wasn't all smooth. Mao had launched a series of political movements, dubbed the "Three Anti" and "Five Anti" campaigns, ostensibly to eliminate corruption and waste but in reality a scheme to punish and purge his opposition, real and imagined. The private business sector was effectively crushed, and farmers were forcibly corralled into workers' communes. Then, after a brief interlude when intellectuals were encouraged to offer criticisms of national policies, the "antirightist" campaign developed to crush those who participated.

The antirightist campaign gave way to the Great Leap Forward. Intoxicated by unrealistic visions of exponential increases in China's agricultural and industrial output, the country embarked on one of the great misguided attempts to disregard natural and physical realities. Mao had no real plan for the Great Leap Forward, other than repeating "We can catch up with England in fifteen years" as a mantra. Unfortunately, all the country's best agronomists, demographers, and statisticians, everyone who might have raised questions about the probability of achieving such astronomical figures, had been purged during the antirightist movement. "It was the time of 'putting politics in charge,'" Fang explained. "You didn't have professionals in charge."

What followed was an astonishing example of delusion. Workers engaged in baseless, idiotic practices, like close planting of seeds (which to the uninitiated would seem to produce higher yields but only resulted in the death of all seeds because the soil didn't contain enough nutrients to support them), while songs like "We Will Overtake Europe and Catch Up to America" played over loudspeakers.

Because sparrows ate sowed seeds, Mao declared war on them, exhorting peasants to bang drums, pots, pans, and gongs in order to keep the birds aloft until they died of exhaustion. The Chinese did in fact kill plenty of birds, even if the provincial records aren't to be believed, but that only freed grasshoppers and locusts to decimate crops. Farmers—the ones who actually understood how to plant—were taken out of the fields to build reservoirs and irrigation canals, dig wells, and dredge rivers. Grotesque exaggerations and absurdities were propagated; during one commune inspection, local officials claimed that dog meat broth made their yam fields more productive.

The pressure to meet the central government's unrealistic output demands left nothing for farmers to eat—campaigns were launched to dig up grain that peasants had allegedly buried, and those who denied hoarding food were tortured and killed. What the state didn't take, natural disasters like droughts finished off. In one county in Henan province, a million people (out of eight million) died of starvation. With more harvest than was even available already promised to government granaries, the locals were left with nothing to eat. Meanwhile China sent grain to countries abroad, often without charge.

Compounding the catastrophe was the herding of villagers into communal canteens, because of an associated plan to boost steel production by melting down farm and kitchen tools in backyard furnaces, which worked out about as well as one would imagine. With their cleavers and woks consigned to the furnace, families could no longer cook for themselves, and the state took total control of the food supply. Police blocked villagers from leaving rural areas. As the famine continued, people resorted to cannibalism, either by exhuming the dead or by killing the living, sometimes even their own family members. Mao blamed the failures of the communes on "rightists" and opportunists in the party. He purged dissenting officials and had his objectors and skeptics murdered.

Given this backdrop, Fang thought himself fortunate to have

been sent to the Soviet Union in 1957 to spend two years studying at the Moscow Institute of Steel. Though not without its own peculiar isolation—foreign journals were even more difficult to obtain than in China—and propaganda machine, the Soviet Union was blissfully free of China's social controls and political movements. Qualified professors ran the universities. Citizens read in public without fear of being labeled class enemies. Many professors owned holiday cabins outside the city and took their leisure time seriously.

When Fang returned to China, the antirightist campaign had subsided, and he settled back into his teaching. In addition to his lectures, he ran experimental labs, having acquired X-ray machines from East Germany and Hungary, some of the first in a Chinese university. He established a graduate program in metallurgy. The Beijing Physics Society asked him to teach an advanced course on solid-state physics for university professors.

In the midst of Fang's teaching, a special central committee chaired by Chinese premier Zhou Enlai began handpicking scientists for a secret project to develop nuclear weapons, code-named "the Ninth Institute." Fang was one of the scientists tapped, and his inclusion was based almost entirely on a misunderstanding. While searching for teaching materials for his X-ray course, he found a useful book that a professor at the Moscow Institute of Steel had written. So Fang took a crash course in Russian and translated the book into Chinese. Thousands of copies of the translation were printed and distributed throughout the country, labeled "college teaching material." The committee putting together the Ninth Institute saw the book, took note of the "author," and added him to their roster. "That's all they knew about me," Fang said.

Fang was assigned to conduct pulse X-ray physics experiments, studying the internal process of nuclear explosions. He had never heard of such things. He took his concerns to a meeting with a high-level director in the Communist Party's Central Committee, who received him courteously but said that his hands were tied. "The list

was signed by the vice premier," he said. "There's no way to decline this."

"But don't you see this is a big change of course in my profession?" Fang said. "I've never even touched this field."

"Well, they want you, so just change course," the director replied.

Fang couldn't even tell his family where he was going, only that he was being transferred and wouldn't be home for a while. In 1963 he reported to his new unit on the arid Qinghai plateau, one of the most remote places in China. Dotted with brackish lakes and surrounded by massive mountain ranges, including the Himalayas to the south, it was roughly the size of France and known as the roof of the world, with an average elevation of fourteen thousand feet. Frost covered the plateau for half the year. The air was so thin that even walking up a flight of stairs was difficult at first.

The Ninth Institute constructed a complex on a large grassland inhabited by only a few nomadic Tibetan herders. Fang quickly saw that, despite the disruption to his career, he was surrounded by the top scientists in China, men with doctorates from America and Europe; he counted eight fellow returnees from American graduate schools. A sense of mission permeated the unit, and since the project was a national priority, requests for staff or equipment fast-tracked through the bureaucracy. "There were green lights all over the country for this job," Fang said.

As the director of experiments, Fang had everything he needed to succeed, but he still wondered if he could really fulfill his duties in a field so far from his specialty. Fortunately, all those esoteric courses he had taken at the University of Missouri, which had no bearing on his teaching in Beijing, had exposed him to the basic knowledge he needed at the Ninth Institute.

The room had grown dark. Da Biao Yi called us into the kitchen for dinner, where she had set out bowls of dumplings and cabbage. Fang Zhen Zhi continued talking while we ate, and dumped the remainder of the cabbage into his bowl so there wouldn't be leftovers.

He would remain with the Ninth Institute for the next sixteen years, going home once a year for forty days. When the Cultural Revolution broke out in Beijing in 1966, Premier Zhou Enlai ordered that no one touch the Ninth Institute, but even the prestige and remote location of the Ninth Institute couldn't insulate it forever. In 1968, as Lin Biao became Mao's designated successor, Zhou Enlai lost influence, and the Ninth Institute sank into the Cultural Revolution.

Lin Biao sent two propaganda teams to Qinghai to "cleanse the team of classes." Fang and three other scientists who had studied abroad were denounced and stripped of their positions. The Red Guards locked them up, along with hundreds of others, in a research building. Every day they were made to bow to a portrait of Mao and sit in the hallway until it was time for them to write "confessions" detailing their personal histories, their capitalistic and bourgeois thoughts and behaviors, and any other antirevolutionary actions. They weren't allowed to do any work other than clean the bathrooms. "The urinal had a layer of urine stains," Fang recalled. "We couldn't remove the stains with detergent, so we used broken glass to make the ceramic shine. Made them sparkling clean. Fortunately, your grandaunt didn't witness this."

Sometimes Red Guards tortured Fang, tying his hands behind his back and raising him up by the arms, a position they called "flying a jet," while they shouted at him to confess this or that. When they thought he had had enough, they let him down and sent him back to the hallway, where the Red Guards kept close watch over him. "It sounds bad to be under guard, right?" Fang said to me. "But there was something good: you didn't get to commit suicide."

During one torture session, the vice-director of Fang's lab, an old revolutionary who had fought the Japanese and was in charge of administrative matters, heard Fang's screams and suspected that his time was coming. He sneaked into the carpenter's shop and hung himself from a beam. They found his body the next day and dumped it with a truckload of coal ash.

By 1970 the storm of the Cultural Revolution had mostly passed in the rest of China, and people accused of minor "crimes" had been released. But for the Ninth Institute, the worst was yet to come. Lin Biao fabricated three "counterrevolutionary" cases in Fang's unit, which gave him the power to seal off the entire grassland and "reform" the unit. Fang and his supervisors were jailed. Three members of the Ninth Institute were outright executed by the Red Guards.

A director in the explosives production unit was pressured to confess that he was organizing a spy ring of a hundred-odd members. The Red Guards told the director to list every member's name and duties, and Fang's name was included. The soldiers ate it up and demanded more, so the director concocted more lies. "It was all phony, done under interrogation to save himself," Fang said. "He later reversed his story, said he made it up. The soldiers got angry. He was a small man, and they pushed his head against the cement wall until he died. He was a director of a research unit, an important person. Nothing could be done."

Fang was then accused of buying faulty equipment. "You cost the socialist base more than ten million RMB," the Red Guards said. That was a capital crime. Somehow Fang managed to convince them that the contracts for that equipment had been signed before he was even tapped for the Ninth Institute. "I almost got shot," he told me. "But that's how they tried to get you back then."

Lin Biao ordered the Ninth Institute moved, and Fang and his colleagues boarded a windowless train and relocated to a gulch in northern Sichuan. They were placed under house arrest in homes vacated by civilians. The guards changed the detainees' surnames to Niu, or "Cow." Fang, now Old Cow, lived under constant threat that someone might fabricate some charge against him. It only took one person to report him and a second to corroborate. If a third person chimed in, the case was final, and he would be executed.

Fang stayed in that gulch for three years, let out of his dark room

occasionally to perform manual labor, until the Cultural Revolution burned itself out. He reckoned that, including suicides, more than two hundred members of the Ninth Institute had died. Incredibly, Fang's first instinct when the turmoil passed was to get back to work. "In the end there was not much to say," he explained. "They were all mad. So many old leaders, who made such contributions to the country, were purged and died of unknown causes. Our own suffering was not worth mentioning. When it was over, it was quickly forgotten. We still had work to do. The worst fear of those who came back from abroad was that they wouldn't get positions where they could work and make a contribution to the country."

Sixteen years after Fang began work in the Ninth Institute, he petitioned the Central Committee to go home. His team's experiments had never failed. He had accomplished everything asked of him. The institute had achieved China's first generation of atomic weapons. In September 1979 he was allowed to return to Beijing. He reclaimed his house at the Steel and Iron University, which had been taken up by two other families during the Cultural Revolution, punishment for being "reactionary academic authorities." Fang left the university for the physics research institute at the Academy of Science, where he worked on China's space program until he retired in 1989.

We had moved back into Fang's rectangular living room, arranged like an academic's office with a large desk beside the window and shelves of books against the wall. I saw a copy of an article he had authored with his graduate adviser, "The Structure of Metal Deposits Obtained by Electrochemical Displacement upon Zinc." It was based on his graduate thesis and published in the *Journal of the Electrochemical Society* in 1951, two years after the Communist takeover, and his name appeared as C. C. Fang. His adviser had sent him the copy. Fang Zhen Zhi sat on the sofa, facing the television, fanning himself. I asked him if he ever thought about leaving China, given all the years of mistreatment he had suffered.

Never, he said.

"You've lived into your nineties, but you don't seem to have any regrets," I said.

"I've thought about this," he said. "Probably because I came from a very poor family and gradually entered the intellectual world. Although I went through much undeserved insult and punishment in those political movements, my life was reasonably smooth. I went abroad, studied, and was able to apply what I learned. I know I am not very smart, but I worked hard and was serious. I changed the course of my research, I completed my mission, I have a sense of accomplishment. Your grandaunt will tell you that in general I didn't help out much at home. I just sat at my desk, reading and writing until meals were served. I was away for sixteen years, caught in the political turbulence of the Cultural Revolution, and could not help my family at all. They had their ups and downs but kept on the right course. They went to good schools, got good jobs, married, and had kids. This was all your grandaunt's doing. Compared to others, my family did well."

"And you have no anger toward the government?" I said.

Fang leaned back in his chair. "Over time the frustration and the upset over unfair situations naturally gets diluted to the point where I have no special feeling about it," he said. "All those years, you couldn't say anything. They made the rules, and fighting it wouldn't get you anywhere. I was like a piece of dough, squeezed into whatever shape they wanted. You sometimes run into unpleasant things, but what was the use of worrying? I've done nothing wrong. I've hidden nothing from the Communist Party. I have no further plans or ambitions for myself. I receive a pension, I live in this house, it's not very high, but not very low, either. Life is good. So considering the environment I came out of, to be lifted to where I am in society, I'm quite *manyi*." He was satisfied.

❧ ❧ ❧

THE NEXT DAY Da Biao Yi made rotini pasta with two choices of meat sauce, pork and chicken, with fresh tomatoes, onions, and ketchup bases. "We like Western foods," my aunt said. "Especially in the summer. Who wants to stand in the kitchen with a wok, stir-frying all this stuff?"

The eldest of Si Yi Po's three children, Da Biao Yi told me that she had been *chadui* during the Cultural Revolution. I used this term all the time when I upbraided locals for cutting in line, but back then *chadui* meant being sent to the countryside for "reeducation." When I asked her age, she gave it in terms of the year she was supposed to take the *gaokao* college entrance exam (a continuation of the tradition of the imperial exams) or graduate from college, opportunities that her generation had collectively lost. "I was class of 'sixty-one," she said. "My sister was class of 'sixty-five. Then the Cultural Revolution started, and everything was a mess. There was no school, no work. The factories were closed. No one had anything to do back then. Everyone was just waiting for their call, where to go. There were four options, and going to the countryside was actually one of the better ones."

In 1966 both Da Biao Yi and her sister were forced to *shang shan xia xiang*, or "go up the mountain, down to the countryside," the term they used for their forced agricultural experience. They didn't leave until 1969. Before the Cultural Revolution, she had attended the Beijing 101 high school, founded in 1946 and renowned as one of the best schools in the country. "Life was good for the family," she said. "The seventeen years between Liberation and the Cultural Revolution, you had struggles and political persecutions, but for the most part, people like us lived well. Dad had a good job. Mom was in the library. We weren't supposed to talk about salaries or things like that, but you knew who was doing better than others."

Then they were assigned to Yanan, about which they knew absolutely nothing except that there would be electricity and running water, so they figured it couldn't be so bad. "Then we got there and saw that we were living in caves," she said. "They would survey the

land for good cave soil—it had to be packed down, like under a road, where the pressure made the soil hard. They'd level the front vertically and start digging the cave. Boys, once they got to be seven years old, they started digging caves. The thinking was that by the time they got to be eighteen or so and ready to marry, they'd have their cave dug by then." The promise of running water turned out to be an empty one, and farmers, who had barely enough to eat as it was, didn't welcome the arrival of more mouths to feed. They subsisted on millet, sprinkled with salt when it was available. "It was so dry," she said. "No water. We had to walk to get water from ditches many times every day, carrying it in buckets. My sister was younger, and she took it hard. She cried and cried, it was so different than what she was used to. I was older. I took it okay."

They wore the same boxy clothing as the farmers, cut from a thick navy cloth. Some nights after washing up with a bucket and a rag, they changed into the school dresses that they had been naïve enough to pack. "The farmers had never seen anything like that before," she recalled. "They'd come from all around and stare at us. We'd sing songs—we mostly knew Soviet ones then—just to feel normal again, to imagine we were back at home, or school."

"Did you understand the reasons for making you do all this?" I asked.

"Not at all! That's what happens when you have people who have never been allowed to think for themselves, and then suddenly they do. It was like an explosion. If they'd had the freedom to think for themselves the whole time, things would have been very different. But they didn't, so you had all kinds of crazy ideas flying around. Looking back, it wasn't that bad. Don't get me wrong, we suffered a lot at the time, but in hindsight, there were some good things that came out of it."

Da Biao Yi's husband walked through the kitchen. "There were no good things!" he grumbled.

"I said 'looking back'!" she called after him. "At the time, no, but

now people with this experience, they understand what it is to really suffer. They can adapt to misfortune. They are able to go up and down the ladder. If my son had had the option to go to the countryside for two years, I think it would have been really good for him."

Da Biao Yi stared in my direction but not at me. "Yes, *chadui, shang shan xia xiang*," she said, shaking her head as she repeated the catchphrases of her youth. "This generation doesn't know much about it, not even my son. Whenever I get going on this, he just rolls his eyes and says, 'Ma, you're talking about ancient history again.'"

For nearly thirty years after 1949, my grandmother had no idea what had become of her family on the mainland. During this time China swung from one movement to another, targeting just about every group in Chinese society: counterrevolutionaries, intellectuals, capitalists, "rightists" . . . the list was as long as it was capricious. Even in 1978, with Mao dead, the Cultural Revolution over, and Deng Xiaoping's open-door policy announced, my grandmother didn't dare risk her family's safety by trying to contact them. It fell on Lewis, who had heard too many stories about relatives he had never met, to reach out. They were in Canada then, and Lewis wrote a short note to Pei Fu reporting that my grandmother was in Canada (he left out the part about her time in Taiwan) and that the family was well. He sent the envelope to the only address my grandmother knew, for Pei Fu's husband: China, Jiangxi, Jiujiang, Xingang, "Chen Jia Ba Fang," literally the "Eight Chen Brothers' Houses." Under the address, Lewis added, as only he would, "Overseas Chinese looking for relatives. Must deliver." And just for good measure, "From Canada" in English. About a month later they received a reply from Pei Fu, who supplied them with the mailing addresses of Pei Sheng and Pei Ke. In 1984, while based in Hong Kong for work, Lewis arranged a reunion for the Liu granddaughters. They all met in Hong Kong and spent a week together except for Pei Fu, who couldn't get permission to leave China; my grandmother would never see her middle sister before she died. "Everyone cried for many days," Lewis recalled.

My last night in Beijing, Si Yi Po shuffled into my room and sat down next to me. "Huan Huan," she said, using my diminutive and patting my leg as she spoke, "when you go back to Taiwan, you tell San Yi Po that we're all fine here, and that if she needs anything, something to eat from Jiujiang maybe, to just let us know. She never asks because she hates to be a bother, but we're sisters, so it's not a bother for me. And tell her to come visit when she has time. The older we get, the less chance we have. I haven't seen her in so many years."

I didn't try to correct her. She handed me the porcelain peach that I had seen in her room, about twice the size of a real one and painted crudely, and told me to take it. A relative had bought it for her eightieth birthday, she said. And when I asked which relative, she said that she couldn't remember where it had come from at all. "Keep it," I said, putting the peach back in her hands. "I'll get it the next time I visit." Si Yi Po smiled, which is what Chinese people do when they don't know what else to do.

MY FINAL STOP before Jiujiang was Shandong province, where Liu Cong Ji, the son of my great-great-grandfather's youngest son, Ting Gong, and the only male of my grandmother's generation, had ended up. I telephoned Liu Cong Ji in Jinan, the provincial capital, to ask if I could visit him. "Of course!" he said, as he wrote down my arrival date. "Now, how do you write your name?"

"Just like the Huan in Qi Huan Gong," I told him.

It was raining in Jinan when I landed. Containing the Yellow River delta and dotted with Neolithic sites, Shandong was the mythical birthplace of the Yellow Emperor and one of the cradles of Chinese civilization, where that glorious five thousand years of Chinese culture began. In 1897 Germany forced China into leasing Jiaozhou Bay and the surrounding area, and the province fell under the German "sphere of influence." The Germans developed coal mines and railroads throughout the territory, and the fishing village of Qingdao,

modernized with wide streets, handsome architecture, electricity, an extensive sewer system, and safe drinking water, became a major port; in 1903 they established what would become the Tsingtao brewing company. Uncle Lewis liked to compare Qingdao to San Francisco and owned a seaside home there for many years.

I spent the bus ride from the airport watching cornfields and stands of willows, the latter an indication of Jinan's famous artesian springs. As the bus reached the outskirts of the city, factories came into view, including a few ceramics companies making sanitary ware. The rain fell harder as we reached the bus station, a relic just off a brand-new thoroughfare.

I got very lost trying to find Liu Cong Ji's house, so he sent his daughter to pick me up in their white Honda sedan. Liu Cong Ji and his wife, a retired doctor, lived with his daughter, Liu Li Nan, a pharmaceutical researcher, in an old army district at the foot of a "mountain." Li Nan's husband worked for a Chinese telecom in Weifang, about three hours from Jinan. Liu Cong Ji's other child, a son, lived in Vancouver, and his grandson was studying engineering at the University of British Columbia. "When I asked you on the phone which Huan you were," Liu Cong Ji said, "and you said 'the same as Qi Huan Gong,' I knew right away what you were talking about, and also that you were very educated and knowledgeable about China. There are lots of Chinese people who have no idea who he is. Unless you're college educated, you aren't going to know characters from the Spring and Autumn Period."

Jinan had been part of Qi Huan Gong's territory and, with its springs, mountains, and four distinct seasons, had been a desirable place to live for most of its habitation. Under Qi Huan Gong, the Qi state managed to rise to prominence, thanks in large part to the work of his prime minister, Guan Zhong, who drafted a philosophy that would not just consolidate his power but also supply the genetic material for the China that had yet to be born. The Spring and Autumn Period was a time of immense cultural and intellectual development,

when the "hundred schools of thought" flourished (and which Mao would later appropriate for his "hundred flowers" campaign). One of those schools was Guan Zhong's legalism, which, as the name implies, centered on the strict enforcement of laws. People were inherently selfish, the legalists maintained, and so the only way to preserve social order was tight control and harsh discipline from above. The state was singular in its importance, so its military strength and economic prosperity were to be pursued above all, including at the expense of the common people's well-being. Guan Zhong centralized power, partitioned the state into areas based on assigned trades, and developed a system that relied not on aristocrats with inherited titles but instead on professional bureaucrats selected based on their talents, a step toward an imperial exam system. Many scholars believed that Confucianism, which most people thought of as the foundation of Chinese philosophy, simply rewrote legalism in less punitive terms.

Qin Shi Huang, the legendary "First Emperor," used legalism to unite China and then rule it with an iron fist, ushering in a dynastic period of centralized power in which Liu Cong Ji said we still were. Just as America had its roots in ancient Greece and Rome, China had its in Qi Huan Gong. "If you can get these things straight, you see everything about how Chinese culture developed," Cong Ji said.

Liu Cong Ji's hair, a wedge of gray centered on his parietal bone, reminded me of Deng Xiaoping's, and his Jiujiang accent had been neutralized by all his time in the north. He used old-fashioned vocabulary and peppered his speech with a tic that sounded like a soft clearing of his throat.

We sat on the sofa in the living room while his wife made us a snack of chrysanthemum tea, moon cakes, and grapes. "Don't just talk the whole time," she said to her husband. "Make sure he eats." Shandong was China's agricultural heartland, and boxes of grapes and peaches occupied one corner of the living room, along with a large watermelon. On the flat-screen television, the size of a coffee table, the evening news droned. Cong Ji paid it no attention, but when

the weather report came on, he stopped everything and watched intently for the Jinan forecast.

Cong Ji grew up in the Xingang house, but neither my grandmother, who was many years older, nor San Yi Po or Si Yi Po, who were closer to his age, had mentioned any interactions with him when they were children. During the Sino-Japanese War, Cong Ji was the first to flee Xingang, well before my great-great-grandfather decided what the rest of the family should do. As the only boy in his generation, Cong Ji's safety was a priority, so my great-great-grandfather sent him with San Gu when she relocated with the Rulison school. The church-organized retreat was efficient and smooth, and he encountered few of the terrors that San Yi Po and Si Yi Po recalled. "I was a little *jiaosheng guanyang*," he said with a small laugh. Spoiled and pampered since childhood.

His protected upbringing, he said, explained why he didn't know much about his grandfather's porcelain. He clearly remembered taking refuge in a villa on Lushan with San Gu, but he didn't know if it belonged to the family or someone else. He only knew of a house in Jiujiang city, purchased after his brother fell ill one summer day, while accompanying Old Yang to the market to buy fruit, and died in the boat on the way to the hospital. That left Cong Ji as the only male heir, so my great-great-grandfather, worried that the countryside wouldn't provide adequate emergency medical care, bought a pied-à-terre in the city near the Tong Wen and Rulison schools. It was a fine house, three stories high with a skywell and two living rooms, but was destroyed in the Sino-Japanese War. As for the rest, he couldn't be sure.

"These things, my impression isn't clear," he apologized. "I was just a kid, following people as they ran, trying to keep up."

In Chongqing my great-great-grandfather reunited with his middle son, Ting Geng, who was working as a road engineer for the Kuomintang, and returned his daughters, Pei Yu and Pei Ke, to him. As Chongqing was bombed relentlessly by the Japanese, my

great-great-grandfather settled with the rest of the family in the suburbs. Then Ting Geng contracted tuberculosis. He died after a year, and his girls went back to San Gu.

When my great-great-grandfather began his journey back to Xingang, he and Cong Ji took a bus from Chongqing and then walked or rode buffalo-pulled carts. They stayed in too many hotels for Cong Ji to count. My great-great-grandfather left Cong Ji with his father in southern Jiangxi, which was under Kuomintang control, and continued home, sneaking through blockades and checkpoints and slipping into Poyang Lake at night. When he reckoned it was safe enough, he sent for Cong Ji's mother, Old Yang, and Pei Ke.

After the war San Gu returned to Jiujiang with Rulison, and Cong Ji moved back to attend Tong Wen in the winter of 1945. The house in Xingang had changed since he left. Of the square of buildings arranged around a courtyard, only a couple remained. Cong Ji graduated from Tong Wen in 1947, but with the civil war raging, he didn't have the opportunity to take the university entrance exams until the next year.

He studied engineering at Southeast University in Nanjing and upon graduating was sent immediately to the Anshan steel factory in Dongbei, the largest one in the country, to help the factory expand according to Russian blueprints. After four years that factory was finished, and his design group was sent to Beijing to build another one. There he met his wife, Pang Zhong Li, in 1958, and they married the same year. She had come from a wealthy family, too. Her father had been the Kuomintang chief of the telegraph and post service in Jiujiang. After she finished medical school, she was assigned to a hospital in Dezhou, working as a doctor and taking care of their children and Cong Ji's mother while he worked in Beijing.

The government wouldn't allow Cong Ji to bring his wife from Dezhou to Beijing, so they stayed apart for fifteen years, seeing each other once a year for seven days during the Lunar New Year. "This

was a real personal suffering for me," he said. "In 1973 I decided it wasn't okay anymore. We were old, our children were grown, we couldn't keep living separately. If she couldn't come to Beijing, then I'd return to Dezhou." Cong Ji punctuated many of his stories with sighs and whispered *aiyous,* as if they were shrapnel working their way out of his body.

Cong Ji's other grandson came home from school as we were talking about the Cultural Revolution. He was tall for a ninth grader, with a flat-top haircut, round wire-rim glasses, and a peach-fuzz mustache. He said hello and disappeared into his room.

During the Cultural Revolution, work basically stopped. "You'd just 'promote' and 'exercise,'" Cong Ji said. "The intelligentsia had to link with the workers and farmers, so they were demoted and exercised. You could farm, work in the factory, do low-level tasks. It wasn't okay if you didn't do it."

Cong Ji's group was doing critical work and was mostly left alone. Every year they had to spend about a week doing manual labor on a farm or shop floor. But because of his father's landowning background, Cong Ji was pulled out to work on a farm in Inner Mongolia for a year.

"What was your reaction to all this?" I asked.

"I didn't really have any special thinking about it," he said. "Everyone had to do it. It was stipulated."

"Didn't you think it was strange?" I said, as Cong Ji's grandson came out of his room and joined us on the sofa.

"Strange or not, it wasn't okay if you didn't go," Cong Ji's wife said, chuckling. "They'd hold a meeting, do an examination, and everyone would criticize you. 'You're straying from the revolutionary path,' and so on, and they'd put a hat on you, saying you're a counterrevolutionary or, worse, a traitor. Who would be willing to go through this? You've worked hard all your life, and then you make this mistake? It'd be bad for your children, too."

Cong Ji's wife got up to steep us a second pot of tea. I asked Cong Ji again if he could remember anything at all about his grandfather's porcelain.

"I didn't notice," he said. "But I was very small. He could have collected it. At that time, if you had some money, what would you have spent it on? Porcelain. But you know, it was all Da Bai who purchased it. It wasn't my grandfather who bought it. Da Bai bought it away from home and brought it back. So yes, he collected, but our family, we didn't have much porcelain. Not a lot of porcelain."

"Da Bai" was the kinship term for Ting Zan, my great-great-grandfather's oldest son, my grandmother's father. That might have explained why my grandmother had such misgivings about her grandfather. It was her father who worked so hard to support the family, to send his youngest brother to St. John's, to pay for his father's land and hobbies. I could imagine my grandmother connecting her father's tuberculosis to having worked himself to exhaustion to satisfy his father's myriad demands from back in Xingang. Ting Gong had aimed to study abroad after St. John's, as many of its graduates did. But his brother's death ended those plans, as it would have been difficult to leave the country without Ting Zan's financial support.

Everything Cong Ji knew about the porcelain was what he heard from San Yi Po, my grandaunt in Taiwan. "She was the eldest at home when they fled, so she knew," he said. "What became of that big cellar, I don't know, and I didn't ask. And then my grandfather was eventually chased out by people, so I don't know what happened to his things. Pei Yu asked me and I told her I didn't have the faintest idea."

"I heard that Grandfather was the big landlord of Xingang," I said.

"No, he wasn't the big landlord. He didn't have much land. How much exactly he had, I can't say, but it wasn't that much."

"But it sounds like your family was pretty comfortable."

"Relatively, yes, it was pretty good. But my grandfather, he was a very thrifty person, because he had been born very poor." He

chuckled. "I'll use an old expression. We weren't raised on being landlords, really. Our economy depended mostly on the people working outside the house, my dad, his brothers, and San Gu. They were all earning incomes. There was a bit of wealth in the family, but after fleeing the Japanese, after spending years in Sichuan, the money was spent."

It surprised me to hear Cong Ji say this, which contradicted everything I had heard about my great-great-grandfather. I wondered if it was just another by-product of him having been the spoiled and sheltered child of the family, or if it was a reflex he had developed, a narrative he created after 1949 that disavowed any insinuation of his grandfather's wealth, the sum of which should have furnished him, the only male heir, with a comfortable life, but instead became a cangue that he wore for decades and might still feel around his neck.

I asked him if my great-great-grandfather's house was still in Xingang.

"All gone," he said. "The government took the house and made a small cotton-processing factory. But the houses weren't enough, so they expanded. Then that year there was a huge flood. After the flood, everyone moved to higher ground. I don't know what happened to the factory after the flood, but it's not there anymore. I returned once in 1999, and all the houses were gone. Finished."

"Are you sure?"

"*Aiyou,* I didn't look that closely. Cong You took me there to have a look, and I couldn't find any foundations or anything. It was all water or fields. There used to be two big trees, a small road, and a grassy area. When I went, I couldn't even find the plot. It's all changed."

That was the first I had heard of a Cong You. I didn't know who he was, but the "Cong" in his name signified that he was of the same generation as Cong Ji.

"What do you think your grandfather thought of all those changes?" I asked.

"Grandfather, he didn't care about politics," Cong Ji said. "Of course, after Liberation, after they took his land, he had an opinion. He couldn't avoid having an opinion then." He gave a somber laugh.

"What about his sons? Did they have any opinions?"

"Da Bai and Er Bai all died young. The real changes didn't start until after the Japanese war, and by then they had all died."

"Er Bai" was the kinship term for Ting Geng. Cong Ji did not mention his own father. He paused for a long while before exhaling an "*aiya*," like a deflating tire.

I SPENT THE next morning in what remained of Jinan's old city and its famous springs. When I got back to Cong Ji's house in the afternoon, he had found a small black-and-white photograph of my great-great-grandfather, taken at a Jiujiang photo studio in the early 1930s. It was the first and only image of my great-great-grandfather that I have ever seen. He is seated on a wooden armchair before a painted landscape and wears a long coat and a fur hat from which tufts of white hair poke out. His wispy beard reaches his sternum, and his lips are pressed into the straight line that comprises a Chinese smile. Next to him stands a young boy of about five years old. "We only have this," Cong Ji said. "It was saved by San Gu." She had never shown him the photograph; the family discovered it while cleaning up her things after she died. Cong Ji wasn't sure if the boy in the picture was him or his older brother. "We never asked her who the boy was," he said.

San Gu returned to Jiujiang with the Rulison school after the Japanese surrender. She had never married, but not for lack of opportunity. Relatives introduced her to one man after another, including a doctor who had studied in France, but no one was ever good enough for her. Then, to everyone's surprise, in 1948, a year before the Communists took the mainland, she married a Kuomintang major general, Guo Wen Can, whom she had met through my grandmother

when Guo was stationed in Nanjing. Guo was tall, handsome, and well mannered, and San Gu fancied him as soon as they met. Few family members approved of the union, as Guo was a widower with three children and the Kuomintang's prospects in the war were dismal. But he was kind to San Gu, and she loved him. Despite the political uncertainty, my great-great-grandfather held a huge wedding banquet in Jiujiang to celebrate San Gu's marriage, under Kuomintang propaganda banners depicting the Communists as poisonous snakes and perverts.

San Gu continued teaching at Rulison while Guo was dispatched to the island of Hainan, where he was to cover the Kuomintang's retreat. He was successful, but his own troops were backed into Yunnan, and he was captured and sent to a prison camp for "war criminals" in Inner Mongolia. By the time San Gu received the news, the Communists were about to march into Jiujiang.

Guo remained in prison for nearly twenty years, until Mao's death, when he and other high-ranking Kuomintang officers were amnestied. He returned to his hometown in Hunan, where he received a residence, a small pension, and a titular position in the Chinese People's Political Consultative Conference. San Gu left Rulison, which had since been combined with Tong Wen into one school, to reunite with her husband. But he was on his last beam of light. His time in jail had made him short-tempered and violent. He forbade San Gu from speaking to other men. He went to his committee meetings and took long walks alone. They had no children of their own, and her husband's children ignored her—the old stepmother from Chinese folk songs. San Gu wrote to Cong Ji, pleading for him to rescue her.

She would spend the rest of her life with Cong Ji, who, in a reversal of his childhood, now took care of her. She remained a vigorous woman for many years, waking up early every morning to take a walk around the lake and then do tai chi. In the afternoons she listened to English programs on the radio—she didn't want to lose the language. At night she taught Li Nan to recite poetry. But then her eyes started

failing. Her ears followed her eyes, and she spent the last five years of her life bedridden, blind and deaf. The only way the family could communicate with her was by tracing out characters on her hand. She died in 1998, and her ashes were taken back to Xingang for burial.

"In our family there were three major characters," Liu Cong Ji said. "Grandfather, Ting Zan, and San Gu. When our economy turned for the good and we were richer, it was due to Ting Zan. But this big group of sisters, when it came to their *peiyang*"—he used a term that encompassed "cultivation," "nurturing," and "education"—"who was it? San Gu. She helped our family so much. Pei Yu, Pei Sheng, Pei Ke, and me, we were all raised by her. Ting Zan died early and we didn't get a chance to know him, but we all knew San Gu, and our family are all very grateful and affectionate to her." Cong Ji called her one of the family's two *gongchen,* ministers who performed outstanding service.

AS WE GATHERED around the kitchen table for dinner, Li Nan opened an ancient bottle of chardonnay, pouring it into thin jade *baijiu* cups about the size of shot glasses. "Who's driving tonight?" Cong Ji said. "Whoever's driving, don't drink!"

I had noticed that Cong Ji had mostly avoided talking about his father, Ting Gong, the youngest of my great-great-grandfather's sons. In one of our early conversations, my grandmother had mentioned that Ting Gong had gotten into trouble with the Communists but refused to elaborate. I had heard from other relatives that while Ting Gong was at St. John's, his father arranged for him to marry a girl from the Xingang countryside, the daughter of a wealthy but uneducated family. Ting Gong went along with it, but the marriage was an unhappy one. Ting Gong had received one of the finest educations available in China, and the gap this created between him and his wife, a farmer's daughter with little schooling or culture, was too far to bridge. Instead, Ting Gong fell in love with a beautiful, urbane cousin

who had studied medicine. He wanted to divorce his wife, but his father forbade it. After Ting Gong graduated in 1924, he took up with this cousin, a woman named Yao Meng Mei, in the provincial capital in Nanchang, while his wife and son remained in Xingang. My great-great-grandfather wouldn't allow him to bring his mistress home with him for the Lunar New Year, so Ting Gong stopped going home.

After dinner we all sat in the living room. "I didn't tell you the last couple of days, but if you'd asked, I would have told you," Cong Ji said. "After Liberation, there were antirightist movements beginning in 1957 throughout the whole country. And my father got labeled a rightist. At that time there were these big meetings and persecutions. All the rightists were the capable people. The people who had no ability, they see all these able people, so they used this campaign to clear the way for themselves."

Ting Gong was isolated, prohibited from communicating with anyone, and forced to attend meeting after meeting where he was publicly criticized and denounced for absurd reasons. "Later, he couldn't take it," Cong Ji said. "He committed suicide in 1958."

Cong Ji didn't learn of it until two years later, from San Gu. Ting Gong's label as a rightist had far-reaching consequences for his descendants, as the Chinese believed that *si bu hui gai*—the dead couldn't repent. At his job Cong Ji was "set aside," frozen out of promotions, ostracized from his co-workers, and under constant threat of persecution. He described spending those years with his tail tucked between his legs.

When the *gaokao,* which had been suspended during the Cultural Revolution, resumed in 1977, Cong Ji's son, Li Dong, registered for it and passed it, but as he prepared to attend university, the administration did a "political check" on his family, saw that his grandfather had been a "rightist," and invalidated Li Dong's test score. By the next *gaokao,* Deng had made the test open to all, and Li Dong passed it again and headed to Xiamen for college, where he learned that half of

the incoming students shared his experience. "Isn't this amazing?" Li Nan said. "It lasted so long, and so many generations felt the impact."

"That's not fair," I said.

"Of course not!" Cong Ji said. "They said that if any one of your family is one of the five bads"—landlords, rich farmers, counterrevolutionaries, criminals, and rightists—"the rest of your family was branded. Just as the emperors used to kill entire families of criminals, this was the same. That's the feudal system. If you belonged to the wrong family, they didn't give you any opportunity to advance. Mao, he was basically an emperor. He just used another name, 'chairman.'"

It wasn't until two years after Mao's death that the Deng Xiaoping–led government began to posthumously reverse the condemnations. In the 1980s Cong Ji received a letter stating that his father was no longer considered a rightist and had been rehabilitated. "We really appreciated that, remedying things," he said. "But the people are already dead. *Mei ban fa.*" Depending on the context, *mei ban fa* can mean "impossible" or "what can you do?"

As they emerged from the Cultural Revolution, the family was so impoverished that Cong Ji's wife used to bring back used medicine bottles from the hospital to use as storage, and the boxes the bottles were packed in, too. If she was out and came upon an old brick, she'd pick it up and bring it home. "If you collected enough bricks, say seven per stack, and put a piece of wood on top of the legs, then you had a table," Cong Ji's wife said.

Purchasing goods, from cloth to bicycles, required ration tickets. Si Yi Po, due to her and Fang Zhen Zhi's jobs in Beijing, was able to acquire more tickets than she needed, and she sent the extras to Cong Ji's family. "I remember when we got our first television, a tiny nine-inch black-white one," Li Nan said. "Si Yi Po pulled some strings so that we could buy one. And once we got it, our house turned into the neighborhood theater."

"We were the first adopters of all the new things," Cong Ji said. "The first to get a television, a refrigerator, a washing machine, an

electric fan. Boy, people were jealous of us then. They really envied that fan. And then we got a new television."

"No," Li Nan said. "First, we got a magnifying glass in front of our old one. Turned it from a nine-inch to a twelve-inch!"

"Yes, but then we bought a proper twelve-inch color television," Cong Ji said. "Si Yi Po helped us get that, too. She was always the first to get new things."

"You know, I think that's all from old Grandpa," Li Nan said. "I mean, back then, they had a saying that the only girls who were any good were the ones who didn't know anything, but he sent all five of those girls not just to school but to Western schools. He was so ahead of his time, so open to new ideas and things. That got passed down to the girls, and they kept it going. I think that's probably one of our family's greatest traditions."

A STUMBLE FROM WHICH THERE IS NO RECOVERING

F OR MY GREAT-GREAT-GRANDFATHER, THE RELIEF FOLLOW-ing the Japanese surrender was short-lived. The Chinese civil war reignited almost as soon as the Japanese departed, the Kuomin-tang and Communists racing to seize control of the former Japanese-occupied territories. The government was bankrupt from the years of fighting, and inflation further demoralized the country. Even the National Palace Museum treasure trucks remained in the country-side, unsure if they should return to Nanjing. Skirmishes escalated between the Communists and the Nationalists. My great-great-grandfather, never one for politics, fended off overtures from both sides and followed the fighting in newspapers. He couldn't abide the venality of the Qing before, and he didn't stand for the Kuomin-tang's corruption now. But he couldn't possibly have agreed with the Communists "redistributing" his land, for which he had worked and saved so hard, and which two sons had died in the process of acquiring.

Jiangxi was the birthplace of Communism, where Mao founded the Jiangxi soviet, and where the Long March began. While my great-great-grandfather was inclined to side with the Kuomintang, most of his sharecroppers sympathized with the Communists, who offered the irresistible promise of being able to take and own the farmland they rented from their landlords. But in villages like Xingang, where

the families had known each other for centuries, an unspoken agreement was enforced. When the Nationalists came through hunting for Communists, Liu would warn the peasants and hide them in his home if necessary. When the Communists prepared for smash and grab campaigns against wealthy landowners, the peasants would tell Liu in advance and let him know where he could hide. After a few days, things would settle down and return to normal.

Despite vast amounts of foreign financial and military aid, Chiang lost battle after battle. Inflation rose to devastating levels, further eroding his power base, and waves of intellectuals, students, and professionals defected to the Communists. As the Communists advanced, many of the wealthy sold off their homes and land and moved their money and collectibles abroad. One day Liu received a letter from a friend in Beijing reporting that the Communists—who had built up a strong base in northern "liberated" China, while the south remained under tenuous Kuomintang control—were close to taking the country, and to prepare for the worst. "If meat costs one hundred silver dollars per *jin*, buy it," the friend advised. "But whatever you do, don't buy land, even if it's offered for only one dollar per *mu*."

As a Communist victory appeared more and more likely, Liu's only remaining son, Ting Gong, urged him to leave. "You'd best sell off this place and our things quickly," he said. "The Communists aren't like the Japanese. They won't ask you to collaborate with them. They won't respect your education or your property. They're going to come after you."

But Pei Fu's husband, who unbeknownst to most had recently switched allegiance to the Communists, assured him he would be safe. "What's this I hear about you leaving?" he said.

"Number Three says we need to leave," Liu said.

"Are the Communists not still Chinese?" Pei Fu's husband argued. "They'll take care of their own people, no matter their politics. Don't go."

"If you don't leave, you're going to regret it," Ting Gong said.

Most of the landlords and rich peasants in Xingang didn't leave. As wealthy as they were for the area, it was all relative, and going abroad, even to Hong Kong, was about as feasible as moving to the moon for them. But of all the people in Xingang, my great-great-grandfather should have known better. Had he not foreseen the end of the Qing and China's subsequent industrialization and Westernization? Maybe he had already experienced enough turmoil and displacement in his lifetime. Maybe he thought nothing could be as cataclysmic as the end of the Qing dynasty. He was nearly eighty, and maybe he couldn't imagine spending the rest of his life, or dying, far from home. The information he gleaned from his newspapers suggested that the Communists would take only "what was empty." A *gang* full of wheat or rice—and other spoils of personal investment or toil—would be left alone. He just couldn't believe that the Communists wouldn't respect a man's personal property.

Ting Gong, with whom my great-great-grandfather had reached détente over his mistress, fulfilled his filial duty by staying at the house. But he did get my great-great-grandfather to agree to a few precautions, and with Old Yang's help they buried his silver, his remaining valuables, and most important, the stack of his deeds to his properties and farmland, the proof that he was a landlord.

When the Communists declared victory a few months later, it was too late for my great-great-grandfather to leave, and he was past the age of running anyway. He had done it once before, when the Japanese invaded, and he hadn't been a young man then, either. But his conscience was clear. He had never committed a crime and had done not a few good things in the village. So he stayed, and the Communists found him without much trouble, alone in his empty manor on the western edge of town, sipping the small cup of warmed sorghum wine that he had every evening, a tonic for warding off arthritis. As the area's wealthiest landowner—the most hated oppressor in the Communists' class struggle—Liu knew they would come for him

first. He stood up, as if he were expecting them, and told them to get on with it.

The Communists had begun executing landlords all over China, retribution for the "crimes" they had committed on peasants and farmers. In Xingang, they hung landlords from trees and beat them or made them kneel on ice for hours. They tortured the women in landlord families by forcing them to walk across frozen ponds in their bare—and often deformed-from-footbinding—feet; as interested as the Communists were in a new China, old habits like one person's crime staining an entire family died hard.

As the local cadres embarked on Mao's promised land reforms, they held a public meeting in the village, where they tied up my great-great-grandfather atop a table and accused him of being a *tuhao lieshen*, or "shady gentry," who'd fattened himself on the people's blood. "You took everything the people grew and kept it for yourself!" the cadres shouted. "How could you have inflicted such evil on the people?"

"Say whatever you want," Liu said. "I don't care. My wife and sons are already dead. The sooner you kill me, the sooner I see them again. And I'll thank you for the opportunity, even as you chop off my head."

The cadres urged villagers to condemn him. But while plenty of villagers had found themselves on the receiving end of a tongue-lashing over the years, no one was willing to step forward and accuse him of being anything more than temperamental. Finally an old woman spoke up. "You people have no conscience," she shouted. "All these years, everything you ate and drank, wasn't it from him? The land you farmed, it was this man's. During the droughts and floods, when there were no provisions, wasn't it this man who took care of you and made sure you ate? Now that he's filled your bellies and raised you into adults, you want to persecute him?" The Communists dragged her away before she could say more.

No one would turn on my great-great-grandfather, so the cadres took him down. Still, they couldn't allow him to go unpunished. So,

like thousands of other landowners, my great-great-grandfather had his house, his property, and his belongings taken from him and was told to *saodi chumen,* literally "sweep the floor and leave."

He moved into a hovel on the edge of his property, made of dried mud bricks and formerly used as a storeroom. Ting Gong's wife followed him. Some villagers tried to take care of him, slipping him food at night. He lived in that small room without a bed or windows for half a year before dying. According to San Yi Po and Si Yi Po, my great-great-grandfather died from repeated beatings. According to Liu Cong Ji, it was cancer. The discrepancy seemed to say as much about my relatives as it did our history. Liu's only surviving son, Ting Gong, buried him in the family cemetery on the hill between the fishpond and Poyang Lake, where he joined all the other ancestors in looking upon the land that no longer belonged to them.

THE NINE RIVERS

TRAVELED TO JIUJIANG THE SAME WAY MY GRANDFATHER'S porcelain had—through Jingdezhen. For centuries porcelain moved out of Jingdezhen on the Chang River, through Poyang Lake to Jiujiang's customhouses, a journey that took days. But that water route has been replaced by highways and flight patterns; the locals I asked in Jingdezhen weren't even sure if it was still possible to reach Jiujiang by boat. Now, after boarding an early-morning bus, the trip to Jiujiang was an uncrowded ninety-minute ride on a brand-new coach still smelling of plasticizer.

Jiujiang was the rare Chinese city that appeared smaller than I expected, a web of narrow streets enclosed by the Yangtze River to the north, Lushan to the south, and lakes to the east and west. As the bus crawled into the city center, I saw no pre-Mao architecture but also little new construction. Even Jingdezhen seemed to have both more ancient neighborhoods and more development, and Jiujiang felt passed over and decaying. I took a taxi from the Jiujiang bus station to the Bayi Hotel that Tang Hou Cun, my grandmother's local cousin, had booked for me. Bayi, or "Eight-One," referred to the August 1, 1927, founding of the People's Liberation Army.

I dropped off my things and went to the lobby to wait for Tang Hou Cun. Instead, Pei Fu's son, Chen Bang Ning, showed up. He reported that Tang Hou Cun had gone fishing, and since we had some

time before Tang Hou Cun got home, he would take me for a walk around the city.

Chen Bang Ning was barely sixty but appeared much older. His hair still displayed the side on which he had slept, his bloodshot eyes ran with mucus, and he had a phlegmy cough that he never covered. His neck seemed to be under constant strain. He smelled of cigarette smoke and alcohol and walked with a slight limp, which didn't stop him from wading into traffic whenever he felt like crossing the street. He was hard of hearing and spoke in a shout. "Do you have that photograph of your mom and her brothers?" he said, assuming I knew which one he meant. "We had one but couldn't keep it during the Cultural Revolution. We had it really tough back then, all the people suffering in denunciations, suicides. It wasn't until Deng came up that things improved."

On our way to the Nengren Buddhist temple, we stopped at a former missionary hospital, now engulfed by a modern medical complex. Only a single cornerstone remained, carved with the Chinese characters for "Water of Life Hospital" and protected behind a Plexiglas cover. Farther on was an old mission compound, including a Catholic church complex built by the French, its former soccer field having been turned into vegetable gardens. Inside the temple gates we paused at a rain stone, a rectangular block of granite, the top of which centuries of raindrops had worn into a bowl, placed there to display nature's relentless power and to serve as an example of persistence.

"I remember very clearly, I was twenty years old, just graduated from high school, and ready to take the *gaokao*," Chen Bang Ning said. "But there was none that year, and we all came over here to smash things."

"Why did you do it?" I said.

"You didn't have a choice. If you didn't go, you were labeled as a reactionary. They smashed all the Buddhas and dragged out the monks trying to protect them. I didn't smash anything, but I went along."

I asked to see old Jiujiang, but Chen Bang Ning said that other than a few houses on one street, nothing from my grandmother's time was left. So we walked to the Yangtze and climbed up the levee to see the water, the color of a dirty mop and catching the apocalyptic sun's colors. Cargo ships drifted in both directions, dwarfed by the wide river. Xingang was about ten kilometers downstream, Chen Bang Ning said.

We walked back to one of the lakes that Jiujiang arranged itself around and boarded a city bus for Tang Hou Cun's house. Along the way Chen Bang Ning pointed to a building in the distance, where San Gu spent many years before going to live with Liu Cong Ji in Shandong. "During the Cultural Revolution, I worried so much that she'd commit suicide," Chen Bang Ning said. "I'd visit her every week to check on her. And she was worried that they would pick me up. We all had culture, so we suffered. We were considered bad people. It's amazing how those events determine the lives of everyone afterward. They could have so easily been in each other's positions. It's all luck."

Chen Bang Ning told me that I was the first member of the family to visit since Lewis had passed through in 1985 on business. "When Lewis came, we were probably the equivalent of Taiwan in the fifties, but we'd already started to improve," he said. "And the last twenty-five years, each day has been better than the last. You see how much of a country's development depends on the ups and downs of life? The politics weren't right for us, but they are now."

Tang Hou Cun lived in a bright three-bedroom unit on the fifth floor of a six-story low-rise for retired electric company employees. He was my grandmother's cousin on her mother's side. His grandfather, Tang Hua Xian, had been born the same year as my great-great-grandfather and passed the imperial examination in the same year, 1895. For many years my grandmother sent money back to his family.

Tang Hou Cun seemed much younger than eighty, moving lightly and with an unhurried primness. He had a thin, long face with hollow cheeks, deep-set eyes, and dyed hair. His seafoam polo shirt was

tucked tightly into gray checkered slacks. "This house is nothing compared to what you're used to in the States, I know," Tang Hou Cun said. "It's very inferior. But we live very comfortably."

We sat down at a square table for the meal that Tang Hou Cun's wife had prepared. Crucian carp that Tang had caught in the morning ("I caught twenty-four pounds today!" he said), sautéed in oil and then simmered in garlic, vinegar, and soy sauce and thickened with piles of roe; quick-pickled cucumber; fatty pork and dried tofu in soy sauce; crispy duck; green beans sautéed with homemade sausage; and a soup of greens, tomatoes, and farm eggs. In keeping with Chinese manners, Tang's wife apologized for the food. "This is just a simple meal with what we have at home," she said.

I was stuffing my mouth as quickly as I could swallow but managed to say, "This is delicious."

Tang Hou Cun brought out a special *baijiu,* explaining that this variety's name had something to do with fate; he repeatedly said that it was fate that had brought me to Jiujiang, and toasted me after nearly every bite. "Here's to you, the first of your generation to visit us," Tang Hou Cun said. "We're so happy you came. Someone from my grandson's generation has finally come." The wine burned all the way down but left behind a pleasant, floral aftertaste. Once I had nearly finished all the food on the table, Tang's wife brought out the rice. "To fill up the space that everything else didn't," she said. "You've hardly eaten anything."

Most of the small talk during dinner took place in the local dialect, about family members for whom I couldn't keep the relationships straight, and family stories that I couldn't understand. I gazed around the house. Scrolls of calligraphy hung on the walls, and the display cases separating the living and dining rooms were full of porcelain. I tried not to act too interested but remarked that it looked like he was a collector. "Yes, I used to go to Jingdezhen all the time, but now I just buy things in Jiujiang," Tang Hou Cun said.

After dinner Tang Hou Cun showed me the books of poetry and history that he had written, and photocopies of my grandmother's records from Rulison, along with an article that she had written celebrating Rulison's sixtieth anniversary in 1932. I couldn't read it but expressed my admiration. Tang Hou Cun repeated much of the family history that I already knew, but with a special focus on and obvious pride in its intellectual achievements.

"We can tell right away that you're very adaptable, not like Lewis and Richard, who are so bossy and temperamental," Tang Hou Cun said, the *baijiu* having loosened him up a bit. Lewis's trip to Jiujiang came up frequently over the evening, and I got the sense that it had left some scars. "We're glad you don't have the character of those two brothers. They have no interest in Jiujiang history or culture or even their family here."

Tang Hou Cun's younger son showed up, a friendly, chain-smoking man with a flat top. A short discussion about what I should call him followed. He was one generation older than I was, so we settled on "uncle." Perhaps my struggle to understand the arcane kinship terms made Tang Hou Cun worry that we weren't going to be able to communicate. "I know a guy, Yin, his son made a fortune in English schools," he said. "Let's go see if he can translate for us."

A wealthy local seemed like a good contact to make, so we stumbled out to the lake, tracing its shore to a gated community of quasi-Western villas and streets lined with foreign sedans. Tang Hou Cun's friend Yin was eighty-three years old and also from Xingang but had lived in England and the United States before he returned to the mainland and married a Taiwanese woman.

Yin and his wife were not expecting us but were too polite to turn us away, so he invited us in, and his wife disappeared into the kitchen to make tea for us. It was a grotesque house, with vaulted ceilings, imitation leather sofas, metallic floral print pillows, and a flat-screen television in the fireplace. The walls overhead were peeling. Yin's son

and grandson were in the next room, but he didn't introduce us. Tang Hou Cun did the talking, and I kept quiet, not understanding the conversation but feeling that I was being sized up. After a few minutes, we stood up and left. Yin had decided not to help.

Tang Hou Cun was good and drunk now, and outside the house he returned to trashing the Chang brothers. "Richard, he came here in 2008 and he didn't even tell us!" Tang Hou Cun said. Richard had considered Jiujiang as a site for a manufacturing facility, and after his tour the city's daily newspaper had splashed a photograph of him with local officials above the fold; Tang Hou Cun had kept a copy of the paper. "That's how we found out about his visit. Can you believe this? Why would he not recognize his own family? We should all have been part of this, to show that he comes from a prominent, cultured, educated family, not some farmer's family. Hang on, I need to take a leak."

Tang Hou Cun walked up to the side of one villa and emptied himself against its wall. "But if he doesn't want to contact us, that's his business," he concluded. "Maybe they think mainlanders want their money. But look, I'm comfortable, what do I want money for? Yes, we've been poor, but we're not poor of mind."

I RETURNED TO Tang Hou Cun's apartment in the morning. We sat in the living room, the sun streaming in while his wife snapped the ends off green beans. On the coffee table were baskets of apples and oranges and peaches that his wife had picked the day before. Military jets screamed overhead every few minutes, setting off car alarms.

Tang Hou Cun's family had owned land, but his father was a gambler and opium addict who sold off his property piece by piece to pay for it. Si Yi Po had described Tang Hou Cun's father as a *baizi*, or wastrel, and said that he once stole his wife's earrings—one of the last items of value that the family owned—right off her ears. Tang's father's first wife was a *shinu*, a stone woman, who bore him no children.

His second wife gave birth to many children, but only a few survived. By the time Tang Hou Cun came along, his family had regressed beyond genteel poverty. The only remnants of their former glory were nineteen cases of books, which his father used to kindle fires.

"My family waned," Tang Hou Cun said. "Only the Liu family, they radiated. There were dozens of people who possessed land in Xingang, but they didn't develop like this, they didn't have relatives in America. Grandfather had culture and knowledge, those were his mediums. He knew that there was no future in farming. Look at how many Lius went to missionary schools. Think of how much that all cost."

"Does anyone still remember him in Xingang?" I asked.

"Faded out," Tang Hou Cun said. "After three generations, who would know Liu Da Xian Sheng?" He repeated the moniker that the villagers used for my great-great-grandfather, "Lord Liu."

When Tang Hou Cun was still young, his father died of tuberculosis, and my great-great-grandfather stepped in to support his family. Tang remembered playing at the Liu house as a child, visiting during the Lunar New Year, and having to kowtow upon entering the house—he described it as "a mansion." Liu had even selected Tang's name for him, which meant "abundant purity."

But my great-great-grandfather didn't take Tang Hou Cun and his mother to Chongqing with him, leaving them in Xingang to spend the Sino-Japanese War under Japanese occupation. Tang recalled the Japanese soldiers as "short and fat. They liked to wear jockey shorts. They looked ugly to the Chinese."

"How did they treat you?" I asked.

"Very nice," he said. "A Japanese lieutenant came to my family and offered wool yarn in exchange for our things." Sometimes a soldier, whom the locals called *taijun,* a term of respect that the Japanese demanded, might offer him a peach or a piece of chocolate. "Our life was okay. As long as you could farm, you could live."

"The Japanese didn't take your crops?"

"No, not for all the years they were here."

"Unlike the Communists."

"The Communists, well, they messed things up. They changed policies, launched movements."

Tang Hou Cun's prodigal father turned out to be a blessing once the Communists took over. The family was classified as "poor peasants," which saved them from the worst persecution, and the Communist policy of opening doors to workers and peasants allowed Tang to apply for a study allowance. He enrolled in school and seemed poised to gain an advantage that had seemed impossible just a few years earlier. Then in 1956 the government unveiled a campaign encouraging citizens, especially intellectuals, to express their opinions, criticisms, and advice for the regime. This campaign became known as the Hundred Flowers Movement, from Mao Zedong's statement "The policy of letting a hundred flowers bloom and a hundred schools of thought contend is designed to promote the flourishing of the arts and the progress of science." The response was muted at first, and Mao had to put his full weight behind the movement to get it going, practically begging for intellectuals to air their grievances. In the summer of 1957 came a deluge of criticisms, most of which would not have been out of place today: corruption and overprivilege among party cadres, government control over intellectuals, poor standards of living, the punitiveness of earlier campaigns against dissenters and "counterrevolutionaries," the culture of fear and silence created by the government, irrational planning practices, and neglect of children's education. The unprecedented freedom of speech led Peking University students to cover a wall—dubbed "Democratic Wall"—on campus with posters critical of the government, and student protests erupted in cities across the country.

Tang Hou Cun got caught up in the zeitgeist, making critical comments of his own. By July 1957, however, Mao quickly reversed course. The government announced its antirightist campaign in August 1957, right when Tang Hou Cun was starting his first year at

Jiangxi Normal University in Nanchang. For more than 300,000 intellectuals, their reward for obeying Mao's initial instructions was to be deemed "rightists" and enemies of the state. The label not only ruined their careers in China but also resulted in them being sent to jail or labor camps, or exiled to the countryside for the rest of their lives. Students were executed. Others, like Liu Cong Ji's father, Ting Gong, were driven to suicide.

One of the ways the government rooted out "rightists" was by issuing a quota. Mao claimed that at least 5 percent of the population consisted of "rightists," and as the campaign wore on, the quotas were raised. Any work unit or school class that found itself under the quota had to fill it by any means. At Jiangxi Normal University, Tang Hou Cun was added to the rolls of "rightists" and expelled from school. He was fortunate to manage to find work at the electric company, where he stayed for the next fifty years. In his free time, he continued to study classical literature, practice calligraphy, and write poems and essays on literary theory. "The Tangs and Lius had this principle, 'Study is the only good thing to do in the world,'" he said. "I did the electric company to eat, but my heart was always in this, culture."

During the Cultural Revolution, Tang threw all his books, including San Gu's collection that had ended up in his possession, into the street so people wishing to destroy the "four olds" could trample them with their feet. "The Cultural Revolution was more severe than anything Qin Shi Huang did," Tang Hou Cun said, referring to the Qin dynasty "First Emperor" of a unified China in 221 B.C., who, in an attempt to destroy any schools of thought or opinions that conflicted with his own, as well as histories that might undermine or diminish his legacy, had the entire archives burned and buried hundreds of scholars alive.

Tang Hou Cun ran back to his library and emerged with a set of threadbound books by a Tang dynasty writer named Han Yu, printed in the 1920s and 1930s. "I bought these in Shanghai during the Cultural Revolution," he said. "Paid twelve *kuai* for them. I reckon

they're worth about twelve hundred *kuai* now, though I'd never sell them."

"How did you manage to buy books then?"

"If I'm throwing out books here, and I buy a few there, who's going to know?" he said. "I couldn't not buy them."

He scurried back to the library to bring out more. Ming dynasty texts, wood-block prints, books from Republican-era publishers. I flipped through them politely and then asked about his porcelain.

Tang excitedly guided me through the living room displays: Ming bowls, blue and white ginger jars, a pair of cloisonné vases, Cultural Revolution porcelains bearing Mao's slogans. He took out a pair of plates painted with a large blue and red fish. "The family had tons of these," Tang said. "We used them around the house."

Then he led me to the spare bedroom, with two cabinets packed with porcelain, some of them marked with imperial seals. He handed me a squat celadon jar with a Kangxi reign mark. "This is from our house," Tang said. "Your grandmother has seen it. She'd recognize it from her childhood."

Finally, he showed me a broken *fencai* teapot marked with Guangxu's seal. "It's real," Tang said. "Your grandmother would also know it. These are all from our old house. I saved them."

Tang said he knew all about the story of the buried porcelain, so I asked him if he remembered seeing any items in Liu's house after the war.

"Let me tell you," Tang Hou Cun said, "all that porcelain Grandfather Liu had on display at his house, it was all from official kilns."

"What about your porcelain collection?" I said. "Were any of those from—"

"I don't have much porcelain anymore," he said, leading me back to the living room and placing me on the sofa. "I also bought coins. Here, I'll show you."

He disappeared into his library again and came out with a box of coins—bronze Han and Song dynasty *wu zhu qian* coins with square

holes, *kuan yong* Japanese coins, Republican silver dollars. "I bought all these Han bronze coins here," he said. "There are so many fakes, but these are real. They were definitely taken out of the ground."

"Did they dig up people's graves during the Cultural Revolution?" I asked.

"No, not then. That came later, based on economic reasons. My old grandfather's grave was looted two, three times."

"What about the Liu family?"

"No, probably not, because the cemetery was near the village. But I can't say for sure. There were some bad eggs in the Liu family."

[18]

THE LONG VALLEY

I HAD PROMISED SAN YI PO THAT I WOULD LOOK FOR THE family's villa on Lushan, so like my fleeing relatives seventy years earlier, I made the trek up the mountain to the former summer resort of Guling. But instead of walking, I rode with Tang Hou Cun's son. On our way out of the city, we stopped at a friend's office to grab a laminated set of papers, which he said would help us on the mountain. After a smooth highway ride for about ten miles, we reached the foothills, and for the next ten miles we made one nauseating S-turn after another up the mountain, Tang burning through a pack of cigarettes along the way. Just before I was sure I would vomit, we reached the tollbooth on the summit. "Let me do the talking," Tang said. He presented the papers, explaining that we were local police inspecting the speed limit signs, while I struck my best arrogant official pose. The tollbooth operator let us through, saving us from paying the entrance fee and, Tang explained, allowing him to take the faster return route down the mountain.

We motored onto Guling's main drag, colonial storefronts on one side and an unobstructed view of the valley on the other. Up the mountainside, veils of fog snagged on spruce, tulip poplars, and blossoming dogwoods, revealing red-and-blue-roofed estates. We made a left at the clock tower in the center of town and, after knocking on a door to ask for directions (and Tang relieving himself on the man's

doorstep), found the youth hostel that I had booked, a sturdy stone building sunk into the mountainside below the street.

The story of Guling began in Victorian England, where a twenty-year-old Cambridge University student named Edward Selby Little fell under the influence of the American evangelist Dwight Moody. A firm believer in the English right to rule, obligation to disseminate its culture, and privilege to be rich and imperial, Little prepared himself for missionary work in California before receiving a mission post in China.

In 1886, at twenty-two years of age, he landed in Shanghai with his wife and headed to his post in Jiujiang. Before Little, most missionaries in China could be dismissed as, in the words of one contemporary observer, "educated, characterless nonentities." They spoke little to no Chinese and came prepared with little more than the Victorian assuredness that the world would bend to their will. But Little mastered both spoken and written Mandarin and proved himself an extraordinarily capable missionary, raising money, building churches, and winning converts like few others.

After a few years of watching his colleagues languish in the fetid summers of Jiujiang, he formed a plan to build a retreat for Europeans on nearby Lushan. He envisioned it as an alpine resort where they could recover from and escape the smothering heat, insects, and illnesses that characterized the Jiujiang summers. Little turned his attention to the mountaintop, where he found "a wild waste and a few stray charcoal burners. One solitary temple broke the solitude, or rather emphasized it. There were no persons claiming ownership of this land as far as could be ascertained."

Little's mastery of Chinese had been a prescient accomplishment, for the fulfillment of his plan became a saga that would bring him into conflict with almost every level of officialdom of the day. He had the gall to believe he could not only have the mountain but also make it into a town, using what amounted to local Chinese slave labor to dig a road and haul goods, furniture, and building material to the

top. He was beaten and his house was broken into, but he would not be swayed. He didn't persuade the mandarins so much as he wore them down.

Eventually Little achieved his vision. The "wild waste" developed into a pleasant village with almost a thousand lavish summer homes, dozens of churches (including a synagogue and a mosque), at least three swimming pools, and a sanatorium. But its heyday didn't last long. The Sino-Japanese War reached Lushan in 1938, and foreigners were ordered to vacate their homes by February 22, 1939. Kuomintang generals moved into Guling's villas—Chiang Kai-shek's wife, Soong Mei-ling, a devout Christian, patron of the missionaries, and the owner of one of the largest villas on the mountain, had been a fixture on the Guling scene for years. Zhou Enlai, years before he became China's premier, traveled to Lushan as the Communists' negotiator to persuade Chiang Kai-shek to unite against the Japanese; a few days later Chiang delivered his famous speech that marked the turning point of the war. After the Communists seized China, the government held two major party meetings on Lushan, endowing the villas with a "Washington slept here" importance that, perhaps more than anything, had saved them from the wrecking ball. Now Lushan's mansions were divided into hotels, residences, and memorials to Chinese luminaries.

I made a tour of the town, marveling at its cleanliness and the melting pot of architectural styles, from Gothic turrets to Japanese gardens. One of the largest and most handsome of the old villas, Villa 175, was a thick medieval stone complex with a sprawling driveway guarded by a row of robust seventy-foot-tall pines. According to the mistake-ridden sign at its entrance, it had been built by an Englishwoman in 1896 and then sold to an American missionary, who in turn sold it to the Kuomintang in 1946. That same year the American ambassador John Leighton Stuart resided there, and during the 1970 Lushan conference Mao himself had stayed there. There were no neon tubes or electrical wires defiling its edifice. The windows had not

been replaced with the white, modern frames that were so common with new construction. Except for the short tongue of red carpet, the same shade as the Chinese flag, protruding from the doorway, the villa's exterior appeared untouched. The front door was open, and I walked inside, where I saw a small counter and many Chinese-style conference rooms. A pair of employees carrying folded white towels chased me out, barking that the villa was "not open."

I found my way to the creek and He Dong Lu, the street to the creek's east and the site of Soong Mei-ling's former property, the Meilu Villa. According to San Yi Po, our family's villa was on the other side of the creek. I bought my ticket to the Meilu Villa and toured the grounds. It was the only villa where both Communist and Kuomintang leaders stayed. In 1959, when Mao arrived for the party conference, he entered the Meilu courtyard and supposedly shouted, "Chiang, here I come!"

I left the Meilu Villa and continued down the road, entering the former American quarter. I passed the Kuling Hotel, its name painted in red and still visible on the wall, a textbook businessman's house, and the old library, KVLING carved above its threshold, to an Episcopal church with stained-glass windows. (Little and other foreigners had modified the spelling of Guling to emphasize its cool summers.) At the bottom of the street was the former Kuling American School, a large four-story stone building that had been transformed into a hotel, air-conditioning units attached below its blue-framed windows like ticks. The school used to sit above two tiers of soccer and baseball fields, but the woods had reclaimed the clearings.

As the light faded, only the white of the dogwood blossoms broke through the palette of fog and moss. I looped back to He Xi Lu, where San Yi Po said I would find our family's villa. I walked the entirety of He Xi Lu, inspecting every building I saw, but I found nothing resembling the row of villas that San Yi Po had described, just a stretch of wild land with a scattering of shabby buildings, a woodshop that the men inside told me had been built after 1949, a few newly constructed

hotels, and an office for which no one knew the history. There were no villas directly across from Soong Mei-ling's; the closest one had been turned into a memorial for Zhou Enlai, because he had stayed there for a time. The woman posted at the entrance didn't know anything about the place and shooed me away.

I headed back to the main drag for dinner. Tang Hou Cun had put me in touch with an Uncle Cai, a relative on my grandmother's mother's side who lived in Guling, and he was waiting for me at a restaurant styled after a Qing dynasty teahouse. Cai was the head of a state business development enterprise that rented out properties. He estimated that of the nearly one thousand villas built during Little's time, approximately eight hundred remained. The city had renovated the exteriors of the post-1949 buildings on the main shopping street to match the historical architecture, and it had prohibited new construction that either interfered with views of the mountain or destroyed historic buildings. Some of the new buildings were so faithful to historical designs that I couldn't tell the difference. "There are no other places like Lushan in China, a mountain town like this," Cai said. "It's unique."

Over *mantou*, sparerib soup, cabbage, and chicken with tofu, Cai admitted that some villas had been torn down. "Twenty years ago we started one of the first projects in town," he said. "We didn't think about history or culture and tore down twenty-four villas before we realized we were wrong. It's a real shame. Yes, the business aspect of the project was improved, but it couldn't compare to what we lost in culture and history. I still feel bad when I think of it. That first mistake was our tuition in learning how to do things better. Now all new buildings have to be architecturally similar to the historic ones, and you can't touch exteriors of the old buildings except to restore them."

Perhaps the villa of San Yi Po's memory had been one of those torn down. I brought up my great-great-grandfather's property in Xingang, and I told Cai that I hoped something could be done about returning it to the family.

"If your uncle Richard had mentioned this when he came to Jiuji-ang, they would have preserved all that land and rebuilt the house," Cai said. "When Richard came back, he didn't even mention his connection with Jiujiang at all. Not a single mention was in the paper. My older brother was the number one in Xingang, and last year he told me to go find Richard and ask if he wanted their land back. But I don't know him. How am I supposed to get in touch with him? Now it's too late. They're auctioning it off to factories."

Lushan was an oasis, but I couldn't stay on the mountain. I knew I was nearing the end of my search and that a showdown awaited. I rushed through the meal so that I could catch the evening screening of *Romance on Lushan,* one of the first post–Cultural Revolution movies produced in China and filmed on Lushan. Built in 1897 for four thousand silver dollars, the movie theater at the head of He Xi Lu had originally been the Union Church. The photograph in the lobby depicted a magnificent church with a peaked roof that doubled the building's height, but the caption made no mention of its original purpose, simply reading, "Theater's original form in 1897." It was converted to a theater, and its roof flattened, in 1960. On one wall hung a framed certificate from the Guinness group recognizing *Romance on Lushan* for setting the world record for "longest first-run of a film in one cinema"; the movie had played in this theater every day since its opening on July 12, 1980.

I shared the theater with about a dozen Chinese tourists, who smoked and talked through the entire movie. Released in 1980, *Romance on Lushan* was one of the first films made after the normalization of relations between China and the United States and told the story of Zhou Yun, the daughter of a retired Kuomintang general now living in America, visiting mainland China for the first time in 1972, during the Cultural Revolution. While touring Lushan, she meets a young man, Geng Hua, and they fall in love. Unfortunately for them, Geng Hua's father is a Communist general who attended the same military academy as Zhou Yun's father. They followed different

parties and were rivals during the civil war, so the romance is doomed to fail. The film was dated yet charming in its limitations—depicting America and American life with any authenticity was impossible for a movie shot entirely in late-1970s China—and political correctness. A painfully long, overwrought scene of Geng Hua and Zhou Yun consists of them in a sun-dappled forest shouting "I love my motherland!" under the pretense of Zhou Yun teaching Geng Hua correct English. But the plot is pure Hollywood, the lovers reuniting on Lushan after the Cultural Revolution in 1977 and their fathers burying the hatchet between them.

I wasn't expecting such an emphasis on reconciliation over dogma, just another of the many surprises I encountered in China and a reminder that this iteration of the country was only about as old as I was. Like Zhou Yun in *Romance on Lushan,* I was the offspring of Kuomintang loyalists, and though my journey to Lushan had not resulted in a romance, I did find a kind of love, if to love something is to accept it.

As an American in China, I had first found my footing in the vestiges of Western visitors to the country. That's what I found so attractive about Shanghai's colonial architecture, Ginling College, Guling. But as a *huaqiao,* I could also connect with the stories of international Chinese. That's why I was so affected by my granduncle Fang Zhen Zhi in Beijing. Yes, his life corralled China's modern history into an elegant personal narrative, but the part of his story that drew me in was not his coming of age in Republican China, or his work with the Chinese nuclear program, or his survival of the Cultural Revolution, but his having studied in Colorado and Missouri. As I untangled the antecedents to his going abroad, I was reminded that the country that had introduced itself to me as chaotic, brutal, and retrograde had a long history of often very progressive intellectualism, and that the centuries of exchanges between China and the West were neither unidirectional nor unequal. Being a *huaqiao* revealed a new world that I,

by an accident of birth, could explore with as much or as little con-frontation as I chose. I began to understand the concept of a *huaqiao* not as a burden but a privilege.

My passage through this former missionary holiday village, where its sturdy architecture masked its transience, made me wonder if per-haps the opposite could also hold true, if in the fleeting I could find something permanent. Could China be separated from her places, people, and things? I thought again of Fang Zhen Zhi, whose love of family and country made him give up pursuing an American Ph.D. and return to wartime China, and who was paid back for his loyalty with years of persecution. And yet when I spoke with him, his patri-otism remained. The China that Fang Zhen Zhi loved might never exist again (if it had at all), but as long as the memories of it survived, it could remain eternal, both a product of China and wholly tran-scendent, just like the porcelain I sought. Corporeal beings eventually leave the world. Places persist under the capricious rule of bulldoz-ers. Stories—of my family, of bygone China—don't have to die. Even their fragments can be reassembled.

And in China there are shards everywhere.

XINGANG MARKS THE SPOT

FTER THREE YEARS OF SEARCHING FOR MY GREAT-GREAT-grandfather's buried porcelain collection, I found myself squeezed into a black Mazda with distant relatives, cruising along the Yangtze River. We headed for Xingang, where my ancestors had lived for more than six hundred years, where twelve generations of them were interred in the family cemetery, and where we hoped to find my great-great-grandfather's former estate and see if Tang Hou Cun could remember where the porcelain had been hidden.

"Look at all this land," Tang said, waving his hand across the window. "It all used to belong to your family. That's why you have culture and education."

We drove the same route along the river that my grandmother would have taken by boat to and from Rulison, but the landscape bore little resemblance to the fractal sprawl of fields, farmhouses, and Buddhist temples of her time. Factories lined both sides of the highway, dwarfing the straw-hatted farmers still working narrow strips of soil squeezed between the neat grids of industrial-size lots. A gargantuan Sinopec oil refinery, more than a square mile in area, blackened the air. Cranes for moving shipping containers straddled warehouses like colossal metal spiders. Bulldozers crisscrossed old farm fields, leveling small rises and hills. On the corners of the vacant, denuded tracts stood giant billboards bearing artists' depictions of the planned

projects: chemical plants or manufacturing facilities with concrete and glass office complexes, water towers, and smokestacks, all connected with miles of aboveground pipelines. The air smelled of tar and burning trash, and the legions of multiton trucks hauling debris kicked up choking clouds of dust.

Tang Hou Cun twisted around from the passenger seat to face me. "This entire place will be factories soon," he said. "First, they'll build the roads, then they'll develop everything. Like Shanghai's Pudong." The area was changing so rapidly that even my relatives, who made annual visits to the family cemetery, lost their bearings, only regaining them once we turned off the highway and entered what remained of the countryside, where the industrialization had not yet metastasized. The land shimmered as we wandered deeper through a series of undulating single-lane roads, passing fishponds, wheatfields, farmhouses, and old graves. Birdsong drowned out the hum of automobiles and machinery. For now this part of Xingang remained China's lake country, speckled with oxbow lakes that had budded from the Yangtze as it writhed through the lowlands toward the Shanghai delta. On the horizon rested the glistening waters of Poyang, a hydrological accident produced sixteen hundred years before when forces snapped the river like a whip and sheared off an enormous oxbow that became the largest freshwater lake in China.

After pulling over again to look for landmarks and orient ourselves, we arrived at the family cemetery. Tang Hou Cun, his wife, his son, and I filed down a path past a small cotton field and old wheat to a clearing where a row of modest stone grave markers were set into a low rise. But this wasn't the original cemetery. It certainly didn't match the description that my grandmother had given me, up on a hill across a pond where the ancestors could keep watch over the house. Tang explained that the year before, all the coffins had been exhumed from the original cemetery because that land had been sold for development and moved to this site, along with the gravestones, on which red numbers had been sloppily painted on their faces to

keep them in order. I could only hope that the stones were properly matched with their remains.

"I know why your grandmother didn't want you to come here," Tang Hou Cun's wife said. "She didn't want you to see this. Her family was very wealthy, and they had everything taken from them. I don't think she ever got over it. She carried that in her heart."

Tang Hou Cun showed me the gravestones. All the main characters in my family's history were there: my grandmother's parents, San Gu, San Yi Po's parents, Liu Cong Ji's parents and brother, and my great-great-grandfather. Other headstones dated back to Qianlong and had ornate carvings of dragons, birds, trees in bloom, flowers, or lotus bulbs. "You should bow to them," Tang Hou Cun's wife said.

"I'm not sure how," I said, feeling self-conscious.

"Just put your hands together and bow," she said. "Pay your respects to them."

"I'll show you," Tang's son said.

I followed him, bowing quickly and feeling silly. "Hello, Grandpa," Tang Hou Cun's wife spoke to the graves. "Your great-great-grandson has come to see you. Please take good care of him, okay?"

We made a stop at my grandmother's mother's house, where construction vehicles had taken large bites out of the neighborhood's topography. A Qing dynasty library had been reduced to a stone threshold and a blanket of roof shingles. But the yard behind the house had retained some of its ancient setting, with three pairs of steles on the bank of a pond ringed with willows and full of jumping fish. Each waist-high slab of stone appeared to be the original stele, too weathered to read, paired with a modern replica. They celebrated Xingang's *jinshi*, those who had succeeded in the palace examination, the highest level of the imperial civil service test system and two steps above what my great-great-grandfather had achieved. "The scenery's pretty nice, right?" Tang Hou Cun said. "You used to be able to take a boat to Poyang from right here." Now the view ended at the highway cutting through the floodplain.

The neighboring house had belonged to another *xiucai,* who also bought porcelain by the boatload. That house was the only Qing dynasty home on the block, locked up behind a cement wall and an iron gate. The square pillars on either side of the gate had traces of red posters, which could have been either Lunar New Year greetings or Maoist denunciations. Tang's wife eyed the loquat trees in the yard, sagging with fruit, and climbed up on a chair to pick them.

"Come on, we have many more places to see," Tang Hou Cun said. "I'll show you how much land your grandmother's family had. So much land. Our silver dollars were in jars this big." He traced out the size of a watermelon with his hands. "We still haven't gotten you home."

The final leg of our journey took us over newly built roads as wide as airplane runways, designed to accommodate heavy trucks but that had been appropriated by local farmers for threshing wheat with old-fashioned flails. We picked up a friend of Tang's, a man named Liu but of no relation to me. This Liu's family had sharecropped for my great-great-grandfather, and he mentioned without prompting that they turned over only forty percent of each harvest to him, a confirmation I was happy to hear.

Finally, we made our way into my great-great-grandfather's former village, now a dirty warren of honking scooters, narrow unpaved streets, and decrepit concrete buildings. As we drove, I reflexively checked the surroundings against the information I'd gleaned over the past few years. The village was indeed a half-day's walk east of Jiujiang. The fields along the river that had belonged to the family were as expansive as my relatives had described. After we made a left at the main intersection, wound around a gentle, inclined turn, and stopped before a tall metal gate, I saw that part of my great-great-grandfather's estate really had been converted into a cotton factory.

The factory gates were closed and secured with a rusty lock. Tang led me up a side path between the factory's wall and a sagging

apartment complex to a promontory from which we could view the entire property.

"Can we go in?" I asked.

"No," Tang said. "The gate is locked, and we don't have *guanxi* with the people in charge."

He shrugged, seemingly content to show me the house from afar, and I momentarily panicked. I had not come this far, spent this much time, only to be deterred on the doorstep. "What if I just climbed over," I said, putting my hands on top of the wall.

"No, no!" Three sets of arms grabbed me.

"You'll hurt yourself, and how could we explain that to your parents?" Tang said. "Let's walk around the other side—maybe there's an entrance there."

Along the rear wall of the old house were pomelo and loquat trees, perhaps offspring of the ones that Si Yi Po had climbed as a child. We found a rickety ladder made of scrap wood leaning against the wall, and moments later we were standing in a roofless house. "So this is where my grandmother grew up," I said. "It's smaller than I imagined."

"Oh, this house?" Tang Hou Cun said. "It's not ours. It was built with our bricks by other people after the family fled. The old house used to be over there." He pointed to a stand of pine trees. "There's nothing left of it."

We walked into the overgrowth. "This used to be really good feng shui," he said, referring to the landscape before 1949. "The area was empty except for your great-great-grandfather's house. It was up on a hill, overlooking the road to town and a lake full of lotus plants and fish." But after the flood in 1954, he explained, the entire village had relocated to higher ground; my great-great-grandfather's house was now one of its lowest points. The lake was drained years ago, Tang Hou Cun added. The land had been auctioned off and was slated to become an industrial park.

I asked Tang if he thought it would be possible to dig for the buried porcelain.

"We can dig for it, but we need to figure out where it was first," Tang Hou Cun said. "But I'm sure no one's ever dug for it."

Tang held his arms before him like divining rods and closed his eyes. The air buzzed with cicadas. "The washroom was over there, I think," he said, motioning for me to follow him to a small clearing. "There was a big cistern we used for baths.

"And over there was the kitchen," he said, pointing to another area. He put one palm against his head and thought. "That retaining wall used to run all the way along the property. That means the garden would have been . . ."

He led me to another spot near where someone—perhaps the same person who constructed the ladder we took over the wall—had planted a few rows of wilted vegetables. ". . . about here."

Tang pointed at the ground. "This is it," he said. "This is probably where they buried the porcelain."

[20]

CHASING THE MOON FROM THE BOTTOM
OF THE SEA

HAD TO ACT QUICKLY. LEWIS HAD CALLED TO SAY THAT HE and a group of relatives were heading to Jiujiang. Liu Pei Ke, the youngest of my grandmother's sister-cousins, was making a pilgrimage to Jiujiang from Texas to do upkeep on the family cemetery, and two of San Yi Po's daughters were accompanying her. Oh, and San Yi Po had passed away in Taiwan a few months ago. No one had bothered to tell me.

"Wait until we all get there," Lewis said. "We can figure out how to dig for the porcelain together." Then he ordered me to book hotel rooms for everyone. "And make sure you book me a hotel room on a low floor. I don't like a high room. And does the hotel have wireless Internet? How far is it from the airport?"

"How the hell am I supposed to know?" I said. I began to see how Lewis might have aggrieved Tang Hou Cun so much.

I feared that too many relatives would meddle. And Pei Ke's loyalties were unclear. Some family members didn't consider her a full-blooded relative, owing to her mother having been Ting Geng's concubine, a common practice when the firstborn was a girl. Chen Bang Ning had told me that while Pei Ke—or Wu Yi Po to me—was working as a doctor on the mainland, she'd written a letter about San Yi Po's husband, which ruined his chances of becoming a full general in Taiwan.

I contacted just about every old China hand or local Chinese that I could think of to ask how I should approach digging for the porcelain. The consensus was that I had a few options. I could try to lease the land without mentioning the porcelain or even my connection to it, making up some bullshit reason—building a new factory, for example—that would require digging. If I found something, and the local authorities didn't care, it was mine. Another option was to try to talk to local intellectuals. Every county or town had a *wenhuaguan*, a center for cultural affairs, and these days local governments were looking for ways to promote their images in order to develop their economies. Someone at the *wenhuaguan* might take an interest in my quest and coordinate with the local authorities for me. Above all, my friends stressed, find a local whom I could trust with the real story of the porcelain. He or she didn't necessarily have to be a government official, just a strong, capable person who could help me think of solutions.

The next morning I stood on the boulevard in front of my hotel and tried to flag down a taxi that could take me to the *wenhuaguan*, but no one knew what I was talking about or where it was. Finally one driver, instead of speeding away, pulled his parking brake and called a friend to ask if he might know. "Please, have a seat, sit down for a bit," he said as he discussed the possibilities with his friend. He hung up and gestured for me to close the door. "I think I know where it is, and if it's not there, maybe they'll know where to go," he said.

He didn't use his horn the entire ride and was so decorous, and thus so out of place in Jiujiang, that I asked for his name and phone number for future trips. Yu Sifu handed me his card. The building where he dropped me off turned out not to be the *wenhuaguan*, but a woman there gave us directions to where it was, about a ten-minute walk. There I was told that the *wenhuaguan* had moved about a year before, and a motorcycle taxi finally took me to the right place. I explained myself to the man in the office, and his ears perked when I mentioned my family's connection to Rulison. He gave me the phone

number for a Zhen Laoshi who had been involved with Rulison, and I dialed it on the porch.

"So what is it that you want?" Zhen Laoshi said after I introduced myself.

I didn't want to tell him about the porcelain without feeling him out first. "To know more about the city when my grandmother was going to school," I said.

"And who is your grandmother?"

I told him.

"I don't know her, but I can look her up. You say she went to Ru Li?" That was the Chinese abbreviation for Rulison, which conveniently contained two native syllables.

"Yes, and her aunt also went there, Liu Ting Yi," I said.

"Ah!" he cried. "I know her! She was my teacher! Please, come meet me at the Jiujiang Library in the morning. I have written some things about Jiujiang history that I can show you."

Heartened, I flagged another taxi to make sure that there wasn't a new factory sitting on my family's old property. I described the route from my memory and hoped I would recognize the turns as we got closer. "When was the last time you were there?" the driver asked. "It's changed a lot. A lot. They're building all kinds of stuff."

We drove past the electric plant and the petrochemical pipes for the oil refinery, and it was so dusty and sooty that water trucks had to wet the roads. As we approached Xingang, I began to worry that I might have come back too late. But once we turned onto Xingang's main drag, I saw that the old property was exactly as I had left it, except for the water towers and a holding pond that had popped up just outside what would have been the front door.

I stopped the oldest of the old men passing by—there didn't seem to be many people under sixty in town—and asked him if the cotton factory, which had seemed defunct the last time I saw it, was still active. "My grandmother used to live here," I explained. "It was her grandfather's house."

"Who was that?" the man asked.

"Liu Feng Shu."

"You mean Liu Da Xian Sheng?" the man said, his eyes widening in recognition. "Yes, he was the big landlord around here. Wait just a minute."

He walked down the road and returned accompanied by a short, sinewy man with a choppy gait. It was Liu Cong You, the relative that Cong Ji had mentioned back in Jinan. Cong You introduced himself as my grandmother's cousin and Cong Ji's older brother. I knew that Cong Ji's only brother died as a child, so I spent most of our conversation trying to figure out how I was related to him. He was difficult to understand, which I ascribed to a thick accent, but the cabbie, who had gotten out of the car and offered to translate for me, explained that he spoke the local Jiujiang dialect, not Mandarin. Liu Cong You was born in 1928, and his grandfather was one of my great-great-grandfather's younger brothers. "I used to call your grandma Big Sister," he said.

Cong You told me that the cotton factory on my great-great-grandfather's land was actually still in use, and he offered to take me into it, charging through the turnstile next to the guardhouse before I could tell him I had already seen it. I had only wanted to verify that the situation had not changed, but I followed him through the gate and into the yard. The man in charge greeted us with suspicion and grudgingly allowed us to have a quick look around.

Cong You explained that part of my great-great-grandfather's land had been acquired from his two younger brothers, both opium addicts, who sold their property to sustain their drug habits. Without land, those two other families declined. Liu Cong You's mother went to work as a servant. The girls were sent off to live with other families. His uncles died young from tuberculosis. His father managed to get an education and worked for a logistics company but smoked and gambled away his earnings and died at fifty-six. "Our family didn't prosper," he said.

Liu Cong You was nine years old in 1938 when his family went

about five miles into the countryside to hide from the Japanese. "Grandfather, his family had money, and we didn't," he explained. "They fled, we hid."

After the war Cong You worked as a footman in my great-great-grandfather's house for a time. "His temper was very odd," he recalled. "If I did things wrong, he'd hit me on the head with his knuckles. Or he'd say, 'If you were standing next to the rice steamer, you'd still starve,' things like that. But he also taught me how to use an abacus, and every night he'd spend an hour or two teaching me."

In 1946 Cong You crossed the Yangtze to work as a janitor in a Hubei elementary school. Two years later he went to Nanjing to seek a job with the arsenal where my grandmother worked, and he stayed with San Yi Po, whose husband took him on as a low-level assistant. Then Cong You's father wrote him to return to Jiujiang—his filial duty as the only son. In 1950 San Gu got him a job as a cook at Rulison. Every evening San Gu made him study for two hours, and that's how he got his education. He married a seamstress in 1953 and was promoted to librarian and then lab manager. He left Rulison in 1962 ("Because the pay was terrible," he said. "I had six kids and one mother and couldn't take care of them all") and worked as an accountant for the Xingang transportation department, those abacus lessons from my great-great-grandfather paying off. He retired in 1984. His wife died in 2009. "I don't regret it," he said of his life. "I get more than a thousand yuan per month. I'm a very happy man."

Liu Cong You said my great-great-grandfather was one of the first to flee when the Japanese arrived. "It was every family for themselves," he said. Some of my great-great-grandfather's belongings were moved into an in-law's house. Another portion went to stay with a relative near where Cong You's family hid from the Japanese. Cong You couldn't be more specific about those belongings. "Grandfather spent his money on land and education," he said. "The rest of the stuff like how much gold, silver, or jewelry, you wouldn't tell people about that, so I don't really know."

Cong You claimed that it was his family who helped my great-great-grandfather after the Communists kicked him out of his house. Cong You's father's vices had disabused him of all his land, making the family clean in the eyes of China's new overlords. Cong You's father even helped Ting Gong arrange for my great-great-grandfather's burial. But Cong You's proletarian roots couldn't protect him from persecution during the Cultural Revolution. He was publicly criticized and forced to wear a sign proclaiming him a *dizhu goutuizi,* a landlord's running dog, or lackey. His entire family was sent to the countryside for three years of farm-labor "reeducation," where he was sometimes forced to make a twenty-mile trip to fetch firewood with a handcart in the middle of the night. "Because of our overseas relatives, we all got punished for them," he said. "We were all implicated."

Standing inside the cotton factory, I asked Cong You where my great-great-grandfather's house had been. He pointed to the warehouses. And when I asked him to locate the garden, he said he wasn't sure. "Here," he said, waving his hand over a vast area that included the concreted square as well as the empty lot. "Do you mean where the buildings are or where we're standing?" I said, trying to get him to clarify. He simply repeated, "Here."

The vegetable patch that I had seen before was still there, and the man from the factory said it was planted by the employees. I spotted a porcelain shard next to the chili peppers. I didn't want to overstay, or raise suspicions any higher than I already had, so I excused myself.

IN THE MORNING I went to the Jiujiang Library to meet Zhen Laoshi, the man I hoped would be my local advocate. I followed him to a small reading room on the top floor where old men sipped tea from thermoses as they leafed through newspapers. Zhen Laoshi was born in 1944 and had taken two years of physical geography with San Gu beginning in 1957, after the Communists reorganized the Tong Wen and Rulison schools into a single coeducational institution. "She

was an outstanding teacher," he recalled. "Always very well put together, quiet, never got angry like other teachers, and carried a Western purse."

He showed me a book of Rulison's post-1949 history and pointed out San Gu's name on a roster of teachers from 1953. She was forty-three years old then, taught fourteen classes of physical geography each week, and earned 245 yuan per month. I flipped through the rest of the history book, looking for information from my grandmother's time at Rulison. All I found was a 1933 faculty roster and a 1948 faculty roster with nothing between. "It was so long ago," Zhen said. "How could they save it until now?"

Zhen Laoshi had independently researched Jiujiang's history for the past thirty years. He produced one of the books he had written, a single edition of photocopied pictures of historical Jiujiang mounted to the pages with tape or glue and handwritten information that he had collected from books and interviews. He was a fine artist, and where photographs could not be found, he sketched in the buildings, including one of the field on the Rulison campus where San Gu had set up a weathervane, anemometer, and platforms for conducting experiments.

I asked him what Jiujiang would have been like when my grandmother was studying at Rulison.

"All the supplies passed through Jiujiang, so it was very alive and raucous and had a great economy," he said. "This was probably when your grandmother was here. Then in 1937 all of Jiujiang fled. Rulison went to Sichuan. The Japanese wanted Jiujiang, which was a strategic spot, and occupied Rulison and Tong Wen. They put antiaircraft guns there and ruined it. There were only four thousand people in the city, from one hundred thousand. Because of the Japanese war, the Japanese were raping women . . ."

He paused briefly, and I sensed emotion welling up in him. "My aunt was going to school, and her classmate jumped in a well to commit suicide to avoid being defiled by the Japanese," he continued. "My

aunt is ninety-three now, and she told me this story last year. I wrote a book about Jiujiang during the Japanese occupation. I interviewed three hundred people. Dr. Bai's daughter came back and wanted to protect Jiujiang—"

He began to cry. I had no idea who Dr. Bai and his daughter were. I suspected that he seldom had an audience. He wept some more.

I still hoped that Zhen Laoshi could be the man everyone had advised me to look for, a knowledgeable, connected local who sympathized with my quest, so I asked him what he had done for work. He said that he had graduated from the normal university in 1963 and worked as a teacher and a principal until 2004, after which he devoted all his time to researching Jiujiang history. "There are lots of people like me in China, who laid the cobblestones," he said, choking up again. "We didn't ask for anything—we just did it for the country."

I tried to think of something that wouldn't make him lose it, and I asked him about the Rulison school. "Rulison was a journalist, who funded the school, and Howe built it up," he said. "Jiujiang was a melting pot for Chinese and Western cultures. All the missionaries would get beaten when they went to Nanchang, but not in Jiujiang. Sun Yat-sen was right—if you bring up Jiujiang, you bring up Jiangxi. Sun chased off the Qing dynasty, but he couldn't finish the job; the Communist Party finished it. Look at how good our lives are in China. In twenty years we'll be on top. In America, they spend, then save. In China, it's the opposite. That's why the United States is in debt, and why China is going to pass the United States!"

He stood up. "Most people didn't care about educating girls, but right here was Rulison," he said, shaking with emotion. "And if you stayed and graduated, it was free. The Chinese have always thought this way. If you help, you're good, we'll believe you. Now Tong Wen and Rulison get money from America, but we don't want it! That's why I'm happy you came. You can see that China isn't lagging. Chinese people are proud."

He barely squeezed out his last sentence before breaking into tears

again. I put my head in my hands. The man reading at the next table had heard enough. "You think Chinese people are proud?" he said, snapping his newspaper. "Because I think they're *bei'ai*." *Bei'ai* means a mélange of negative emotions, including grief, sorrow, depression, and melancholy.

Zhen Laoshi composed himself. "Well," he said, "you have your opinions, and we have ours."

"But you've been chirping that stuff in my ear for more than an hour."

"That's your opinion, then."

"I don't want to have an opinion. I just want to sit and read my paper."

"I'm ready to leave, anyway," Zhen Laoshi said. We collected our things. I walked him outside, thanked him for his time, and waited to see which direction he went so I could go the opposite way.

So ZHEN LAOSHI had proven unreliable. And Tang Hou Cun, despite knowing that I was in town, didn't call or answer his phone. I called Uncle Cai in Lushan, the member of the local development board, and told him I would like to see him. "Yeah, sure, I'll be in Jiujiang this week," he said. "Maybe we can have dinner then."

"Sounds great," I said. "One more thing—I also wanted to ask for your advice on something."

"I don't have any advice."

"I haven't even asked the question yet."

"I'll give you a call when I'm in the city, and we can have dinner, and you can tell me what you're thinking," he said, ending the conversation. "Send me your phone number."

I still had not heard from Tang Hou Cun, so I went over to his apartment. He seemed preoccupied and agitated. Apparently the impending arrival of the overseas family members had stirred old resentments from being slighted by Lewis many years ago. "We all

met in Wuxi," Tang Hou Cun explained. "You call me, I'm going to go, and I don't need you to pay for my ticket. I'm not country folk. Pei Sheng was there, everyone, and we went to a company to meet a foreign man in Wuxi. Lewis introduced him to Pei Sheng and his cousin but not to me. I don't know why. But I spent two thousand RMB to see the family, and you don't even acknowledge me? Then I took them all to the train station, and when I was about to step into the train with them, he told me to get off! He completely ignored me and treated me like a second-class citizen. Do I look like a bad man? No education? I know they think mainlanders are poor, that we'll ask them for money. But we've never asked for anything. Lewis's temperament is so bad. When he came, he didn't see the family cemetery. Neither did Richard. I don't know if this is a Christian belief or what. Just ignored us."

I apologized on their behalfs. Tang Hou Cun didn't seem assuaged, but I pressed on and asked him about digging for the porcelain.

He waved his hand vigorously. "I can't help you," he said. "Number one, I don't want to get involved in Liu family business. Number two, you're not the one to do it. This is the Lius' wealth and property, and you're not a Liu. It should be Liu Cong Ji's son, or your Wu Yi Po. But I can't help you. Otherwise people will say that I'm greedy."

WITH JUST TWO DAYS left in Jiujiang before Lewis and Wu Yi Po arrived, I was determined to accomplish something. I'd lain awake the night before trying to come up with a plan and thought that I'd hit on a good one. Uncle Cai had blown me off, Tang Hou Cun wouldn't help, and Zhen Laoshi was unstable, so I dialed the last local person I knew, Yu Sifu, the taxi driver.

We drove into Xingang amid the familiar dust and smog. Yu Sifu parked at the intersection where Xingang's two roads met, and I stopped in a market to buy a pack of cigarettes for later. I had forgotten where Liu Cong You lived and found him by asking people on the street. He emerged through a furniture shop wearing a thin white

T-shirt, canvas shoes, and navy pants many sizes too large for him, cinched with a belt.

I asked if he could take me to see the house again. We walked down to the alcove overlooking the property. There I asked him again where my great-great-grandfather's house and garden had been, and I explained to him what I hoped to do.

"No way!" Cong You said, waving his hand. "It's the state's now— you won't be able to do anything."

"Are you sure? I'm not asking for much from them."

"Impossible." He frowned and dug his chin into his chest.

"What if we asked the *cun zhang*?" I said. The office of the village chief was just down the street.

"He won't agree, either."

"What's he like?"

"A young guy. He doesn't know or appreciate any of this history. But if you want to talk to him, I'll take you there."

We marched a few houses down to the two-story white building housing the village administration. In the courtyard, a woman smashed dark seedpods with her feet. All the officials had gone home, she said. They wouldn't come back until the next day. We returned to the car, where Yu Sifu was waiting. "Did he tell you what he was thinking of doing?" Cong You asked him. I didn't see any use in trying to keep my plan a secret and explained my reasoning to Yu Sifu.

"I understand what you're saying," Yu Sifu said to Cong You. "It's the state's, yes, but it's not that big a deal, is it? The factory is already closed down, and they've rented it out to private citizens."

We stood at the intersection. "Should we ask the village official first?" I said.

"No, this isn't something you should involve him with," Yu Sifu said. "He doesn't care about these things. I think you should talk to the factory manager."

Yu Sifu checked his watch. He had to hand off his car in one hour. "We should make a decision," he said.

"Okay, let's ask the manager," I said. "First him, and then the village head if he doesn't agree. We'll just keep going higher if we need to, right?"

"Yes, that's how you should do it," Yu Sifu said.

We walked into the factory, where we were met by the manager I had encountered the other day. He invited us into his "office," a concrete cell with a rusty bed frame and a box spring. I offered him a cigarette from the pack I had bought, which he accepted and set on the table. I explained my idea to the manager, with Yu Sifu and Cong You filling in the gaps, and he seemed receptive. "I understand, but it's my son who owns the company, so I'll have to consult with him first," he said. "I can't just make this unilateral decision. It's not a big request, but I have to make sure it won't bring me trouble later. So I'll call my son today. Come back tomorrow at nine a.m. and I'll have an answer for you."

As we got back into Yu Sifu's car, he reassured me that he didn't think I was going to have any trouble. "But if it is a problem, just tell him that you'll compensate him," he said. "A few hundred RMB should be enough."

YU SIFU PICKED me up the next morning, and we made the drive back to Xingang. I learned that he was thirty-six and from Guling, where his wife was a tour guide, and that they had an eight-year-old son. "It's a nice place," he said of his hometown. "But they're so focused on the tourism industry that they don't pay enough attention to education, so the schools are not very good and the teachers are not paid well." So like scores of Americans, they moved to a place with better schools, buying a house in Jiujiang city, where they lived with his retired parents. They rented out their house on Lushan for most of the year and spent the hottest parts of the summer there. "The weather's only good in the summer," he said. "Other times it's so wet from all the fog. Nice for growing special fog tea, but not nice to

live with. Nothing ever dries. Your towels and blankets stay wet. The spring water, which is very tasty and sweet, has a lot of minerals, so if you drink it all your life, you tend to get kidney stones."

We parked at the top of Xingang's main street, collected Liu Cong You, and went into the factory. It turned out that the man we spoke to the day before was a longtime subrenter of the factory who had no decision-making power. He called the *chang zhang,* or factory director, the real man in charge, and directed us across the yard to another small "office," with dusty upholstered chairs, a bed, and a desk. "Offer him a cigarette," Cong You whispered as the *chang zhang* approached. "You need to learn how things are done here." The *chang zhang* entered the room, an older man with a sagging, sallow face, distrustful eyes, and a mouth that hung open to reveal rotten teeth. He seemed annoyed and spoke mostly in grunts as I introduced myself. I pulled out two cigarettes and offered them to him. He refused.

That threw me, so I started talking before I lost my nerve, reciting the pitch that I had been practicing the past few days. I explained that the factory was built on my great-great-grandfather's old property, and that I had come all the way back from America to see my ancestral roots. "Now that I've finally made it here, I'm overcome with emotion," I said. "It's so meaningful to see where my family came from. There will be a group of overseas relatives coming here soon, to also see this place for the first time, and I would like to plant some fruit trees and flowers on the patch of vacant land, to both beautify the spot and also pay my respects to my forebears. It will be a nice surprise for my relatives when they arrive. I would do all the work and the trees and flowers would be yours to keep."

I thought this proposal would be a slam dunk, having seeded it with all the things I thought Chinese found irresistible. What Chinese man, especially one who lived through all the deprivations of the past sixty years, could argue with fruit, filial acts, and free labor?

The *chang zhang* began shaking his head and waving his hand before I even finished. He turned to Liu Cong You, whom he apparently

knew, and said, "I don't know anything about this history. This has been a cotton factory since I was born. I'm fifty-nine years old, and I'm going to retire next year, and I don't want anyone coming back to me later and bothering me about the property."

He shifted his attention to me. "You say this used to belong to your family," he said. "That's none of my business. This was a cotton factory in 1950, and it has been ever since. Whatever it was before, I have no idea. And I don't want anyone leaving anything here that they can come back and try to use to claim the land—you understand what I'm saying?"

Liu Cong You nodded emphatically and said, "Yes, of course, that's the way it is." I glared at him.

Yu Sifu spoke. "Look, he came from so far away, and he probably won't have any opportunity in the future," he said. "He just wants to do this little thing."

"No way," the *chang zhang* said. "I don't know who you are. I don't know what your family had to do with this. That's none of my concern. If you leave something here, what's to stop you or someone else from coming back and bothering me in the future about this property? You say you want to leave it for your family to see. What if the trees and flowers die? Then there's nothing for them to see, and it's my fault. And what if I want to build something else, or the government wants to build something else, and those trees are there? It's going to be trouble to cut them down."

"What if he signs something promising not to bother you?" Yu Sifu said, reading my mind.

"What good is a contract? That's no use to me. That's not going to stop anyone from bothering me. It's just a piece of paper."

"Contracts are very powerful where I come from," I said. "You can trust me, I won't bother you later at all. What can I do to make you comfortable, to reassure you?"

"Nothing."

The more options I suggested to the *chang zhang*—think of this

as a gift to you, think of this as beautification, think of all the fruit you'll enjoy—the more resistant and paranoid he became. Then Yu Sifu brought up the prospect of compensation, the last card we had to play.

The *chang zhang* shook his head again. "That's not the issue," he said. "It's not about money. It's about putting something in the ground and then leaving it there. That's going to bring me trouble."

"But it won't," I said, feeling desperate. "I promise you. You have to believe me."

"How do I know? How can you promise that?" He told me to go to the *gongxiaoshe,* or district development office, and find the official who supervised the property, a man named Liu Ping. "If he agrees with you, then there's nothing I can do. But I'm not going to make any decision."

"If it will make you comfortable, I will go talk to the official," I said. "But we're already here, and it will take another half day to find him. I only have this opportunity to do this, which has been a dream of mine for many years. What if we went and talked to the village head?"

"No, he's not going to have any influence on this matter, only the district official," the *chang zhang* said. "If he agrees, then I agree, but only if he says so. I can't give you the say-so. I won't give you the say-so."

I sat back on the bed and imagined horrible deaths for the *chang zhang.* So this was what the past century had done to China, I thought, scorched it of intelligent, reasonable, cultured people and transplanted uneducated, inept, paranoid thugs in their place. At that moment, I could not have hated Chinese people more.

The conversation ended and we left. "What exactly was his hesitation?" I asked Yu Sifu. "I understand that he's worried about us trying to come back and stake a claim to the property, and that the whole overseas Chinese thing is a complication rather than a benefit, but what can I do to reassure him? I offered to sign a contract. I offered to compensate him. What else can I do?"

"The more options you suggest, the more problems he has," Yu Sifu explained. "He just doesn't believe you. There's nothing you can do about it."

"That's right, there's nothing you can do," Cong You echoed.

"Hey, uncle, do you want to help me or not?" I snapped.

"I want to help you, of course! But what you're trying to do can't be helped. *Mei ban fa!* I'd love to help, but this just isn't possible."

I sighed. "So I guess all we can do is find the official he told us about."

"You can, but the odds of getting him to agree are pretty small," Yu Sifu said. "He's going to think just like this guy."

"Maybe he's open-minded."

"I doubt it. The odds of that are also very small."

"Great," I said. "What if I offered to rent the property?"

"Actually, that might have gotten you somewhere," Yu Sifu said. "If you just went in at first and said you wanted to rent the place, what's the next step, you could have talked straight business."

"So I messed things up by talking about my family and stuff?"

"Yeah, that just made him nervous. He wants to ensure his *houdai ziyou*." That is, he wanted to ensure that his future generations would be free of trouble.

I stood outside the factory wall, thinking. None of us wanted to go try to find a local official on short notice. But I was resolute about putting a shovel into the dirt of my great-great-grandfather's property. I no longer cared about recovering any porcelain. I just wanted to complete the act, if only to score points against that evil *chang zhang* and, by proxy, the five thousand years of craven history and fifty years of thuggery from which he had sprung.

I snapped my fingers. "Hey, what about this?" I said. "What if we got some trees, planted them, and then took them out? We'll fill in the holes and not leave any trees there?"

Yu Sifu and Cong You looked at each other. "That actually might work," Yu Sifu said slowly, as he ran it through his mind. "There's no

trace of anything, and that's what he's worried about. Yes, that might work."

We filed back into the factory and walked around the yard looking for the *chang zhang*. "You think he's hiding from us?" Yu Sifu said, only half joking.

After a few minutes, the *chang zhang* walked out of a warehouse. Yu Sifu took the lead this time, explaining our new proposal, and the *chang zhang* didn't immediately say no. Sensing an opening, Yu Sifu pressed forward, while Cong You, again the yes-man, interjected encouragement. "You see?" Cong You said. "There's nothing left, no trace. We'll just come in, plant some trees, maybe let him take some photos, take the trees right out, and we're gone."

"It makes no sense," the *chang zhang* said. "What good is planting a tree and then taking it right out?"

"It doesn't make sense to us, either, but this is his dream," Yu Sifu said. "It's something he really wants to do, so just let him do it. He's not going to leave anything, so there's nothing to worry about."

"Nothing to worry about!" Cong You said.

The *chang zhang* looked pained. Yu Sifu repeated the arrangement, twice, three times, while Cong You observed what a clean transaction it would be, but the *chang zhang* never made a visible assent. Finally he dipped his eyes, and we had our permission. We thanked him and left to find trees and tools.

"How many trees do you want?" Cong You said.

"As many as possible," I said. "How about three, with big roots?" I wanted an excuse to dig as deep as I could.

Cong You had a shovel and a pickax in his house, and I walked the street looking for a hand trowel. None of the hardware shops carried them; the closest thing I could find were thin masonry trowels for spreading cement, and the shop owners tried to persuade me that they were suitable substitutes. And no one sold trees. The only nursery that anyone knew of was an hour away by car. Cong You inquired with some neighbors, who said they had plenty of trees. We followed

them out of the village center, across a newly tarred road with a row of wan saplings on the median strip, to a massive building site where old houses and trees were being cleared for new housing. A few stands of homes and trees remained, their perimeters gnashed by machinery. The trees that the neighbor showed us were all too small or too large or already encased in concrete. I spotted a few fruit trees, about twelve feet tall with foliage that suggested substantial roots, in the garden of one of the remaining residents. "What about those?" I said.

"If I were them, I wouldn't let us take those trees," Yu Sifu said.

No one answered the door, and we moved on. "This place is all going to be flattened," Yu Sifu remarked. "It's only a matter of time. They're going to lose those trees anyway."

Cong You said that he knew another spot to look for trees, and we followed him back into the village and turned down a road that cut between rice fields. In the brush along the road, we found two camphor trees and a loquat tree. These had sprouted from large old-growth trees that had been cut down for wood, he said, and would have nice, big roots. He jumped into the brush with the shovel and began digging. Yu Sifu and I shouted for him to stop—it wasn't proper for him to be doing such work with two young men standing by. Fine, Cong You said, but he wouldn't allow me to do it, either. He walked back up the road to find a worker to dig up the trees. A while later he returned with a friend who looked even older, carrying a pickax and a shovel. The friend got to work on the trees and began hacking through the roots just a few inches below the surface.

"Wait!" I cried. "That's too shallow. Get as much of the root as possible."

Cong You's friend complied, but the underground sections were still just a foot or so long. These were not the roots I had hoped for, but they would have to do. We carried the trees through the village back to the factory to plant them, but were told that the *chang zhang* had left for lunch and would return in an hour or so. Cong You reminded the man that we had already cleared everything with the

chang zhang, and we headed down to the empty lot. I was just about to sink the blade of the shovel into the soil when a factory employee ran down from the office and told us to stop. The *chang zhang* had called and said we weren't to do anything until he returned. I began worrying that he would renege on his promise. "He can't go back on his word," Yu Sifu assured me. "That's why I confirmed it so strongly with him."

I took Cong You, his friend, and Yu Sifu to lunch, which I barely tasted, unable to think about anything except finally being allowed to dig on my great-great-grandfather's property. All the other Lius had left Xingang, Cong You's friend said, gone to the city or Shandong or overseas. Cong You was the only one left, and it fell to him to keep the *jiapu*, two volumes of the Liu genealogy that contained the twelve generations that were born in Xingang (I was the fourteenth generation, but since *jiapu*s were patrilineal, my name wasn't recorded in it). When I tried to pay for lunch, Cong You shoved me away from the cashier with surprising strength.

On the way back to the factory, I stopped to buy a carton of cigarettes for the *chang zhang*. Yu Sifu helped me pick the brand, Jinsheng, which he said wealthy people smoked. The *chang zhang* arrived at the factory a few minutes after we did. "Offer him the cigarettes," Cong You whispered. I approached the *chang zhang* as he parked his electric scooter next to his office and presented him the carton. He physically recoiled and refused to even touch the cigarettes. I sheepishly put the cigarettes back into my bag, and we walked down to where my great-great-grandfather had buried his porcelain.

"I didn't expect him to do that," Yu Sifu said.

We set down our trees and tools. The *chang zhang* joined a few workers taking a break in the courtyard while machines processing cotton groaned in the warehouse. "So," Cong You said, "where should we dig?"

As I surveyed my options, I began to realize just how unlikely it was that my gambit would yield any buried porcelain. Even with

much of the land occupied by warehouses and outbuildings, and the concreted yard between the structures, the open area that I could dig took up almost an acre, a sizable portion of which was covered with thick stands of young trees or already claimed by the vegetable patch. And for all I knew, my great-great-grandfather's garden might have been sealed under the concrete on which the *chang zhang* and his employees sat, watching my every move.

I settled on digging three holes in a line beginning on the edge of the concrete yard and moving toward the vegetable patch. I took the shovel and sank it into the ground. Cong You's friend grabbed the pickax and started digging another hole, working as quickly as he could. "Please, uncle," I said, "you don't have to help. Let me do it."

He continued digging. "No, no," he huffed, "it's fine." A few powerful, efficient strokes later, he was halfway to the necessary depth for planting the tree.

"Stop digging!" I hissed. "I'm not being polite here. This is something I want to do myself."

I walked over and snatched the pickax from his hands. He and Cong You stood to the side while I finished the three holes. I tried to take as long as I could, and dig as deeply as I could, but the soil was dry and full of debris, and every time I looked up to see what the *chang zhang* was doing, he was staring right at me. I turned up fragments of old bricks and roofing tiles, a piece of a decidedly modern blue and white mug, and as I got deeper, a few shards of clay storage vessels. I struck the top of a metal pipe, stuck vertically and firmly. Each shovelful of dirt made my folly all the more obvious, yet also raised my hopes anew, and I tried to formulate a plan in case my next thrust hit the wooden top of the vault—I had been so consumed by the digging that I hadn't considered what I'd do if I actually found something. Sensing the *chang zhang*'s agitation, I turned my back to him, pretended like I was dusting off my shoes, and quickly palmed a piece of a storage vessel and a shard of a blue and white bowl or teacup that had surfaced. Cong You and I "planted" the trees, and I made a

big show of taking photographs, using it as an excuse to examine the property more closely. The trunks of the trees were so thin that their crowns appeared as three small green clouds hovering a few feet over the ground.

I asked Cong You's friend what he remembered about my great-great-grandfather's place. "This whole row was the Liu family houses," he said, pointing to the warehouse farthest from the street, at the bottom of the slope.

"Where was my great-great-grandfather's garden?" I asked.

"There, where the concrete is," he said. "This vacant area here—that was Cong You's family's garden."

We pulled out the trees, packed up the tools, and left.

"I don't feel that satisfied," I told Yu Sifu. "I was hoping to find some traces of my family, you know, like spoons or bowls or things."

"Oh, we weren't digging nearly deep enough for that stuff," he said. "Think about it. That factory was built there, and before that things had been built over many times. I mean, we're talking almost a hundred years ago. You need to dig three, four times deeper to find your family's things."

THAT NIGHT AS a heavy rain fell, I fantasized about sneaking back into the factory with a shovel, but I had no equipment and no way of getting there, and how much progress could I have really made in a few hours before dawn? I had thought that the mere act of digging would be enough, but it only raised more questions; I would not be satisfied until I tore open the entire place. Maybe that was for the best. Maybe I had conducted this search the way I had—naïvely, indirectly, protractedly—because part of me wanted my family's things to stay buried. Maybe I didn't really want to know. I had created my own mythology, and maybe that was enough.

Until then I would continue looking for the likeness of my family's

lost treasure in every piece of porcelain that matched its age. Even when I showed the blue and white shard to Edie later, and she dated it to the nineteenth century—"That could have belonged to your family," she said—I wondered how I could ever know for sure. My great-great-grandfather's porcelain, objects that had distilled slowly and incrementally out of a culture that simmered for over five thousand years, had boiled away in the new China's eyeblink immolations, leaving only vapors. At best, they had been swallowed up and paved over, imprisoned with other relics of old China, for which the country, bent on crowing about its past from the distant remove of its ageless present, no longer had any use.

Perhaps that was the natural state of excess. China had too much history, Jiangxi too much porcelain, and the diaspora too many stories like my family's. I was reminded of what a local pastor had said to me one night at dinner, when we had ordered far too much food and I watched in amazement as he stuffed down all the leftovers, including nearly a half-gallon of rich pork and mushroom soup, out of habit. "Back in the day, there wasn't enough, so you couldn't waste food," he said between cheek-swelling gulps. "Now that people have so much, they waste it like nobody's business."

THE PHONE IN my hotel room woke me at seven a.m. "Man! Where the hell are you?" Lewis demanded. "We're all having breakfast."

"Doesn't it go until nine-thirty?" I said.

"Just get down here."

The dining room was full, the hotel staff setting out chafing dishes of greasy noodles, wilted vegetables, hard-boiled eggs, and other Chinese breakfast items. Two of San Yi Po's daughters occupied one table with the younger daughter's husband. I sat with Lewis and Wu Yi Po, a small, vigorous woman who greeted me with a smile and squeeze. She had short graying hair and wore running sneakers, track pants, a

long-sleeved T-shirt, and a quilted vest. She carefully picked out the yolks of her two eggs and ate only the whites, a habit she shared with both my grandmother and my mother.

Lewis had filled her in on the porcelain. "I'll do what I can," she said. Over the years in America, she had developed a chattiness that she punctuated with light pats on the arm or shoulder of the person to whom she was speaking, and her English was nearly flawless.

"So there really was porcelain?" I asked.

"Oh yes," she said. "There was a lot of it. My grandfather loved his porcelain. I remember one guy came over once to show him his collection, and my grandfather said, 'This is junk! I have stuff in my kitchen that's older than this.'"

"Was there still porcelain after the war?"

"Yes, but fewer than before. There was a *mao tong,* a big cylinder for putting umbrellas. All kinds of porcelain in the kitchen for tofu, bowls, and things. I think there was one set we brought out for Chinese New Year. Mostly blue and white, mostly from Jingdezhen."

"Okay, what do you need me to do here?" Lewis said. "We need to get our story straight, so we're all speaking the same language. First, we have a confrontation with them." He bumped his fists together. "Then we'll compromise. And we've got a big group, so they know we're serious. We'll go ask for the house back, and then hear what they have to say, if we need to get documentation or anything, and then we'll ask to buy or rent it. But we don't tell them about the porcelain."

"No, definitely not," Wu Yi Po said. "Otherwise they'll dig it themselves!"

"Right, we don't tell them a goddamn thing," Lewis said. "Just tell them we want it back for sentimental reasons, and we'll think about what we want to do with it later. Then we dig, and if we find something, we're gone. And if we don't, we're still gone."

I knew much of Lewis's optimism was just manic posturing, but I couldn't help getting excited. Maybe I had gone about it all wrong.

Maybe I should have waited for help. I hoped that I hadn't ruined anything with the tree stunt, which I didn't mention.

"I have a very good present for the official, too," Lewis continued. "I brought a mint set of American coins. I brought two sets, one for Chen Bang Ning and one for an official, but maybe it'll be better to give the official both."

Chen Bang Ning arrived to take Wu Yi Po to run some errands for the cemetery, which the family would visit together the next day. I had no choice but to join the rest of the family on a tour of Jiujiang.

Lewis changed into an outfit that only he could pull off, slacks with a University of Georgia baseball cap, a nylon University of Georgia jacket, and a University of Georgia belt buckle. "Goddamn, I haven't been back here in twenty-five years," he marveled. "There weren't any tall buildings last time. Last time I was a big shot. Now I'm a nobody. That's a big difference. But the culture hasn't changed."

Lewis had come to Jiujiang the first time in 1984 as the vice-president of China operations for a Thai conglomerate that was one of the first and largest foreign investors after the country opened; he built poultry production plants and feed mills across Jiangxi, including one in Jiujiang. When he learned that Pei Fu had Parkinson's disease but the family couldn't buy medicine for her, he mailed it from Hong Kong every month for five years. The first time he met Tang Hou Cun, he was living in a hovel that didn't even have a bathroom, and he took credit for getting Tang Hou Cun a promotion by bringing him along to his meetings with high-level government officials. He also gave a few hundred yuan to Tang Hou Cun's widowed mother whenever his work took him through Jiujiang.

THE NEXT DAY we visited the family cemetery. Lewis traded his baseball cap and jacket for a dress shirt and a University of Georgia Bulldogs tie. The drive to Xingang was the same, a straight shot through the petroleum plant, but the industrial zone beyond it had

spread. New roads crisscrossed Xingang, wide and dusty and lined with white concrete and long plastic pipelines waiting to be buried. The stretch of winding single-lane road to the cemetery was much shorter than I remembered.

After lighting firecrackers (for announcing our visit) and burning stacks of fake money (for keeping the ancestors rich in their afterlife) in the cemetery, we piled back into the cars and headed for the old Liu house. Trash burned on both sides of the road, making Lewis cover his mouth with a handkerchief. The car stopped on the road where the front door of the house would have been, were it still standing. A cluster of eight enormous white water tanks blocked part of the view. Everyone seemed satisfied with having seen that much, but Lewis insisted on taking a closer look. Liu Cong You was waiting for us at the gate of the cotton factory with his sister and one of his daughters. The relatives greeted one another, and Liu Cong You led the group through the gate for a quick look around. The *chang zhang* was there, scowling. I tried to avoid making eye contact with him.

I asked Wu Yi Po if anything looked familiar. "In my memory, there was a building here," she said, pointing ahead. "And then a garden, a little slope, and trees. The old house would have been there, where that building is."

"Was it the same size?"

"Yes, about as big," she said. "Not as tall, though."

We left to meet Tang Hou Cun at a restaurant in the village. After lunch, we all headed to the river to see the levee that my great-great-great-grandfather had built. It extended from the northern tip of Xingang perpendicular to the river for two hundred meters, then made a right angle at a temple and ran straight along the river for more than a kilometer, two gentle, vegetation-covered slopes that met about twenty feet above the fields. A dirt road ran along its crest. "There was a big flood in 1860," Tang Hou Cun said, "and Liu Fu Chu, Grandfather Liu's father, cooperated with two of his friends to build this dam. He wasn't an official or anything, just built it himself and saved the

village. He didn't get anything for it. Didn't ask for anything, either. That's not how things were. People talked well of you afterward. That was enough."

The levee was concreted over later and overrun in the flood of 1954. Chen Bang Ning began to tell stories of the area, going back to the Three Kingdoms era. I caught only bits of what he said and turned to Wu Yi Po for help. "Ah, that's China," Wu Yi Po said. "There's too much history. No one can keep it straight."

Tang Hou Cun sang the praises of my great-great-grandfather again, but this time with uncharacteristic archness. He had participated in a lot of *baijiu* toasts at lunch. "The Liu family made all its money in two or three generations," he said. "But you all didn't utilize the Liu history or culture. Otherwise you could've set up a factory or farm or something."

Back at the hotel, Lewis and I independently drew maps of the layout of the old house based on what we'd heard from relatives, and they matched. I asked him what he thought about our chances for digging. "That's why I insisted on seeing the house," Lewis said. "The ownership is very complicated. They can tell us a good story: prior to 1954 it was ours, but after the flood it was all destroyed. You can ask for your old house back, if it's still there. But if there's no house, no way. I think there's a less than one percent chance for us. We're never going to get the property back. If Richard had invested here, we could ask to lease the land, but now no fucking way."

"Or people might have dug it up," I said.

"No way. Only three people knew about it."

"But both Grandma and San Yi Po said that relatives dug it up after their grandpa took the family west. What if it's still in Xingang? How do I persuade people to let me see their porcelain without making them feel like I'm going to accuse them of stealing or try to take it back?"

Lewis shrugged. "Well, Huan," he said, "sometimes you have to bury the history and try not to dig it up. But let's go ask Wu Yi Po."

We found her watching television in her room. She opened a package of biscuits for us, crunchy and faintly sweet. "No," Wu Yi Po said, "Grandpa never dug up what he buried. When he came back, there was still the war with the Japanese, and the civil war right after that. It was constant fighting, and he never got the opportunity to recover his things. It's possible the other relatives or neighbors dug it up, because no one was there, and they all knew we had money, but our family never dug it up."

Wu Yi Po thought for a moment. "You know who may have taken it, was Tang Hou Cun's uncle," she said. "He was a degenerate gambler, and when Grandpa died, he put a ladder over the wall and took everything out of the house. No one stopped him."

"Where would those things be now?" I asked.

"Long gone. Sold off to pay his gambling debts."

I sighed. "These stories, they just keep changing," I said. "I thought talking to more people would make things clearer—"

"But they just make things more confused," Wu Yi Po said. "Yes, I know. But that period was so messy. No one really knows the history. But go with your San Yi Po. Her memory was good."

"I heard that the only three people who knew about the porcelain were Grandfather, Old Yang, and San Yi Po," Lewis said. "She helped carry things."

"San Yi Po was Grandfather's favorite," Wu Yi Po said. "She was very *jingming*." Shrewd and astute, having both book and street smarts. "She had good social skills and knew how to deal with people, so Grandfather taught her everything. He trusted that she would be fair and not greedy or selfish when it came to dividing up his things after he was gone. That's why she was by his side when he buried his things."

THE NEXT DAY I accompanied Wu Yi Po to the quarry, where she was going to buy some polished stone blocks for the cemetery. We

boarded an ancient bus blaring Chinese pop ballads for a teeth-rattling, stomach-churning ride. The houses along the road all had red-tiled roofs, courtesy of the local government. The rice harvest was coming in, and the paddies were drained, with dry stalks bundled into cylinders. We took the bus all the way to the end of the line, where stone workshops had clustered at the foot of Lushan. The year before, Wu Yi Po had made a tour of China and Taiwan visiting family. At San Yi Po's, she saw recent photographs of the family cemetery, which looked "like a junkyard." Liu Cong Ji was technically responsible for the cemetery's upkeep but was unable to travel, so Wu Yi Po appointed herself as the caretaker. On this trip she hoped to beautify some of the cemetery's landscaping.

Wu Yi Po told me that I had met her before in Dallas when I was young. I couldn't remember, and I wondered why it had been only once, when my family went to visit my grandmother almost every summer. "Your grandmother and I were very close," she said. "From 1988 to 2004 we'd see each other twice a month."

Wu Yi Po was only four years old when the family fled, and her memory of the war years was spotty. "I remember standing on my grandfather's lap and brushing his beard," she said. "Ting Gong, the St. John's graduate, he was so dirty. He threw his socks everywhere, spit everywhere. That habit came from the Qing dynasty, smoking *shuiyan*, tobacco from water pipes. It created lots of phlegm, and they spit it out. Between the Japanese war and Liberation, that's where my memory is best."

After the war she attended the Rulison school. Four American teachers remained, but they all left in 1949 when the Communists arrived. Jiujiang was taken without a fight. The Kuomintang government simply left, and after three days the Communists landed in boats. Wu Yi Po remembered them being professional and courteous. They slept on the streets, announced to all the businesses to carry on as usual, and moved into the vacant government buildings, sealing up all the files. It was almost eerie how calm things were. "We were

all holding our breath, trying to wait and see what happened," Wu Yi Po said.

Then the changes began. Students had to fill out forms asking for their surnames, names, and *chengfen,* or "social classification." That was a new term coined by the Communists; the Kuomintang had not used this word. And Wu Yi Po had to fill in "landlord" every time.

That summer students attended a mandatory "brainwashing program" to *shouxun,* or "receive training." "It was so funny," Wu Yi Po said. "They wanted to educate you about the Communist Party, what they were doing, and they'd tell all the stories how the Western powers invaded China, made China poor, how the Kuomintang abused people, that's their story. Most of their officials were not well educated, so they tried to make the speech as long as possible. They thought the longer the better, and oh my gosh, we were so bored. They just talked bullshit."

Some of the students couldn't believe they had to listen to people with grade school educations lecture them on history, and corrected them. Nothing happened to those students at the time, but they were later barred from attending their desired college or pursuing their desired vocation. In each of those sessions, a cadre recorded what everyone said, and the pressure on the students to save themselves led some to say whatever the cadres wanted to hear. "You have to say, and if you don't say, you're kicked out of there," Wu Yi Po explained. "You wanted to get close to them to get some benefit. Sometimes they'd just make things up. Or they'd twist words or take things out of context, and that hurt a lot of people." Wu Yi Po was disqualified from participating once they learned of her background. The rest of the summer she avoided talking to her classmates. "It was very cruel," she said. "You isolate yourself. You don't know what would happen the next day. You feel your hairs stand up."

"I knew things were not going to be good for me or my family," she continued. "Most of the time I like to say something, but I kept quiet then. It's kind of instinct. The sixth sense. You can sense the

cold there. And you cannot keep too quiet, either, or they'll say you're hiding something, so you have to join the group, laugh. You had to pretend. I just did whatever to protect myself."

Ting Gong advised Wu Yi Po to get the hell out of Rulison, so in 1950 she tested into a military nursing school and left Xingang. By joining the army, Wu Yi Po hoped to distance herself from her family background. But it also meant she could never go back, not even when Ting Gong wrote her to report her grandfather's death. *Don't tell anyone,* he warned her. *Don't show any emotion.*

"Of course you feel sad, but at the same time, you had to take everything and not let it out," she said. "Don't feel anything, don't say anything, just do your work. I don't even like to think about it now, because it's no use. You can't do anything about it. Besides, you were young, you hoped you'd get a better future later in life. I got a chance to get out of there. I wanted to keep moving."

In school, she kept a low profile—"Don't ask, don't tell," she said—and hoped to slip through the cracks of the nascent bureaucracy. She had a brief scare when she insulted the team leader of one of her training courses, an incompetent, illiterate woman who was nonetheless put in charge because she was politically suited for the position. One day Wu Yi Po couldn't take it anymore and muttered, "Bullshit, she can't even speak right." Someone overheard her and reported it, and Wu Yi Po received a warning. "After that I learned my lesson," she said. "Never say anything to anyone, ever."

She breezed through the rest of her courses and graduated in 1952. She had just turned eighteen but was sent to the Korean front to help treat soldiers. She worked in an operating room for a year and a half, doing "lots of bone and plastic work." During the war the Communists arranged marriages for older Chinese soldiers, and Wu Yi Po was introduced to a commander many years her senior. When they asked about her background, she said her parents had died and that she had lived with her grandparents and aunt. Her grandfather had a bit of land and sometimes rented it to someone. "They didn't ask for

details," Wu Yi Po said. "I was already in the army, and a lot of people wanted to get married, so they needed a supply of girls. Once you're in, you're in."

After the Korean War, Wu Yi Po attended medical school and lived in Dongbei for many years. She got a chance to go to the United States as a visiting scholar in 1986 and after the Tiananmen Square massacre applied for refugee status.

THE NEXT MORNING, Lewis, Wu Yi Po, and I caught a taxi for the *gongxiaoshe* department, to find Liu Ping, the local official who the *chang zhang* told me had authority over my family's old property. We drove to a plain three-story building in an alley crowded with food carts next to a shopping center; only some tattered red banners on the doorframe indicated we were in the right place.

We climbed the stairs to the top floor. I expected Lewis to take the lead, having dealt with and gotten what he wanted from Chinese officials far above Liu Ping's position. If he was just a fraction as insistent here as he was with other people, Liu Ping would have no chance. Emboldened, I started thinking about where we could rent excavation equipment and wondered if I should contact an archaeologist I'd met in Jingdezhen. But Lewis dawdled, waiting for me to go in first. "So what are you going to say?" he asked.

I told him, but he looked skeptical. "Yes, that might work," Wu Yi Po said, grabbing his arm. "Give it a shot. Why not?"

I led them up the stairs, but Liu Ping's office was empty. In another room I found a pair of men at their desks, smoking. Liu Ping was out, one of the men said, expecting us to leave. After a bit of cajoling, I convinced the man to call him.

He had a brief exchange with Liu Ping in the local dialect and then handed me the phone. I noticed that Lewis was still in the hallway, suddenly preoccupied with his phone. I introduced myself to Liu Ping and tried to explain my desire to rent the property.

"Oh, no, I can't do that," Liu Ping said. "If you want to do that, you need to talk to the Lushan or Jiujiang government."

"I see. Which one?"

"Yes, exactly."

"Sorry, you said either the Lushan or Jiujiang government. Which one should I talk to?"

"Yes, that's right."

He seemed to be doing it on purpose, and I thought it best to get off the phone before I said something impolite. "Sorry, my Chinese isn't very good, and I'm worried I'm misunderstanding you," I said. "Maybe you can talk to my grandaunt. She's here beside me."

I handed the phone to a startled Wu Yi Po, who looked as if she weren't expecting to provide anything more than moral support. "Hello, with whom am I speaking?" Wu Yi Po said in her most pliant voice. "Are you local? So am I! Can you speak Jiujiang dialect? Yes? Wonderful! Please feel free to speak Jiujiang dialect." She explained that she was a Xingang native and repeated our desire to rent the property, but he gave her the same runaround. I looked for Lewis, who still had not entered the office.

Wu Yi Po hung up, and we left. "He said he can't help us and that we need to go talk to the Xingang government, or Jiujiang government, or whatever," she reported. "He wasn't clear with me, either. But the point is he's not going to help and isn't going to introduce us to the right person, either, so we have no *guanxi* if we try somewhere else."

Lewis finally spoke. "That was a polite way of telling us to fuck off," he said.

We walked back to the street and stood in front of the shopping center. I wasn't sure what more to do or say. Wu Yi Po nodded toward a KFC. "Why don't we get a coffee," she said. Lewis said he wanted to get his shoes shined and would meet us in the restaurant.

Wu Yi Po and I drank our coffees in silence. After a few minutes, Lewis rejoined us. "What the hell, man?" I said. "What happened in there?"

"I know my limitations," he said. "I could tell right away that they weren't going to help. There wasn't anything I could do there. I used to have power. Not anymore."

"Great," I said. "Now what?"

"Now nothing," Lewis said. "If you stay here, they're going to just pass the buck."

"Maybe we should just tell them about the porcelain," I said. "See what they say."

"Why the hell would you let someone else dig for our stuff?" Lewis said. "If we're not going to dig it, no one is."

I didn't say anything for a while. Lewis stared out the window. "Hey, Huan," he said, "China changes. You think in 1983 I knew China would be like this? I'd be a billionaire. If Wu Yi had known, would she have left? Maybe you can't dig, but you can pass this story down to your son, and by then China will have changed, you can buy land, and he can do it. It's like Yu Gong Yi Shan."

"What's that?" I said.

"It means 'foolish man moving mountain,'" Lewis said. "It's a story." Wu Yi Po nodded in recognition. "This old man in ancient times lived in a house right in front of a mountain," Lewis continued, "and it was very inconvenient for him to go anywhere. So one day he went out with a shovel and started to try and move the mountain. The other people in the village all laughed at him, said he was a fool. And he said, 'What are you laughing at? Maybe I can't move it, but I have sons, and my sons will have sons, and eventually we're going to have enough people to finish the job.' And they did it!"

I WAS STILL thinking about that story the next morning, when I accompanied Wu Yi Po and Lewis to the former Rulison school. Wu Yi Po wanted to have a look around at her old school and drop off a few copies of my grandmother's testimonial booklet at the alumnae office. For better and worse, China happens on its own time, so I tagged

along to see what remained of the institution that had played such an important role for my family.

Situated on a shady, treelined avenue along the lake, Rulison and its brother school, Tong Wen, once had adjacent campuses separated by a wall, but the wall had since been knocked down, the schools combined, and the institution of more than three thousand students was officially renamed "Jiujiang No. 2 Middle School."

We entered the front gate, along which hung red posters of Tong Wen's famous alumni, student prize winners, and the top scorers from the previous year's *gaokao,* arranged by the rank of the university to which they had won acceptance. A long walkway led to the original Tong Wen building. To our left, beyond a full-size soccer field, the terrain rose, and a few of the old Rulison buildings remained.

We entered the Tong Wen building. The interior was spare, utilitarian, and downtrodden but fairly well preserved. Most of the doors, askew in their frames, were closed and locked. Between the cracks we saw exhibits and display cases relating to the school's history. At the top of a flight of rickety stairs, we found a woman in an office. Wu Yi Po explained to her the family's connection and showed her my grandmother's booklet. The woman seemed uninterested and suspicious. She was in the education department, she said, and couldn't help. We would have to talk to the principal. Wu Yi Po asked if she could open the doors to the history exhibition. The woman had already returned to her papers. Go downstairs and ask the person in charge of the building, she said, without looking up.

Downstairs, Wu Yi Po knocked on the building manager's door. A woman slightly younger than Wu Yi Po answered, looking angry. "Hello," Wu Yi Po said. "I'm an old alumna, and they told me upstairs to ask if you could open the door to those rooms."

"Not possible. Go ask the principal."

"Oh, sure," Wu Yi Po said, keeping her voice light. "Could you tell me where to find the principal?"

The woman turned away and walked into the long, narrow room.

"Can you tell me the principal's name?" Wu Yi Po continued, stepping into the doorway. "Miss? Miss?"

The woman walked back and shut the door in Wu Yi Po's face.

"Fucking China, man," Lewis said.

Outside the building a group of students pointed us to the principal's office, in an expansive multistory building encased in yellowing sanitary tiles. On the third floor we found the office for the alumnae association and were sent up one floor to the principal's office. Lewis drifted away to play with his phone. At the principal's office, a circumspect administrator stonewalled Wu Yi Po. Lewis suddenly appeared. "Listen to me!" he said, sticking a finger in the administrator's face. "This is my aunt. Our entire family were alumnae of this school. My mother is Liu Pei Jin. I'm the former president of the Zhenda chicken farm. Your people were extremely rude to her just now. She's come all this way from America, and you turned your back on her. I'm very upset with the way you've treated us."

The principal arrived, a middle-aged man with dyed hair and wearing dark pants and a white dress shirt, the picture of a second-tier city bureaucrat. Lewis shifted his aim without missing a beat. "My brother is Richard Chang," he barked at the principal. "He came here a few years ago and met with the mayor and the party secretary. You know how many Zhenda chicken farms are in China? Two. And do you know why they are here? Me. We've donated lots of money to this school over the years, and yet when we show up, we had the door closed in our faces. My aunt's being polite, but I have to say this. How can you treat her like this? I'm very angry." Lewis went on, detailing every instance of rudeness we experienced and insinuating that we knew highly placed people who could make their lives miserable. It was dazzling to witness.

The principal held out his hands in a conciliatory pose. "We're so sorry," the principal said. "We weren't expecting you. If you'd just called, we'd have made arrangements. Please accept our apologies."

In a blink Lewis switched from anger to grace. "It's fine," he said, smiling and making expansive motions with his arms. "We just didn't think it was right, whether or not we'd made an appointment. I'm sorry for getting upset."

The principal dispatched two underlings to show us around the campus. One of them produced a camera, and we all posed for a photograph. The principal took the booklets from Wu Yi Po with two hands. "And of course we'll accept these booklets," he said, flipping through one for our benefit. "We're very grateful. We'll put them in our library."

As we reentered the old campus to begin our tour, one of the underlings circled us like a paparazzo, snapping photographs, and the other prattled about the school's history, its size, and the age and number of its camphor trees. "Hey," I said to Lewis, "what was that all about?"

"Sometimes I'm a son of a bitch, but it works, man," he said.

"Where was this when we went to see that official?"

"Oh, this is easy," he said. "Getting the house back is kind of difficult."

The underling led us back into the Tong Wen building and unlocked the doors to the exhibitions. The wooden floors groaned under our feet. On the walls were old photographs, arranged in a rough chronology from the schools' founding through the Communist takeover. There was a portrait of an elderly Gertrude Howe, her name written as Hao Geju in Chinese in the caption. The photographs from before 1949 showed students wearing dresses and bobby socks, or skirts and leggings, faculty dressed in a mixture of Chinese and Western clothes in various colors, a group of boys in basketball uniforms, and costumed girls giving dance performances on the lawn. After 1949 the dress became uniform and drab. There were shots of girls drilling with wooden rifles, students working in factories, farms, and fields, and a "political exercise" parade through downtown Jiujiang. In a photograph of the school's students and faculty gathered

before the Rulison dormitory in 1954, everyone wore shapeless, dark clothing. Before them, occupying the most prominent position in the frame, was their farming equipment.

Wu Yi Po peered at the photographs, looking for people she knew or recognized. "Oh, there's Ms. Ferris!" she said, pointing to a smiling woman with short hair and bangs swept to one side. "She had a mouth. Spoke her mind. She said something and got run out in 1950."

In another group photo, she pointed to a man wearing a light-colored worker's jacket. "See that guy?" she said. "That's the guy after Liberation who would watch you."

The underling seemed anxious to return, so we let him close up the rooms and said goodbye. We walked up the hill to the old Rulison campus, where the dormitory and academic building remained, their handsome brick exteriors and window trims tangled in a web of electric wire, water pipes, air-conditioning units, and corrugated metal awnings. The arched colonnade of the academic building's patios on each floor had been sealed up to create more interior space, and the corridor that had connected it to the dormitory was gone. The courtyard between the buildings was taken up by a blue metal structure on which someone's laundry dried.

San Gu had lived at the end of the second floor of the dormitory, Wu Yi Po said. The campus had been oriented toward the street, from which a treelined drive entered, curving past a lawn, a basketball court expressly for the girls, a pecan tree that the girls liked to pick from, and residences for the foreign teachers, where Ms. French sometimes invited students to have tea with her. "It's all gone," Wu Yi Po said. "Oh, they changed so much."

My GREAT-GREAT-GRANDFATHER had been one of three *xiucai* in Xingang. He was good friends with the other two, Tang Hou Cun's grandfather, Tang Hua Xian, and his younger brother, Tang Ren Zhi, who served as the general manager of the Minsheng Shipping

Company, which ferried goods up and down the Yangtze, from Shanghai to Chongqing. The three of them were said to have been in constant competition over who had the best porcelain collection. Tang Ren Zhi's position put him in regular contact with the Fuliang county commissioner in Jingdezhen, and he later wrote a biography of the commissioner. Tang Hou Cun reckoned that their friendship dated to about 1912. That might have been the detail that San Yi Po had appropriated in her recollections of her father. According to Tang Hou Cun, Tang Ren Zhi, who had lived next door to my grandmother's mother, had the most and best porcelain of the three village scholars, and as the leakage of imperial goods became more audacious after the Qing abdication, Tang Ren Zhi acquired a number of imperial porcelains, some of which were given to him directly by the Fuliang commissioner.

Before I fell out of favor with Tang Hou Cun, he had mentioned that some of Tang Ren Zhi's collection of imperial porcelains had survived. They used to be in Jiujiang but were recently moved to another town. He didn't explain why, but I got the impression it was for safekeeping, part of the same tradition that had resulted in the National Palace Museum collection's interprovincial travels.

On my last evening in Jiujiang, I called Tang Hou Cun and asked if he would take me to see those porcelains, and he agreed. We took a taxi to Ruichang, a town about thirty kilometers directly west of Jiujiang and known primarily for raising the best *shanyao*, or medicinal yams, in the province. It used to take hours to reach from the city, the taxi driver told me, but now it would be about thirty minutes thanks to the new highway. The highway was indeed new and, despite the light poles planted every few meters on each side, completely dark and choked with dust. It didn't seem to bother the driver, who left the windows open, forcing me to put my shirt over my face just to breathe. "Yes, it's bad," the driver said when I mentioned the dust to him. "It didn't used to be, but they've industrialized both sides of the highway. Lots of dust."

The windows stayed open, and we soon reached Ruichang's central roundabout, cluttered with construction and lit mostly by neon lights diffused through the nighttime smog. After pulling over twice to ask for directions, we took one of the unlit arteries to a gloomy Communist-era apartment building with metal bars over the ground-floor windows. Tang Hou Cun's relative, an elderly man wearing slippers, emerged from the shadows to greet us and led us into one of the jail-like first-floor apartments. The flat was dim, lit by bare bulbs and cluttered with old junk and outdated calendars, and consisted of one large, concrete-floored open space divided into a living room and kitchen by a threadbare floral print sofa. Opposite the barred windows were a row of bedrooms. Through the doorway of one I saw a mattress and a stack of silk-covered boxes. The relative introduced us to his grandson and granddaughter-in-law, a couple about my age, who rose from the kitchen table and stood nervously while Tang Hou Cun repeated the reason for our visit. No one invited us to sit down or offered tea. The grandson walked into the room with the boxes. "Okay," Tang said to me, "we'll take a look at the pieces and then we'll leave."

The grandson returned with two boxes, cleared a spot for them on the kitchen table, and removed a blue pear-shaped vase and a flambé red *ru* vase with decorative handles and a squared mouth. They had been gifts to Tang Ren Zhi from the Fuliang county commissioner. The grandson handed them to me one by one. Everyone stood, unnaturally tense, as if someone might be watching through the windows or I might break the pieces or run out with them.

"This is a *jihong ping* and a *cui lan ping*," Tang said, either wanting to show off his ceramic bona fides or remind me that he thought my Chinese was terrible. *Cui lan*, or "blown blue," he explained, referred to how glazers would use their mouths as bellows to spray the glaze onto the unfired vase. Even in the weak light, the vase pulsed with a rich blue luster, as if layered with every shade in the spectrum. *Jihong*, or "sacrificial red," was a radiant shade of crimson that potters had

sought to replicate for centuries but was so costly and complicated that it gave rise to the joke "If you want to go broke, make red glaze porcelain." Just as Europeans would later mix eggshells and bones into clay in search of the arcanum that would fire into perfectly white porcelain, Chinese craftsmen hoped that adding crushed coral and agate to their glaze formulas would create the depth they sought for their red. According to one of the many legends surrounding Jingde-zhen, the Ming emperor Xuande demanded red porcelain for worshipping the sun god and issued an imperial decree for Jingdezhen to produce it. The craftsmen tried again and again to no avail (archaeologists in the 1980s discovered acres of smashed red porcelain), and Xuande imprisoned, tortured, and threatened to execute those who failed. Finally the daughter of a jailed potter threw herself into the flaming kiln in protest, and when the doors were opened days later, they discovered the pieces were perfectly fired and colored. From then on that red was called *jihong*.

I turned the vases over to see that both bore the reign mark of Guangxu, the second-to-last emperor of the Qing dynasty, though the blue one's mark was pierced through and the red one's was rubbed away; effacing the seal was a common practice when the emperor gave imperial wares as gifts. These were real imperial porcelains, not in a museum, an auction house, or wealthy collector's home. They had remained in China for their entire existence, no more than a hundred miles from their birthplace, and had somehow managed to survive a century in which everyone, Chinese or otherwise, seemed intent on removing them or destroying them.

"So do you all live here?" I asked, trying to lighten the mood.

"Yes," the grandson said.

"Huan, no time for conversation," Tang snapped. "Take some photos, and then we're leaving."

It didn't occur to me until later that those vases might very well have once belonged to my great-great-grandfather. Wouldn't the trio of Xingang *xiucai,* in the spirit of erudite competition, have

bought and traded porcelains with one another? And for all the exalted figures in the Liu genealogy, there seemed to be just as many shady characters who weren't above stealing the family porcelain. Tang Hou Cun's no-good father was still around when my great-great-grandfather fled to Chongqing, when I imagined him at his most desperate. Who would have stopped him or someone else from digging up the Liu treasures or selling the details of their location to someone while my great-great-grandfather was away, or after he died? Tang Hou Cun had even told me that the Tang families were the ones who really "played" porcelain, and many of the pieces in my great-great-grandfather's collection were the ones they didn't want. Perhaps Tang was rushing me because he worried that I might try to reclaim the vases.

I fumbled with my camera and snapped some blurry, underlit photos. Stalling, I asked the grandson how the family had managed to keep these pieces for so long. "They were hidden in the walls of their house during tumultuous times," the grandson answered.

"They're great pieces," I said. "You should display them."

That elicited a sharp, humorless laugh from the grandson. "Our financial standing isn't good enough to display them," he said, shaking his head.

Tang had pressed himself alongside me and began to physically move me toward the exit. There was so much more I wanted to ask. "Well, they're worth something now," I said, hoping to admire the vases just a little longer. "You could put them in auction."

"They mean too much to the family," the grandson said. "Someone tried to buy them a few years ago, but we refused to sell. They have too much sentimental value. We've had a fire, a flood, and two earthquakes, and we've protected them well. We won't sell them."

Then Tang Hou Cun pushed me out the door and back into the darkness.

A Note on Sources

UNDERSTANDING CHINESE HISTORY CAN FEEL LIKE TRYING
to drink while you're drowning, and the excess of perspectives, room
for debate, and changing understandings often resign the amateur
historian to, instead of verifying the truth, making sure information
is not untrue. When it came to my family history, I had no choice
but to take my relatives' words for it, though I attempted to triangu-
late what they told me as much as possible. With regards to Chinese
history, particularly local histories, my first encounter with it was
often in conversation, after which I would look up whether or not
what I was told was, indeed, the case—a process limited by the num-
ber of available English-language sources. Though I try to present as
broad a historical context as possible, it's up to the reader to decide
what and how much to believe, just as I had to. Any inaccuracies are
unintentional.

Much as the blurring of fact and mythology is part of Chinese
history, so too was the case for my family's history, especially the di-
alogue that I recount verbatim from relatives. Since so few primary
sources from my great-great-grandfather's, great-grandfather's, or
even grandmother's generation survived, I was left to trust the recol-
lection of family members in reconstructing dialogue for those scenes.

Certain background sources were not as fraught and were thus in-
valuable. For Chinese history in general, I leaned heavily on Jonathan

Spence's *The Search for Modern China*. Material on the Palace Museum's history came from Bruce Doar's research. The background on the construction of the Ginling College campus came from Jeffrey W. Cody's article "Striking a Harmonious Chord: Foreign Missionaries and Chinese-style Buildings, 1911–1949." Essays by Pankaj Mishra and Ian Johnson provided information about the Great Leap Forward. Other sources I consulted include Jin Feng's *The Making of a Family Saga: Ginling College* and *Colossus Unsung* by Bob Molloy.

Acknowledgments

ONE OF THE MANY THINGS I WAS INTRODUCED TO IN CHINA was the idea of *renqing*, a kind of Chinese Golden Rule that I encountered throughout my time there and long afterward. This book would not have been possible without the countless—and occasionally nameless—people who exemplified *renqing* by assisting me without hesitation or expectation of reciprocation.

For those who can be named, I must start with my family. Thank you to Richard and Scarlett Chang for their boundless generosity, support, and concern for my well-being. A full accounting of all the reasons for my appreciation would be too long to list, and I hope that my affection for them is as evident as theirs was for me. To Lewis Chang, who was an indispensible source of both Chinese and family history, who never hesitated to help with matters big or small, book-related or not, and who has been one of my staunchest allies throughout this project. And to Andrew Chang, whose kindness was expressed in both faith and works, including reviewing early drafts of the manuscript.

A special thanks to my parents, who defied stereotype with their unfailing encouragement in my writing in general and the pursuit of this book in particular, for their love and sacrifices. They patiently and ungrudgingly served as counselors, research assistants, and translators, often in on-call capacities, and never once reminded me

that I probably wouldn't have needed so much help if I hadn't complained so much about attending Chinese school when I was young that they allowed me to quit. Sorry about that. And I'm grateful for my lifelong friendship with my brother, Fong.

One of the greatest joys of writing this book was the opportunity to discover or reconnect with the far-flung members of my extended family, who never failed to humble me with their hospitality. My grandaunts, Liu Pei Yu, Liu Pei Sheng, and Liu Pei Ke, and granduncles, Fang Zhen Zhi and Liu Cong Ji, spent many days with me sharing their memories. Tang Hou Cun and Chang Guo Liang treated me as one of their own. It's still difficult for me to comprehend everything that my grandmother Liu Pei Jin experienced during her life, which she lived with grace and love. I dearly wish that I could still talk to her.

When I joined SMIC, I gained another family, and I'm glad that those connections have remained even as we've been dispersed across the globe. My heartfelt thanks to all the friends who made contributions large and small to this book. Edie Hu for treating a broke writer no differently than one of her millionaire clients and allowing me to pester her with questions about porcelain history. All the folks in Jingdezhen, including Caroline Cheng, Takeshi Yasuda, Eric Kao, and Dryden Wells at the Pottery Workshop, Jacinta Huang, Ding Shaohua, Diana Williams, and Kai E and Huang Fei for helping me explore an endlessly fascinating place. Thank you to Karen Cohen for literally helping keep me sane. And Harriet, the undisputed greatest dog in the world; I hope you're doing well in Shanghai.

I'm indebted to John Moffett at Cambridge University's Joseph Needham Institute and Ching-fei Shih and Emily Lin from the National Taiwan University for reviewing portions of the manuscript relating to Chinese and porcelain history. Connie Shemo, Robert Murowchick, Sammy Or, Oliver Radtke, and Yibin Ni were also especially helpful in providing a better understanding of various parts of Chinese history. I did my best to get everything right, and any errors

are both unintentional and mine alone. The Netherland America Foundation was kind enough to support this project with a grant.

I've been waiting many years to thank my writing teachers in print: Beverly Lowry, Steve Goodwin, Dick Bausch, Susan Shreve, and Nancy Schoenberger. Alan Cheuse, whose literary journalism class led me to Leonard Roberge, who edited my first story, and Erik Wemple, who gave me my first newspaper job, where I learned everything I know about journalism. I'm thankful to Josh Levin at *Slate* for the opportunity to keep writing while in I was in China.

Thank you to Howard Yoon, friend and agent, for his wisdom and guidance. I'm grateful to Vanessa Mobley at Crown for her unwavering enthusiasm and insightful edits in shaping the manuscript, and to Miriam Chotiner-Gardner and Claire Potter for carrying it across the finish line.

I'm writing this from Amsterdam, my home for the past few years and where I never expected my search for my family's buried antiques would have taken me. But that's all thanks to my wife, Jennifer, who reminds me every day that I found a treasure far greater than porcelain in China.

Index

American-born Chinese (ABC), 40, 44
 language facility of, 97–99
 as outliers, 51–57, 106
 perspective of, 316–17
antirightist campaigns, 269–70, 291,
 292, 306–7
August the Strong, king of Saxony,
 186–87

Bainbridges auction house, 225–26
Bayi "Eight-One," 299
Beijing:
 Forbidden City, 85, 141, 150, 224
 Imperial Palace, 149
 Summer Olympics (2008), 258–59
 Summer Palace, 86, 223
 Yuan Ming Yuan, 80–81
Bonny (friend), 72, 74–75
Böttger, Johann, 186–87
Boxer Uprising, 91, 93, 223–24

Cai, Uncle, 314–15, 332
Castiglione, Giuseppe, 80, 84, 185
Chang En De (Andrew):
 and author's arrival and orientation
 in China, 13–17, 19–20, 27, 39
 and grandmother's illness and
 death, 239–41

health problems of, 47
job with Richard, 13–14
and meeting with Party officials, 70,
 72–73
Chang Guo Liang, 118, 160, 162–68
Chang Nan, 182
Chang Rugin (Richard), 164, 165, 349
 author's job with, 12, 14, 26–27,
 34–51, 58
 author's visits with, 14, 23–27
 business habits of, 48–49
 community projects of, 11
 companies founded by, 10–11, 18,
 71, 117, 304; see also SMIC
 evangelism of, 27, 49–51
 and family porcelain, 241
 and family visits, 303, 304, 315
 and Lewis, 66–67, 241
 meeting with Party officials, 70–75
 political connections of, 23, 71
 resignation from SMIC, 239
Chang Ruyi (Lewis), 137, 165–66, 260,
 281
 and family porcelain, 257, 324, 346
 and family property, 346–47, 354–
 56, 359
 and family visits, 65–68, 132, 258,
 279, 301, 303, 324, 332–33, 345–49

Chang Ruyi (Lewis) (*cont.*):
 investments of, 11, 47
 jobs of, 13, 347
 and Richard, 66–67, 241
 at Rulison, 356, 358–59
Chen, Maggie, 193, 194, 202
Chen Bang Ning, 299–301, 347, 349
Chen Duxiu, 141
Cheng, Alice, 224
Cheng, Caroline, 194–97, 214, 215–16, 227
Chenghua, Ming emperor, 222, 228
Chen Laoshi, 42, 251, 253–55
Chiang Kai-shek, 2, 11, 50, 67, 141–42
 campaign against warlords, 3
 flight to Chongqing, 247–48
 levees dynamited by, 152
 at Lushan, 127, 148, 312
 mausoleum of, 140
 and National Palace Museum, 142, 150, 151, 153
 Northern Expedition, 265
 political platform of, 141
 retreat to Taiwan, 153, 164, 267
 and Sun Yat-sen, 107–8
 vs. Communists, 151
Chicago, Field Museum, 8
china, birthplace of the term, 182
China:
 changing, 356
 civil war, 152–53, 169, 294, 350
 College English Test, 204
 Communism in, *see* Communism
 concubines in, 85
 copying in, 39, 214–15, 226
 daily life in, 29–34
 diaspora of antiques from, 223–24, 225
 digital piracy in, 32
 end of dynasty in, 3

examination system of, 39, 77–78, 83, 90, 93, 94, 111, 140, 169–70, 204, 265, 284, 291, 320
fake antiques of, 216–17
female infanticide in, 110
financial crisis in, 119
"five bads" in, 292
foreign trade with, 80, 84, 162, 184, 223
"four olds" in, 307
fruit in, 54–55, 100–101
guanxi (social network) in, 39
Hundred Days' Reform (1898), 90
Hundred Flowers Movement, 306
inheritance system of, 87
Japanese invasion of, 1–5, 9, 63, 163, 247–48, 283
library of, 9
map, xii-xiii
marriages arranged in, 94–95
missionaries in, 311, 331
modernization of, 85, 105
Mongol conquest of, 183
national treasures of, 151–53
"Ninth Institute" (nuclear weapons program), 271–75
public transportation in, 17, 21
railroads in, 92–93
Republic of, 107–8, 110, 140
revolution (1911), 149
self-examination, 140–41
Spring and Autumn Period, 281–82
stigma of stepmothers in, 88
Taiwan and, 168–71
technology in, 41, 104, 169
xenophobia of, 169
China Ceramic Museum, 189
Chinese culture, 21–23
 and ABCs, 51–56
 author's illiteracy about, 76–77
 continuation of, 227

and education, 149
 Han, 185
 porcelain in, *see* porcelain
 preservation of, 151–53
 Taiwan as repository of, 142, 143,
 153
 tea, 161–62
 underground, 80, 307
Chinese language:
 and behavior, 103, 104
 changing, 103–4, 105
 characters of, 98
 chengyu, 106
 in Chinese-speaking household,
 97–98
 and culture, 106
 English equivalents of, 105–6
 four tones in, 98
 iconography of, 104, 106
 kinship terms, ix-x
 lessons in, 12, 19, 27, 99–106, 119
 names, x, 43–44
 pinyin transliterations, ix, 43, 144,
 169
 in Taiwan, 138
 translations, ix, 43
 Wade-Giles conventions, ix, 43, 93,
 143, 169
Christa (instructor), 39
Christie's, Hong Kong, 225–26
Cixi, Empress, 77, 85–86, 90–92, 187,
 223
Communism:
 birthplace of, 294
 and civil war, 152, 294
 internal strife fomented by, 153,
 306
 Kuomintang vs., 142, 145, 151, 267,
 294
 land redistribution by, 294, 297
 and Long March, 294
 and privatization, 187–88

rise of, 9, 10, 140, 312, 331
 and social classification, 352
Confucian teaching, 39, 77
 Communist criticism of, 141
 traditional, 109–10, 127
Crystal (language teacher), 101–6
Cultural Revolution, 42, 166, 244, 276,
 285, 291
 criticisms in, 306
 destructiveness in, 300, 307
 and economic change, 101
 end of, 279, 292
 and "four olds," 307
 mob violence in, 300
 persecution in, 273–75, 329
 "reeducation", 277–78, 329
 and sculpture, 195

Da Biao Yi (Taiwan aunt), 134–35,
 145, 146, 148
Da Biao Yi (Beijing aunt), 260, 272,
 277–79
Dai Chang Pu, 136, 137–38, 145, 235
Deng Xiaoping, 39, 279, 291, 292,
 300
Ding Shaohua, 203–5, 207, 211, 212,
 231–32

education:
 and Chinese culture, 149
 in Qing dynasty, 93–94
 sishus (academies), 77–78, 110
 traditional, 118
 of women, 94, 110–14, 156, 331
England, country potters in, 189
Entrecolles, François Xavier d', 186
Er Yi Po, *see* Liu Pei Fu

Fang Zhen Zhi, 259–62, 264–76, 292,
 316, 317
Field Museum, Chicago, 8
Frederick I, Emperor, 186

Fuliang, author's travel to, 211–13
Fu Sifu, 198–202

German "sphere of influence," 280–81
Giles, Herbert, 93
Ginling College, Nanjing, 113–14, 125, 156, 246, 249–56
grandmother, *see* Liu Pei Jin
Great Leap Forward, 105, 166, s269–70
Guangxu, Qing emperor, 86, 90, 92, 308
Guanyin (goddess of mercy), 235
Guan Zhong, 281–82
Guling, author's visit to, 310–16
Guo Wen Can, 288–89

haigui (sea turtles), 40
Han Yu, 307
Heshen, power of, 82–83
Hong Kong:
 ceded to Britain, 82
 Japanese invasion of, 158
Hongwu, Ming emperor, 184, 228
Hong Xiuquan, 83
Hongzhi, Ming emperor, 85, 222–23
Howe, Gertrude (Hao Geju), 111, 359
Hsu, Fong, 239, 241
Hsu, Huan:
 childhood of, 7, 13
 Chinese lessons of, 12, 19, 27, 99–106
 on digging for family porcelain, 227–28, 230, 241, 323, 325, 333–35, 339–44
 and food, 54–55, 58–59
 his own apartment, 100, 193–94, 202–3
 job with Richard's company, 12, 14, 26–27, 34–51, 58
 and meeting with Party officials, 70–75
 mythology created by, 344–45
 name of, 36–37, 42–43, 45, 67–68, 245, 280
 teaching English, 246
 traffic confrontations of, 119–24
 travel to China, 12
Hu, Edie, 220–26
Hu, Speaker, 71–74
Huang Fei, 213–17, 219–20
Hundred Days' Reform (1898), 90
Hundred Flowers Movement, 306
Hutian kiln, 209

Imperial Gardens, destruction of, 84–85
Ivy (human resources), 35–37, 42

Jacinta (guide), 175–77, 193
Japan:
 artists in, 197
 ceramics in, 189
 China invaded by, 1–5, 9, 63, 163, 247–48, 283
 China occupied by, 152, 235, 305–6
 Manchuria attacked by, 151
 modernization of, 169
 Pearl Harbor attacked by, 158
 Rape of Nanking, 156, 247–49
 and Sino-Japanese Wars, *see* Sino-Japanese Wars
 surrender in World War II, 139, 152, 266, 294
Jewel (human resources), 99–100
Jiangxi, Long March from, 294
Jiang Yi Ming, 227, 229–30
Jiang Zemin, 48, 189
Jiaqing, Qing emperor, 83
Jingde, Song emperor, 182
Jingdezhen, 194–97
 archives of, 231–33
 author's move to, 192–94, 202–3

author's travel to, 172–73
development, 229
imperial kilns in, 9, 73–74, 80, 147, 183, 184
kaolin deposits near, 183–84
kiln museum in, 178–79
Liu family history in, 211, 257
market in, 213, 215–20
in Mongolian occupation, 183
political cadres in, 188–89
porcelain in, 148, 172, 176–77, 180–92, 224, 244, 299
Pottery Workshop in, 173–77, 179–80, 189, 194, 195, 197, 204
research center in, 227–30, 243
Sanlu Temple in, 211
Sculpture Factory in, 195–97
Jinling Arsenal, 159–60, 163
Jiujiang:
author's travel to, 299
Communist takeover of, 351
history of, 330–31

Kai E, 204–5, 206–7, 213, 215
Kang Cheng (Ida Kahn), 111
Kangxi, Qing emperor, 80, 184, 185, 216, 223, 308
Ketagalan aborigines, 143
Khan, Kublai, 183, 184
Kong Rong Rang Li, 101–2
Ko Sijia (Scarlett), 23, 238, 240
Kuling, 313; *see also* Guling
Kuomintang, 107–8
and civil war, 152–53
and Communists, 142, 145, 151, 267, 294
corruption of, 142
and Sino-Japanese War, 2, 131
in Taiwan, 142–43, 166

Lao Tzu, 171
Lee, Bruce, 45

Library of Congress, Washington, D.C., 151
Lin Biao, 273, 274
Lin Zexu, 81–82
Little, Edward Selby, 311–12, 313
Liu Cong Ji, 108, 135, 235, 236, 258, 280, 301
and antirightist campaign, 291, 292
author's visits with, 281–93
childhood of, 125, 128, 283–84
and San Gu, 289–90, 291
Liu Cong Jia, 108, 283
Liu Cong You, 287, 327–29, 333–35, 336–37, 339–44, 348
Liu Feng Shu:
birth and early years of, 77–79
charity of, 87
and Chinese history, 92
and civil war, 294–95
and Communist takeover, 296–98, 329
culture of, 305, 307
death of, 298, 329, 353
estate of, 1, 79, 86–89, 95–96, 145, 235–36, 258, 286–87, 296, 321, 327, 328, 353
family tree, xi, 117
final years of, 294–98
fleeing Xingang, 5, 127–31, 157, 234–35, 283–84, 305, 322, 328, 351, 364; (map), xiv
household of, 126, 145
and Japanese invasion, 1–5, 9, 63, 235, 350
photo of, 288–89
porcelain buried by, 115–16, 128, 136, 148, 151, 155, 262, 263–64, 318, 323, 350
porcelain collection of, 2, 4, 10, 74–75, 89, 146, 227, 229, 286, 308, 346

Liu Feng Shu (*cont.*):
 return to Xingang, 235–37, 284;
 (map), xiv
 and Sino-Japanese War, 127–31
 strong personality of, 109, 126–27
 as teacher, 78–79, 130, 234
Liu Fu Chu, 348–49
Liu Li Dong, 291
Liu Li Nan, 289, 290, 292–93
Liu Pei Fu [Er Yi Po], 108, 136, 279,
 295, 347
 death of, 117
 and Japanese invasion, 2–3
 and wartime evacuation, 128
 in Xingang, 125, 126, 147
Liu Pei Jin (grandmother):
 author's visits with, 46, 60–65,
 68–70, 115–19, 246
 birth of, 96, 107–8
 early life of, 109–11
 and Ginling, 113–14, 125, 156, 166,
 247, 253, 256, 257
 illness and death of, 238, 239–41,
 244–45
 in Macau, 4, 64, 157–58, 159, 234
 marriage of, 160
 munitions factory work of, 159–60
 name of, 108
 old photos of, 145
 and porcelain, 116–17
 and religion, 135, 166
 return to China, 158–59
 and Rulison, 111–12, 113, 303, 318,
 325–26, 356, 358, 360
 in Shanghai, 11–12, 26
 and Sino-Japanese War, 130–31
 in Taiwan, 10
 in Xingang, 108–11
Liu Pei Ke [Wu Yi Po], 108, 279
 and author's visit, 345–47, 348–60
 and family cemetery, 324, 347, 348,
 351

 and family porcelain, 350, 354–55
 in Guizhou, 136, 235
 in military nursing school, 353–54
 and Rulison, 236, 351–52, 356–60
 and wartime evacuation, 128, 129,
 351
 in Xingang, 125, 284
Liu Pei Sheng [Si Yi Po], 108, 165, 279
 author's visit with, 257–58, 259–64,
 280, 304
 and family porcelain, 262, 263–64
 and Japanese invasion, 3
 marriage of, 266
 in the military, 130
 and ration tickets, 292–93
 at Rulison, 234
 in Xingang, 117, 125, 126, 128
Liu Pei Yu [San Yi Po], 108, 125
 author's visit with, 132, 134–38,
 144–47, 153
 death of, 324
 family memories of, 211, 314
 and family porcelain, 118–19, 128,
 350
 marriage of, 136, 137–38, 145, 235
 in the military, 130
 at Rulison, 136, 234
 visit to Xingang, 153–55
Liu Ping, 338, 354–55
Liu Ting Geng:
 birth of, 88
 as civil engineer, 94, 125, 135, 283
 concubine of, 324
 death of, 135, 234, 284
 in Jingdezhen, 192, 232
 and Lushan villa, 148
Liu Ting Gong:
 birth of, 88
 and Communism, 295–96
 death of, 291, 307
 education of, 94, 286
 family abandoned by, 129, 234

family of, 116, 235, 280, 290–91, 298
mistress of, 291, 296
work of, 125, 236
in Xingang, 351, 353
Liu Ting Yi [San Gu], 89, 301, 307
death of, 290
marriage of, 288–89
in Nanjing, 113–14, 125
at Rulison, 111–12, 113, 136, 236, 283, 284, 289, 326, 329
wartime evacuation of, 128, 131
Liu Ting Zan:
birth of, 88
death of, 112
family of, 109–10, 111, 117–18, 127, 128, 286, 290
railway work of, 94, 95, 96, 109, 117, 127
studies of, 108, 109
Liu family:
blossoming of, 305, 349
culture of, 307, 333
daughters educated, 110–14
old photos of, 144–45, 288–89, 351
sisters' strength in, 290, 293
and wartime evacuation, 128–31, 136
in Xingang, *see* Xingang
see also Liu Feng Shu
Long March, 294
Luo Sifu, 196
Lushan:
film about, 315–16
Liu family villa in, 310, 313–16
resort of, 127, 148, 311–12, 335

Mao Zedong, 75, 105, 292
and civil war, 50, 152
death of, 279, 289
and Long March, 294
in Lushan, 312, 313

political movements of, 142, 269–70, 297, 306–7
and porcelain (Mao ware), 242–44, 308
sculptures of, 195–96
maps:
China, xii–xiii
Liu Feng Shu's journey: fleeing Xingang, xiv; return to Xingang, xiv
Poyang floodplain, xv
May Fourth Movement, 105, 141, 142
Ma Yin-jeou, 67
Meissen porcelain, 187
Mencius, 110
Ming dynasty, 181–82, 184, 222–23, 228, 247, 308
Moody, Dwight, 311
Murphy, Henry, 252

Nanjing, 246–48
as dynastic capital, 247
Ginling in, *see* Ginling College
as Jinling, 246
Rape of Nanking, 156, 248–49
Nanjing Safety Zone, 247–49
Nationalist army:
and civil war, 152–53
and Communists, 3, 142, 145, 267, 294
and Japanese invasion, 2, 131
see also Chiang Kai-shek; Kuomintang
National Palace Museum, 142, 149–53, 294, 361
Needham, Joseph, 170

Old Yang, 4, 283
and burial of property, 296
return to Xingang, 236, 284
wartime evacuation of, 5, 128, 130, 235

Olympic Games, Beijing (2008),
258–59
Opium Wars, 9, 77, 81–82, 83, 84, 85,
90, 91, 159, 223

Panda Chinese, 100–106
Pang Zhong Li, 284, 285–86
Pearl Harbor, 158
People's Liberation Army, 299
porcelain:
auctions of, 222–27, 244
authenticity of, 226–27
copies of, 214–19, 226–27, 244
dragon kiln period, 190, 209
emperor's reign marks on, 184, 216,
308
foreign trade in, 81
in history, 181–87, 228–29
imperial kilns, 86, 147, 184–85, 187,
361
in Jingdezhen, see Jingdezhen
kaolin in production of, 183–84,
187, 218
Liu family collection, see Liu Feng
Shu
Mao ware, 242–44, 308
Meissen, 187
in National Palace Museum,
149–53, 361
as priceless, 216
from Qing dynasty, 147, 149,
184–85, 216, 223, 224
quality of, 223
in Seattle Art Museum, 8–9, 74
shards, 190–92, 198, 199–202, 204,
206–7, 228–29, 317
and Tang Hou Cun, 308, 323, 361,
364
and Tang Ren Zhi, 361,
362–63
and tea culture, 162
Western influences in, 185, 187

wide interest in, 73
Zhang's collection of, 242–44
Poyang floodplain, map, xv
Puyi, Qing emperor (last emperor),
92, 150

Qianlong, Qing emperor, 8–9, 80,
82–83, 150, 184, 216
Qi Huan Gong, 67–68, 281, 282
Qing dynasty, 351
and Boxer Rebellion, 91
education in, 93–94
end of, 3, 9, 83, 89, 92, 110, 296, 331,
361
porcelain from, 147, 149, 184–85,
216, 223, 224
and railroads, 92–93
rise and decline of, 79–86, 221
Qin Shi Huang "First Emperor," 282,
307
Qi Sifu, 205–11, 212

Rabe, John, 247, 248–49
Romance on Lushan (film), 315–16
Rulison-Fish Memorial School:
author's visit to, 356–60
Liu family daughters as students in,
111–14, 144, 234, 236, 283, 351
and Liu Pei Jin, 111–12, 113, 303,
318, 325–26, 356, 358, 360
and San Gu, 111–12, 113, 136, 236,
283, 284, 289, 326, 329
and Tong Wen Academy, 289,
329–30, 331, 357
wartime evacuation of, 128, 131, 234

San Gu, see Liu Ting Yi
San Yi Po, see Liu Pei Yu
Sassoon, Victor, 17
Schleman, Laura, 145
Seattle Art Museum, 8–9, 74
Shang dynasty, 181

Shanghai, 17–19
 author's arrival in, 13–18
 author's return to, 238–40
 Communist takeover of, 267, 268
 shopping in, 18–22, 28–29
 skyline of, 18
Shanghai Museum, 221
Shi Er Heng, 260, 261
Shi Meiyu (Mary Stone), 111
Sima Guang, 111
Sino-Japanese Wars, 9, 64, 118
 First (1895), 86, 90, 92, 93
 Second (1937), 127–31, 151, 157, 263,
 265, 283, 305, 312, 350
Sivin, Nathan, 170
Si Yi Po, *see* Liu Pei Sheng
SMIC (Semiconductor Manufacturing
 International Corporation),
 11, 66
 author's orientation to, 35–40,
 45–49
 employees of, 51
 and financial crisis, 119
 financing of, 47–48
 Internet connections in, 41
 IPO, 47
 lawsuit against, 46–47, 239
 regulations of, 44–45
 reorganization of, 239
Smith College, 250, 253
Song dynasty, 111, 152, 182–83, 213
Soong Mei-ling, 127, 148, 312, 313
Sotheby's, Hong Kong, 220–27
Stuart, John Leighton, 312
Sun Yat-sen, 107–8, 141, 331

Taipei, 132–34
Taiping Heavenly Kingdom, 83–84
Taiwan:
 as Asian "tiger," 141
 assimilation of, 144
 author's time in, 132–34, 138–55

Chiang's retreat to, 153, 164,
 267
 China and, 168–71
 food in, 139–40
 government in exile, 171
 as Japanese colony, 139
 Japanese occupation of, 90
 Kuomintang in, 142–43, 166
 language in, 138
 Liu family in, 10, 160, 167–68, 267
 as repository of Chinese culture,
 142, 143, 153
 tea country of, 161–62
 228 Massacre in, 142–43
 White Terror in, 142
Tang dynasty, 181
Tang Hou Cun, 324, 332–33, 347,
 348–49
 and author's visit, 258, 299, 301–9,
 314, 318–23, 360–64
 and family porcelain, 308, 323, 361,
 364
Tang Hua Xian, 301, 360
Tang Ren Zhi, 360–61, 362–63
Tao Te Ching (Lao Tzu), 171
Ten Great Factories, 187–88, 195, 196
Thousand Character Classic (poem),
 105
Three Kingdoms era, 349
Thurston, Matilda Calder, 253
Tong Bin, 179
Tong Wen Academy, 112, 234
 and Rulison, 289, 329–30, 331, 357
Tongzhi, Qing emperor, 77, 85, 86, 92
TSMC (Taiwan Semiconductor
 Manufacturing Corporation), 10,
 46, 239

Vautrin, Minnie, 249

Wang Laoshi, 249–55
Wedgwood pottery, 187

Wellesley College, 250
Wild Strawberries movement,
 140
women:
 bound feet of, 110
 education of, 94, 110–14, 156,
 331
 not seen in public, 125
WSMC (Worldwide Semiconductor
 Manufacturing Corporation), 10
Wu Yifang, 250–51, 254
Wu Yi Po, *see* Liu Pei Ke

Xianfeng, Qing emperor, 85
Xingang:
 author's intention to visit, 118–19,
 147
 author's quest in, 318, 323, 325,
 336–42, 344–45
 and civil war, 294–95
 Communist takeover of, 116, 146,
 148, 296–98, 306
 development in, 322, 326
 flood (1954) and relocation of, 117,
 322
 Japanese invasion and occupation
 of, 1–5, 305–6
 Liu family cemetery in, 118, 298,
 309, 319–20, 324, 333, 347–48,
 350–51
Liu family in, 108–11, 112, 125–31,
 236–37, 342
Liu family property gone from, 146,
 148, 287, 321, 349
Liu family visits to, 117, 146–47,
 153–55
Liu in, *see* Liu Feng Shu
Xuande, Ming emperor, 222, 228
Xu Xia Ke, 172

Yanan, 277–78
Yao Meng Mei, 291, 324
Yasuda, Takeshi, 180, 186, 189, 190,
 191, 195, 219
Yellow Emperor, 280
Yongle, Ming emperor, 228
Yongzheng, Qing emperor, 80, 82, 184,
 216, 224
Yuan dynasty, 183–84
Yu Gong Yi Shan (foolish man moving
 mountain), 356
Yu Sifu, 325, 333–35, 337, 339–42

Zhang (guide), 178–79
Zhang, Ms. (landlord), 193–94,
 202–3
Zhang Laoshi, 42
Zhang Songmao, 242
Zhen Laoshi, 326, 329–32
Zhou Enlai, 271, 273, 312, 314